THIRSTY?
BOSTON

THE LOWDOWN ON

WHERE THE

REAL PEOPLE

DRINK!

Edited by Victoria Young and Minh T. Luong

Printed in the United States of America

First Printing: July, 2009

10 9 8 7 6 5 4 3 2 1

Library of Congress Cataloging-in-Publication Data
Thirsty? Boston:
The Lowdown on Where the Real People Drink!
by Hungry City Guides
224 pages
ISBN 13: 978-1-893329-42-3
I. Title II. Food Guides III. Travel IV. Boston

Production by Bonnie Yoon Design

Visit our Web site at www.ThirstyCityGuides.com

To order this Thirsty? or our other
Hungry City Guides,
or for information on using them as corporate gifts,
visit us at HungryCityGuides.com

Hungry City Guides are available to the trade
through SCB Distributors:
(800) 729-6423
www.SCBDistributors.com

Hungry City Guides strives to
provide you with books that are made from at
least 40% post consumer waste recycled fiber.

THANKS A BUNCH...

...to our contributors
Jennifer Adams, Kaitlin Alayan, Leah Bagas, Abby Bielagus, Jason Burnsworth, Suki Chang, Paul Collins, Chris Coveney, Bree Cummings, Jill D'Urso, Colleen Devine, Kate Finnegan, Lawrence Fong, Siobhan C. Ford, Joe Gallagher, Nolan Gawron, Django Gold, Kate Golden, Joshua L. Goldstein, Bridget Halverson, Shanon Heckethorn, Jessica Holmes, Jaime Kerry, Charlie Knoll, Andrew Ladd, Sarah Leech-Black, K. N. Liao, Kimberly Loomis, Minh T. Luong, Sam Mazzarelli, Avalynn Michaels, Stéphanie Naudin, Jason O'Bryan, Deepak O'Reilly, Kashlin Romero, Bridget Pelkie, Alison Pereto, Brandy Sprague, Neely Steinberg, Ryan Rose Weaver, Ashley Rossington, Matt Rusteika, Courtney Scott-Howard, Christina Tuminella, Alexis Vandeventer, Andrew Wiley, Arna Wilkinson, Stacy Williams, Sarah Wolf, Victoria Young.

...and to the people who helped make it all happen
Mari Florence (the mastermind behind the Hungry? guides), Bonnie Yoon (for her talents in design and production), Kaelin Burns, Heather John, Nadia Economides, and Jillian Williams (for taking the book through the final stages).

CONTENTS

CAMBRIDGE

SOMERVILLE

KEY TO THE BOOK

ICONS

Most Popular Menu Items

 Beer

 Coffee

 Cocktails

 Tea

 Wine

 Smoothie

 Desserts/Bakery

Ambience

 Early Bird

 Night Owl

 Live Music

 Editor's Pick

 Dance

 Solo

 Sports Bar

 Romantic

 Open Mic

 Outdoor

 Meet

 Landmark

 Strip Club

 Waits

 People Watching

Cost

Thirsty?
Cost of the average drink:

$	$5 and under
$$	$5 - $10
$$$	$10 - $15
$$$$	$15 and over

Payment

Note that many places that take all the plastic we've listed also take Diner's Club, Carte Blanche and the like. And if it says cash only, be prepared.

- **VISA** Visa
- **MasterCard** MasterCard
- **AMERICAN EXPRESS** American Express
- **DISCOVER** Discover
- **ATM** ATM
- **$** Cash only

Tipping Guide

If you can't afford to tip, you can't afford to drink. Remember, if the drinks are brought to you or made for you, you should probably leave a some sort of tip. Here's a guide to help you out:

Cost of Tab	Scrooge <15%	Thirsty? 20%	Thirsty! 25%
$ 15	<2.25	3	3.75
$ 25	<3.75	5	6.25
$ 35	<5.25	7	8.75
$ 45	<6.75	9	11.25
$ 55	<8.25	11	13.75
$ 65	<9.75	13	16.25

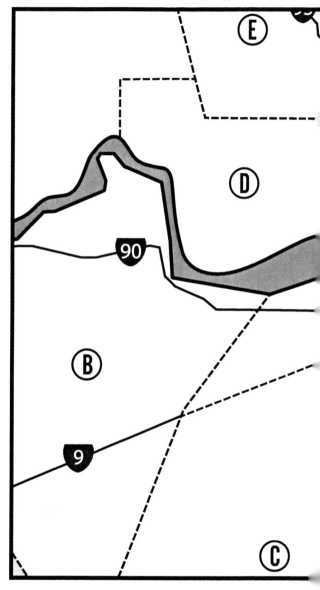

(A) DOWNTOWN BOSTON
- Financial District/Downtown Crossing
- North End
- Fort Point/Seaport District
- Beacon Hill
- Chinatown/Theater District
- South End
- Back Bay
- Fenway/Kenmore Square

(B) BOSTON – GO WEST
- Allston
- Brighton
- Brookline: Brookline Villag
- Brookline: Washington Sq

93

93

Boston Harbor

Ⓒ **BOSTON – GO SOUTH**
 - Jamaica Plain
 - Roxbury/Mattapan/Dorchester
 - South Boston

Ⓔ **SOMERVILLE**
 - Davis Square/Teele Square
 - Union Square
 - Medford

Ⓓ **CAMBRIDGE**
 - Kendall Square • Harvard Square
 - Central Square • Porter Square
 - Inman Square • West Cambridge

PLEASE READ

Disclaimer #1
The only sure thing in life is change. We've tried to be as up-to-date as possible, but places change owners, hours and menus as often as they open up a new location or go out of business. Call ahead so you don't end up wasting time crossing town and arrive after closing time.

Disclaimer #2
Every place in this guide is recommended, for something. We have tried to be honest about our experiences of each place, and sometimes jab or two makes its way into the mix. If your favorite spot is slammed for something you think is unfair, it's just one person's opinion! And remember, under the Fair Use Doctrine, some statements about the establishments in this book are intended to be humorous as parodies.

And wait, there's more!
While we list hundreds of drinkeries in the book, that's just the beginning of the copious eating and drinking opportunities in Boston. Visit ThirstyCityGuides.com for additional reviews, updates, and all the information you need for your next dining out adventure.

Tip, Tip, Tip.
If you can't afford to tip you can't afford to eat and drink. In the United States, most servers make minimum wage or less, and depend on tips to pay the rent. Tip fairly, and not only will you get better service when you come back, but you'll start believing in karma (if you don't already).

Road Trip!
And, next time you hit the road, check the Hungry? City Guides to destinations including: Chicago, New York, Washington DC, and many, many more!

Don't Drink and Drive.
We shouldn't have to tell you this, but we can't say it enough. Drink responsibly. Don't drive after you've been drinking alcohol, period. If a designated driver is hard to come by, take the bus or call a cab to take you home. Split the cost with your friends to make it more affordable.

Share your secrets.
Know about a place we missed? Willing to divulge your secrets and contribute? Visit our website at www.ThirstyCityGuides.com and click on "Contact Us". We'll be happy to hear from you!

INTRODUCTION

Boston, despite being the official capital of Massachusetts and the unofficial capital of all of New England, is relatively small. With 17 bars per square mile, the exploration of new places is part of everyday life. The Boston bar scene is undeniably influenced by the propensities of sports fans, college students and the Irish, but is also heavily swayed by tourists, locals and really any other well-rounded consumer. The constant flow among overlapping communities, the ever-changing economic status, and the city's enduring love for fine cuisine and drink shape Boston into a city worth exploring.

Thirsty? Boston guide delves into the quirky qualities and subtle flair behind each local business while celebrating the liquids and libations we eagerly seek out. Beer is taken quite seriously here with the tremendous support of local and microbreweries. Wine, too, is an inseparable aspect of the dining culture, which is already closely knit with the bar scene. Classic cocktails are considered to be a crafted art that is nostalgically intertwined with Boston's history and tradition. And new generations strive for odd concoctions and savvy flavor combinations that may or may not have a stance in the future of cocktailing, but are delectable nonetheless. And though Boston may have a reputation for its overall alcohol intake, the nonalcoholic beverages also share a role in the daily grind. Well-trod coffee and tea shops feel the local love from their under-caffeinated regulars and thirsty connoisseurs.

As a barista and bartender, a writer and (budding) connoisseur, and as a human, as ordinary and extraordinary as any other person, I am appreciative of the many curious facets and underlying commonalities that make each place both strange and wonderful to each person of our kaleidoscopic society. Through my experience with this guide, I have discovered an unexpectedly earnest dedication in each of Boston's bars and cafés towards providing quality, however it is deemed fit. Ambiance and attitude are just as important as the products themselves. People don't just patronize businesses, they become a part of a subculture, and whether they realize it or not, they are contributing to a scene and an overall identity. If there's one constant in this town, it's that everyone has a niche—all you have to do is know where to find it.

—*Victoria Young*

DOWNTOWN BOSTON

FINANCIAL DISTRICT/DOWNTOWN CROSSING

An Tain

Cheap beer and a place to drink it.

$

31 India St., Boston 02110
(between Milk St. and Franklin St.)
Phone (617) 426-1870

CATEGORY	Dive Bar
HOURS	Mon-Fri: 10 am-2 am
	Sat/Sun: 6 pm-2 am
GETTING THERE	State (Blue, Orange) and Aquarium (Blue) are nearest stops for public transit. Parking is generally okay with street parking and pay lots in the area.
PAYMENT	
POPULAR DRINK	Notoriously cheap beer.
FOOD	Just the usual bar munchies to get hungry people full.
SEATING	Besides the bar, you can park yourself at any bar or high top you deem so worthy.
AMBIENCE/CLIENTELE	There's not much for decor except a jukebox and a dartboard. Loud music fills the space looming above and its no surprise to find college students dancing around, especially on a weekend night. People come to have a great time for not much out of the wallet.

—*Deepak O'Reilly*

Bell in Hand

Drink up and dance around in one of the oldest taverns in America.

$$

45 Union St., Boston 02108
(between Hanover St. and North St.)
Phone (617) 227-2098 • Fax (617) 916-5402
www.bellinhand.com

CATEGORY	Dance Tavern
HOURS	Daily: 11:30 am-1:40 am
GETTING THERE	There is street parking and parking lots in the area. The nearest public transit is Government Center (Green, Blue), State (Orange, Blue) and Haymarket (Orange, Green) stations.
PAYMENT	ATM
POPULAR DRINK	Beer is the overall favorite, especially among the boys, the diners and the daylight-drinkers. But as the night lingers on, cocktails and mixed drinks become the juice that feeds the frenzy. Bopping around with a beer-loaded belly is just a bad idea.
FOOD	All the typical food you'd find in any standard New England bar can be found on the Bell in Hand menu. They're not looking to feed, they're in the business of quenching.
SEATING	The low key dining area that is kept tucked away is the only room with standard seating at tables (plus a bar). The remainder of the bar is dedicated to floor space. If you're looking for a seat in the dance arena, the stools along the bar are your best option unless you can snag one of the very few tables around.
AMBIENCE/CLIENTELE	To show their true commitment to inebriation, Bell in Hand contains a total of five bars. One for the dining area, two facing each other on the lower level club

area and two separating the upstairs into sections.
The lower level has the stage where they have DJs
and bands, but it is quite clear from the line to get
upstairs that there is a different vibe upstairs. After a
long wait for a few steps, you'll find good music, disco
platforms, and a mob of intoxicated people. It's the
kind of place that attracts the 20's and 30's range.

EXTRA/NOTES Beware the cover charge and the Disneyland lines. A
line to get in, a line at the bar and a line to get upstairs.

—*Charlie Knoll*

Blackstone Grill

For pub crawl beginners.

$$

15 Union St., Boston 02109
(between Hanover St. and North St.)
Phone (617) 523-9396 • Fax (617) 523-8163
www.theblackstonegrill.com

CATEGORY Beer Pub

HOURS Mon-Sat: 11 am-2 am
Sun: Noon-2 am

GETTING THERE There is scattered metered street parking and plenty of
pay lots in the area. The nearest T-stop to this location
is State (off the Blue and Orange Line) and Govern-
ment Center (off the Blue and Green Line). Haymarket
(off the Green and Orange Line) is not too far either.

PAYMENT

POPULAR DRINK The selection on draft is small, but they make up for it
with good picks for bottles. A full bar means cocktails
and mixed drinks too, but occasionally a glass of wine
is ordered.

UNIQUE DRINK The Hpnotiq Cosmo is a sinful mix of Absolut Citron
and Hpnotiq liqueur with a splash of cranberry and
lime.

FOOD Standard but quality pub fare of sandwiches and burg-
ers make up the majority of the menu. A raw bar and
seafood specialties give it some Boston flair.

SEATING Blackstone Grill is ready to take on the mad haul of a
pub crawl.

AMBIENCE/CLIENTELE Locals and regulars in their 20s and 30s put this in
their rotation of Union Street pubs to frequent.

—*Suki Chang*

Bond

The perfect pair of bar and district.

$$$

250 Franklin St., Boston 02110
(between Oliver St. and Pearl St.)
Phone (617) 451-1900
www.bondboston.com

CATEGORY Theme Lounge

HOURS Daily: 11 am-2 am

GETTING THERE The hotel offers valet parking and there are lots and
street parking in the area. Government Center (Blue,
Green), State (Orange, Blue) and Downtown Crossing
(Red, Orange) are all nearby T-stops.

PAYMENT

POPULAR DRINK Bond takes great pride in their specialty libations,
which intrigue a good handful of people. Still, people

stick to their preferences here with a bottle of beer, scotch on the rocks, a glass of wine or a martini of their own choosing.

UNIQUE DRINK Money is the inspiration for the cocktails and martinis. For each president found on our legal tender, there is a cocktail like "The Franklin" and for each type of coin, there is a martini in its name, such as the "Nickel Martini." Sip up your favorite form of cash and do not fear the Million-Dollar Martini.

FOOD International small plates of upscale comforts and cuisine will cost you a pretty penny, but consider it an investment in your endorphins. Discover Bond's renditions of Asian, Italian, French and American dishes such as foie gras, arancini, escargot, cheeseburger, and cashew and coconut milk curry chicken.

SEATING Bond is wholly a lounge, but the center section is made up of angular couches and low tables. Along the walls you can find comfortable seating along couches and armchairs and there is seating at the neat, mirrored bar. An exclusive balcony is available for private events.

AMBIENCE/CLIENTELE After you've been greeted by our familiar faces of our currency, a tall room of five gorgeous chandeliers, mirrors and the healthy glow of lamps stuns you before you walk through the main entrance. Presidents of past and present currency hang high on the walls, watching over the suits and wealthy foreigners as they indulge in one of the highest forms of decadence the city has to offer. Even these professional socialites cannot fill the exorbitant amount of space between the floor and ceiling with all their schmoozy after-work chatter. If only they kept Pink Floyd on loop.

EXTRA/NOTES Bond sits where the former Federal Reserve Bank once existed. It's all too appropriate.

—Victoria Young

Coogan's

💁 🍸 🍷

Traditional Irish Boston pub.
$$
171 Milk St., Boston 02109
(at India St.)
Phone (617) 451-7415
www.irishconnection.com/coogans

CATEGORY Beer Pub

HOURS Mon-Thurs: 11:30 am-8 pm
Fri: 11:30 am-2 am
Sat: 4 pm-2 am

GETTING THERE There are a few metered spots around but a wise decision would be to take the T either to Aquarium (Blue Line) or walk from Faneuil Hall.

PAYMENT [AMERICAN EXPRESS] [MasterCard] [VISA]

POPULAR DRINK They have a decent amount of drinks on tap including your Irish staples and great deals on Bud drafts.

FOOD The food is more than decent and they have a really tasty onion soup.

SEATING There is plenty of seating and standing room. The bar is an island so it offers plenty of stools. Beware: if you go after work, you might not get a seat right away.

AMBIENCE/CLIENTELE Coogan's is a great example of a typical Boston Irish pub. Depending on what time of day you go, you will get a different crowd. After work you see a lot of young professionals since it is right in the Financial

District but at night, you will catch the drinking and dancing crowd.

EXTRA/NOTES The best time to go is after work when the place seems really alive. At night the pub clears up some space for a dance floor, but it can be a hit or miss crowd, depending on the day. Some weekends it is popping, but others it is a ghost town. You definitely want to go in the evening on Thursdays at 7 pm when it is trivia night. Don't miss it!

OTHER ONES Part of the Glynn Hospitality Group who also owns The Black Rose, The Purple Shamrock, Dylan's, Jose McIntyre's, Clery's, and Hurricane O'Reilly's.

—Leah Bagas

Elephant and Castle

A jolly good time for suits and the likes.

$$

161 Devonshire St., Boston 02110
(between Milk St. and Franklin St.)
Phone (617) 350-9977 • Fax (617) 350-0299
www.elephantcastle.com

CATEGORY Beer Pub

HOURS Daily: 6:30 am-11:30 pm

GETTING THERE Street parking and pay lots can be found all around the Financial District. Elephant and Castle can be reached by the Red, Green, Orange and Blue Line by taking any of these nearby T-stops: Government Center, Downtown Crossing and State.

PAYMENT

POPULAR DRINK Elephant and Castle offers a wide range of spirits from their full bar for a good price. The beer selection is a nod to the British Isles and you'll find most people with a pint in hand.

UNIQUE DRINK Spiked coffee is a steamy way of sneaking in some hard stuff while getting wired. The Twisted Coffee here is made up of coffee, hot chocolate, Bailey's and orange vodka and it's prettied up with whipped cream and cherry. For something a little zesty the Blueberry Tea is made up of Grand Marnier, Amaretto and Orange Pekoe tea.

FOOD Lunch and dinner boasts a large menu of hearty Boston-Irish fare with some English favorites. The bar menu has a smaller set of stomach fillers.

SEATING The long gorgeous bar is the centerfold that is buffered with high top booths and tables. On the outskirts of the bar area, in front and on the higher set levels, standard tables will seat people looking to enjoy some grub.

AMBIENCE/CLIENTELE The Financial District piles in plenty of business people looking to loosen their ties and get rowdy. It's also a hit among an older set of locals that enjoy the classic feel of the mahogany and mirrors. The hotel attached can draw in tourists for a quick meal and the long stretch of windows will nab anyone from the streets looking for a cold glass of beer. Elephant and Castle keeps it loud and casual for anyone to get their kicks.

EXTRA/NOTES Elephant and Castle throws nifty little events to entice even more of a specialized crowd, such as trivia night, karaoke or murder mystery fun.

—Bree Cummings

CLASSIC COCKTAILS AND MIXOLOGY

The Alchemy of Alcohol

For a town of less than 700,000, I am consistently amazed that there are at least three different bars within a ten-minute walk of my house that specialize in proper, old school cocktails. I'm not talking about a chic nightspot with cosmos and the homogenous, drearily simplistic champagne cocktails. I'm talking about a place where I can get a raw egg in my drink.

Mixology is an interesting trade, as it is both deeply rooted in paying homage to the past, and steadily, inextricably reaching for what's new. Take the newest (and dare I say best) gun on the block, Barbara Lynch's Fort Point bar, **Drink**. The bartenders are all consummate professionals with a seemingly endless reservoir of recipes. There is no bar menu. You just walk in the door, probe your imagination for what you could possibly want, and tell your bartender, "I want a vodka drink that tastes like pink grapefruit but isn't sour at all," and viola. It's there, along with a name for the cocktail and a small history lesson about it, if you're interested.

As the biggest and most accessible, Kenmore Square's **Eastern Standard** is the flagship of the Boston cocktail bars. Like many of these bars, it evokes a sense of the gay and roaring 20s, a magical time when alcohol was illegal but apparently everyone drank like gods. It's a solid introduction to the world of cocktailing with an extensive and adventurous drinks list, and while amazing by all normal criteria, it's too big and popular to maintain the precision the boutique places can.

A temptation in the cocktail world is to "wow" with lunatic ingredients (blackberry jelly, maple syrup, etc.) and while interesting (and often delicious), **No. 9 Park**, in Beacon Hill, focuses instead elegance and precision. Their signature drink, the Palmyra, is simplicity itself: vodka, mint, lime. But for this, No. 9 places a strong emphasis on the perfection of the ingredients, the best vodka for the best drink. The bartender I spoke to told me he had to endure 30+ hours of interviews before he was hired, and formed a working knowledge of bitters, vermouths, and a galaxy of odd foreign liqueurs in order to make the best out of every single drink.

And these are just the biggest and most popular. **Green Street Grille**, in Central Square, has a seven page cocktail list with the talent and ingredients to back it up. It's a cozy neighborhood bar with Christmas lights on the ceiling. It's certainly not a dive, but far from the swanky corridors of swankdom, and yet mixology reigns. Here you can get everything from a perfectly crafted martini to a Peanut Butter Flip: scotch, peanut butter, simple syrup, one whole egg (basically 2/3 of the way to a cookie).

Rendezvous in Central Square will reinvent scotch for you with the Mamie Taylor. **Craigie on Main** just down the street is an incredible new bar, with bartenders who frequently light some/ all of the ingredients on fire. **Deep Ellum**, in Allston, looks like a place you'll find six guys named Roscoe, but will give you some of

the best cocktails of your life. And it goes on and on.

I had no real interest in Mixology when I moved here two years ago, and now I have a hard time settling for anything else. It's amazing, new, and delicious. Buyer beware.

Drink
348 Congress St., Boston 02210, (617) 695-1806,
www.drinkfortpoint.com

Eastern Standard
528 Commonwealth Ave., Boston 02108, (617) 532-9100,
www.easternstandardboston.com

No. 9 Park
9 Park St., Boston 02108, (617) 742-9991, www.no9park.com

Green Street Grille
280 Green St., Cambridge 02139, (617) 876-1655,
www.greenstreetgrill.com

Rendezvous
502 Massachusetts Ave., Boston 02139, (617) 576-1900,
www.rendezvouscentralsquare.com

Craigie on Main
853 Main St., Cambridge 02139, (617) 497-5511,
www.craigieonmain.com

Deep Ellum
477 Cambridge St., Allston 02134, (617) 787-2337,
www.deepellum-boston.com

— *Jason O'Bryan*

Fajitas and Ritas

Homemade margaritas that actually taste homemade.
$$
25 West St., Boston 02111
(between Tremont St. and Washington St.)
Phone (617) 426-1222
www.fajitasandritas.com

CATEGORY	Cocktail Bar
HOURS	Mon-Tues: 11:30 am-9 pm
	Weds-Thurs: 11:30 am-10 pm
	Fri: 11:30 am-11 pm
	Sat: 11:30 am-10 pm
	Sun: Midnight-8 pm
GETTING THERE	There is no street parking around the area. Best bet: T to Park St. (Red/Green Line) or Boylston St. (Green Line).
PAYMENT	
POPULAR DRINK	The best reason to go to Fajitas and Ritas is by far the homemade margaritas. They have all the traditional flavors and because they aren't made from a syrupy mix, you can do a lot of damage. They taste so good you will forget how many you have had or how you just wrote your name on the bathroom wall.

UNIQUE DRINK	The best thing to do is try the margarita of the day. There is a different one on special all the time. Also, don't get distracted by the delectable margaritas because they also have sangria. Because it is hard to decide which one to order, I say live it up and go for both!
FOOD	The menu isn't too pricey and has some good solid Mexican food and great vegetable quesadillas. You also get free chips and salsa when you sit down.
SEATING	There is a small bar area so the best bet is to grab a table or a booth. Best seats are either by the window for people watching or against the wall in a comfy booth.
AMBIENCE/CLIENTELE	Fajitas and Ritas is covered in murals, from mariachi players to personified margaritas, there isn't a wall left uncovered. If you wrote your name in the bathroom, no one would notice. The murals stimulate the eyes but the place still feels almost like an industrial space. The crowd is on the younger side, and it can get very busy around dinner time or on the weekends.
EXTRA/NOTES	The place will actually stay open until 2 am if you rent it for a private party. This is a good stop before hitting up the cinema or the Theater District, which is really close by.

—Leah Bagas

The Greatest Bar

Boston sports bar for the new millennium.

$

262 Friend St., Boston 02114
(at Causeway St.)
Phone (617) 367-0544
www.thegreatestbar.com

CATEGORY	Sports Bar
HOURS	Mon-Fri: 4 pm-2 am
	Sat/Sun: Noon-2 am
GETTING THERE	There is a parking lot across the street that might run you up $20 or more, depending on how long you stay. Meter parking is available as well, but as with all downtown Boston locations, it is wiser to take the T: North Station on the Green and Orange Lines is about a block away.
PAYMENT	
POPULAR DRINK	Like many sports bars, the Greatest Bar sells a lot of Bud Light, Jim Beam, and Captain Morgan. The generally standard drink menu here makes it clear that it's the ambience of the place and location (a block from the Garden, home of the Celtics and Bruins) that bring in the customers.
UNIQUE DRINK	One of the newest additions to the Greatest Bar drink menu (per the bartender) is what they call "FBI," or "Fruity Boru Infusions." The bar infuses Boru, a vodka imported from Ireland, with various fruits in a big glass jar with a spigot at the bottom. What results is a drink that tastes like fruit juice but is actually straight liquor.
SEATING	The Greatest Bar has two levels, one at the ground floor and one sort of mezzanine. Wooden tables dot the whole space, with waitress service all around.
AMBIENCE/CLIENTELE	Greatest Bar seems to cater to both the after-work and sports-nut crowds (which is certainly not to say that

the two are mutually exclusive). The centerpiece of the room is a huge projection screen television that is probably ten or twelve feet wide; the whole of the place seems to circle around it like a planet around the sun. If the big test of a sports bar is whether one can see the score of the game from absolutely anywhere in the room, the Greatest Bar gets an A.

EXTRA/NOTES It is worth mentioning that the interior of the Greatest Bar is significantly more classy-looking than what one might expect from a sports bar. The kitsch of the traditional sports bar is abandoned in favor of a mahogany-colored wood and stone design, which, in the dim lighting, allows the bar to retain its pub cred without alienating those of us who are used to more expensive establishments. Check out the mural of memorable Boston sports moments and personalities, too. (It's on the ceiling.)

—Matt Rusteika

Hennessey's

A rockin' kitschy pub.

$

25 Union St., Boston 02108
(between Hanover St. and North St.)
Phone (617) 742-2121
www.somerspubs.com

CATEGORY Beer Bar

HOURS Daily: 11 am-2 am

GETTING THERE Street parking and parking lots are both available in the area. The nearest public transit stops are Government Center (Green, Blue), Haymarket (Green, Orange) and State (Orange, Blue).

PAYMENT

POPULAR DRINK Beer is a common choice, but the great wall of liquor that towers behind the bar is a tempting alternative.

UNIQUE DRINK The case of the mysterious vat of red liquid is now officially closed. It's a painless blend of strawberry and raspberry vodka with cranberry juice and lime for your shooting pleasure at just 3 bucks a pop.

FOOD Irish and American favorites make their way onto this menu of pub grub.

SEATING The well-worn bar takes a regular beating from the bro-dudes and zealous sports fanatics. Slabs of thick warped wood make up the table tops scattered around in cubbies of partially-secluded space. A narrow sectioned off area with its own mini bar makes for a fine retreat for small private parties. The peculiar seating arrangements are a fun quirk of this otherwise regular pub.

AMBIENCE/CLIENTELE Amidst the soft pub glow, a neat collection of antiques hovers high on the walls to match the eccentric furniture. This cozy Union bar is frequented by local boozers that throw this Irish pub into the regular rotation. As part of the Union St. pub crawl scene, tourists occasionally make their way in search of a unique Boston bar experience.

EXTRA/NOTES Hennessey's make-shift stage area is booked for live music every night of the week.

—Bridget Halverson

The Hub Pub

Neighborhood Pub in Tourist Center.

$$

18 Province St., Boston 02108
(between School St. and Bromfield St.)
Phone (617) 227-8952
www.thehubpub.com

CATEGORY	Beer Pub
HOURS	Mon-Sat: 11 am-2 am Sun: Midnight-2 am
GETTING THERE	One block from State St. (Orange/Blue Lines) and a short walk from Downtown Crossing and Government Center. No one can claim it's inconveniently located.
PAYMENT	
POPULAR DRINK	There's a full bar, but it's best to stick to beer here. Try a local brewer. And if you're willing to venture beyond the comfortable Sam Adams, go for Harpoon's UFO Hefeweizen.
FOOD	Choose from a wide selection of sandwiches and burgers with neighborhood-inspired names like the Boston Common and the Beacon Hill Club and get a virtual tour with your meal.
SEATING	Sit downstairs and scrutinize the postcards of historic sites embedded in the bar or head up to the "loft" seating, offering space for you and your Freedom Trail tour group. If you're lucky, you might snag a spot at the rounded balcony booth that overhangs the lower bar and gives you a clear view of the History of Boston mural on one wall.
AMBIENCE/CLIENTELE	Though it's located in the midst of Boston's most tourist-heavy area, the Hub Pub attracts a mixture of patrons, from office workers stopping in to catch a few minutes of a Sox day game on their lunch break to the older locals whiling away an afternoon to the out-of-towners taking a breather from Faneuil Hall. The regulars maintain a mildly insulting banter with the bartenders as they argue sports, which is entertaining to overhear, though it may make you doubt the sign outside calling it "The Friendliest Pub in Boston." Don't worry, this is how Bostonians bond and they'll eventually include you if you want in on the conversation.
EXTRA/NOTES	The myriad of television screens alone, enormous and easily visible from nearly anywhere upstairs or down, should be enough to fill the place, especially on game night. But given the vast floor space, you'll likely have plenty of breathing room and actually be able to hear your friends talking to you, a boon if you prefer comfort to the tightly-packed hipster hangouts.

—Bridget Pelkie

JP Stat Restaurant & Bar

Loosen that tie and order up a pitcher.

$$

99 Broad St., Boston 02110
(at Franklin St.)
Phone (617) 357-8287
www.jastats.com

CATEGORY	Neighborhood Bar
HOURS	Mon-Fri: 11 am-2 am Sat: 4 pm-2 am

GETTING THERE	Parking can be found on the streets or at pay lots in the Financial District. The nearest T-stops include Aquarium (Blue), State (Orange and Blue) and Downtown Crossing (Red and Orange).
PAYMENT	[payment icons]
POPULAR DRINK	Beer and mixed drinks are a standard order here.
FOOD	Meat-heavy starters, entrees and sandwiches fill the menu for some delightful pub grub.
SEATING	Find a seat at your choice of the bar, high-top or table.
AMBIENCE/CLIENTELE	Locals find comfort in this neighborhood bar and the Financial District draws in a substantial after-work crowd that lingers for long hours.

—Avalynn Michaels

Les Zygomates

A jazzy French wine bar to get your heart pounding.

$$$

129 South St., Boston 02111
(between Essex St. and Beach St.)
Phone (617) 542-5108 • Fax (617) 482-8806
www.winebar.com

CATEGORY	Wine Bar
HOURS	Mon-Fri: 11:30 am-1 am Sat: 6 pm-1 am
GETTING THERE	Metered street parking can be found all around and should not give you too much of a problem. The Financial District has many pay lots to offer. T-riders will be pleased to find South Station is just down the street from Les Zygomates. Valet parking is available Tues-Sat starting at 6 pm.
PAYMENT	[payment icons]
POPULAR DRINK	With an outstanding wine list of mostly French and Italian selection, bottles of wine are uncorked at most tables. You can opt for many by the glass or even a few ounces for just a taste. The raw bar has its own wine list so you can perfectly pair your shelled delights with the appropriate white.
UNIQUE DRINK	Wine tastings take place every Tuesday at 7pm for $30. Each one has its own theme based on region or type of wine. It's a chance to try and compare wines while gaining knowledge about different wines.
FOOD	A thoughtful compilation of French cuisine provides an upscale taste of those delectable earthy flavors.
SEATING	With wonderful window-side seating, linen-cloth tables spread out through the rooms, and two bars, Les Zygomates has no problem seating 150 people comfortably. The private dining room can accommodate up to 40 guests.
AMBIENCE/CLIENTELE	Soft lighting creates a warm and inviting atmosphere that, combined with the nightly live jazz music, is an alluring treat for a romantic night out. Here you may find lovers talking quietly over a bottle of wine or people silently delighting in the mellow jazz.
EXTRA/NOTES	Impress your friends with this one. Les Zygomates is pronounced lay-zee-go-matt. It roughly translates to "the muscles in the face that make you smile." Restaurant closes from 2 to 4pm Mon-Fri, but the bar stays open.

—Victoria Young

The Littlest Bar

With a big heart. (Aww.)

$

102 Broad St., Boston 02110
(between Franklin St. and High St.)
Phone (617) 542-8469

CATEGORY	Neighborhood Bar
HOURS	Mon-Sat: 10 am-2 am
	Sun: 11 am-2 am
GETTING THERE	There is ample parking on the streets and in pay lots that can be found all around. The nearest T-stop is South Station (Red, Silver), Aquarium (Blue) and State (Orange, Blue).
PAYMENT	
POPULAR DRINK	Although a full bar is at your service, cheap beer in the form of pints or pitchers can be found on most tables.
FOOD	All your favorite pub grub is ready and waiting to prepare you for a long night of boozing.
SEATING	High top counters extend out from the walls and front little nooks keep intimate tables. There is plenty of space by the bar for lingering.
AMBIENCE/CLIENTELE	Don't be fooled by the name. This place may be charming, but it's certainly not the littlest around. Of course, this little fib doesn't affect people's love for their neighborhood watering hole.

—Victoria Young

Marliave

Time stands still in this back alley gem.

$$

10 Bosworth St., Boston 02113
(between Tremont St. and Province St.)
Phone (617) 422-0004
www.marliave.com

CATEGORY	Cocktail Bistro
HOURS	Daily: 11 am-1 am
GETTING THERE	Street parking is difficult to find, but there are plenty of parking garages in the area for a charge. Marliave is quite accessible to public transportation. It sits near Park St. (Red and Green Line), Downtown Crossing (Red, Orange, and Silver line), and Government Center (Blue and Green Line).
PAYMENT	
POPULAR DRINK	Among the large one-paged drink menu of classic drinks renamed with a kitschy twist you can find a familiar blend, like Mr. Daniels (Gentleman Jack and Coke), or an enticing quirky blend, like The Great Experiment (Hendrick's Gin, mint, lemon, orange and cucumber).
UNIQUE DRINK	A savvy molasses concoction: Molasses Flood 1919. Sailor Jerry's rum, molasses, lime and bitters. Boston Tea Party: Sauza tequila, Earl Grey tea, ginger beer and lemon. They also tip their hat to the sober folk. Methyphobia (irrational fear of alcohol): grapefruit, lime, mint and sugar.
FOOD	Two menus, one for upstairs and one for downstairs dining, are designed with French, Italian and New England influence. The upstairs menu is a grueling compilation of continental cuisine, the kind of dining you save for special occasions. The downstairs menu

consists of an equally thoughtful, but more casual fare, which is also much lighter on wallets. With both menus available until 10pm, Marliave is what you make of it—a lunch, dinner or late night experience.

SEATING Two dining levels, each with their own vibe and each equipped with a bar and tables aplenty. A small raw bar area is tucked away below for extra seats for adventurous seafood enthusiasts.

AMBIENCE/CLIENTELE Remember in The Shining, when Jack conjures up a bartender in his mind? That's what it felt like to walk into Marliave for the first time with that rare moment to consider if everything is a dream. And I am most glad it was not. Behind the classic architecture lies beautiful marble bars, sleek decor with a black and white palette, and an overall vintage look and feel. The upper floor is much darker and more intimate with a serene cityscape vista. The place attracts classic cocktailers, romancers, and food connoisseurs alike.

EXTRA/NOTES You might feel hesitant to walk down the dark alley where Marliave resides, but trust me. It's there and waiting to delight any one who strolls through the door.

—*Victoria Young*

Max and Dylans

Shoe shines, stuffed olives and liquid nitrogen.
$$$
15 West St., Boston 02111
(between Tremont St. and Washington St.)
Phone (617) 423-3600
www.maxanddylans.com

CATEGORY Cocktail Bar

HOURS Mon: 11:30 am-Midnight
Tues-Sat: 11:30 am-2 am
Sun: 11:30 am-Midnight

GETTING THERE There is metered street parking, which is hard to find, or garage parking. After 4pm everyday, parking in the LaFayette Garage in the Hyatt Hotel is $10 with validation. The closest public transport is Downtown Crossing (Orange, Red and Silver line) and Park Street (Red and Green Line).

PAYMENT

POPULAR DRINK Though wine is popular among many diners, the martinis are also a hit. If you like it dirty, make sure to ask for the olive of your choice, stuffed with bleu cheese, goat cheese or jalapeño.

UNIQUE DRINK The signature drink is a watermelon martini. Boooring. Until you add a little liquid nitrogen. Fresh watermelon is shaken with sugar and mixed with watermelon vodka specially frozen right at the table with liquid nitrogen. Brilliant.

FOOD It's comfort food with a touch of pizzazz. Five different types of mac and cheese to choose from, some asian cuisine for appetizer choices, and your unsurprising entrees.

SEATING Unexpectedly, there are three levels to this bar and restaurant. The first level has a bar with bar seating and tables spread all around in little nooks and by the window. The second level has a small dining area, tucked in here and there as well as a counter seating overlooking the first level. The third level is even more

seating for dining as well as a bar towards the back with a few high tops for drinks.

AMBIENCE/CLIENTELE The interior architecture and the seating arrangements make this place a funky little place to grab an alley way drink. Sexy black and white photos and fun decor really try to pull in the younger crowd, but it seems that the prices scare away the students. You tend to find the 30s crowd of business professionals having a few chatty drinks in the corner. Who else would have the proper shoes to get a free shoe shine from 4 pm-7pm, Mon-Fri?

OTHER ONES 1 Chelsea St. Charlestown 02129, (617) 242-7400

—Victoria Young

MKT

Hike up your skirts and loosen your ties. It's time to lounge, baby.

$$

21 Broad St., Boston 02109
(between Broad St. and Batterymarch St.)
Phone (617) 367-0658 • Fax (617) 227-3611
www.mktboston.com

CATEGORY Cocktail Lounge

HOURS Mon-Fri: 3 pm-2 am
Sat: 5 pm-2 am

GETTING THERE Street parking and pay lots are ample in this part of Boston. The nearest T-stop is Aquarium (Blue Line) and State (Blue and Orange Line).

PAYMENT [DISCOVER] [AMERICAN EXPRESS] [MasterCard] [VISA]

POPULAR DRINK The fancy pull of this place gets more cocktails in hand. Though the suits stick to beer generally.

FOOD A mix of standard of comfort food and sandwiches with an extra effort to be classy. In case you feel fancy, order shrimp cocktail and a cheese plate to go with your nachos and Chicken Caesar Wrap.

SEATING The lounge area has a circular bar with seating all around and tables along the sides. The upper floors have more seating, VIP areas and another bar.

AMBIENCE/CLIENTELE The decor is simple but eye-catching with black and white tiled floors contrasted with detailed red chairs and long wooden tables and walls bring out a raw earthiness. A 9-to-5, 30 plus crowd is prominent for a casual dinner in a preemptive after hours scene of loud music and dancing.

—Alexis Vandeventer

Mr. Dooley's

With a sprinkle of rustic charm.

$$

77 Broad St., Boston 02109
(between Milk St. and Franklin St.)
Phone (617) 338-5656
www.somerspubs.com

CATEGORY Neighborhood Tavern

HOURS Mon-Fri: 11:30 am-2 am
Sat: 11 am-2 am

GETTING THERE Pay lots and street parking make driving here pretty breezy. The nearest T-stop is State (Blue and Orange) and Aquarium (Blue).

PAYMENT	
POPULAR DRINK	Beer is the main squeeze at Mr. Dooley's.
FOOD	A full menu of nothing beyond standard pub grub.
SEATING	Tables fill the space between the bar and the booths lining the walls.
AMBIENCE/CLIENTELE	Mr. Dooley keeps a collection of black and white pictures and kitschy remnants that exude a tinge of country feel. A small stage for local bands to jam for the chatty crowd of mellow 25 plus and then some.

—*Deepak O'Reilly*

Paddy O's

The pub crawl half-way point.
$$
33 Union St., Boston 02108
(between Hanover St. and North St.)
Phone (617) 263-7771
www.somerspubs.com

CATEGORY	Beer Pub
HOURS	Daily: 11 am-2 am
GETTING THERE	Right in the heart of Downtown, there are plenty of parking lots that you can pay your way into. There's also scattered metered parking that can be hard to find most times, though not always impossible. State (Blue, Orange), Haymarket (Green, Orange), and Goverment Center (Green, Blue) are all stations in close proximity to Paddy O's.
PAYMENT	
POPULAR DRINK	Although they have a small cocktail menu and a full bar to back it up, beer is the most frequented beverage on the menu, though the selection is fairly standard.
FOOD	Here you'll find a filling fare of appetizers, burgers, sandwiches, steaks, seafood and Boston-Irish plates.
SEATING	From the front door to the back windows, the seating arrangement is spread out so you can choose your seat according to your mood. Sit by an artificial fireplace in the front area where you are more isolated from the crowd or towards the back where the fenced off area gives the lounge seating an intimate touch. You can sit along the long stretch of the bar or at the stone columns with stools to face the game or at the many tables lining the walls, each with a hint of privacy. It can get crowded on weekend nights, but there is still room to move around.
AMBIENCE/CLIENTELE	As one of the many bars along Union St., this tavern is often included in the fine Boston tradition of pub crawls. The area attracts local Bostonians and tourists alike, and this bar receives many of them for a beer and a meal. Inside, the ambiance is made up to drive forth the Boston feel with stone walls and lanterns glowing, candelabras and rod iron fences, Irish drums and antiques. There are music events (karaoke and live bands) here and there, which is much preferred to the jukebox filth they usually play overhead, just loud enough to get lodged in your brain forever. But when the place is bustling, people are more concerned with finding a special friend to chat up.
EXTRA/NOTES	Depending on the night, there may be a cover charge and coat check fee.

—*Charlie Knoll*

The Point

Boozy fun and cheap eats. Everyone wins.

$$

147 Hanover St., Boston 02108
(between Congress St. and Blackstone St.)
Phone (617) 523-7020 • Fax (617) 523-4556
www.thepointboston.net

CATEGORY	Beer Pub
HOURS	Daily: 11:30 am-2 am
GETTING THERE	There are pay lots and street parking in the area. There are T-stations all around, but the closest is the Haymarket stop on both the Green and Orange Line.
PAYMENT	[AMERICAN EXPRESS] [mastercard] [VISA]
POPULAR DRINK	Beer is a winner among the people there for the pub aspect. When the upper level opens up for a dance party, mixed drinks bring the tempo up and the bodies feel the need to bump around.
FOOD	A pretty serious menu of cheap plates of Italian favorites, sandwiches and pub grub. You don't have to break the bank to load your belly with good things. Let it be known that Monday nights are 25 cent wing nights and tacos are 3 for $5 on Tuesdays.
SEATING	The bar sits on street level with tables and high tops around with room for a bustling night to blossom. The upstairs kicks into gear for live music and fun events where there's room for dancing to ensue.
AMBIENCE/CLIENTELE	The Point hides in the corner of a stretch of bars by Faneuil Hall where locals and regulars indulge in after work drinks and beyond while tourists might stumble in and find themselves closing down the place. Most nights have crowd-pleasing events going on that bring in young, casual socialites. Trivia on Tuesday and Karaoke on Wednesday bring in a particular crowd of enthusiasts. Live music and DJs are featured Thurs-Sat nights to kick up the dance action.

—*Lawrence Fong*

Purple Shamrock

Yet another pub.

$$

1 Union St., # B, Boston 02108
(at North St.)
Phone (617) 227-2060
www.irishconnection.com

CATEGORY	Beer Pub
HOURS	Mon-Fri: 11:30 am-2 am
	Sat/Sun: 9 am-2:30 am
GETTING THERE	There are pay lots and street parking in the vicinity. The Orange, Blue and Green Line can help you get to a nearby T-station such as State, Government Center or Haymarket.
PAYMENT	[DISCOVER] [AMERICAN EXPRESS] [mastercard] [VISA]
POPULAR DRINK	What can I say, bro-dudes love beer.
FOOD	Nothing especially eye-catching, just a full menu of New England favorites.
SEATING	Regular tables fill the spaces not dedicated to the bar.
AMBIENCE/CLIENTELE	Purple Shamrock is filled with tourists looking for Irish fun and locals just looking to get wasted, which is essentially the same thing. DJs, karaoke and live

bands make this a happening nighttime music venue and this place is big on game nights.

—*Jason Burnsworth*

Red Sky

Classy white-collar downtown retreat.
$$
16 North St., Boston 02109
(at Congress St.)
Phone (617) 742-3333
www.redskyboston.com

CATEGORY	Cocktail Bar
HOURS	Daily: 11:30 am-2 am
GETTING THERE	There are a few garages nearby, all of which can get a little expensive, depending on the day, and given Red Sky's proximity to the TD Banknorth Garden. Meter parking is also available, although scantily so. Haymarket Station on the Orange and Green Lines is right around the corner.
PAYMENT	
POPULAR DRINK	While the standard beers and wines that one would expect to see at any bar are available here (as well as some more high-class champagnes and the like), Red Sky's specialty drink menu is extensive and distinctive. Check out their namesake, the Red Sky Martini ($10). It's made with Stoli Citrus, Pomegranate Liqueur, Sprite, and cranberry juice.
SEATING	Cushy red couches fill the area next to Red Sky's large front window, which looks out onto Boston's historic Faneuil Hall Marketplace. Elsewhere, a few chest-height wooden pub tables stretch to the back of the room in a row. The fifteen- to twenty-seat bar faces two flat-screen televisions and, in the warmer months, they set up a few patio seats outside.
AMBIENCE/CLIENTELE	Red Sky is a warm, intimate establishment that's comfortable enough to accommodate the after-work crowd and trendy enough to warrant a visit when you're out on the town for the night. This place seems to attract the professional set, regardless of age. Convenient to many office buildings in the Financial District and Boston City Hall, Red Sky draws in more men with ties than guys in t-shirts.
EXTRA/NOTES	If you like unique mixed drinks in a posh downtown location, Red Sky is where it's at. Although Red Sky has both beer and french fries on the menu, this place isn't really suited to beer-and-french-fries people. Instead, it's classy and luxurious, and everyone there looks fabulous. So if you're out some night and you're looking for a slightly fancier alternative to the string of Irish pubs on Congress St., look no further than right around the corner at Red Sky.

—*Matt Rusteika*

RumBa

Finally. A reason to pluck from your money tree.
$$$$
510 Atlantic Ave., Boston 02110
(between Pearl St. and Congress St.)

Phone (617) 747-1000
www.intercontinentalboston.com

CATEGORY Hotel Lounge

HOURS Daily: 11 am-2 am

GETTING THERE The hotel offers valet parking and there is street parking in the area. South Station off the Red Line is the nearest T-stop. Valet parking is available through the Intercontinental hotel. There is also street parking all around and pay lots in the area. Red Line's South Station sits just a few blocks away for anyone on foot.

PAYMENT

POPULAR DRINK Rum-based beverages are what this place exists for. RumBa has an international collection of distilled rums and often holds tastings to show them off. The champagne bar serves delicious bubbly concoctions that are nose ticklers and crowd pleasers.

UNIQUE DRINK Try the best of both worlds—a champagne mojito is a crispy delight. That's just skimming the top. There's a wide array of interesting cocktails to indulge in. Or if you're feeling rather exorbitant, and have no need for 275 dollars, try the Golden Fizz, made up of Hennessy Paradis, Grand Marnier 150, Angostura, Dom Perignon, 1998 and sprinkled with 23 karat gold. I have no words.

FOOD An expensive compilation of seafood and raw bar picks are available until midnight. There is also a short list of fancy appetizers.

SEATING The main bar is surrounded by a spread of comfortable lounge seats and armchairs. The champagne bar discreetly sits in another room where a length of red cushioned love seats and cozy armchairs. Oftentimes people will find the open hotel couches are preferable and people venture outside of the bar to find a nook within the posh lobby setup.

AMBIENCE/CLIENTELE Boston's collection of swanky lushes flock here for a decadent good time in the lounge areas while tourists, from the hotel mostly, enjoy casual drinks at the bar. RumBa is swimming in sophisticated opulence that is mostly concentrated in the sexy champagne bar.

EXTRA/NOTES RumBa has nothing to do with the Latin dance style and more to do with the Baaahsten accent that would turn the words "rum bar" into "RumBa." How clever.

—*Victoria Young*

Sorriso

A North End escapee.

$$$

107 South St., Boston 02111

(between Essex St. and Beach St.)

Phone (617) 259-1560 • Fax (617) 259-1561

www.sorrisoboston.com

CATEGORY Wine Bistro

HOURS Mon-Fri: 11:30 am-11 pm
Sat: 5 am-Midnight

GETTING THERE There is street parking and pay lots available in the area and valet is also offered. Sorriso is a 5 minute walk from South Station off the Red Line.

PAYMENT

POPULAR DRINK Sorriso boasts an intimidating list of Italian wines to pair a fine bottle with dinner as well as an extensive

list of digestives for after. A well-rounded cocktail list sits at the bar for anyone looking to meander from these choices.

UNIQUE DRINK The refreshingly crispy Ruby Fizz—Prosecco, fresh grapefruit juice, bitters and a mint garnish.

FOOD Earthy Italian dishes make up the bulk of the bar and dinner menu. The bar menu also has a small list of pizzas for a more casual night.

SEATING The bar area with just a few high tops expands into a full dining area with an elegant array of tables and a few seats around the brick oven fire. Curtained off in the back sits a private dining room complete with a small bar of its own.

AMBIENCE/CLIENTELE Sorriso can be the setting for romancers to eye-snuggle over a bottle of wine and a good meal followed by a spoon-fed dessert with lots of giggles and cooing. (Though it's not quite as graphic as I described it.) Friends come here for a rare meal around big tables or a place to split a bottle for a mellow night. It's also a favorite among workaholics for an after-work drink.

EXTRA/NOTES To entice people to this gem of a neighborhood, Sorriso offers their pizzas for $5 every Monday.

—*Alexis Vandeventer*

Sushi Teq

Worlds collide as mouths rejoice.
$$$
510 Atlantic Ave., Boston 02210
(between Pearl St. and Congress St.)
Phone (617) 747-1000
www.intercontinentalboston.com

CATEGORY Theme Bar

HOURS Mon-Fri: 5 pm-Midnight
Sat: 3 pm-Midnight

GETTING THERE The hotel offers garage and valet parking. Street parking is bit trickier to find. Red Line South Station is just a few blocks away.

PAYMENT

POPULAR DRINK Sushi Teq carries an outstanding collection of tequila, each with its own tasting guide to assist you in finding the ultimate tequila for your taste buds. A selection of tequila flights with ¾ oz. tasting of each preselected group are available and served with your choice of salt, cinnamon, Sangrita, lime and orange slices. It's no surprise that margaritas are a big hit. A long list of other tequila-based creations is available as well as a Frozen Margarita Flights of three 2-ounce samples.

UNIQUE DRINK The Jalapeño Margarita, one of their signature libations, is a made-to-order spicy classic with fresh slices of jalapeños and limes.

FOOD An innovative compilation of fusion sushi rolls is the highlight of the menu with bold items such as Pizza de Sushiteq with fresh salmon and tomato, garlic onion chips, shrimp paste, frisée and jalapeno peppers over a crisp tortilla crust. The more standard sushi and an a-la-carte menu is for anyone who prefers the traditional flavors.

SEATING The modestly-sized room can only accommodate so many people with their mod little tables and seats.

When the weather is nice, the hotel's garden area opens up and can be used to seat more people.

AMBIENCE/CLIENTELE The cross-seas cultural fusion has Sushi Teq overflowing with personality. People aren't just lured in by the pulsating wall of colors like zombies. It's a high energy venue for a tequila frenzy and a gourmet sushi feast. It's a good thing the hotel has a cab stand up front.

EXTRA/NOTES Education leads to appreciation. Sushi Teq inserts small paragraphs worth of tequila history and the art of sushi.

—*Victoria Young*

The Tap

Cheap beer. Cheap wings. Is there really more to life?

$

19 Union St., Boston 02108
(between Hanover St. and North St.)
Phone (617) 367-0033

CATEGORY Beer Pub

HOURS Mon-Sat: 11:30 am-2 am
Sun: Noon-2 am

GETTING THERE Set in the heart of Boston, this area has many pay lots and street parking is all around, though not always the easiest to find. There are a few T-stations in the area. Government Center, State and Haymarket stops encircle this area and can be reached by the Green Line, Orange Line and Blue Line.

PAYMENT

POPULAR DRINK Beer is everyone's best friend here. Molsen is just $2 a pint or $8 a pitcher.

FOOD Happy hour is what it's all about with 25 cent wings. Without wings, it's just standard pub grub with some Southwestern zing.

SEATING Stools for everyone. It's a high-top kind of place.

AMBIENCE/CLIENTELE The murky dive feel is part of the appeal to the young locals that frequent this place for beer, wings and live music.

—*Suki Chang*

Umbria

The classy dining is just a cover-up for the layers of lounge and club space above.

$$$

295 Franklin St., Boston 02110
(between Broad St. and Batterymarch St.)
Phone (617) 338-1000
www.umbriaristorante.com

CATEGORY Wine Bistro

HOURS Mon-Fri: 11:30 am-2 am
Sat: 5 pm-2 am

GETTING THERE There are parking lots and street parking in the area. The nearest T-stop, though not always the most convenient, is Aquarium off the Blue Line. It may be more convenient to walk from a further stop such as Downtown Crossing off the Red and Orange Line.

PAYMENT

POPULAR DRINK A full stock of Italian wines is ready to make mouths purple with sweet grape nectar. Only a few can be

served by the glass. The nightclub floors get more requests for mixed drinks and cocktails to keep a steady course towards inebriation.

UNIQUE DRINK The Venetian Fizz (Prosecco with a tiny scoop of sorbet) is a refreshing treat and the Mexiccino (Patron Café XO and steamed milk) is essentially a tequila based latte. You be the judge.

FOOD The full service restaurant offers slightly adventurous Italian dishes for a hefty price.

SEATING The first two levels are dedicated to the proper dining experience. Three more levels of lounge and bar area open up ample room to sprawl out or let loose.

AMBIENCE/CLIENTELE Umbria is widely considered to be an upscale Italian restaurant for serious dining among lovers and cherished friends. The dark lighting keeps it quiet with the open kitchen filling the void with the sound of chefs hard at work. The night scene draws in a more carefree crowd for some trendy lounging, though the juxtaposition of such differing atmospheres is a bit odd and unexpected.

EXTRA/NOTES Factual fun: Umbria is a central region in Italy.

—*Bridget Halverson*

Union Oyster House
Decades upon decades of seafood and drinks.
$$
41 Union St., Boston 02108
(between North St. and Hanover St.)
Phone (617) 227-2750
www.unionoysterhouse.com

CATEGORY Beer House

HOURS Mon-Thurs: 11 am-9:30 pm
Fri/Sat: 11 am-10 am
Sun: 11 am-9:30 pm

GETTING THERE Valet parking is available Mon-Sat starting at 5:30 pm with a fee of $12. They also validate parking for the Parcel #7 Garage. Or you can try your luck with metered street parking. The closest public transit are the following: Haymarket (Green and Orange Line), State (Orange and Blue Line) and Government Center (Green and Blue Line).

PAYMENT

POPULAR DRINK Since Union Oyster House caters to a wide spectrum of people stopping in with different agendas, the bar is hit with a grab bag of beverage orders. Wine and beer are common orders among diners whereas those lounging by the bar are enticed by cocktails, mixed drinks and beer.

FOOD Sitting at the bar, you have a small selection of raw bar choices, samplers and sandwiches. Should you choose to dine in, a complete menu of seafood galore is just a point of the finger away from being in your belly.

SEATING At first glance, the Union Oyster House looks like a decently-sized venue, especially for its age. Take a little venture past this corner or up some stairs and you'll find room after room after room of bars, tables and booths. I'd guesstimate their maximum capacity at about a bazillion. You will rarely find a long wait for a seat here. This also means there are rooms aplenty to fit private functions, large and small.

AMBIENCE/CLIENTELE If Union Oyster House was a lady, she'd be looking good for her age. There are a few antiquated aspects about the decor and the seating, but nothing that doesn't amplify the overall quaintness. Not to the point of cooing, but just enough to maintain composure and admire the history behind the building.

—*Victoria Young*

The Vault

Suits dig this mellow retreat.
$$
105 Water St., Boston 02109
(between Broad St. and Batterymarch St.)
Phone (617) 292-3355 • Fax (617) 292-3358
www.thevaultboston.com

CATEGORY Beer Bar
HOURS Mon-Fri: 11:30 am-2 am
Sat: 5:30 am-2 am
GETTING THERE Parking can be found in pay lots or metered spots around the area. The nearest T-stops are State off the Orange and Blue Line, and Government Center off the Green Line.
PAYMENT
POPULAR DRINK Despite the number of fun cocktails and martinis this place can whip up, most of the customers stick to their pints.
UNIQUE DRINK Some feel-good concoctions like Mr. Happy (Absolute Citron and lemonade) or Transfusion (Absolut, Welch's grape juice, and ginger ale) are sure to make you grin.
FOOD A pleasing selection of New England tavern favorites from salads to burgers. Happy hour has great deals and delicious picks.
SEATING The long mahogany bar keeps a set of high tops nearby and a whole other room is dedicated to regular table seating.
AMBIENCE/CLIENTELE The Vault is a magnet for men dressed up in all the corporate attire who've stumbled in from the Financial District. The dark, sophisticated tavern feel is just what is needed to offset a hard day's work.
EXTRA/NOTES Tip toe downstairs and peek at the underground lair of vaults.

—*Bree Cummings*

Vintage Lounge

A modern edge for a casual place.
$$
72 Broad St., Boston 02110
(between Milk St. and Franklin St.)
Phone (617) 482-1900 • Fax (617) 482-1933
www.vlboston.com

CATEGORY Wine Lounge
HOURS Daily: 11:30 am-2 am
GETTING THERE The nearest T-stations are Aquarium off the Blue Line and State off the Orange and Blue Line. Parking is usually not a problem with plenty of street parking and pay lots in the area.
PAYMENT

POPULAR DRINK Over 30 wines by the glass and another 100 by the bottle make wine a popular choice, especially among diners. Cocktails and beer are more common in the lounge area.

FOOD A wide variety of New American dishes with international inspirations.

SEATING The front bar area comes equipped with sleek black furniture that makes up the trendy little lounge. The lounge extends into another stretch of a bar with a few high tops in the midst. Enclosed behind long curtains, two small dining rooms provide an intimate setting for a fine feast.

AMBIENCE/CLIENTELE Set in a string of casual Financial District bars, Vintage Lounge brings a quality of sophistication to a cozy after-work scene. The hotel across the street brings in plenty of tourists and business travelers.

—*Avalynn Michaels*

NORTH END

Artú

Late night pizza and cocktails.

$$

6 Prince St., Boston 02113
(between Hanover St. and Moon St.)
Phone (617) 742-4336 • Fax (617) 248-0808
www.artuboston.com

CATEGORY Cocktail Bistro

HOURS Daily: 11 am-2 am

GETTING THERE There is very limited street parking available around the North End. There are a few public garages to park at for a fee. For public transportation, take the Orange or Green Line to Haymarket.

PAYMENT

POPULAR DRINK Though there are wine and cocktail drinkers lining the bar here, one intriguing favorite is the Artú Doli: tropical pineapples infused with Stoli Vodka. Tastes like pineapple juice with a splash of vodka when it is quite the opposite. The dispenser sits right on the bar to show you just how the magic works. It's just a jar filled to the brim with slices of fresh pineapple soaking in vodka. Straight up or on the rocks, but I recommend the latter.

UNIQUE DRINK The bartenders have their own spot on the menu for their creative concoctions aptly labeled "Mystery Infusions." This cryptic cocktail is the ever-changing combination of whatever is in season or at hand. This generally involves fresh produce of sorts, but it can also mean melted Werther's candies in your beverage. Regardless, it's a clever ploy to keep the intrigue. Worked on me.

FOOD Get ready to be excited. Bar menu. Served until 1am. I always find that the moment I realize I don't have any food left in the fridge is just around 10pm, when every restaurant and bar has stopped serving food. These are always a good find. And the menu is pretty diverse for a late night meal—panini, antipasti, pasta,

grill items, and pizza. They really do up the pizza with gourmet topping combinations. Stuff your drunk face with gorgonzola, prosciutto and potato pizza. How could you lose? This place also has a proper lunch and dinner menu that is like an extended version of the bar menu. In case you made it in time.

SEATING There are two rooms for dining, each with their own quirky vibe. The bar area is just the bar and little standing room. If there is a wait to be seated and the bar is filled, you may be waiting outdoors.

AMBIENCE/CLIENTELE At first, the snazzy looks felt too hip for the relaxed scene normally found in the North End. I was pleased to find the place remains a casual venture fit for any occasion and the dining rooms seem to enjoy the warmth of people's chatter and laughter. People come here for a casual lunch outing, an after-work treat or a late night venture.

OTHER ONES 89 Charles St., Beacon Hill, Boston 02114, (617) 227-0499

—Victoria Young

Bacco

Romance your lady or fellow with this quality North End pick.

$$

107 Salem St., Boston 02113
(at Parmenter St.)
Phone (617) 624-0454 • Fax (617) 523-1814
www.bacconorthend.com

CATEGORY Cocktail Bistro

HOURS Mon-Fri: 5 pm-1 am
Sat/Sun: 4:30 pm-1 am

GETTING THERE Street parking is next to impossible, but there is a parking garage, Parcel 7 garage, at 136 Blackstone St. that will offer a good deal for a validated ticket from Bacco. For the closest public transportation, take the Orange or Green Line to Haymarket.

PAYMENT [AMERICAN EXPRESS] [MasterCard] [VISA]

POPULAR DRINK Wine is the obvious choice among patrons to pair with the Italian cuisine, especially with such a well rounded selection of Italian wines. Downstairs by the bar, the cocktail list is prone to perusers. The St. Germain cocktail and the chocolate martini are two preferred choices.

UNIQUE DRINK Feeling a little under the weather? A gingertini should pick you right back up. Made with Absolut vodka, homemade ginger syrup, squeezed lemon and candied ginger. You probably won't get any better, but you're sure to feel dandy.

FOOD The menu is made up of Italian and Mediterranean cuisine fit for a romantic swoon session or a celebratory occasion. As are the prices. If you're looking for a small plate of something special, their appetizers are thoughtfully put together, though still a bit pricey. If you're lucky enough to catch their occasional 5pm to 7pm half-off appetizers happy hour, I would suggest trying the Arancine, a fontina and basil risotto fritta with oven-roasted tomato ragu. And the calamari and stuffed red peppers are also quite the treat.

SEATING The ground level floor has a beautiful long bar with plenty of seating as well as a few tables generously

spaced out for private cocktail comfort. The upstairs houses a room of tables for food seekers. Occasionally, the limited table seating can lead to a crowd in the bar area while the hungry diners await their turn with martinis in hand.

AMBIENCE/CLIENTELE Bacco is recognized as one of the North End's romantic hot spots. The dark and moody bar area brings out the depth and warmth of the dining room. Grab a seat by the tall windows or talk side by side at the bar and steer the night into whatever climate fits your chemistry.

—Kashlin Romero

Boston Common Coffee Co.
Flavor shots and muffin tops.
$
97 Salem St., Boston 02113
(between Cross St. and Prince St.)
Phone (617) 725-0040
www.bostoncommoncoffee.com

CATEGORY Coffee Café

HOURS Mon-Fri: 6 am-9 pm
Sat/Sun: 7 am-9 pm

GETTING THERE On the T, take either the Orange or Green Line to Haymarket. Parking is a nightmare. There is some metered street parking, but there are also some garages in the area to park for pay.

PAYMENT DISCOVER AMERICAN EXPRESS MasterCard VISA

POPULAR DRINK With a variety of seasonal flavored lattes with enticing names of our favorite munchables, such as Candy Cane latte or Jr. Mint Latte, this café rocks out lattes galore. I realize that it's just a jumble of obvious flavor shot combinations, but the sentiment is there. Honestly, who could resist ordering caffeinated S'mores?

UNIQUE DRINK Can't decide between a chai latte and a hot apple cider? The solution is simple. Chai-der. Brilliance.

FOOD Pretty stacks of pastries line the bakery case for picking out a snack for breakfast or a pre-meal treat. Muffin tops are no longer a Seinfeld invention, but an everyday option. For the ones with tummy space, a list of panini are available for the choosing. The Traditional, tomato, mozzarella and pesto, is a refreshing choice. And always check the panini of the month for new sandwich combinations. The John Wayne pops up occasionally and steals the show with its chicken, bacon, cheddar and ranch dressing.

SEATING Among the dozen tables available sits two inviting arm chairs and a cozy couch for the taking. For solo diners and laptop users, a high counter facing out the window is a prime choice.

AMBIENCE/CLIENTELE The mellow vibe this place offers might have something to do with the living room they plopped down in the middle of their café. With fireplace and rug and all, the café transforms into a place to get away from your stuffy living room and step into one where everyone around you is doing just what they came for, be that reading a pile of textbooks, returning e-mails or quietly catching up with friends. With all the caffeine and scrumptious food you need readily available, you won't be leaving for a few hours.

EXTRA/NOTES Boston Common Coffee Co. also bears the title Boston Beanstock Co. This little ambiguous name game has caused me at least 5 minutes of argument, only to find they were both acceptable. This is me trying to save you a potential 5 minutes.

OTHER ONES 10 High St., Boston 02110, (617) 695-9700

—Alexis Vandeventer

Caffe Vittoria

Stylish café for Italian coffee and dessert.

$

296 Hanover St., Boston 02113
(at Wesley Pl.)
Phone (617) 227-7606 • Fax (617) 533-5340
www.vittoriacaffe.com

CATEGORY Coffee Café

HOURS Daily: 7 am-Noon

GETTING THERE T: Green or Orange Line to Haymarket.

PAYMENT $

POPULAR DRINK Pistachio, blackberry, cinnamon, and mocha coffee; espresso and cappuccino; three full liquor bars. The upstairs one is more for coffees and wines, the downstairs for the cigar parlor, with an impressive menu of single-malt scotches, champagnes, grappa, martinis, and aperitifs.

FOOD Tiramisu, cannoli, ricotta pie, and an impressive menu of gelati.

SEATING Three different seating areas: a brightly lit front room with about 15 decent-sized marble tables; the older, and a bit shabbier Caffe Vittoria Originale next door with about 25 tables; and a dark, but cozy cigar parlor downstairs.

AMBIENCE/CLIENTELE A gathering spot for Italian-American locals by day, a trendy after-dinner spot by night, Caffe Vittoria has an ambience that morphs from one room to the next. The newest, front room is gleaming and a place to be seen, with towering, polished espresso machines, silver sconces and coffee grinders on the walls, and a pounded tin ceiling. There's a jukebox in the back belting out the tunes of Sinatra or Italian opera, and accompanying the hiss of espresso makers and clinking dessert forks. The slightly dingier original café next door is a bit more intimate and abuzz with socializing. Downstairs an old-boy's club gathers to sip vermouth, smoke cigars, and take in Italian soccer games on a big-screen.

EXTRA/NOTES Claims to be the first Italian café in Boston. The service is aloof but decent. They pretty much let you be unless you need them.

—Kimberly Loomis

Cantina Italiana

Follow the neon drip to Italian hedonism.

$$

346 Hanover St., Boston 02113
(at N. Bennet St.)
Phone (617) 723-4577 • Fax (617) 723-6357
www.cantinaitaliana.com

CATEGORY	Wine Bistro
HOURS	Daily: 11:30 am-11 pm
GETTING THERE	Street parking is a major problem, which may tempt you into using the pricy $20 valet available. You make the choice. For public transportation, take the Orange or Green Line to Haymarket.
PAYMENT	DISCOVER AMERICAN EXPRESS MasterCard VISA
POPULAR DRINK	Without a full bar, and only a few cordials and beers, wine is most certainly the drink of choice. Get a bottle for the table or sip on a hearty red at the bar, which is covered with shelves and shelves of wine bottles, to give a good show of their commitment to the beauty of fermented grapes. Their wines are selected from all over the world, so you can color your tongue whatever shade of purple fits your mood.
FOOD	As the oldest restaurant in the North End, Cantina Italiana takes wine seriously, but only as a companion to their traditional Italian dishes. Experience the homemade pasta with the Gnocchi al Forno, the Lasagna al Forno, or the Bombolotti alla Buongustaia, made with spicy Italian sausage, fresh basil, marinara, parmigiana, and goat cheese over a wagon-wheel pasta.
SEATING	The wine bar is quite small and offers only a few seats, and feels slightly awkward to sit at. I suggest keeping the lonely table company in the hidden nook by the window. It's a quiet little hide out. As for the restaurant, the room snakes around with tables and booths designed to fit big plates and large parties. They have both, so come hungry and make a reservation.
AMBIENCE/CLIENTELE	During the peak dining hours, an uproar of laughter and lively conversation will put a halt to your peaceful dinner plans. If you come with a hedonistic attitude, you will leave with a teeth-stained grin on your face.

—Bridget Halverson

Florentine Café

A North End place to linger.

$$$

333 Hanover St., Boston 02113

(at Prince St.)

Phone (617) 227-1777

www.florentinecafeboston.com

CATEGORY	Cocktail Bistro
HOURS	Daily: Noon-Midnight
GETTING THERE	There is street parking, but it is hard to come by. Local garages are the best bet for drivers. For public transportation, take the Green or Orange Line to Haymarket.
PAYMENT	DISCOVER AMERICAN EXPRESS MasterCard VISA
POPULAR DRINK	At the tables, wine is a common pick. The beautiful grandiose bar may persuade you to consider something with a bit more ingredient complexity and the signature martini list can be of service. Fruit-inspired concoctions, like Wild Blueberry and Peartini, are not unheard of, but they still sound alluring. And the bartenders are well prepared to bring it the best they got.
UNIQUE DRINK	The Spiced Apple Pie cocktail caught my eye. Vanilla whiskey, spiced apple juice and a touch of cinnamon. Gimme.

FOOD There is a full menu made up of slightly fancied up Italian fare that is decently priced and of pretty good quality. If you need some direction, lobster ravioli is where it's at.

SEATING Besides the glorified bar seating, small 2-tops are squeezed close together allowing for an intimate listening-in of your neighbors' conversation. I must admit, it is a good use of space and better than having a ridiculous wait every night. Plus, it's part of the culture of fine dining. The art of ignoring those around you. For the bigger parties or the longer waits, there is more table space in the lower levels, though no window view.

AMBIENCE/CLIENTELE People are drawn in for different reasons. Some are locals having a glass of wine at their favorite bar, some are tourists searching for that quintessential North End restaurant, and some are couples in search of a place to romance each other. The ambiance is key to the allure of Florentine Café. The restaurant sits on a corner of the busiest street in the North End. Tall windows that open outwardly as doors in the warmer months allow a fresh breeze roll through. A painted Italian scene mural lurks unobtrusively in the background. There are small tables of couples staring out the window and talking aimlessly with a bottle of wine between them. It has the potential for romance. Or at the very least, potential for a nice lunch.

—Bree Cummings

Goody Glover's

An Irish haunt in the Italian corner.
$$
50 Salem St., Boston 02144
(at Cross St.)
Phone (617) 367-6444
www.goodyglovers.com

CATEGORY Beer Pub

HOURS Daily: 11 am-1 am

GETTING THERE Parking is a nightmare in the North End. There are a few parking garages in the area for drivers. To get there by the T, take the Green or Orange Line to the Haymarket station.

PAYMENT

POPULAR DRINK The bartenders brew up a mean sangria, making it one of the more commonly ordered beverages. Interestingly enough, sangria means "bloody" in Spanish and Portuguese, putting a little more spook into the theme of the pub. If sangria doesn't bewitch you, there is a full bar available. And I promise I'll stop with the witch references.

FOOD Goody's is a pub first and a restaurant second. That being said, their menu options seem to have more variety and consideration put into them than most standard pub fare. For appetizers, the crispy egg rolls and buffalo style chicken wings are great finger food items. For a filling dish, try the the 10oz. black Angus bacon cheddar cheeseburger, served with hand-cut fries and homemade ketchup. Homemade ketchup, people! You should be flocking.

SEATING The first noticeable characteristic of this bar is that it has just that. A bar. There are no tables, and no room for tables even, and just a small ledge by the windows and some scattered stools offer more spontaneous seating areas. This was until I saw the sign for the upstairs lounge. When I scurried up the stairs, I realized that the lounge area looked much like a small set of tables for dining with another bar at the end of the way. This bar had seats, stools by the bar and a line of more stools for anyone wanting to use the ledge lining the window to create a separate seating area overlooking the beautiful city buildings. This bar has a limited capacity, but it doesn't get filled to the brim all too often so they are generally able to accommodate.

AMBIENCE/CLIENTELE This Irish gem is largely overlooked. They keep a low key profile and generally tourists flock to the North End for a non-pub. (Though this is probably for the better.) Another reason may be that the bar takes some exploration to experience the whole vibe. Quaint as the bottom level may be, it may be a bit too dark and claustrophobic for some. The upstairs offers some relief with tall, glowing ceilings and a set of tall windows overlooking Boston. Witch hats, eerie candelabras and autumn leaves hung around bounding twig wreaths are used as decor meant to drive forth the memory of Goody Glover, a woman accused of witchcraft in 1633, for which she was eventually hung. But if nothing else entices you, at least stop in for a quick drink after work and enjoy the view out the window. It is unexpectedly gorgeous and serene. You just might find yourself a new hangout. Or a place to take a date.

—*Deepak O'Reilly*

The Living Room

The house party you always dreamed of.

$$$

101 Atlantic Ave., Boston 02110
(at Richmond St.)
Phone (617) 723-5101 • Fax (617) 720-2966
www.thelivingroomboston.com

CATEGORY Cocktail Lounge

HOURS Daily: 11 am-1 am

GETTING THERE Street parking can be a nightmare. On Thursday, Friday and Saturday nights, there is $18 valet parking. Or if you park in the Lewis Wharf Parking (28 Atlantic Ave.) just down the street, a validation from The Living Room will knock off $2 from the fee. For non-drivers, the Blue Line Aquarium stop and the Orange and Green Line Haymarket Stop are close by.

PAYMENT

POPULAR DRINK The bartenders rock out martinis like it's their job. And technically it is. Most often, the sweeter, fruitier drinks are ordered out of the extensive martini menu.

FOOD The Living Room plays it safe by covering all the food bases. A broad spectrum of menu options keeps a question mark over quality but works to keep the majority pleased. Just about any type of cuisine is at your fingertips, whether it be shrimp and avocado eggrolls, Mediterranean salad, chicken taquitos, lamb kebabs, lobster ravioli or franks and beans. If I had to throw it all into one category, it would be comfort food, which is most appropriate to their theme.

SEATING Couches and armchairs are spread out among high-tops and tables. A dining area is available for the basic dining experience. The outdoor patio area opens up for seating during the appropriate seasons.

AMBIENCE/CLIENTELE This lounge fulfills all the expectations of its name. Spacious rooms are decked out with everything you've every wanted as part of your living room; high ceilings, big screen TVs, the 150-gallon saltwater aquarium overlooking your martini bar and that perfect color scheme. Though there is a sentiment towards comfort, most people treat it like the hip lounge it is and are dressed up like they're hosting a block party. If you really want to crash in with sweats and baggy clothes, aim for their weekend brunch.

—*Victoria Young*

Stanza dei Sigari

A smoker's paradise.
$$$
292 Hanover St., Boston 02113
(between Prince St. and Parmenter St.)
Phone (617) 227-0295
www.stanzadeisigari.com

CATEGORY Cocktail Lounge
HOURS Daily: Noon-1 am
GETTING THERE Street parking is available, but it is hard to find. There are garages in the area for drivers to use for a fee. For public transportation, take the Green or Orange Line to Haymarket (closest) or North Station. The Aquarium stop on the Blue Line is also fairly close.
PAYMENT
POPULAR DRINK Cigar smokers like to keep it classy. If they aren't sipping on a single-malt scotch or a hearty port, they're delving into the selection of cognac. Stanza dei Sigari keeps a solid liquor selection with a wide variety of labels.
FOOD With a drink in one hand and a smoke in the other, your hands are too occupied for such matters as utensils. Also, there's is no food at Stanza.
SEATING The two rooms are decked out with table tops, couches and arm chairs for comfortable style.
AMBIENCE/CLIENTELE The tattered brick walls of this classic cigar parlor are covered with antique oddities, framed cigar labels, and display cases galore. The dim and smoky room is filled with loud-laughers, storytellers, and smokers. On a busy night, matches are lit every minute, the puffing ensues and the room soon gets hazy. Certainly not a place for the weak of lung.
EXTRA/NOTES Welcome addicts and enthusiasts all! Cigarette smokers can light up without a fee.

—*Victoria Young*

Vinoteca di Monica

Relaxed wine bar.
$$$
143 Richmond St., Boston 02113
(between Hanover St. and North St.)
Phone (617) 227-0311 • Fax (617) 227-3381
www.monicasfoods.com

CATEGORY	Wine Bar
HOURS	Mon-Thurs: 5:30 pm-10:30 pm
	Fri/Sat: 5:30 pm-11 pm
	Sun: 5:30 pm-10:30 pm
GETTING THERE	Valet, street parking or validated parking at Congress St./Parcel 7 Garage. Nearest T stop: Haymarket, Government Center, and Aquarium.
PAYMENT	
POPULAR DRINK	The wine list is extensive with many wines offered by the glass or the half bottle. The bar recently received a full liquor license so they now offer beer and a full list of cocktails, though most people here stick with the wine.
UNIQUE DRINK	The wine list includes options from Argentina, Australia, California, Chile, Italy and Umbria. There are several sparkling wines on the list, which are typically harder to find.
SEATING	The bar is small, to say the least. However, it is a very comfortable space that is separated from the main dining room thus making it the perfect place to have a drink while you are waiting to be seated. About 6-8 people can sit at the bar and there are several high tables. Tables are often filled with diners so the space can feel a little cramped and you are not guaranteed a seat at a table if you are just there for drinks.
AMBIENCE/CLIENTELE	Monica's has been one of the North End's best and most frequented restaurants since it opened in 1995. It recently expanded its space to include the wine bar. The entire restaurant underwent renovation making the space much more modern and stylish while maintaining the North End charm that the clientele craves. What makes the space especially alluring is that it can feel warm and cozy on a snowy evening yet also light and open on a hot summer evening when all of the windows open out onto the street.
EXTRA/NOTES	This spot is the perfect place to have a drink before or after dinner in the North End, even if you are not dining at the restaurant itself. A warning: even if you come to Monica's with the intention of simply getting a drink, you will most likely find yourself asking for a menu. Also note that the website has not been updated since the renovation and does not do justice to the restaurant itself.

—Kate Golden

FORT POINT CHANNEL/SEAPORT DISTRICT

The Barking Crab

A crabulous summertime spot.

$$

88 Sleeper St., Boston 02210

(between Northern Ave. and Seaport Blvd.)

Phone (617) 426-2722

www.barkingcrab.com

CATEGORY	Beer House
HOURS	Daily: Noon-10 pm

Summer:
Mon-Weds: Noon-11 pm
Thurs-Sat: Noon-1 am
Sun: Noon-11 pm

GETTING THERE There is a parking lot outside the restaurant. It can be hard to find a spot on hopping nights. Lucky for drivers there's a pay lot sitting just next to it. There are also lots and metered parking around the area, but it might require a bit of a trek. Same goes for walkers or public transit riders. The nearest public transit is the South Station stop off the Red and Silver line. Bring your walking shoes.

PAYMENT

POPULAR DRINK A healthy list of regional microbrews makes those warm summer days by the sea that much more glorious. Pitchers of draft beer are a good choice to split among friends. Margaritas are a refreshing treat for those scorchers.

UNIQUE DRINK Their signature Crab Cocktail, made with coconut rum, pineapple rum, light rum, dark rum, pineapple juice, orange juice, fresh lime juice, grenadine and bitters will give you a steady buzz and a Barking Crab souvenir cup.

FOOD Get your fill of crustaceans from a bucket of shrimp to a clambake food frenzy.

SEATING Wooden picnic benches are lined up in rows on the tented outdoor area and well-worn country tables are strewn about the indoor section. This is a summer hot spot so even with plenty of seating, there is usually a wait for the outdoor area.

AMBIENCE/CLIENTELE Set just off the marina, The Barking Crab attracts seafood lovers and tourists in search of a Boston experience. The decor does not disappoint with nets and catches strung up with lights while tarps make up the ceiling making the place feel like a simulated quaint fisherman's bar. It's a great afternoon spot to grab a pitcher of beer and some shelled grub.

EXTRA/NOTES The Barking Crab occasionally features live music at night. Call or check their monthly schedule only for times, dates and performances.

—*Lawrence Fong*

Blue Wave

The actual ocean may be preferable compared to this dud.

$

343 Congress St., Boston 02210
(between Sleeper St. and Farnsworth St.)
Phone (617) 790-0720 • Fax (617) 790-0740
www.bluewavelounge.com

CATEGORY Beer Bar

HOURS Mon-Weds: 11 am-10 pm
Thurs: 11 am-1 am
Fri/Sat: 11 am-2 am

GETTING THERE There is metered street parking that should not be hard to find. There are also some pay lots in the area. The nearest public transit is South Station on the Red and Silver line.

PAYMENT

POPULAR DRINK Typical sweet martinis and cocktails with enticing names are the only featured options on their list of

libations. The Gumdrop Martini is a perfect example. In theory, it's like a fantastical candyland journey but with Chambord, Midori, peach schnapps, blue curacao and pineapple juice, the sugar rush might make you comatose. A decent wine list is available for a tamer choice as well as a few beers on tap.

FOOD A wide variety of tempting comfort food provide all the lunch time options any business professional might seek out like sandwiches and salads. The long list of appetizers can also provoke some late night snacking.

SEATING Semi-booths line the walls while semi-booth high tops take dead center. The bar takes up one wall while two stylish high-backed leather couches sit isolated on the side, each creating their own nook. With so many seating choices in just one room, there is a surprising amount of open space.

AMBIENCE/CLIENTELE The Financial District just across the water draws in a lunch time rush of suits looking for a jazzy place to enjoy their hour away from the office. After a long day, some business folk swing in for a drink before heading home. The nighttime scene taps into a whole different vibe from the daytime escape. The soft blue glow, flowing curtains and the vibrant color palette conjure up a serene underwater scene that allows for a relaxing meal on slow nights among the dribble of people. A DJ is brought in for themed music nights every Thursday, Friday and Saturday, drawing in people dressed in their fashion forward looks and pampered hair waiting impatiently for a good time to come to them.

EXTRA/NOTES On the last Wednesday of every month, you can come here for poetry from 10pm to 2am.

—*Alexis Vandeventer*

The Channel Café

Cozy art gallery with tasty offerings.
$$
300 Summer St., Boston 02210
(at A St.)
Phone (617) 426-0695
www.channel-cafe.com

CATEGORY Cocktail Café
HOURS Mon-Weds: 8 am-3 pm
Thurs Fri: 8 am-10 pm
Sat: 5 am-10 pm
GETTING THERE Take the T to South Station and walk across the Channel, or find metered parking on Summer St.
PAYMENT
POPULAR DRINK They have a good selection of beers on tap: Harpoon IPA, Harpoon UFO, PBR, Ipswich Ale, and Pilsner Urquell for $4.50 a pint. Red and white wines include Merlot, Pinot Noir, Primitivo, Chardonnay, Sauvignon Blanc, Pinot Grigio and a sparkling Cava ranging from $5- $9.50 a glass. The White Sangria ($6.50) is made from owner Ana Crowley's secret recipe.
UNIQUE DRINK With only a beer and wine license they have tapped into their creativity with "wine cocktails." Try the Port Side Fizz: ruby port, Cava, and lime; or the Pear Gingersnap: pear cider, ginger beer, and Lillet. On nights

FOOD that they serve dinner, take advantage of the Burger and a Draft Beer special for $10 from 5 pm-7 pm. The Channel Café offers a great selection of healthy, eclectic and appetizing options for breakfast, lunch, and dinner at very reasonable prices. You could eat there every week and not run out of good dishes to try. From veggie or lamb burgers to creative salads, falafel, quesadillas, and burritos for lunch to the chicken under a brick, mushroom raviolis, or Catfish Po' Boy for dinner. Please note the hours as they are only open for dinner from Thurs-Sat.

SEATING There is one large table for bigger groups, several smaller tables, and a couple spaces at the bar. Get there early for lunch if you want to get a seat.

AMBIENCE/CLIENTELE The Channel Café is a favorite lunch spot for the ever-growing art community in South Boston. The space itself could be an art gallery, and is in fact connected to one owned by the proprietor of the café. The café has a lofty feel with lots of natural light, and has some permanent art pieces on display by local artists.

EXTRA/NOTES Owner/artist Ana Crowley can be found behind the hostess stand most days. Of note, when a new exhibit opens in the attached gallery, the café often hosts a reception open to the public. The ambience becomes a bit more sophisticated and intimate in the evening, and makes for a fun night indulging in the arts.

—Paul Collins

The Daily Catch

A summertime gem for waterside seating.

$$

2 Northern Ave., Boston 02210
(at Sleeper St.)
Phone (617) 772-4400 • Fax (617) 772-4402
www.dailycatch.com

CATEGORY Beer Bistro

HOURS Mon-Fri: 11:30 am-9 pm
Sat: Noon-9 pm
Summer:
Mon-Sat: 11 am-11:30 pm
Sat: Noon-9 pm

GETTING THERE There is a pay lot across the street and other lots and street parking further out. The Daily Catch is located by the marina, making it hard to get to. The nearest T-stop in South Station off the Red Line.

PAYMENT

POPULAR DRINK Beer, wine and cordials make up their drink list.

FOOD Sicilian-styled seafood and Italian classics.

SEATING The modest indoor area has booths and tables, but the real treat is the summertime outdoor setup of tables and a small bar by the marina.

AMBIENCE/CLIENTELE The courthouse and the Financial District draw in a hungry lunchtime crowd. The huge open space outside by the water make this spot a great patio gem for anytime of day. Relax on those hot summer days with a beer or a bottle of crisp wine and some hearty Italian seafood.

OTHER ONES 323 Hanover St., Boston 02113, (617) 523-8567

—Bree Cummings

Drink

The art of crafting the perfect cocktail.

$

348 Congress St, Boston 02210
(between Farnsworth St. and A St.)
Phone (617) 695-1806
www.drinkfortpoint.com

CATEGORY	Beer Bar
HOURS	Daily: 4 pm-1 am
GETTING THERE	There is street parking as well as parking lots around. The nearest public transit is South Station (Red and Silver line).
PAYMENT	
POPULAR DRINK	Ordering drinks here gives you good odds to finding the best cocktail you've ever had. And it's because the bartenders here are not only some of the best Boston has, but they also go through meticulous measures to ensure that your beverage is executed with a professional dexterity and made with quality ingredients. Right down to the ice cubes. A 50-pound dense block of ice services all the ice in the house. It just needs to be chipped, shaved or smashed according to each drink's requirements. Fresh produce patiently awaits their turn to play a role as a twist or a squeeze. Potted spice plants are not plucked until a beverage demands a mint leaf or a hint of basil. Flavor additions come from a set of medicinal bottles so as to get a chemist's precision of a drop of liquid. A spread of shiny apparatuses are neatly placed at each station to assist in the process. Start to finish, it may take a solid five minutes to make one drink, but there is no rushing genius in a glass.
UNIQUE DRINK	Tap into the creative minds of these mixologists and offer a concept that will inspire a drink. A mood, a color, a flavor. Challenges do not phase these liquid prodigies.
FOOD	Small bites of classy comfort food that may not appease the hunger, but if you want more, it's probably because it was that damn good.
SEATING	The bar pushes out from the wall into three branched sections for each bartender to keep their own workspace. This configuration allows more bar surface area for more seats to gather around your preferred cocktail artisan. (And patrons do have their favorites.) Other than the bar seating, there are a few other areas to huddle around, but not much. The bar is where the magic happens and with growing popularity, Drink can attract a large crowd around the bar's perimeter.
AMBIENCE/CLIENTELE	Set in an obscure basement in Fort Point, an already isolated Boston neighborhood, Drink is a hidden gem for cocktail enthusiasts of all levels of appreciation. People come dolled up and ready to watch with awe the craftsmanship behind each libation. Drink strays from that pesky beverage menu and provokes a classic bartender-customer relationship, and the dialogue created is contagious. It is not uncommon to find strangers evoking conversations with one another about their beverages. Even in the murky underground lair that is Drink, a sophisticated charm that delights and ensorcels people to trek back again and again.

—*Victoria Young*

Lucky's Lounge

An underground (literally) neighborhood bar with a 50s feel.

$$$

355 Congress St., Boston 02210
(at A St.)
Phone (617) 357-5825
www.luckyslounge.com

CATEGORY	Cocktail Lounge
HOURS	Mon-Fri: 11 am-2 am
	Sat: 6 pm-2 am
GETTING THERE	Parking on street and nearby lots. Approximately a 10-minute walk from South Station (walk north to Congress, cross bridge).
PAYMENT	
POPULAR DRINK	While Lucky's has a decent selection of beers, the cocktails here are the stars of the show. With a mix of tart, fruity gems like the raspberry-based Lucky Lady and dessert-inspired drinks like the Godiva martini and classic espresso martini, you could make a full meal from the cocktail menu (and it's obvious that some locals do).
UNIQUE DRINK	The Fort Point neighborhood of South Boston combines the hip and savvy of downtown Boston with the old-school charm of Southie, and the bar experience reflects that. You're sure to see a sidecar on the menu, and it'll be made traditionally, shaken expertly and rimmed with something sophisticated, but served with a neighborly, unpretentious smile.
FOOD	Lucky's has an excellent menu, with American classics and dishes inspired from many world cuisines. It's what old Southie residents might call "yuppie food," with prices to match, but the portions are large and the quality is high. The menu features both traditional pub food like nachos, as well as tasty healthy options like vegetarian egg rolls and chopped salad. It also includes a daily "slider" (mini-burger) special.
SEATING	Lucky's is packed during primetime hours, so if you're planning to find a table with a group, be prepared to come early or wait. However, the hostesses at Lucky's are universally polite and friendly, and a lively bar scene with attentive bartenders makes waiting a pleasure, not a pain.
AMBIENCE/CLIENTELE	Lucky's does not have a sign to mark it. It's just a doorway at the corner of a nondescript brick building, leading into a garden-level space, and the windows are opaque, giving nothing away about what's inside. Because of this, it has the feel of a secret speakeasy, where only those in the know go to get their kicks. The crowd is diverse: locals and business people lunch there during the week, young professionals with bags slung over shoulders take over on weeknights, and families and hipsters flock to the Sinatra brunch on Sunday mornings.
EXTRA/NOTES	As noted above, Lucky's has no sign or other marking, just look for the address, and on busy nights, a crowd of smokers lingering around the entrance of a staircase on the corner of Congress and A Sts. If you're looking for a less-crowded, more intimate experience, try going in the early evening on a weeknight, after happy hour and before 10 pm. Lucky's Sinatra brunch is also worth checking out, with a live Sinatra cover band playing all afternoon and a satisfying, savory brunch menu.

—*Ryan Weaver*

Morton's 1221 Bar

The Power, the Passion (fruit foam), and the Mortini.

$$$$

Two Seaport Ln., Boston 02210
(at Northern Ave.)
Phone (617) 526-0410
www.mortons.com

CATEGORY	Cocktail Bar
HOURS	Mon-Fri: 11:30 am-11 pm Sat: 5 pm-11 pm
GETTING THERE	Morton's is accessible by auto, the Silver Line (WTC stop) and even by water taxi. Parking is available in nearby lots for a fee.
PAYMENT	
POPULAR DRINK	With an eight-page, leather-bound drink menu dedicated to their vast selection of martinis, cocktails, beers and spirits, there is something for everyone from your grandfather to your co-worker's girlfriend. Martinis and beers seem to be the most popular choices. The house "Mortini" starts at $11.75 and is served in a sturdy, oversized martini glass. Don't be embarrassed to order a Long Island Ice Tea, which is included in the section dedicated to "Timeless Cocktails." Unlike many bars, you can even order hot cocktails like a Hot Toddy, without getting a sneer from the bartender who has to leave the bar to hunt down hot water. Try the Morton's Coffee with Amaretto, Bailey's, Creme de Cacao, fresh whipped cream and a cinnamon sugar rim.
UNIQUE DRINK	The "Heavenly" martinis are a novelty that's served in those giant spill proof martini glasses and topped with a passion fruit "foam" made with egg whites. Beware, though, of the heavenly mustache that you will get when you take your first sips. Even for a margarita snob the heavenly margarita tasted quite good once I made it through the thick foam.
FOOD	Morton's has great deals on bar bites during their so called Power Hour: Mon-Fri 4:30 pm-6:30 pm, and 9:30 pm-11 pm. For the price of a McDonald's drive-through meal you can get crab cakes, petite filet Mignon sandwiches, oysters, shrimp cocktail, and blue cheese fries.
SEATING	When it's packed during Power Hour, the bar can seem pretty small. In reality, there are about 25 seats in the rounds with a close up and personal view of the brown-vested bartenders who are in constant motion from mixing, muddling, and taking care of business. Four high tops flank the side of the bar, and everything is within view of the three flat screens.
AMBIENCE/CLIENTELE	Located next to the offices of Fidelity Investments and the Convention Center, Morton's attracts a masculine, corporate, power suit type of 30 and over clientele. Though it can be a sausage party during certain times, they haven't forgotten about the ladies (the evidence lies with the nice little hooks under the bar where you can stash your purse).
EXTRA/NOTES	The 1221 bar was named after December 21, the date of the Blizzard of '78, where people trekked to Morton's original Chicago location on cross-country skis.
OTHER ONES	Morton's is a chain of steakhouses. Check out their website for other locations.

—*Minh Luong*

YOU *CAN* TAKE IT WITH YOU

For a wine drinker, an indication that a night out is going well is the decision to order another bottle of wine. What to do, however, if soon after the cork is released, spontaneity steps in with new plans, or closing time is at hand, or an impending food coma leads one towards comforts of home? Every wine drinker in New England has been in this predicament: to chug and jet, or to leave it behind?

Now the law is on our side in the decision-making process! Patrons of hotels and restaurants can take unfinished bottles of wine, as long as they were purchased with a meal. This law appeared a godsend straight from Bacchus.

What do you need to do to qualify for wine carry-out? First, you need to eat a meal. Unfortunately a quick bite appetizer doesn't qualify as a meal. The law defines a "meal" as:

> "the purchase by 1 person of a diversified selection of food which ordinarily is classified as an 'entrée' or 'main course' which ordinarily cannot be consumed without the use of tableware and which cannot be conveniently consumed while standing or walking.' For a purchase by '2 or more persons' a meal means 'a diversified selection of food which is priced at more than $20.00 and ordinarily cannot be consumed without the use of tableware and which cannot be conveniently consumed while standing or walking.'"

The gist? Play it safe: order an entrée with your wine, whether flying solo or with others. When you make the decision to take the wine with you, simply let your server or bartender know about your decision and the rest is up to them.

"All the guests have to do is ask," says Steve Johnson, owner of Rendezvous restaurant in Cambridge. "We have the sealable bags, and we follow the guidelines set forth by the License Commission to properly execute the carry-out."

Next, they need to reseal the bottle (one bottle per patron) and secure it in a wine doggie bag, described as "tamper-proof transparent bag that insures that the patron cannot gain access to the bottle while in transit after the bag is sealed." This bag is supposed to deter you from sipping en route, safeguarding you from the open container law, whatever your mode of commuting. Proof of date and purchase of your wine with a meal appears in the form of a receipt affixed to the bag. Once this bag is in hand, you're ready to roll.

Does this law have wine lovers flocking to restaurants, ordering wine by-the-bottle instead of by-the-glass? Johnson has noticed a discreet difference. "I suppose that this convenience has impacted our wine sales in a slightly positive way, but not in any real quantifiable percentage." He supposes that the decision lies more in the diversity of wine list than the attributes of the law. "We probably get 2 or 3 requests a week. Not very many people really inquire about this measure while dining in our restaurant. We already offer so many options for people to properly dose their

consumption of wine when they come here, such as wines by the glass, 500ml carafe and bottle, that this only adds one more option to that list."

What is the motivation then? Perhaps it simply lies in the ability to take home the experience of the wine. What better way to relinquish oneself of any buyer's guilt from splurging on a special bottle than by getting another drinking session out of it.

Johnson summarizes that "if we have any idea that certain guests might be interested in taking advantage of this policy, we let them know that purchasing a full bottle that they might not finish wouldn't necessarily result in waste for them but that they can take the rest home and drink it the next day. Some wines are just fine, or even better, 24 hours later." With "take home" wine you have the option to revisit that warm and fuzzy feeling all over again at home.

— *Jennifer J. Adams*

Persephone

This place makes its own rules.
$$$
283 Summer St., Boston 02210
(between Melcher St. and A St.)
Phone (617) 695-2257 • Fax (617) 695-2258
www.achilles-project.com

CATEGORY	Cocktail Bistro
HOURS	Tues-Thurs: 11:30 am-Midnight
	Fri/Sat: 5:30 pm-1 am
GETTING THERE	There are a few parking lots in the area as well as street parking. South Station (Red Line) is the nearest T-stop.
PAYMENT	
POPULAR DRINK	Persephone's cocktails make patrons stagger with the sweet sway of inebriation. Each one is dolled up with a variety of ingredients to make you curious for more. The moderately-sized wine list is well received and ordered by many, especially with dinner.
UNIQUE DRINK	To give you a taste of their speciality cocktails, here are a couple favorites: One Night in Bangkok - tequila, St. Germain, thai basil, lime and Cointreau. Arnie P.'s Tea Shot - Rain lavender lemonade vodka, dry vermouth, St. Germain, mint syrup assam-ceylon tea and lemon juice.
FOOD	Upscale plates of local, organic, sustainably raised or harvested ingredients with an emphasis on delectable seafood dishes. An updated prix fixe menu is offered every Tuesday, Wednesday and Thursday. The bar menu is an equally thoughtful list of small bites.
SEATING	Once you get past the boutique, a lounge area greets you with a set of odd cushioned shapes for couches, a few high tops and a bar. Walk further and find an open room with innovative tables that sit on sets of bars that can be adjusted according to party size. It's a subtle, but brilliant touch.
AMBIENCE/CLIENTELE	Behind what looks to be a closed-for-the-night boutique clothing shop sits a hip little bar with a serious

kitchen. A DJ spins into the late hours and most of their TVs are dedicated to either a classic black and white nickelodeon or Wii sports for young-at-heart sophisticates. The bar radiates an orange glow upon the entire lounge area and large windows set in the brick wall give the room space. If you're bored for even a moment, entertaining coffee table books are tucked into the lounge tables or you can even browse the Achilles Project with the suspended clothing racks and the wall of sleek new shoes. Persephone is designed for the hip and fashionable, but casual visitors should not be intimidated by the scene. This place is well equipped to delight anyone in the mood for something different.

—*Victoria Young*

Tamo Bar

Seaport Libation Lounging.
$$$$
One Seaport Ln., Boston 02210
(at Northern Ave.)
Phone (617) 385-4324
www.tamobar.com

CATEGORY	Hotel Bar
HOURS	Mon-Thurs: 11:30 am-Midnight
	Fri-Sun: 11:30 am-1 am
GETTING THERE	Pay for parking in a nearby lot, or take the Silver Line to the World Trade Center Stop. If you're coming from across the bay then take the water taxi.
PAYMENT	
POPULAR DRINK	The Tamo Martini: a fruity, jewel toned concoction made from Stoli Razz, Chambord, and Champagne. Beer lovers will enjoy their selection of draught beers including Rapscallion Honey (NH), Anchor Steam (CA), Shipyard Ale (ME), Peroni, and Sam Adams.
UNIQUE DRINK	With drink choices such as the Lemon Cake and the Blueberry Peach Cobbler, Tamo Bar features a martini list that reads like a dessert menu. The PB & J Martini, made with Frangelico, Chambord, butterscotch Schnappes, and splash of milk will help you regress back to your childhood. The Basil Gimlet with Grey Goose, lime juice, and fresh basil is a clean, refreshing and aromatic cocktail that serves as a good palate cleanser. If you feel like splurging and/or showing off, order a $145 glass of the Louis XIII Remy Martin Cognac.
FOOD	A bar menu featuring appetizer plates in two sizes: small and large. The handmade dumplings are nice and juicy!
SEATING	With spacious 17-seat bar, booths and high tops, there is ample room to spread out or hold a private conversation or important business negotiation.
AMBIENCE/CLIENTELE	First and foremost, Tamo is a hotel bar in one of the most rapidly developing new areas. With its proximity to Downtown, the Convention Center, the ICA Museum, the Bank of America Pavilion outdoor concert venue and scores of office buildings, you'll find yourself among business travelers with convention center name tags, Fidelity Investment employees with their neck ties loosened, and anyone else who is

down in the Seaport for a good reason. Unlike most Boston bars, don't feel like you'll be overdressed in a suit or pumps, it seems like everyone is in some sort of business attire.

EXTRA/NOTES Tamo is named after the special type of Japanese wood that showcased in the bar's signature "cracked ice" design. Don't worry if you get too tipsy to figure out the tip. Tamo is one of the few bars in Boston to include the service charge of 18% on your bill to save you more time for drinking and enjoying the view of the water.

—*Minh Luong*

Water Café at the ICA

Museum with a view.
$$
100 Northern Ave., Boston 02210
Phone (617) 478-3291
www.icaboston.org/visit/water-cafe

CATEGORY Museum Café

HOURS Tues-Weds: 10 am-5 pm
Thurs-Fri: 10 am-9 pm
Sat/Sun: 10 am-5 pm

GETTING THERE Take the Red Line to South Station. At South Station take the Silver Line to the World Trade Center stop. Exit left onto Congress St. Walk one block to the corner of B St. and turn right, crossing Congress St. Follow B St. for one block. At the corner of B St. and Seaport Blvd. cross the street and turn left. At the next corner, turn right onto Northern Ave. The ICA is on the right. You will pass the entrance to Anthony's Pier 4 and two parking lots before coming to the driveway leading to the ICA entrance.

PAYMENT

POPULAR DRINK Let's face it, you're not coming here to get wasted and to rack up the digits, you're coming here to check out the newly built Institute for Contemporary Art (ICA). But why not raise a glass to the world of art while you're here? The view of the water is spectacular on a clear day, and the outdoor seating is stellar for having a sip of wine after browsing their thought-provoking art works. The service staff are attentive and friendly, even flirtatious. Order at the counter and they will bring your food and beverages to your table. It can get windy outside alongside the water so extra layers are recommended if you are sensitive to the cold.

SEATING They have plenty of outdoor and indoor seating.

AMBIENCE/CLIENTELE This café serves as a cafeteria for the museum employees and visitors, so expect the art crowd, art students, and tourists.

EXTRA/NOTES The Diller & Scofidio designed museum will be appreciated by architecture buffs. Admission to the museum is FREE on Thursdays from 5 pm-9 pm, and for families (up to 2 adults accompanied by children 12 and under) on the last Saturday of each month.

—*Minh Luong*

BEACON HILL

21st Amendment

Drink up! It's your constitutional right.
$$

150 Bowdoin St., Boston 02108
(between Beacon St. and Mt. Vernon St.)
Phone (617) 227-7100
www.21stboston.com

CATEGORY	Neighborhood Tavern
HOURS	Daily: 11:30 am-2 am
GETTING THERE	There isn't too much available street parking, but there are a few public pay lots in the area. On the T, take the Red or Green Line to Park Street. Walk up Park St., turn right on Beacon St. and left on Bowdoin St. where the bar will be to the right. 21st Amendment is located next to the State House.
PAYMENT	
POPULAR DRINK	The Speakeasy, which is simply a Gin and Tonic with lime, is a common order for the gin lovers. I'd recommend a Long Island iced tea, or some variety, just to really stick it to the 18th amendment.
UNIQUE DRINK	Prohibition Punch is a medley made up of Myers rum, Bacardi rum, Bacardi limon, Malibu, Cointreau, pineapple, OJ, sour mix, cranberry juice.
FOOD	The 21st Burger, with caramelized onions, swiss cheese, smoked bacon, onion rings, is the best pick for munching meat eaters. I recommend the Balsamic Roasted Portobello Mushroom Burger to any veggie fans.
SEATING	There are many seats at the bar and a few tables as well as a small dining area with table seating. With only two rooms, this neighborhood joint can fill up pretty quickly on a busy night.
AMBIENCE/CLIENTELE	21st Amendment attracts groups of young locals and a few blue collars all looking to let loose while appreciating constitutional history the best way they know how: drinking.
EXTRA/NOTES	A brief history lesson: The 21st amendment is celebrated for its repeal of the 18th amendment, which banned the manufacture, sale, or transportation of alcohol. Though it was not illegal to drink, that's essentially what they were after. But since 1933, we Americans can enjoy our drunken, boozy ways without having to open up a speakeasy. Huzzah!

—*Kashlin Romero*

6B Lounge

A chic lounge with an escape route to a casual world.
$

6 Beacon St., Boston 02108
(at Somerset St.)
Phone (617) 742-0306 • Fax (617) 742-9779
www.6blounge.com

CATEGORY	Cocktail Lounge
HOURS	Mon-Tues: 11 am-Midnight
	Weds-Sat: 11 am-2 am
	Sun: 11 am-Midnight

GETTING THERE Though there isn't much street parking, there are a few public garages around the area. Through public transportation, take the Red Line or Green Line to the Park St. stop and walk up Park St. Make a right on Beacon St. and it will be on your right.

PAYMENT

POPULAR DRINK Their martinis are the highlight of the lounge, with many of them made with fresh fruit purees. The Metropolitan, a pomegranate martini, is one of the more popular ones, as we are living in the days of tasty antioxidants.

UNIQUE DRINK Peruse the dessert martinis for some liquid treats. They get a little kooky, like the Banana Cheesecake martini, but it's well worth the exploration.

FOOD The bartender emphatically recommended the Herb Grilled Chicken Caesar as well as the Buffalo Chicken Nachos, which she ordered immediately for herself. I guess if the nachos can make the bartender drool, they're worth ordering.

SEATING Besides the few seats at the bar, there are also a few tables divvied up among the tucked away corners. A couple cozy booths are planted for an intimate dining experience and a small lounge area in the back provides a few long couches to lean back and mellow out.

AMBIENCE/CLIENTELE 6B puts in a mighty effort to turn their skinny space into a hip little lounge. Tall private booths and a swanky little seating area are great corners to sip on their martinis and margaritas with style. Although it is tucked away on Beacon Hill, 6B gets a mix of clientele not excluding lobbyists and state representatives. Mostly anyone just looking for a quiet, chic martini lounge. And if that's too much to handle, there's always Emmets Irish Pub just a hallway away for a more casual evening. It's like a secret passage in Clue to the other corner of the board.

EXTRA/NOTES Check out their $6 margarita Wednesdays. They will not disappoint.

—*Avalynn Michaels*

75 Chestnut

Beacon Hill's comfort zone.

$$

75 Chestnut St., Boston 02108
(at River St.)
Phone (617) 227-2175 • Fax (617) 227-3675
www.75chestnut.com

CATEGORY Cocktail Bar

HOURS Mon-Thurs: 5 pm-Midnight
Fri/Sat: 5 pm-1 am
Sun: 5 pm-Midnight

GETTING THERE Valet parking is available in the evening for $16. There is metered parking on the streets, but it is usually hard to find. The nearest T-stop is Charles/MGH on the Red Line. If you're taking the Green Line, Arlington, Boylston and Park St. are all close contenders.

PAYMENT

POPULAR DRINK Wine and cocktails.

UNIQUE DRINK 75 Chestnut infuses their own vodka that goes into some of their specialty martinis, such as the Grand Appletini, Pineapple Martini and the Raspberry Kiss Martini.

FOOD Upscale American meat-heavy comforts.

SEATING A small bar area takes up a corner and tables and booths make up the dining area.

AMBIENCE/CLIENTELE 75 Chestnut has a set of loyal regulars that frequents their restaurant for the works. Beacon Hill locals and business types are often found here chatting up a storm.

EXTRA/NOTES Sunday Jazz Brunch goes on September through June with pricey, but gourmet plates of breakfast favorites and a Bloody Mary bar with lots of fresh ingredients to dress up your morning cocktail how you see fit. Chocolate samplings are featured Saturdays at noon and cookie tastings on Tuesday nights.

—Suki Chang

The Beacon Hill Pub

Downtown Boston's ultimate dive, stashed in the classiest of neighborhoods.

$

149 Charles St., Boston 02108
(at Charles Cir.)

CATEGORY Dive Bar

HOURS Mon-Sat: 11 am-2 am
Sun: Midnight-2 am

GETTING THERE To say that street parking in Beacon Hill is a challenge would be an understatement. Just take the Red Line to Charles/MGH.

PAYMENT **$** **ATM**

POPULAR DRINK Paper signs on the walls advertise a $6 Red Bull-and-vodka special. Bottles of Molson Canadian for $2.75 and $3.25 Bud Light draughts puts BHP in the running for cheapest bar in Boston.

UNIQUE DRINK Where else can you find Busch, Michelob, Budweiser, and Bud Light, all on tap? Even ordering a Cosmopolitan at BHP would earn you a concerned look from the other patrons and the bartenders alike. A whiskey and ginger is about the fanciest thing you'll see here.

SEATING A few tables in the front of the bar, but mostly standing room and scattered bar stools. BHP is made up of two rooms, each with its own dilapidated bar.

AMBIENCE/CLIENTELE On the weekends, BHP is packed with college students, recent grads, and young professionals. The bar attracts its fair share of true-blue Boston natives as well, who come to watch the Red Sox or the Celtics on one of BHP's many televisions. Complete with foosball table, jukebox, and the Big Game Hunter arcade game, BHP relishes its status as the only real working-class outpost in an affluent Beacon Hill neighborhood that has been home to such wealth as Senator John Kerry, actress Uma Thurman, and business magnate Jack Welch.

EXTRA/NOTES If you're looking for the cheapest possible drink in downtown Boston, the Beacon Hill Pub is, without a doubt, the only place you need to visit. If your search is based on any other criteria, then you might want to try someplace else. In its defense, though, BHP radiates an authentic, gritty Boston vibe, so if you've never been to town before, it's worth it to stop by.

—Matt Rusteika

Bin 26 Enoteca

A place to wine down.

$$$

26 Charles St., Boston 02114
(between Chestnut St. and Beacon St.)
Phone (617) 723-5939
www.bin26.com

CATEGORY	Wine Bistro
HOURS	Mon-Thurs: Noon-10 pm
	Fri: Noon-11 pm
	Sat: 11 am-11 pm
GETTING THERE	Aside from the hard to find street parking, there is a valet location at 65 Charles Street where the charge is $16.00 per car. Additional parking may be available at the Common Garage or Charles St. For public transit, the closest T stop is MGH on the Red Line and Arlington on the Green Line.
PAYMENT	
POPULAR DRINK	There's no escaping the influence of wine when you step inside the doors. They even have wine taps for their more popular wines by the glass. And you even get your choice of tasting size (100mL, 250mL, 500mL and 750mL), making it easy to romp around the wine menu and introducing your taste buds to new wine ventures. It is only on rare occasion that anyone would order a beer. But feel free to, they do have some.
FOOD	Whether you're looking to pair wine with your food or food with your wine, Bin 26 offers a small but well-composed menu to suit your fancy. From artisan cheeses to beef carpaccio and marinated octopus to pork loin milanese.
SEATING	The J-shaped bar can fit in plenty of singles or pairs while the remainder of the restaurant fills two small rooms with tables for diners.
AMBIENCE/CLIENTELE	Wine is the core inspiration to the decor. The pillars holding up the ceiling are also shelves for wine bottles. The back wall is decked out in wine labels transformed into wallpaper. A strip of corks makes up the coat rack. It's wine country, my friend. And anyone who thinks differently has not yet embraced their inner wino.

—*Victoria Young*

Cheers

Where no one really knows your name.

$$

84 Beacon St., Boston 02108
(at Brimmer St.)
Phone (617) 227-9605 • Fax (617) 723-1898
www.cheersboston.com

CATEGORY	Theme Bar
HOURS	Mon-Thurs: 10:30 am-11 pm
	Fri/Sat: 10:30 am-12:30 am
	Sun: 10:30 am-11 pm
GETTING THERE	There is not much street parking, but the Boston Common Garage, a pay lot located on Charles St., is available for drivers. When taking public transit, there are three stops that are about the same distance. For the Green Line, the Arlington or Park St. stop. For

the Red Line, the Park St. and Charles/MGH stop. Cheers is located just across the street from the Public Gardens.

PAYMENT [payment card logos]

POPULAR DRINK If you're trying to recreate the show, beer. If you have a favorite Cheers character, you're in luck because the main characters have their own beverage named after them, usually dependent on alliteration.

UNIQUE DRINK The Cheers Beer is regular beer put into a souvenir Cheers glass, a glass mug imprinted with the Cheers logo, which goes home to your cup collection.

FOOD They serve the standard pub fare that is relabeled to include the persona of our favorite Cheers characters, which apparently costs more to make since the prices can be a little absurd. Stick with the eNORMous burgers or the Sam's Starters combo platter.

SEATING There are a few seats at the bar and the walls are lined with tables. There is another dining room in the back for the busy hours.

AMBIENCE/CLIENTELE You won't find Norm or Cliff at this soul-gutted bar. The bar is now a tourist trap visited almost solely by the out-of-towners and new-in-towners. In turn, the bar has seized the opportunity of a different client base and has turned their once neighborhood pub into an homage to the show. The walls are filled with framed pictures of Cheers moments and characters as well as baseball photos (Sam was a former Red Sox pitcher). And of course you can purchase all the Cheers hats, cups, shirts and plush teddy bears you need for your memorabilia display case at home.

EXTRA/NOTES A forewarning: This bar looks nothing like the Cheers set. The formerly called Bull & Finch Pub was a neighborhood pub that inspired the location of the Cheers setting. It's a few degrees from even being close. The new location in Faneuil Hall was built just for those with their heart set on the appearance and not necessarily the history. Even there, it's a stretch.

OTHER ONES Faneuil Hall Marketplace, Quincy Market, South Boston 02109, (617) 227-0150

—Ashley Rossington

Clink

See and be seen at this swanky hotel lobby bar.

$$$$

215 Charles St. @ Liberty Hotel , Boston 02114

(at Cambridge St.)

Phone (617) 224-4004

www.libertyhotel.com/clink

CATEGORY Hotel Bar

HOURS Mon-Thurs: Noon-Midnight
Fri/Sat: Noon-2 am
Sun: Noon-Midnight

GETTING THERE Meters are in the area and parking lots are down the street in Beacon Hill. Pay a ridiculous price to valet park at the Liberty Hotel or take the Red Line to the MGH Stop right across the street.

PAYMENT [payment card logos]

POPULAR DRINK Plunk down on the posh couches and lounge chairs or take a seat at the bar and choose from an array of high-end alcoholic beverages. Bottles of champagne

run the gamut from semi-affordable to blow-your-paycheck expensive- a $650 1996 Dom Perignon Rosé may set you back a bit in the finance department, but it's worth every sip. Cocktails range from $13-$17, wines $6-$16.

UNIQUE DRINK Order the "Mumbai Express," Mandarin Blossom Vodka, mango, ginger, and lime juice. Or, if you're in the mood for a bubbly concoction, try one of the many champagne cocktails, like the "First Degree," Belvedere Vodka, sparkling sake, and creme de peche.

FOOD Pricey menu items come in small, medium, or large plates. Delicious cheese and charcuterie selection is perfect for sharing over cocktails and wine.

SEATING Couches and lounge chairs are strewn throughout the lobby; bar seats and banquettes make up the bar area.

AMBIENCE/CLIENTELE Not willing to pay the $425 price tag ($5500 for the Presidential Suite) for a night's stay at Boston's newest luxury hotel? Then why not live vicariously through one of the lodgers while sipping on a delicious beverage under a soaring 90-foot rotunda. One of the Liberty Hotel's two watering holes, Clink resides in the lobby of this former Beacon Hill jailhouse (Alibi is the other bar/lounge. Clink. Alibi, get it?) After walking through the hotel's illuminated front entrance, an escalator takes you up a flight level to a beautifully decorated atrium. The concierge/check-in area for guests is the first thing you'll see; around the corner is the bar. With its open layout, unique architectural design and hot-to-trot crowd of fashionable twenty and thirty-somethings, this is the place to be in Boston.

EXTRA/NOTES The carpeted lobby is a blessing for the stiletto-clad set. No Birkenstocks allowed. Get here early on the weekends as lines will form by 9 pm.

—*Neely Steinberg*

Emmets Irish Pub

A casual pub with an escape route.

$$

6 Beacon St., Boston 02108
(at Beacon and Somerset St.)
Phone (617) 742-8565 • Fax (617) 742-9779
www.emmetspub.com

CATEGORY Beer Pub

HOURS Daily: 11 am-2 am

GETTING THERE There is street parking, but not much. If driving, it is probably best to find a pay lot in the area. The closest public transit is Park Street station that can be reached by the Green or Red Line.

PAYMENT [Discover] [American Express] [MasterCard] [VISA]

POPULAR DRINK Emmets is known for their Irish Coffee, which means you can find me there on a cold, snowy day.

FOOD Check out their burgers or some Irish cuisine, like their Shepard's Pie or Corned Beef sandwich.

SEATING There is seating at the bar and the rest of the place is filled with tables for dining and drinking. It never gets too crowded, unless it's St. Paddy's.

AMBIENCE/CLIENTELE Emmets is a little pub slightly tucked away that welcomes in the locals for drinks and eats. It doesn't get too crazy so it's great for a low key night to chat with friends, have a beer, and watch the game. If it's too casual for you, just head through the short hallway in

the back and wha-bam, you're in Lounge 6B, which steps up the snazzy. It may seem like a whole new place, but it's the same owner.

EXTRA/NOTES A brief history lesson: Robert Emmet is one of the Irish nationalists who led the rebellion against British rule.

—*Bridget Halverson*

No. 9 Park

The scale goes to 9.

$

9 Park St., Boston 02108

(at Beacon St.)

Phone (617) 742-9991

www.no9park.com

CATEGORY Cocktail Bistro

HOURS Mon-Sat: 5:30 pm-Midnight

GETTING THERE It's 1 block off the Park St. stop on the Red and Green MBTA lines. Valet parking is also available starting at 5pm for $16, which may be advisable as metered parking is available on Park St., but very limited.

PAYMENT

POPULAR DRINK Famed bartender and all-purpose-cocktail-God John Gertsen has his fingerprints all over the bar at No. 9 Park. He left an outstanding bar staff in his wake, and the cocktail list at No. 9 Park reflects his superfluously educated allusions to the best of cocktails new and old. The menu is unnecessary as the bartenders can conjure up anything for you, but certainly the most popular drink is the Palmyra: an elegant mix of vodka, fresh mint, and lime juice. Equally accessible is the surprisingly delicate Pear Martini. Unlike others, it does not mob the cocktail with oversweet (and fairly blunt) pear vodka, but instead contains Grey Goose, Poire William, and pear nectar. These two are also available in a 2oz taster's flight along with the No. 10, the other drink in highest demand.

UNIQUE DRINK No. 9 Park is the only bar in the world to offer the Henry V Flip. It's a brandy base, with added allspice dram, Chambord, simple syrup, and, just for good measure, one whole egg. The cocktail menu is seasonal, and with the allspice and egg, this is an excellent cold weather drink, sure to change as the months progress. This drink is a good example of the behind-the-scenes cheekiness that pervades the cocktailing bars: it gets it's name from the Chambord, as Henry V of France was the Count of Chambord in the middle of the 19th century. See? Cheeky.

FOOD If the bar were in any other location, it would be the clear centerpiece of establishment, but while the bar is very popular, the food is the star. Multi-award winning chef Barbara Lynch keeps the menu rotating with French and Italian inspired dishes, focusing heavily on simplicity and elegance of flavor. The signature dish, if there were one, would be the prune-stuffed gnocchi, which came with seared foie gras and a vin santo glaze, and is exactly as good as it sounds. She also recently debuted a bar menu which is not light on fare (lobster risotto, roasted skate wing).

SEATING The bar itself is relatively small, about twelve seats, and almost always full. It's not the type of place in which standing feels entirely appropriate, so you may

be marooned without a seat. There is a small loungy-couch area at the front window that can accommodate a larger party of drinkers, but more than seven or eight would be crowded, as the room is mostly devoted to the restaurant.

AMBIENCE/CLIENTELE No. 9 Park is the kind of place in which you instinctively feel alien if you're under 40 and don't drive a car with oak paneling around the center console. Sitting about 25 feet from the lawn of the Capital, it attracts a seemingly endless multitude of wealthy, older people in suit and tie. I don't think I'll ever own clothes nice enough to blend in at No. 9 Park, but surprisingly, no matter what I'm wearing, I have never felt uncomfortable there. The egalitarian edict must have come down from the top because I have never recieved a cold glance or any condescension whatsoever from any level of the staff, from the general manager on down.

EXTRA/NOTES If there is one thing that sets it apart among all the others in the world of hyper-upscale cocktailing, it's that No. 9 Park is the one of the only restaurant/bars where the food is as good as the drinks, and vice versa. It doesn't favor one over the other, and would promise a memorable night if you went for either.

—*Jason O'Bryan*

Panificio

Mellow out at this local Beacon Hill stop.

$$

144 Charles St., Boston 02114
(between Revere St. and Cambridge St.)
Phone (617) 227-4340
www.panificioboston.com

CATEGORY Coffee Bistro

HOURS Daily: 8 am-9 pm

GETTING THERE There is street parking and a garage on Charles St. for drivers. For public transportation, the Charles/MGH T-stop on the Red Line is the closest.

PAYMENT

POPULAR DRINK Espresso and coffee beverages are the essential drink of the morning. As the sun gets lower to the ground, wine and beer becomes the favored drink, especially among diners.

FOOD From the outside, you would think this place serves the usual coffee accompaniments, pastries and what not. Maybe some salads or sandwiches. And you would be right. In addition to its basic eats, a small bistro menu appears at night for a more serious dining experience. Here you can find Prosciutto Wrapped Scallops or Pan-Roasted Duck Breast.

SEATING Aside from the regular table tops, there is a counter lining the window with seating as well as a few seats at the actual counter and some tucked away in the corner of the entrance.

AMBIENCE/CLIENTELE Set in the posh shopping area of Beacon Hill, Panificio can draw in a good amount of hobnobbing from the curious passersby that needs quenching. And people generally find what they're looking for with the relaxed atmosphere and the broad selection of food and drink.

—*Jason Burnsworth*

The Sevens

A pub lover's pub.
$$
77 Charles St., Boston 02114
(between Pinckney St. and Mt. Vernon St.)
Phone (617) 523-9074
www.sevensalehouse.com

CATEGORY	Neighborhood Pub
HOURS	Mon-Sat: 11:30 am-1 am
	Sun: Noon-1 am
GETTING THERE	Good luck on the street... the Common Garage is nearby. Take the Red Line to Charles/MGH or the Green Line to Boylston.
PAYMENT	
POPULAR DRINK	The Sevens is beer and wine only, so favorites are limited to the standards you find elsewhere, typical domestic beers and inexpensive wine bottles. There's a good selection of Boston beers, but the wine list is mostly the standard Californian stuff.
UNIQUE DRINK	The Harpoon brewery makes a special Sevens brew that you will find only here — a darkish, bitter ale with a higher alcohol content. (Cynics suspect it's just repackaged Harpoon Munich Dark, but would that really be so bad?)
SEATING	Like so many old Boston bars, The Sevens is long and narrow, and seating is hard to come by, especially at busy times, but they do have a few booths by the windows that can accommodate larger groups.
AMBIENCE/CLIENTELE	The Sevens is pretty dimly lit, which, depending on your perspective, makes it either cozy or a dive, and being in Beacon Hill it caters to a bizarre mix of yuppies, tourists, and students from nearby universities. But the size and tone of the place quickly winnow out anyone who doesn't fit in, ensuring that the crowd is always warm, friendly, and never overwhelming, just as a pub should be.
EXTRA/NOTES	The Sevens is better suited to post-prandial drinks. It's fun at any time of day, though, thanks to the jukebox, dartboards, talkative staff, and TVs tuned to major cultural events (in Boston this usually means sports, though they have been known to show the Oscars in February).

—*Andrew Ladd*

CHINATOWN/THEATER DISTRICT

Avila

Trendy place for good wine and Mediterranean food.
$$$
1 Charles St. S., Boston 02116
(at Staurt St.)
Phone (617) 267-4810 • Fax (617) 267-4840
www.avilarestaurant.com

CATEGORY	Wine Bistro
HOURS	Mon-Thurs: 9 am-10 pm
	Fri-Sun: 9 am-11 pm

GETTING THERE Valet parking is available after 5 pm daily for $16 per car. There is metered street parking, though oftentimes it is hard to find. There is also parking in the Motor Mart Garage for a fee, which can be discounted with a validation from Aliva. The closest public transit is Boylston and Arlington (both Green Line) and Chinatown (Orange Line).

PAYMENT

POPULAR DRINK Even with a full bar, the emphasis is placed on their wide selection of wines, which is largely preferred for both dining and the bar. With a Mediterranean mentality, they keep the wine list diverse.

FOOD With Greek, Italian, French, Spanish and Portuguese influences, this bistro proudly bears the name of Modern Mediterranean. With the additional "modern" implies the freedom to stray from authenticity in the name of fine dining. Overall, they take on a creative approach to their eclectic selection, though the execution may not always be pristine.

SEATING The boat-shaped bar can seat a number of people, as well as the table tops surrounding it that comprise the bar area. There is another huge section of tables for full service dining, which also includes a small counter seating that faces the open-face kitchen so you can watch where the magic happens. Function rooms are also available for bigger parties.

AMBIENCE/CLIENTELE Avila attracts a wide range of people from business people to theater goers, generally an older crowd. The tall ceilings and windows call attention to the already long, spacious rooms. Beyond the warm lighting, the trendy decor lacks any real flare and the non-desrcript music occasionally crosses over into cheesy. The place may not razzle-dazzle, but its still a hip little spot to grab a drink and a fitting meal.

—*Alexis Vandeventer*

Felt

Jetsons meet Vegas in an attempt to win your swanky little heart.
$$$
533 Washington St., Boston 02111
(between West St. and Avery St.)
Phone (617) 350-5555 • Fax (617) 350-0116
www.feltclubboston.com

CATEGORY Pool Lounge

HOURS Tues-Sat: 5 pm-2 am

GETTING THERE If you park in the LaFayette Parking Garage (1 LaFayette Ave. directly across from Felt), it is just $10 all night after 4pm with validation. The nearest public transit stop is Chinatown off the Orange and Silver line. It is also close to Downtown Crossing, Park St., and Boylston stops.

PAYMENT

POPULAR DRINK Of all the pretty martinis whipped up, One Night in Paris, Purple Haze and Captain's Quarters are the most frequently ordered, all of which are exceptionally sweet.

FOOD Food is generally an afterthought for the people who decide to go to Felt, but they do have a full menu of a variety of cheap comfort food that is worthwhile if you got the grumbles.

SEATING	There are four levels to the monstrosity that is Felt. The first is your basic bar and seating area combo. The second and third are dedicated to billiards tables, though the third level is VIP only. The fourth is a nightclub with a stage and a bar. Within these levels, there is plenty of space for sitting, standing, dancing and other means of existing. The ground level is where you will find a small dining area for food along with plenty of bar seating, both at the bar and high tops. And they have a diverse set of trendy chairs, varying along the comfort spectrum. Choose your seat wisely.
AMBIENCE/CLIENTELE	It's all just one big amalgamation of all the stylish materials and textures they could get their hands on. Metal, curtains, wood, brick, plush, plastics and lights. (Oddly enough, no felt.) Long white columns and a winding staircase bring faux elegance. Curtains draped over brick walls. Walls made of fuzzy blocks. It's all very swanky, like some hybrid of Las Vegas and the Jetsons, but what this place needs is substance.
EXTRA/NOTES	Two floors worth of billiards. A game of pool is free every Tues-Fri, first come first serve. There are some awkward angles and walls or columns occasionally making shots absurdly difficult, but it's still a good time.

—*Deepak O'Reilly*

Intermission Tavern

Swanky martinis in a relaxed atmosphere.
$$$
228 Tremont St., Boston 02108
(between Boylston St. and Stuart St.)
Phone (617) 451-5997
www.intermissiontavern.com

CATEGORY	Neighborhood Bar
HOURS	Daily: 11 am-2 am
GETTING THERE	Located smack in the middle of downtown Boston, it's easiest to take the T to the Boylston stop on the Green Line. Intermission is located about a block away from the stop.
PAYMENT	
POPULAR DRINK	If you're looking for decadent and creative martinis, but don't want the swanky, overpriced atmosphere of some other downtown bars, try these on for size: The French Kiss features Absolut Citron, Chambord, and pineapple juice; and the Intermission has Starbucks liqueur, Jameson whiskey, creme de menthe, and whipped cream. Delicious.
UNIQUE DRINK	The Key Lime martini boasts "Stoli Vanilla Vodka, liqueur 43, fresh lime juice, with a splash of midori and whipped cream, chilled and shaken, served in a graham cracker rimmed martini glass." A little slice of heaven in a glass!
FOOD	Perhaps even better than the flashy martinis are the hefty burgers and golden onion rings. My favorite? The cowboy burger, a huge beef patty dressed in barbeque sauce, cheddar cheese, and topped off with an onion ring hat. Giddyup!
SEATING	Intermission is outfitted with several cozy booths and tables in the long, narrow bar. It's usually not too

crowded, so if you have a larger group, you can pull tables together easily.

AMBIENCE/CLIENTELE You'll see an eclectic mix of hipster college students from nearby Emerson, older theater-goers grabbing a drink after a performance, and mid-20s professionals taking part in happy hour. Everyone blends together well in the dim, wood-paneled bar.

EXTRA/NOTES With theaters abound in the neighborhood, there's no telling who you'll see at Intermission. I once even saw Oscar-winning actor Chris Cooper drinking a beer at the bar, nonchalantly chatting with the bartender and other customers.

—*Jill D Urso*

Jacob Wirth

German beer and food that is definitely wirth the trip.

$$$

31-37 Stuart St., Boston 02216

(between Tremont St. and Washington St.)

Phone (617) 338-8586 • Fax (617) 426-5049

www.jacobwirth.com

CATEGORY Beer Bar

HOURS Mon: 11:30 am-9 pm
Tues-Thurs: 11:30 am-10 pm
Fri: 11:30 am-1 am
Sat: 11:30 am-Midnight
Sun: 11:30 am-9 pm

GETTING THERE Orange Line to New England Medical Center.

PAYMENT

POPULAR DRINK The establishment's most exquisite feature is its long mahogany bar. The perfect place for a drink. Above it, a Latin motto proclaims "SUUM CUIQCE"—to each his own—and they have about 32 different drafts to go around, including imported German, Dutch, Belgian, and English brews. There's everything a serious beer drinker would need, ranging from Pilsners to Hefeweizens to dark beers. Two are brewed locally and exclusively for the restaurant: Jake's House Lager and Special Dark. All of the draft beers are available by the pitcher from $8 for a pitcher of Bud Lite to $28 for a pitcher of the imported Belgium beer Affliglen Blond. The wine list also features a nice array of Rieslings.

UNIQUE DRINK It's clear that their martini list is designed to attract patrons of the elderly female persuasion with concoctions (and I don't use the term lightly) like the "Bad Girl"—Triple 8 Orange and Peach Schnapps, with Cranberry and sweet and sour mix. The only bad girl who you'll see drinking this one is probably someone's grandmother at their Emerson College graduation dinner. And then there's the "Swedish Fish:" Jose Cuervo Gold, Chambord, Creme de Banana, Sweet and Sour Mix, And a Dash of Rose's Lime.

FOOD Anything involving German sausages—the mixed grill features smoked bratwurst and weisswurst, while Jake's Special prepares the same meats, only boiled. The meats are fresh and flavorful, and meant to mix with the side dishes in the same forkful. Only the mixed grill includes sauerkraut, but both dishes are served with German potato salad and rotkohl, a.k.a.

pickled red cabbage. The sauerkraut is fairly ordinary, but the German potato salad (made with bacon and onions) is more memorable. For an updated version of traditional German comfort food, try the potato pancake appetizer—the flavor of the green onions within the pancake is complemented by a delightful chestnut crème fraîche sauce and applesauce.

SEATING Catering to packed theater crowds, JW's can seat up to 265 people: eight spaces for eating directly at the bar, 24 tables around the bar, and small and large wooden tables in the dining area. JW is busiest during pre- (4 pm-7 pm) and post- (10 pm-Midnight) theater hours.

AMBIENCE/CLIENTELE Lively and gregarious, with a knowledgeable and friendly staff adding to the good cheer; the place hasn't changed all that much in 134 years—sepia-toned photos (largely of Wirth's family and the restaurant) and former wine lists and menus adorn the walls, reminding modern patrons that Jacob Wirth's is truly an authentic, 100 percent Bostonian landmark.

EXTRA/NOTES Every Friday, since 1988, Mel Stiller has lead a piano sing-a-long (8 pm–midnight).

—*Christina Tuminella*

The Liquor Store

A typical girls' night out, or your momma's worst nightmare.
$$
25 Boylston Pl., Boston 02116
(between Charles St. S. and Tremont St.)
Phone (617) 357-6800
www.liquorstoreboston.com

CATEGORY Theme Club

HOURS Fri/Sat: 9 pm-2 am

GETTING THERE Parking in the downtown area is usually a nightmare, especially if it's Red Sox season. Best thing to do would be to take the Green Line to Boylston St.

PAYMENT [Mastercard] [VISA]

POPULAR DRINK The Liquor Store is a bar in The Alley with a live DJ, a mechanical bull, and stripper poles. Drinks run from $5.50 for a Bud Light to $8.25 for a mix drink served in a small plastic cup.

SEATING It's a great place for big groups (especially party bus riders) with three bars, comfy couches along the walls, a private seating area behind the DJ, and a huge, central dance floor.

AMBIENCE/CLIENTELE Bring your friends, your cowboy hat, and your dancing shoes (absolutely no sneakers or work boots allowed). Bikinis are encouraged on Friday nights for the bikini bull riding contest, a chance to win $200 and qualify for $5,000. This is the perfect place to host your 21st birthday, college graduation, or Jack and Jill party. This spacious, wild, dancing joint is one of the many Boston party bus destinations and attracts big crowds of twenty-somethings ready to party. The colorful strobe lights, gated bottles along the walls, and general ambience incite Liquor Store patrons to boogie down and mingle. And if you want to remember the night for years to come, you can buy Liquor Store paraphernalia by the door.

EXTRA/NOTES There is a $5 cover charge. If you get stuck behind a large group of party bus riders, it could take a while to

get in. Like most trendy bars in Boston, to avoid lines and expensive covers, get there before 11 pm. See the website for the official dress code. Just a tad shy of an actual strip joint, the hot bartenders (mostly female) wear low-cut Liquor Store shirts, and some will even mix your drink in ass-less chaps.

—*Stephanie Naudin*

Roxy
A glam little nightclub. And by little, I mean HUGE.
$
279 Tremont St., Boston 02116
(between Stuart St. and Marginal St.)
Phone (617) 338-7699
www.roxyplex.com

CATEGORY	Dance Club
HOURS	Fri/Sat: 10 pm-2 am
GETTING THERE	When street parking gets rough, which it will on a Friday and Saturday night, there are garages all around the area for a fee. When taking the T, the nearest stop is NE Medical Center (Orange and Silver line) and Boylston (Green and Silver line).
PAYMENT	
POPULAR DRINK	Mixed drinks and cocktails are all the flavor on Friday nights. Saturday nights attracts more beer drinkers.
FOOD	Why eat when you can dance?
SEATING	The expansive venue has plenty of standing and dancing room with lounge couches lining the perimeter for those who just want to cool off for a dance intermission or crowd watch in style.
AMBIENCE/CLIENTELE	The decadent ballroom has one main dance area with a stage and a second story overlooking the sexy chaos below. Five bars are conveniently placed in every which direction for your drinking pleasure. The extravagance lies in the luxurious decor of plants and pillars, statues of lions guarding the door, grand staircases and beautiful lighting. And the venue is equipped with all the necessities to host concerts, shows, corporate parties and private events, which is what most of the week is dedicated to. Friday nights are dedicated to Top 40, House, Reggatone, Mash-up and Latin music, while Saturday night is gay night.
EXTRA/NOTES	Beware the cover charge. There will be one ranging anywhere from $5 to $15, unless you're a lady on a Friday night before 11pm. Also, there is a strict dress code which is as follows: no baggy jeans, no ripped jeans, no sneakers, no hats, no timberlands, no athletic wear, no game jerseys. You have been warned.

—*Suki Chang*

Sweetwater Café
A hipster hangout hidden in a charmless yuppie zone.
$$
3 Boylston Pl., Boston 02116
(at Boylston St.)
Phone (617) 351-2515
www.sweetwatercafeboston.com

CATEGORY	Cocktail Bar

HOURS	Mon-Sat: 11:30 am-2 am
	Sun: 5 am-2 am
GETTING THERE	Take the green line T to Boylston. When you get out, cross Boylston St. and take a right. Boylston Pl., an alley will be on your left.
PAYMENT	
POPULAR DRINK	The martinis are tasty and strong, and the bar is generous with its well liquor (for instance, the well vodka is Absolut.)
UNIQUE DRINK	Take the time to get to know the bartenders. Jeff will be happy to tell you about what new drink he's working on this week, and sometimes gives you a sample for free.
FOOD	There's typical pub food, but one standout is the "hot dog bar," where you can get a huge variety of toppings, including BBQ chicken, on your frank for one low price.
SEATING	A sizeable bar and lots of tables upstairs; downstairs, some couches and a small bar, including a stage for a band.
AMBIENCE/CLIENTELE	Young people in the neighborhood with a bit of style tend to come here after work. There's also a fair amount of grad students from Emerson College. The dominance of 90's alternative rock on the house music system should indicate the general slant of its clientele.
EXTRA/NOTES	Don't miss the Big Buck Hunter arcade game, one of the new classics of bar entertainment.

—Joe Gallagher

The Tam

Bring cash and coins. It's a dive bar.

$

222 Tremont St., Roxbury 02118

(between Boylston St. and Stuart St.)

CATEGORY	Dive Bar
HOURS	Mon-Weds: 8 am-1 am
	Thurs-Sat: 8 am-2 am
	Sun: Noon-1 am
GETTING THERE	The closest public transit stop is Boylston on the Green and Silver line. The Chinatown and NE Medical Center stops off the Orange Line are also both close by. If driving, there is metered street parking available. or there are expensive parking lots around.
PAYMENT	$ ATM
POPULAR DRINK	Even with a full bar, beer is a good friend to the barflies that stool up to the bar.
FOOD	The closest they come to serving food here is the vending machine half stocked with all your favorite pocket change goodies.
SEATING	It's stools or standing here. Either at the bar or around the mini-counters that bud out of the walls.
AMBIENCE/CLIENTELE	Set on Tremont St., lining the Public Gardens, just down the street from Emerson College, and in the Theater District, The Tam collects an interesting little mix of active drinkers. Lit almost solely by the neon beer signs, this bar screams dive from the moment you walk in. And if what you're looking for is cheap drinks and Big Buck Hunter, this is the place to be.

—Victoria Young

Tantric
Indian food and innuendos.
$$

123 Stuart St., Boston 02116
(between Tremont St. and Charles St.)
Phone (617) 367-8742 • Fax (617) 367-8745
www.tantricgrill.com

CATEGORY	Theme Bistro
HOURS	Mon-Thurs: 11:30 am-10 pm
	Fri/Sat: Noon-11:30 pm
	Sun: Noon-10 pm
GETTING THERE	Metered street parking is available but often times hard to find. There are parking garages in the area for a varying fee. The nearest public transit is Boylston on the Green Line.
PAYMENT	
POPULAR DRINK	Hot Lips. Persephone's Pleasure. Kama Sutra. Passionate Kiss. The bar menu really drives home the sexual theme of the place with erotic inspirations for their drink names. I suppose they're ordered in hopes of luring the passion out of any night or sending slightly conspicuous signals to a date. If that's not your style, or you're trying to enjoy a meal with the parents without embarrassing innuendos, wine or beer is probably a more appropriate choice.
UNIQUE DRINK	Aside from the usual libations, Tantric offers a few Indian beverages to match their cuisine. Nimbu Pani, lime soda with lime juice. Essentially a version of limeade. Mango Lassi, a classic yogurt smoothie made sweet or salty. Taj Mahal Lager, a 22oz. bottle of Indian beer.
FOOD	Tantric serves Indian cuisine day and night, but is better known for their popular lunch buffet special. At the bar, you can find cheap and quick eats. The food manages to escape the sexual name game, except for the dish Chicken 69. That's for those who want to drive home the message.
SEATING	Within the single tall room sits an L-shaped bar with a few high-tops that comprise the seating area. The remainder of the room is filled with tables for diners, including a small intimate nook with a few tables for those special diners.
AMBIENCE/CLIENTELE	Located in the Theater District, Tantric is often visited by a variety of people that are usually headed to a show or movie. The decor is made up mostly of large art pieces and framed handwoven crafts, keeping an overall simple presentation. Aside from the draped intimate room and dim lighting, the atmosphere does not drive home the theme of sensuality. Instead they present themselves as fine dining. And in actuality their food and drinks are affordable for anyone that might have an itch for Indian cuisine. Does that mean that everyone wins?

—Ashley Rossington

SOUTH END

BOSTON'S GAY NIGHTLIFE SCENE

Boasting diverse nightlife options, including a distinctive blend of great gay restaurants and bars, and a lively rotation of sexy club nights, Boston is sure to satisfy even the most discerning of gay night owls.

The South End is commonly regarded as the gay hub of Boston and you will find a slew of shopping, theatre, dining and drinking options. Surprisingly, some of the best spots for mixing, mingling, and manhandling mayhem are the bar and lounge scenes within this area's hottest restaurants.

Located amongst the trendy galleries and design showrooms of Harrison Ave., **ROCCA** is a spacious and contemporary lounge that welcomes groups of all sizes, accommodating intimate duos or rowdy bunches with flexible, sleek furnishings. The perfect setting to kick off, or finish off, an evening, ROCCA's scene is a varied mix ranging from attractive, young neighborhood regulars to destination dinner guests.

The chic white interiors of **Stella** greet restaurant-goers with mod design and a bustling bar and lounge scene offering prime see-and-be-seen potential from the street-level windows. Though there is sure to be plenty to nibble on "off the menu" at this hot-spot, Stella's kitchen serves delish Italian fare until 1:30 am with special late-night bar menu.

Head to the aptly named **28 Degrees** for perfectly mixed martinis in this sexy, dimly lit lounge. Hit up their happy hour for $1 oysters, a natural aphrodisiac. Nightly, 28's in-house DJs spin down-tempo jazziness, though Sunday's are when things really liven up. The city's top drag acts, namely the unforgettable Miss Kris Knievel, take the "runway", reviving Whitney, Mariah, Cyndi and all the rest of the best, dragging guests out of their seats and into the fray.

Jacques Cabaret serves up a full menu of outrageous drag performances 7 nights a week, 365 days a year. Boston's most bodacious 'babes', Mizery, Destiny, Lakia Mondale, Fena Barbitall and the aforementioned Knievel, strut their stuff, lighting up the funky, worn-in cabaret bar.

Gay bars in Boston range from straight-up raunch (in a good way) to your classic, go-go video bar. **The Fritz** is a long-standing local favorite. Touted as "Boston's Gay Sports Bar" Fritz is as basic a watering hole as you can imagine, but plays host to a cast of colorful characters throughout the week.

Reputed as the "Dirty Birdy", **The Boston Eagle**'s nickname pretty much says it all: Rikers Island-style bathrooms, salty bartenders and pool tables for all kinds of "games". True, The Eagle is devoid of style or disinfectant, but it does possess a grimy charm that keeps loyal fans coming back for more.

The go-to gay bar in town, **Club Café**, draws the biggest mid-

week crowds on Wednesday nights, but this homo hub is always buzzing. On Fridays and Saturdays the dance floor crowds and cheesy Top 40 dance hits fill the dank air. After 2 am join the famed Club Café Sidewalk Sale, the best last-ditch effort in town.

Head to **Machine** in the Fenway on Fridays. (Feel free to stop by its sister bar, **Ram Rod** on your way downstairs if you're seeking something a little more "leather-y".) Also, for real late night entertainment take a stroll through the famed Fens to join some more intimate gatherings.

The Theatre District's dance hot-spot, **Roxy** hosts Epic Saturdays that always live up to the name with high-energy house music and a dizzying crowd. And, when you think you've just about had enough, Hot Mess! Sundays at **Underbar** to close out the weekend with a bang.

Rocca
500 Harrison Ave., Boston 02118, (617) 451-5151,
www.roccaboston.com

Stella
1525 Washington St., Boston 02118, (617) 247-7747,
www.bostonstella.com

28 Degrees
1 Appleton St., Boston 02116, (617) 728-0728,
www.28degrees-boston.com

Jacques Cabaret
79 Broadway, Boston 02116, (617) 426-8902,
www.jacquescabaret.com

The Fritz
26 Chandler St., Boston 02116, (617) 482-4428,
www.fritzboston.com

The Boston Eagle
520 Tremont St., Boston 02116, (617) 542-4494

Club Café
209 Columbus Ave., Boston 02116, (617) 536-0966,
www.clubcafe.com

Machine (upstairs)
1254 Boylston St., Boston 02215, (617) 536-1950,
www.machine-boston.com

Ram Rod (downstairs)
1254 Boylston St., Boston 02215, (617) 266-2986,
www.ramrod-boston.com

Roxy
279 Tremont St., Boston 02116, (617) 338-7699,
www.roxyplex.com

Underbar
275 Tremont St., Boston 02116, (617) 292-0080,
www.underbarsuperlounge.com

—Sam Mazzarelli

The Beehive
The Best Sting in Town.
$$$$
541 Tremont St., Boston 02116
(at Hanson St.)
Phone (617) 423-0069
www.beehiveboston.com

CATEGORY	Cocktail Lounge
HOURS	Daily: 5 pm-2 am
GETTING THERE	Street parking is a possibility. You can take the T to Back Bay Station on the Orange Line, but it is a hike. Best bet? Take a cab.
PAYMENT	
POPULAR DRINK	The Beehive Julep is definitely the most popular beverage here. Although simple with its Rum, muddled orange, Liquor Creole (distilled from oranges) and Lime, this magical beverage brings on a good time with no hangover. Three times a charm! This place is all about the cocktails, the Kir Royal, and the Patron margaritas with fresh lime juice are also divine.
UNIQUE DRINK	Everything on this drink menu screams attitude and pizzazz, with supreme mixology to back it up. Try the La Vie en Rose Champagne cocktail with lychee infused cognac, the Blonde Sidecar with St. Germain, or if you're feeling frisky, the Cougar, made with Lichido liquor (French made lychee liquer), orange bitters, and Champagne.
FOOD	Yes, there is a full menu. This place is one stop shopping and all of it, top notch. Full dinner dining and seating is available at the bar upstairs.
SEATING	This place does every single thing right. But the downstairs is where it's at. Problem is: everyone that frequents this hot spot knows it. Seating can be found in front of the live music stage, where lovebirds can enjoy their drinks and listen to very good live jazz and soul acts. The bar is spacious, and there's more seating spread about downstairs. Upstairs, the atmosphere is more relaxed and intimate, but festive nonetheless. The seasonal patio is another example of incredibly unique real estate in Boston's South End neighborhood.
AMBIENCE/CLIENTELE	The long queue winding around the ticket kiosk in front of this swank, all-inclusive hot spot screams "this place is all the rage," but a Beehive new-bee would not necessarily know that the action takes place downstairs. Either flash your Beehive VIP card or alternatively go to the holding pattern located in the bar upstairs to the right, don't worry the door man will tell you exactly where to go. If you're in a group, have a drink then head one-by-one to the "restroom" and meet everyone next to the bar downstairs. This is failsafe plan. With live music most nights, interesting cave-like atmosphere complete with chandeliers and velvet curtains, and scrumptious classy drinks, the majority of the clientele you'll find here are seasoned foodies, fashionable South Enders, International grad students and professionals who are friendly and tend to mix well. The Beehive is also known as one of the best places to meet singles 30 and over.

EXTRA/NOTES Jazz Brunch served Saturday 11:30 am-3 pm and Sunday 10:30 am-3 pm. Bar Menu is served from 3 pm-5 pm on weekends.

—Shanon Heckethorn

The Boston Eagle
Slighty divey, always entertaining, dimly lit neighborhood gay bar.
$$
520 Tremont St., Boston 02116
(at Dwight St.)
Phone (617) 542-4494

CATEGORY	Gay Bar
HOURS	Mon-Fri: 3 pm-2 am Sat: 1 pm-2 am
GETTING THERE	On street parking is scarce so most take a cab or the T. Closest MBTA: Back Bay Orange Line or E. Berkeley Silver Line
PAYMENT	$
POPULAR DRINK	This is a straight up (no pun intended) bar, with a tiny beer selection, and drinks tending towards the simple (think Stoli Raz and tonic, not any of those crazy fruit-ini combinations. The upside of this is the bartenders here have heavy, heavy pours, and the drinks are cheap.
UNIQUE DRINK	Don't expect signature cocktails or specialty beers here.
SEATING	Barstools at the bar and at a drink rail across the center of the room, a few high-top tables with stools, and a low bench along one wall.
AMBIENCE/CLIENTELE	There's no sign with the name outside, just a big Eagle over the door (get it?). Not the sleazy Eagle most other city's gay scene seems to have, but a neighborhood bar that turns into the "last resort" bar as the clock ticks towards last call. It's dark, cruisy, and has the single most disgusting men's room in Boston, which for some reason seems to be a point of pride. (Ask the bartender for the ladies room key if you can't stomach the men's room). Virtually deserted until at least midnight on most nights, it is reliably busy after midnight with a mixed crowd of gays from the A-list wannabe's to the...erm... older gentlemen. There is even a smattering of women mostly out with their gays. The best entertainment is watching legendary bartender Jack Repetti verbally spar with his patrons. At best you're "honey," and at worst "Vera" or maybe "Miss Ohio." It's all in good fun, though some don't seem to get it.
EXTRA/NOTES	Some of the best dance music in Boston! It's a shame there's no dancing! There are a couple of pinball machines in the corner, and one pool table in back which is closed during busy periods (hey! extra seating!!).

—Chris Coveney

Coda Bar and Kitchen
Chic, but laid back. Tasteful, but wallet-friendly.
$$$
329 Columbus Ave., Boston 02116
(at Dartmouth St.)
Phone (617) 536-2632 • Fax (617) 536-2633
www.codaboston.com

CATEGORY	Neighborhood Bar
HOURS	Daily: 11:30 am-1 am
GETTING THERE	Street parking only. Or take the MBTA Green Line to Copley and walk south on Dartmouth St.
PAYMENT	
POPULAR DRINK	This drink menu isn't the lengthiest, but it is certainly comprehensive. Looking for a cocktail? CODA serves up some drinks you may not find everywhere: Mai-Tais and Sangria (served with Hennessy and Patron), Pear Nectar Martini (Grey Goose La Poire vodka, Goya pear nectar, simple syrup), and a Blood Orange Mojito (Bacardi rum muddled with blood oranges and fresh mint). You can certainly find Bud Light on the beer list, but you'll also spot Chimay on tap. Fourteen wines are available by the glass or bottle, twelve by the bottle only.
UNIQUE DRINK	It's impossible not to enjoy the subtle sweetness of the Grapefruit Summer Press (Absolut Ruby Red vodka and wild elderflower liquor) or for the En Fuego (Jose Cuervo Gold with pomegranate liquor and fresh Odwalla pomegranate juice), reminiscent of a margarita on the rocks, but decidedly different.
FOOD	Entrees range from $9-$20, but hearty appetizers and salads start at just $6.
SEATING	This is a tight space and they don't take reservations, but you'll be surprised how quickly you find a spot to settle in. You have your choice of seats: at a table near the front, a high table parallel to the bar or at the bar itself. No matter where you land, you'll be well taken care of.
AMBIENCE/CLIENTELE	Candlelight bounces around the room, off original artwork and brick and wood-paneled walls. This is a grown-up crowd looking for a not-too-loud, relaxed spot for a whole host of occasions: after work, dinner, or late night drinks.
EXTRA/NOTES	Reasonable prices are hard to come across in the South End, but CODA is the exception. It's warm, cozy, and comfortable with a friendly staff to boot. The drinks are cause enough to give this place a try, but the food also has quite the reputation.

—*Kaitlin Alayan*

Delux Café

A hipster hangout for fans of Elvis, Eloise and Cartoon Network.
$$
100 Chandler St., Boston 02116
(at Clarendon St.)
Phone (617) 338-5258

CATEGORY	Dive Bar
HOURS	Mon-Sat: 5 pm-1 am
GETTING THERE	Parking in the South End is iffy, but Delux is closer to Copley Sq. than most South End spots. Take the T to Copley or better yet, Back Bay Station.
PAYMENT	**$**
POPULAR DRINK	Try the Tremont Ale on tap.
UNIQUE DRINK	For being so far north from the border, some bartenders can make a mean margarita.
FOOD	Far more than their drinks, Delux is known for their quesadillas and the addictive salsa served alongside. This may be due to the fact that Didi Emmons, of

Veggie Planet, Pho Republique and Haley House fame, cheffed here and left her mark of fresh, reasonably-priced comfort food on the café's beer-spattered menu. Venture into the delicious daily specials (everything's under $20), or play it safe with a cheap and spicy chicken quesadilla.

SEATING Limited and cramped, expect a wait during peak dining and drinking times.

AMBIENCE/CLIENTELE Delux appears on the outside and inside to resemble a dive, with a major dose of irony. Elvis record covers and tinsel adorn the wooden panels inside; pages ripped from an old Eloise book paper the tiny bathroom walls. Cartoon Network flickers quietly, without fail, from the corner television. Lumberjack-like butch gay men meet up at the bar while young theater-goers fresh from a production at the Boston Center for the Arts, get together with the actors who've just left the stage. Meanwhile, neighborhood yuppies gather around the small tables for a catch up session over slow-roasted pork, mac 'n' cheese or some other tasty comfort food. Everyone but the square-est visitors should feel welcome here.

EXTRA/NOTES It's normal for one waitress to serve the entire restaurant, even on a busy night, so be prepared to be patient when waiting for drinks and food. If you forget to bring cash, there are several nearby ATMs on Tremont St.

—*Ryan Weaver*

Fritz

Is this gay sports bar the gay Cheers?
$$
22 Chandler St., Boston 02116
(at E. Berkeley St.)
Phone (617) 482-4428
www.fritzboston.com

CATEGORY Gay Bar

HOURS Daily: Noon–2 am

GETTING THERE Limited parking on street (Be careful to avoid resident spaces. You WILL get a ticket). Closest MBTA station is Back Bay on the Orange Line.

PAYMENT

POPULAR DRINK Good beer selection including Newcastle Brown (when have you seen THAT at a gay bar?) along with all the normal cocktails you'd expect, nothing innovative here. As with most gay bars, the drinks are strong and inexpensive. They also have a rarity: waiters who circulate around the bar.

FOOD Fritz serves a very decent brunch on Saturday, Sunday and holiday Mondays until about 3 pm.

SEATING A dozen low and high-top tables and chairs are scattered around the long, narrow room, along with banquettes along the windows (which open in good weather to the street)

AMBIENCE/CLIENTELE Fritz is billed as a "Boston's gay sports bar." If a few flat-panel TVs with sports on constantly, and gay men pretending to be interested counts, it is. But it's also a friendly neighborhood place, and one of the few gay bars without the attitude in Boston. The crowd ranges from young club types, to middle aged businessman,

with a smattering of blue color and bear types. Sunday from about 4 pm-8 pm is packed and a lot of fun; perhaps the friendliest Boston gay bars ever get. There's generally good music playing as well.

EXTRA/NOTES Fritz has regular dart nights, and a storied softball team (check out the trophy case!). There's a small tree-screened smoking area outside reached from an internal door. Fritz also hosts the annual block party street dance outside during Pride in June, a highlight of many Bostonians pride celebration

—*Chris Coveney*

Pho Republique

L'Indochine meets Moulin Rouge.

$$$

1415 Washington St., Boston 02116

(between Pelham St. and Union Cross St.)

Phone (617) 262-0005

www.phorepublique.net

CATEGORY Cocktail Lounge

HOURS Daily: 5:30 pm-1 am

GETTING THERE Sparse South End parking, valet or better yet, cab it. Orange Line-Back Bay is the clsest you'll get from the T.

PAYMENT

POPULAR DRINK Lychee martinis here are definitely a sweet slice of heaven and understandably one of their most popular beverages. Mango martinis and their sake selection will whet your whistle, but if you're dining with a crowd the must-have seems to be the scorpion bowls, complete with never-ending straws and a porcelain chalice.

UNIQUE DRINK The bartender previewed a nice shot-concoction of red chili infused alcohol with a coffee, chocolaty richness not on the menu yet, but should have been added yesterday.

FOOD Full menu of French Vietnamese fare, including the requisite Pho noodle soup, crispy Tuna and avocado spring rolls, and many other good dishes. Food is served until 12:30 am, Weds-Sat, and Midnight, Sun-Tues.

SEATING Plenty of long benches for groups, small tables for more intimate dining.

AMBIENCE/CLIENTELE A winner for its ambience, this lively, sexy joint makes every hipster feel at ease. With Indochina inspired decor and the hum of the crowd, the drinks flow easily at this South End hot spot.

—*Shanon Heckethorn*

Toro

Cocktails that rival the tapas.

$$$

1704 Washington St., Boston 02118

(between Springfield St. and Worcester St.)

Phone (617) 536-4300

www.toro-restaurant.com

CATEGORY Cocktail Bar

HOURS Mon-Thurs: 5:30 pm-10:15 pm

Fri: 5:30 pm-11:45 pm

GETTING THERE	Sat: 5 pm-11:45 pm
	Street parking on Washington St. and valet parking. It's a bit of a trek, but you can take the Orange Line to Massachusetts Ave. and walk right down to Washington St.
PAYMENT	DISCOVER AMERICAN EXPRESS MasterCard VISA
POPULAR DRINK	The drink menu features a great selection of Spanish refreshments from wines, sangria, and a Calimocho, a blend of Coke and red wine, which is surprisingly good,
UNIQUE DRINK	Most of the drinks are exceptionally unusual for a town that loves their Guinness and vodka sodas. The cocktail menu is full of interesting ingredients, which is no surprise since the restaurant is owned by James Beard Award winning chef, Ken Oringer, who is known for his innovative use of ingredients in his cooking. Try the Caramelized Caipirinha with caramelized limes and top tier Brazilian cacacha or the Jack Malmsey with Applejack Brandy, Malmsey Madeira, and maple syrup. If you're feeling festive, attention seeking, and have some semblance of hand-eye coordination, you must try drinking from the Porron, a glass bottle with a long spot to pour Spanish sparkling wine, Cava, straight into your mouth. Be sure to tilt your head back to get the full buzz before you pass it on.
FOOD	Irresistible pinchos and tapas such as Foie Gras with pear and bacon chutney, chicken empanadas, traditional Spanish tortillas, sea urchin stew, Kobe sliders, patatas bravas, bacalao, and grilled corn with melted Spanish cheese.
SEATING	Post up to the 14-seat bar, great for eating and imbibing. If you have a group, snag a communal high top table or any one of their dining tables.
AMBIENCE/CLIENTELE	Since its doors opened in 2006, Toro has been packed with adventurous foodies who love Toro's easy-going, stylish, sexy vibe. The brick walls and warm fireplace give it a cozy, yet industrial feel. You'll see a mix of artsy and professional South Enders, restaurant industry insiders, and serious foodies drinking and eating here.
EXTRA/NOTES	Toro does not accept reservations, so be prepared to wait during peak times. Restaurant Industry Nights take place on the first Thursday of each month from 11 pm- 1 am.

—*Minh Luong*

Wally's
The best place for live jazz in Boston, period.
$
427 Massachusetts Ave., Boston 02118
(at Columbus Ave.)
Phone (617) 424-1408
www.wallyscafe.com

CATEGORY	Beer Bar
HOURS	Daily: 4 pm-2 am
GETTING THERE	A few local parking garages, but almost no street parking. Take the Orange Line to the Massachusetts Ave stop and walk a block. Or take the #1 Massachusetts Ave Bus to Columbus Ave.

PAYMENT	
POPULAR DRINK	Bar is no-nonsense: bottled beers, a few wines and the usual assortment of liquor. The special stuff's on the stage, man.
FOOD	You can buy kid-sized bags of Cheetos for some reason, not sure why. Perhaps their timelessly cool "Chester Cheetah" character is the only deserving mascot of the jazz world.
SEATING	Tables for about twenty, perhaps ten seats at the bar, everyone else stands in whatever nook or cranny they can stake out. Get there early! The place can probably hold 50 or so people, provided one of them isn't the fire marshall.
AMBIENCE/CLIENTELE	A very comfortable and friendly venue despite the close quarters. Clientele ranges all over the map, with a love of music bringing together yuppies, college students, old-timers and hep cats from all walks of life. A fantastic date atmosphere, the place emanates a sophisticated authenticity that you can channel towards your own hipness.
EXTRA/NOTES	Started during the be-bop heyday of post-WWII, Wally's was the only Boston club to last. Mr. Walcott, the original founder, was the first black club owner in New England. Though he died in 1998, the beat goes on 365 nights out of the year with jazz, latin, blues, funk, and fusion (the good kind). Bring your sax for the jam sessions on the Sundays if you think you're bad(ass) enough.

—*Neely Steinberg*

BACK BAY

Bonfire

A beautiful hotel bar found inside a steakhouse.
$$$
50 Park Plz., Boston 02116
(between Charles St. and Arlington St.)
Phone (617) 262-3473 • Fax (617) 457-2350
www.bonfiresteakhouse.com

CATEGORY	Hotel Bistro
HOURS	Mon-Thurs: 5 pm-10 pm Fri/Sat: 5 pm-11 pm
GETTING THERE	The Motor Mart Garage is just across the street from Bonfire. Besides that, there is metered street parking that can be difficult at times. The nearest public transit available is the Arlington stop off the Green Line.
PAYMENT	
POPULAR DRINK	With a strong tequila selection, it's hard to reach for the wine list. The margaritas are phenomenal and perfect for a casual venture out. Hotel rooms can be so stuffy with those expensive single-shot bottles. The Sangria is worthwhile, especially with a group of lushes. And you should try the Caipirinha as it is a noted favorite.
FOOD	Bonfire boasts a mean steak selection, but they also have a taqueria menu made up of tasty tacos. These plates come for a pretty penny.

SEATING	One long room provides tables and booths for the hungry meat-eaters dining their way to satisfaction and a curvy bar with plenty of seats for ordering up a round of drinks to begin the night. A private dining room can seat larger parties at the long table set in an opulent wine den.
AMBIENCE/CLIENTELE	There is a certain elegance that is not generally found in hotel bars and restaurants that can be found here. The bar is the main focal point with its beautiful shape and fine details that bring out its majestic aura. The red hues and intricate decor drive home the moody sophistication of it all.

—Lawrence Fong

Brownstone

Prime Boston culture.

$$

111 Dartmouth St., Boston 02116
(between Colombus Ave. and Stuart St.)
Phone (617) 867-4142
www.irishconnection.com/brownstone.html

CATEGORY	Beer Pub
HOURS	Mon-Sat: 11 am-2 am
	Sun: 10 am-3 pm
GETTING THERE	Surrounded by two parking garages on Dartmouth St. Directly next to the Orange Line/Commuter Rail Back Bay T Station.
PAYMENT	AMERICAN EXPRESS · Mastercard · VISA
POPULAR DRINK	Brownstone is your typical pub style bar, which has a complete wine/beer list, as well as your selection of basic alcoholic drinks.
FOOD	Brownstone is one of the few bars that serves food until 2 am. They carry a "late-night" menu, which consists of breakfast and night-time snacks. Dinner recommendation: Brownstone Burger with bacon, cheese and glazed onions is hard to top!
SEATING	There are plenty of tables and booths scattered around the comfortable bar. The front wall facing Dartmouth St. consists of windows, which open up onto the street on nice days.
AMBIENCE/CLIENTELE	The location for this establishment is ideal, situated on one of Boston's busiest, tree-lined streets. During the day, you will find everyone from families to businessmen enjoying lunch. After a mellow dinner, evenings pack up a bit on weekend nights. It has become known as the new "Clery's," generating an older crowd and attracting folks who do not wish to wait in an enormous line on weekend nights.

—Stephanie Naudin

The Cactus Club

Tangy, salty, with a punch.

$$$

939 Boylston St., Boston 02115
(between Boylston St. and Hereford St.)
Phone (617) 236-0200
www.bestmargaritas.com

CATEGORY	College Bar

HOURS	Mon-Tues: 4:30 am-10 pm
	Weds: 11:30 am-10 pm
	Thurs: 11:30 am-11 pm
	Fri/Sat: 11:30 am-Midnight
	Sun: 11:30 am-10 pm
GETTING THERE	The Cactus Club is a three-minute walk from the Hynes Convention Center stop on the Green Line. Metered street parking is available on Boylston St., but you may have to drive around the block a couple of times to find a spot. As with anywhere near Fenway, it's highly recommended to avoid driving here on nights when there's a Sox game.
PAYMENT	DISCOVER AMERICAN EXPRESS MasterCard VISA
POPULAR DRINK	The Cactus Club claims to have the best margaritas in Boston. The boast is not far off the mark. Having spent a recent Saturday night quite literally stuck between clusters of pub-crawling BC seniors and the bar, I was transfixed by the bartender's efficient margarita-mixing method. Each glass was dipped first in lime juice, then crusted with thick salt before being filled with the sweet and tangy freshly-shaken drink. The 3 G's Marg is made with Sauza Tres Generations. Add lime juice, triple sec, and sour mix, and you've got a stellar margarita.
UNIQUE DRINK	My personal favorite is the "1843 Marg," made with Cuervo, vanilla-flavored Liquor 43, a splash of orange juice, and the Cactus Club's special "secret sour mix." They also offer mojitos and pomegranate margaritas, if traditional's not your thing. And for those who like sharing, there's the "Cactus Bowl," a 4-liquor, 46-ounce sassy answer to the tired "Scorpion Bowl."
FOOD	The enchiladas, empanadas, nachos, and quesadillas are a perfect complement to the margaritas here, maybe even good enough to eat without one. The menu options are easily customizable as well, which appeals to the picky eater. You can choose your fillings, toppings, even flavor of tortilla for your quesadilla. You can also choose from more than just chicken or beef. There's also pork, shrimp, fresh vegetables, refried beans, even salmon for fajitas. This many options, plus a reasonable price range and potent drinks keep the crowds happy.
SEATING	If you don't mind waiting, the patio is a prime location for summer people-watching. Indoors, the restaurant can, and will, accommodate large groups and accepts reservations Sun-Thurs for parties of 8 or more (for indoor seating only).
AMBIENCE/CLIENTELE	A framed copy of Boston Magazine from 1993 hangs on the wall beside the door to the women's restroom. The cover features a peppy woman in a bright red pantsuit and the Cactus Club's accolade of being the "Best Pick-Up Spot" in Boston. Though you (thankfully) won't find many perky pantsuit-clad ladies these days, you will find plenty of hot young 20-somethings, forced to press up against each other in the bar on crowded weekend nights. There's a definite college party vibe going on, lots of chicks in tube tops and dudes in backwards baseball caps, but it's a fun scene if you're in the mood to have a good time.
EXTRA/NOTES	Like free food? Show up Sunday nights from 10 pm-Midnight and indulge in a free taco bar!

—Jill D Ursc

A CUP OF ZEN

The Japanese Tea Ceremony

"Cha Zen ichi mi" is a saying in Japanese that translates to "Tea and Zen are one body." The seed of the tea tree and idea of Zen arrived together in Japan in the 13th century and grew together. Zen is focused on life and to be aware of each moment of life. Zen is more a philosophy than a religion because Zen does not talk about life after death. Zen people say, "If you have an idea of heaven, why not try to have heaven now in this lifetime?" This thought brought about the question, "How can we have a heavenly moment, a valuable moment?" Tea ceremony was an answer to this question. It was not only a way to share a cup of tea, but also a way to share an appreciation for life, and to share a peaceful, calm feeling.

Once a week at **Kaji Aso Studio** we hold Japanese tea ceremony. When guests come to tea they first walk through a small garden to the tea house and enjoy the moment of the season, such as the flowering trees of spring, the cool shade of summer, the glowing moonlight, the ripening fruit of autumn, or a winter snow fantasy. At the tea house guests remove their shoes one at a time before entering the tea room.

Tea ceremony begins with a light, sweet tea. This is a meditative quiet time when people enjoy the tranquility of the tea house and watch the host prepare the bowls of tea. Each guest drinks one cup at a time and one bowl of tea is shared between three people.

After everyone has had tea, we pass the centuries old bowls and utensils around and use this time for reflective conversation. The tea house is small and intimate, so there is one conversation, instead of many side conversations. The subject of conversation often turns to the history of tea ceremony or Japanese culture, but it can be about anything. It is taboo to talk about politics or money because these subjects agitate people. However, the conversation should be natural and the host helps it stay unified and focused. Light humor is fine.

There is a short break to revisit the garden and stretch our legs. When we come back to the tea house we enjoy heavy pastries and strong tea. It is very delicious! Tea is such an important beverage and maccha, the tea used for the ceremony, is especially valuable and healthy.

Naturally, tea itself is the focus of tea ceremony, but what happens around the tea is also part of the enjoyment. The atmosphere of the garden and tea house is provided by the host. It takes a few days to set up because we clean the garden and prepare the tea house. Based on the season, we organize the artwork, flower arrangements, tea bowls, sweets, and topic of conversation.

The atmosphere and attitude that people bring to tea are also an important part of the tea ceremony. Both host and guests should be responsible to provide the best atmosphere possible. This includes a humble attitude, a sense of respect and a calm mind. Each person has to make an effort to cooperate to be together. The movement used in tea ceremony came from the ancient Japanese Noh theater.

This movement is very gentle, slow, peaceful and distinctive. The air remains calm and does not shake. Because the tea house is small you do not have to speak loudly.

Mr. Aso, founder of Kaji Aso Studio, wanted to introduce the universal value of tea ceremony. When he came to Boston in 1967 he noticed that Americans love being active and do not sit still even to have a cup of coffee. Tea ceremony gives you the opportunity to stop and quietly enjoy time and space so we can receive and appreciate the world.

Over the years so many facets and details came into tea ceremony. Mr. Aso cleaned up the unnecessary heavy part of tea ceremony to make sure that it was well-connected to the place where it began, emphasizing the enjoyment of tea, friendship, and of the season.

The only way to know tea ceremony is to come to tea. Each time you come, you build up your knowledge of tea and your enjoyment of life. The motto for tea ceremony is "ichi go ichi e" – "one moment full of friendship." In one meeting if we truly share a valuable moment, it is as if we are friends forever.

Kaji Aso Studio
40 St. Stephen St., Boston 02115, (617) 247-1719, www.kajiasostudio.com

— *Kate Finnegan*

Café Jaffa

A colorful Middle Eastern spot for eats and drinks.
$$
48 Gloucester St., Boston 02115
(between Boylston St. and Newbury St.)
Phone (617) 536-0230
www.cafejaffa.net

CATEGORY	Theme Café
HOURS	Mon-Thurs: 11 am-10:30 pm
	Fri/Sat: 11 am-11 pm
	Sun: Noon-10 pm
GETTING THERE	There is metered street parking around the area. The closest T-stop is Hynes Convention Center stop on the Green Line.
PAYMENT	
POPULAR DRINK	Among the great non-alcoholic beverages, Lemonana, homemade lemonade with mint, is a great choice. There is also Turkish coffee available for the caffeine fiends. Beer, wine, and sangria are often ordered in the later hours.
UNIQUE DRINK	Café Jaffa offers some Israeli wines as well as a small selection of imported beers from Israel and Lebanon.
FOOD	The highlight of this place lies in the large selection of all your favorite Middle Eastern foods.
SEATING	The long room is filled front to back with intricately designed table tops for your casual dining pleasure.
AMBIENCE/CLIENTELE	The vivid colors and paintings really spice up the rather casual setting to make it almost dateworthy. It's a great place to grab a bite and drink a pitcher of

sangria or lemonana with friends before hitting the bars.

EXTRA/NOTES For just a few dollars, pick up an Israeli newspaper here.

—*Charlie Knoll*

Cigar Masters

The boy's club.

$$$

745 Boylston St., # 3, Boston 02116
(between Fairfield St. and Exeter St.)
Phone (617) 266-4400
www.cigarmasters.com

CATEGORY	Theme Club
HOURS	Mon-Sat: Noon-1 am Sun: Noon-Midnight
GETTING THERE	There is metered street parking that is free after 8pm and all day Sundays. Also, the Prudential Center Garage is just down the street. The closest public transit is Copley off the Green Line.
PAYMENT	DISCOVER · AMERICAN EXPRESS · MasterCard · VISA
POPULAR DRINK	To choose from the menu of wine and beer, it all depends on taste. And affordability. Wine is well above 10 dollars a glass, unless you buy a bottle. In that case it is anywhere from 40 to 450 dollars. Beer is slightly cheaper at 5 to 15 dollars a glass, which the higher price range is reserved for the great selection of Belgian beers. So if your pockets feel heavy, listen to those taste buds and knock back a few glasses of whatever suits you with a cigar in hand. Because that's class.
FOOD	Here is the food offering in its entirety: cheese and fruit plate, charcuterie plate, mini filo, and nuts and olives. That's all. But with cigars and good libations, what else could you need?
SEATING	There are two rooms of leather armchairs, couches and a few table tops here and there. The small bar in the front can seat a few who have no one but the bartender to chat with. A sectioned off room is available for the fancy folk.
AMBIENCE/CLIENTELE	To start, it's hard to find. Even when you're staring right at it, it camoflauges with the surrounding darkness, and when you realize you are there, it looks closed. It's quite sneaky, like a treehouse club, but I suppose that's what draws in the predominantly male crowd. The smoky darkness is only broken by flaring matches and the glow of the sports channel.
EXTRA/NOTES	A $10 dollar lighting fee is enforced for any smoking products not purchased at Cigar Masters.

—*Jason Burnsworth*

City Bar

Dark and sexy: a great first date place to impress your date with.

$$$

55 Exeter St., Boston 02116
(at Boylston St.)
Phone (617) 933-4801
www.citybarboston.com

CATEGORY	Cocktail Lounge
HOURS	Daily: 5 pm-2 am
GETTING THERE	Metered parking (free after 8 pm) and valet. One short block from Copley MBTA Green Line and a couple blocks from Back Bay MBTA Orange Line
PAYMENT	[Discover] [American Express] [MasterCard] [VISA]
POPULAR DRINK	Excellent cocktails include a killer Moscow Mule, a Watermelon Mojito, and the Pear Passion Martini.
UNIQUE DRINK	The specialties here are the infusions: the diabolique bourbon (with fresh and dried figs, cinnamon and vanilla bean) and the cocktails (tiki tonic: rum, tequila, passion fruit puree, and pineapple juice).
FOOD	The food, from the kitchen of adjoining Azure restaurant, runs the gamut of lounge food such as polenta fries, kobe beef burger sliders, and excellent house-made potato chips. It's all very good, though not cheap. Still a great place to get a light bite to share with your drinks.
SEATING	Couches and low tables as well as a few dozen small table and chairs. There is a long bar along the back wall.
AMBIENCE/CLIENTELE	Very dark, chic, and romantic. The bar is lit by LED lights, which are best when not cycling through the colors. This small bar can get backed up after work with scenesters, but is well worth any wait for the cool but comfortable vibe.
EXTRA/NOTES	The restrooms (outside off the hotel lobby) are also quite stylish with backlit marble trough sinks, monitors with news above the urinals and nice finishes throughout.
OTHER ONES	425 Summer St., Boston 02210, (617) 443-0888

—Chris Coveney

Clery's

A neighborhood favorite.

$$

113 Dartmouth Street, Boston 02116

(between Dartmouthand Columbus in the Back Bay)

Phone (617) 262-9874

www.irishconnection.com/clerys.html

CATEGORY	Beer Bistro
HOURS	Daily: 11 am-2 am
GETTING THERE	Street parking requires residential permits, although you may find meters on Columbus and Dartmouth. There is garage parking in the Dartmouth garage across the street and the Back Bay MBTA Station is just a few steps away.
PAYMENT	[American Express] [MasterCard] [VISA]
POPULAR DRINK	In typical pub style, Clery's offers an extensive wine list and 16 beers on tap, in addition to a fully stocked bar.
SEATING	Although Clery's is packed with patrons, one can usually find a place to sit. Tables line the window-paned walls, and several booths fill the back of the bar. Two bars and one dining area pack the top floor; a small dance floor and a third bar are located on the bottom floor for late-night dancing.
AMBIENCE/CLIENTELE	Clery's serves as a restaurant during the day, so you can find everyone from families to young friends dining at this establishment. The young singles crowd

that frequents this local pub usually visits after work, or late on weekend nights, so expect a line at the door during those times. Otherwise, Clery's is a casual spot to sit and eat lunch, or catch up with friends, until the crowd begins to form.

EXTRA/NOTES The line on weekend nights can be extremely long, so get there before the crowd shows up. There is also a line to get into the basement downstairs, but it does disappear at some point in the evening.

—*Jessica Holmes*

Club Café
Where to take your PFLAG Mom.
$$$
Columbus Ave., Boston 02116
(at Clarendon St.)
Phone (617) 536-0966
www.clubcafe.com

CATEGORY Gay Bar
HOURS Mon-Thurs: 4 pm-10 pm
Fri: Noon-2 am
Sat: 2 pm-2 am
GETTING THERE Parking at meters around the area is possible if you are lucky. Close to MBTA Back Bay and Arlington stations.
PAYMENT [Discover] [MasterCard] [VISA]
POPULAR DRINK Wide range of beer and cocktails served at three bars. As with most gay bars, the bartenders deliver heavy pours, taking the sting out of the slightly elevated drink prices.
UNIQUE DRINK Drink menu has a wide variety of decent drinks from classic cocktails to newer drinks like pomegranate martinis.
FOOD Bar food is available in the front bar from the attached "209" restaurant including staples like a hummus plate, very decent nachos, chicken fingers, sandwiches and burgers at reasonable prices.
SEATING Seating at tables in the front of the bar, and limited stool seating at small tables in the back two rooms, though at peak periods there is lots of standing around.
AMBIENCE/CLIENTELE A multi-year "Best Gay Bar in Boston" award winner, Club Café—aka Club Half-Gay—is the somewhat swanky gay club you can comfortably take your supportive p-flag Mom or your straight co-worker to. It's a pretty-boy (and some pretty lesbian) kinda place, which can seem cliquish (but this is Boston, like you're not used to THAT). It's full of video screens playing music videos and the occasional comedy clips, which can be distracting in a good or bad way, depending how well your date is going.
EXTRA/NOTES Thursday is THE night to go out to Club Café, where the front bar is packed with lesbians, and two back rooms are packed even tighter with slightly dressed up gay men. Other theme nights include karaoke, live "text message cruising," and record and movie release parties. Also a reliable after-work place if you are a suit-fetishist.

—*Chris Coveney*

Cottonwood Café

Make your brain stem tingle with a pitcher of margarita.

$$

222 Berkeley St., Boston 02116

(at St. James Ave.)

Phone (617) 247-2225

www.cottonwoodboston.com

CATEGORY	Cocktail Bar
HOURS	Mon-Weds: 11:30 am-10 pm
	Thurs-Sat: 11:30 am-11 pm
	Sun: 11:30 am-10 pm
GETTING THERE	The Cottonwood offers parking validation in the Back Bay Parking Garage. There is also metered street parking available, though it can be hard to come by on certain nights. The nearest public transit is Arlington stop on the Green Line or Back Bay stop on the Orange Line.
PAYMENT	
POPULAR DRINK	Why order margarita by the glass when you can share the icy love with a pitcher? All of the margaritas offered can be ordered by the pitcher, making this place a great spot to put on your party boots and socialize. There are also specialty drinks and martinis that each have their own fruity flare. The beer and wine list is there for anyone not in the mood for a sugar rush.
FOOD	A full menu is available with Southwestern cuisine favorites and contemporary variations. Good food.
SEATING	There is room after room of tables and booths, which is great for group functions. There is one bar in the main café area where people can more casually dine or drink.
AMBIENCE/CLIENTELE	In terms of decor, the place feels like a hipped-out Denny's with a sprinkle of Southwestern flare, like their Sauza and chili lights strung along the booths. It often comes off as a fancy way to eat Southwestern food, which it may very well be, but the red and blue lights don't fool me. To me this place is a great to flock to after work for gorging and order a few pitchers of margaritas. Which is really all I could ask for.

—*Bree Cummings*

Crossroads

MIT Fraternities' Unoffical Bar.

$$

495 Beacon St., Boston 02115

(at Massachusetts Ave.)

Phone (617) 262-7371

www.crossroadspubboston.com

CATEGORY	College Pub
HOURS	Daily: 11 am-2 am
GETTING THERE	Street parking on Beacon St. or Massachusetts Ave., 3 blocks from Hynes Convention Center Stop on Green Line, or Kenmore Sq. Stop. The #1 Massachusetts Ave. bus takes you right to the Crossroads of Beacon and Massachusetts Ave.
PAYMENT	
POPULAR DRINK	This is a classic Boston Pub so the beer flows freely from $3.50 for a Bud, to $4.75 for a Guinness. They also have Stella, Blue Moon, Bass, Harp, and Cider Jack on tap and available by the pitcher; Amstel Light, Heneiken, and Smirnoff Ice available in bottles. They

have a full liquor license, with cocktails ranging from $3.50-$7. Don't get carried away, though, this is not a fancy cocktail kind of place.

FOOD Cheap, but good, bar food that caters to the college crowd. Wings, creative pizzas, burgers, and more.

SEATING Crossroads has two levels. The first floor contains a bar, booths, and high tops and has more of a restaurant fell. Upstairs you get more of the bar atmosphere with another bar, and a few scattered high tops flanking the walls.

AMBIENCE/CLIENTELE Crossroads is a great stalwart dive pub in a high rent neighborhood. It attracts the MIT frat boys and girls that live on its block, as well as old timers and neighborhood regulars. If you're into relaxing with your Guinness and throwing some darts while catching the Sox Game this is your place.

EXTRA/NOTES Crossroads has got your social schedule covered. Mondays: Irish Session, Tuesdays: Dart Night, Wednesdays: Free Pizza with pitcher, Thursdays: Beirut Night(AKA Beer Pong) Free Wings with pitcher, Saturdays: $8 pitchers, and Sundays: Trivia Night.

—Minh Luong

Finale

Gourmet adult candyland.

$$$

1 Columbus Ave., Boston 02116
(between Arlington St. and Park Pl.)
Phone (617) 423-3184
www.finaledesserts.com

CATEGORY Dessert Bar

HOURS Mon: 11:30 am-11 pm
Tues-Thurs: 11:30 am-11:30 pm
Fri/Sat: 11:30 am-Midnight

GETTING THERE The Motor Mart Garage and the Boston Common Garage are the two closest garages to Finale. The prices vary and Finale does not validate. There is also metered street parking, which can be hard to find at times. The closest public transit is the Arlington stop off the Green Line.

PAYMENT DISCOVER AMERICAN EXPRESS MasterCard VISA

POPULAR DRINK With drink pairings matched with each dessert offered, indulgers order the suggestions given to bring out the full flavor experience. Often times, people opt for spiked coffee and hot chocolate or dessert martinis instead of a fork-intensive alternative. Wines, ports and sherries are also popular, especially among the few enjoying actual food.

UNIQUE DRINK One of the greatest ways to experience any liquid delight is to order a flight of it. Try flights of port, sherry, wine, sparkling wine, ice wine, and Grand Marnier. For a real treat, try their Hot Chocolate flight featuring the three signature flavors: traditional bittersweet, rich hazelnut, and white chocolate with a hint of orange.

FOOD There is a lunch menu with sandwiches and salads for the lunch-breakers. For the "Prelude" dinner menu, there are a scatter of options for munchables like pizza, antipasto platters and salads. But really, it should be obvious from the rich air of brownie musk that people come here for the sweets. The dessert menu is the driving force behind Finale's existence.

And they do it well. Get your fill of chocolate or tarts or crème brûlée or cheesecake, cupcakes, brownies, sorbet, tiramisu…it's just an orgy of all things lovely.

SEATING The room is filled to the max with tables for dining, but even with a few extra seats by the espresso bar, this place can get a wait going pretty quickly. And there's not much waiting room inside.

AMBIENCE/CLIENTELE Finale attracts anyone with an excuse to splurge on gourmet goodies for the mouth. The boisterous, sugar-veined crowd keeps the volume up and the energy high, which might be a little too hyper for a romantic setting, but you really cannot go wrong with delectable, spoon-licking delights to close out a perfect night.

OTHER ONES • 1306 Beacon St., Brookline 02446, (617) 232-3233
• 30 Dunster St., Cambridge 02138, (617) 441-9797

—Alexis Vandeventer

Flash's Cocktails

Neighborhood cocktails and cheap eats.
$$
310 Stuart St., Boston 02116
(between Arlington St. and Berkeley St.)
Phone (617) 574-8888
www.flashscocktails.com

CATEGORY Cocktail Bar

HOURS Mon-Sat: 11:30 am-2 am
Sun: 5 pm-2 am

GETTING THERE There is metered street parking if you can find a spot, or there are parking garages for at least $10+ fee. Through public transportation, Arlington stop (Green Line) is the closest.

PAYMENT

POPULAR DRINK The cocktail menu is divided into two sections, Flashbacks (old classics) and Flash Forwards (new creations). Each Flashback drink comes complete with a paragraph explanation of the drink's origin and etymology. The Flash Forwards, having no history, are followed with a grandiloquent spiel. If you're not in the mood to read a novella of a menu, ask the bartender for a recommendation, or perhaps a new cocktail in the works. Of the newer generation, the Elder Berry Bleu and the Winter Cosmo are the favorite picks. I don't think I need to speak for the classics.

UNIQUE DRINK Supposedly, the Flash Forwards are all fresh and funky new concoctions. So I say close your eyes and point a finger.

FOOD If you come solely for the food, you may be disappointed. Come thirsty and their menu of cheap comfort food is just what you need to keep all those cocktails company down in the tummy.

SEATING Besides the small lounge area made up of a couple couches, the U-shaped bar is surrounded by high-tops and tables.

AMBIENCE/CLIENTELE From the bright neon sign to the fresh interior, this place pulses out a funky attitude that lures in the young crowd from the local neighborhood like lost children to a gingerbread house. It's simply a kickback bar to get your cocktail on.

—Avalynn Michaels

Haru

Sake to me.

$$$

55 Huntington Ave., Boston 02228

(at Ring Rd.)

Phone (617) 536-0770 • Fax (617) 536-0660

www.harusushi.com

CATEGORY	Cocktail Bar
HOURS	Mon: 11:30 am-11 pm
	Tues-Sat: 11:30 am-Midnight
	Sun: 11:30 am-11 pm
GETTING THERE	For drivers, there is rarely street parking, in which case there is always the Prudential Center garage. A discounted parking rate comes with any $10 purchase from any store, restaurant, cart or kiosk in Prudential Center, just make sure to get validated. The nearest public transit is Copley or Prudential on the Green Line or Back Bay on the Orange Line.
PAYMENT	
POPULAR DRINK	Aside from the ever so popular Japanese sake and beer, there are regular cocktails and wine. Though not particularly suited with a Japanese meal, the mojitos and champagne concoctions are quite scrumptious.
UNIQUE DRINK	Sake, by glass or bottle, is the classic addition to any Japanese meal. If you're having trouble deciding between the different types, try the sake flight, 4 for $12 and learn your sake. Or just drink it. Here, not only do you have a variety of sake to choose from, you can also mix it up with a modern edge with sake cocktails.
FOOD	Chopstick-intensive dishes here—sushi is the main attraction to this restaurant.
SEATING	A hot little bar area on one side and a full restaurant layout, sushi bar and all, on the other. Seating is ample, but can get crowded during peak dining times.
AMBIENCE/CLIENTELE	Fine Japanese food entices people into Haru for a chic dining experience, but the sake and cocktails are a surprising complement. The Prudential Center can drive in plenty of tourists and suits, but the blend of traditional and contemporary Japanese styles make it perfect for those not-so-frugal nights, either with friends or a date.

—*Charlie Knoll*

Kings

Booze and bowling.

$$$

50 Dalton St., Boston 02115

(between Boylston St. and Scotia St.)

Phone (617) 266-2695 • Fax (617) 266-2251

www.backbaykings.com

CATEGORY	Theme Lounge
HOURS	Mon: 5 pm-2 am
	Tues-Sun: 11:30 am-2 am
GETTING THERE	The Pilgrim Parking Garage is located just above Kings on Dalton Street. For a discount of $5, get your ticket validated. There is some street parking in the area though often hard to find. The nearest public transit is Hynes/ICA on the Green Line (anything train except E).
PAYMENT	

POPULAR DRINK Specialty mixed drinks, frozen cocktails, and sweet martinis are all fun, fruity ways to get sloshed and have a good time. The boys tend to stick to beer and standard spirit plus mixer, but they can't resist a flavored mojito for long.

UNIQUE DRINK Fish Bowl for Two has Shakka Grape, Three Olives Grape vodka, Blue Curacao, pineapple rum with Red Bull, pineapple juice and sour mix with Swedish fish garnish swimming about for a final touch.

FOOD Kings has a wide array of comfort food that is aiming to please. A long list of appetizers is great for parties, burgers and pizza is available for a casual munching and a basic set of entrees is a serious consideration for those lounging in the restaurant.

SEATING King's is an enormous venue with 16 ten pin bowling, a separate billiards room of eight luxurious tables, several bars and a lounge area. The attached restaurant area and bar can seat 85 in their retro booths and easily accommodates big parties. Separate rooms and VIP areas can also suit big parties and events.

AMBIENCE/CLIENTELE Kings is mainly known for their cosmic bowling set-up with loud music and kooky lights. Randy college kids flock here for easy access to rowdy fun, but you can find a mixed crowd of people just there for the love of the game. And the booze too.

EXTRA/NOTES Bowling here doesn't come cheap, but Kings does cater to those who may not always have the means to afford a night of fun. Mondays are Industry Nights after 9 pm; just bring in a business card or pay stub from your restaurant, hotel or bar. Tuesdays feature trivia night and college students (with a valid Student ID) bowl for free AND get to put their well-educated brains to the test. They also have specialized nights for music. Wednesday nights feature open-mic night. And Thursdays have Karaoke.

—*Kashlin Romero*

L'Aroma Café

Euro chic on Newbury St.
$$
85 Newbury St., Boston 02116
(between Berkeley St. and Clarendon St.)
Phone (617) 412-4001
www.laromacafe.com

CATEGORY Coffee Café
HOURS Mon-Fri: 7 am-7 pm
Sat: 7:30 am-7 pm
GETTING THERE Green Line T to Arlington or Copley.
PAYMENT
POPULAR DRINK Because they're owned by Timeless Teas (conveniently located just upstairs), L'Aroma has an impressive tea selection. Espresso drinks are also delicious.
UNIQUE DRINK Try the flavored black teas, a bowl-sized latte, or a daily special drink. One recent favorite is the Vanilla Mate Latte (hot or iced).
FOOD Well-made sandwiches and salads abound. Also, try the authentic (and rather formidable) biscotti: very dunkable and very satisfying.
SEATING The several small café tables (with lovely ceramic decoration) fill up during lunch rushes and on weekends, but usually it's possible to find a seat for one or

two. But step delicately, so as not to knock over your neighbor's cappuccino.

AMBIENCE/CLIENTELE Stop by for a brief pause from shopping on Newbury St. for a hot beverage and a book or to catch up with an old or new friend. Nestled between BCBG, Max-Mara, and Victoria's Secret in Boston's chicest shopping district, L'Aroma's customers appreciate quality drinks and are willing to pay for them.

OTHER ONES Check out Timeless Teas, located upstairs, which is under the same ownership.

—*Kim Liao*

M.J. O'Connor's

Your average upscale Irish pub. Big and boring.
$$
27 Columbus Ave., Boston 02116
(at Church St.)
Phone (617) 482-2255
www.mjoconnors.com

CATEGORY Beer Pub
HOURS Daily: 11 am-2 am
GETTING THERE If you park in the Radisson parking garage at 200 Stuart St. after 3pm, M.J. O'Connor's validation will get $10 off a $20 charge for the whole day. There is metered street parking, but it is very difficult to find. When riding the T, take the Green Line to Arlington.
PAYMENT DISCOVER AMERICAN EXPRESS MasterCard VISA
POPULAR DRINK Even though this place lacks the Irish feel, most people drink the Irish drink: Beer.
FOOD An Irish fare is offered here for lunch and dinner. Among a more standard menu of salads and sandwiches are some Irish specialties like Bangers and Chips, and Shepherd's Pie. Like a wave of a cultural wand, French onion soup becomes Irish by using Guinness as part of the base. I don't know if it counts, but I give points for effort.
SEATING This place is HUGE. It's borderline absurd. And they've filled their space with different types of seating spread out in different nooks each with a different feel to it. There are some private booths, or one-sided booths, tables with small stools, high stools lining the wall, stools at the bar, round tables, square tables, long tables, short tables...I feel like Dr. Seuss. The point is they have seating. And a lot of it.
AMBIENCE/CLIENTELE O'Connor's is made to feel both homey and majestic. There are beautiful murals painted along the walls, shelves of books and other such antique trappings, and a rustic stone fireplace that is lit occasionally. Gorgeous woodwork lavishes the walls and bars, and golden light radiates from the ceiling lamps. Still behind all the hoopla, the place lacks some internally-powered spirit. The pub is connected to a hotel, which brings in a lot of tourists who seek out an authentic Irish experience and get this place. Even with all the other types of people who file in here, everyone seems isolated from one another. I guess the place is a little too big to get that community pub feel.
OTHER ONES 425 Summer St., Boston 02210, (617) 532-4600

—*Deepak O'Reilly*

Match

Mini burgers and big martinis make for a night not to remember.
$$$$
94 Massachusetts Ave., Boston 02228
(between Commonwealth Ave. and Newbury St.)
Phone (617) 247-9922
www.matchbackbay.com

CATEGORY	Cocktail Bar
HOURS	Daily: 5 pm-1 am
GETTING THERE	Valet for $15. Or take the Green Line to the Hynes Convention Center stop and walk less than a block.
PAYMENT	AMERICAN EXPRESS · MasterCard · VISA
POPULAR DRINK	Among their fruity fun concoctions, the pop rocks martini (where pop rocks rim the glass of your sweet libation) receives the most attention.
UNIQUE DRINK	Ironically, a classic martini made with just gin and vermouth is rare amongst all of the complicated concoctions.
FOOD	Basic American fare with occasional Asian infusion. The gimmick here is the mini burgers, otherwise known as sliders, which deserve a try. The tuna steak burger is actually pretty good, but when they say mini, they mean mini so order at least two.
SEATING	The large central bar is where all of the action is, both in the bartenders shakin' and the clientele mackin'. There is also opportunity for a real sit-down dinner at one of the many tables in the large space. Bring someone or get lucky at the bar.
AMBIENCE/CLIENTELE	There is a small after-work crowd because of the bar's prime real estate at the end of Newbury St. in the Back Bay. But it is when the clock strikes 9 pm that the real action happens. Women (including the waitstaff) wear little more than high heels and the men are pressed, gelled and doused in cologne. Necks are turning and eyes are traveling up, down and all around.
EXTRA/NOTES	The owners of Match also own the extremely popular Jillian's and Lucky Strike Lanes.

—Abby Bielagus

Oak Bar

Mahogany, gilt, and pricey martinis, but oh, what a gorgeous room!
$$$$
138 St. James Ave., Boston 02116
(between Dartmouth St. and Clarendon St.)
Phone (617) 267-5300
www.theoakroom.com

CATEGORY	Hotel Bar
HOURS	Daily: 11 am-1 am
GETTING THERE	There are pay garages and on-street meter parking, but the MBTA is your best bet. The Green Line Copley Station and orange line Back Bay stations are steps away.
PAYMENT	DISCOVER · AMERICAN EXPRESS · MasterCard · VISA
POPULAR DRINK	Martinis and classic cocktails are the draw here, especially considering the swank setting.
UNIQUE DRINK	Martinis are served in elegant small glass carafes, set in ice buckets. Each serving is about 2 martinis worth.
FOOD	Steakhouse and a raw bar.
SEATING	20 or so small tables and deep wingback chairs and some sofas.

AMBIENCE/CLIENTELE	Ornately gilded ceilings, expanses of mahogany paneling and low lighting befit the hotel bar of a grand old hotel. It's old school and elegant, but not uptight at all. The teal lights at the stairs are the only misstep in an otherwise gorgeous decor. Note the evening Dress Code: No Shorts, Hats, Cut-Out/Tank-Top T-Shirts, or Sport Sandals.
EXTRA/NOTES	A gorgeous, civilized bar worth getting dressed up to go to and a great place to impress a date or an out-of-towner looking for a "Boston experience." Live music Tues-Sat nights.

—Chris Coveney

The Otherside Café

Casual drinks with serious attitude.
$$
407 Newbury St., Boston 02116
(at Massachusetts Ave.)
Phone (617) 536-8437
www.myspace.com/othersidecafeboston

CATEGORY	Beer Bar
HOURS	Mon-Thurs: 11 am-1 am
	Fri/Sat: 11 am-2 am
	Sun: 11 am-Midnight
GETTING THERE	Green Line T to Hynes Convention Center (B,C, or D lines); #1 Bus to Massachusetts Ave. and Newbury St.
PAYMENT	
POPULAR DRINK	Perfect for beer lovers who also enjoy healthy food and/or hipsters, Otherside has an extensive list of draughts on tap available both in pints and pitchers as well as special drafts of the day or week. Selections vary. Recent favorites on tap include Allagash White and BBC Coffeehaus Porter. Also available is an even larger list of bottled beer, and several excellent wines, all organic and available by the glass. Vodka-lovers, however, should leave their martini glasses at home. Without a full liquor license, the libations in other happy hour offerings are limited to liqueurs.
UNIQUE DRINK	Try any white wine; some favorites include the Riesling and the Clairette. Unique and delicious mixes include the Black Forest (Guinness and Lindemann's Framboise) and the Sake Mary mixed like a Bloody Mary, but with an extremely potent blend of sake and rice wine.
FOOD	Full menu of everything from snacks (chips and salsa, fruit and cheese) to breakfast, lunch, or dinner. Specials include raw and/or vegetarian selections, but if you're in the mood for comfort food, have the vegetarian chili topped with cheddar cheese and sour cream.
SEATING	Two floors give you a wide variety of ambiance; sit upstairs in cozy booths, downstairs at bar-height tables, or outside on the deck.
AMBIENCE/CLIENTELE	A local, but not unfriendly, crowd. Regulars include students from nearby Berklee and BU, local artists and musicians, and anyone else who has caught the Otherside bug. Beer lovers and vegetarians of all walks of life coexist with surprisingly little friction. And at the end of an afternoon or evening out on the deck, everyone's practically family.

EXTRA/NOTES Check the website or stop in to find out about special events and movie nights.

—Kim Liao

Parish Café

Innovation and variety couldn't be more satisfying.

$$

361 Boylston St., Boston 02116
(between Arlington St. and Berkeley St.)
Phone (617) 247-4777 • Fax (617) 247-3210
www.parishcafe.com

CATEGORY Cocktail Bar

HOURS Mon-Sat: 11:30 am-2 am
Sun: Noon-2 am

GETTING THERE There is metered street parking on Boylston St, which runs until 8pm, except on Sunday. The nearest public transport is Arlington stop on the Green Line, which is just down the block.

PAYMENT

POPULAR DRINK The outstanding beer list boasts 75 beers that, if ordered all within a year, will win you a personalized Parish Mug Club beer stein. The cocktail list is constantly being revamped with new concoctions but some favorites include The Wandering Poet and The Wade Into Trouble.

UNIQUE DRINK Many of their cocktails were designed by bartenders both old and new. Ask your bartender for recommendations or if there's anything in the works.

FOOD A full menu is served until 1am daily of all the sandwiches and comfort food to soothe the drunk munchies. The assortment of sandwiches really steal the show as they are not only scrumptious, especially the Regal Regis or the Dbar, but are designed by local and respected chefs. It brings a special variety in flavor combination that will lead you to find your sandwich's creator and thank them personally for the wonderful contribution to your tummy. An easy task considering the names and restaurants of each chef are written under the respective sandwich.

SEATING There are definitely times when the long curvaceous bar and the surrounding tables can only seat so many butts, but most people scurry to the outdoor patio seating during the warmer seasons.

AMBIENCE/CLIENTELE Parish Café sports a mellow neighborhood vibe where people nurse their sandwich-stuffed bellies with beer and cocktails. The good music overloads your endorphins as you collapse into a omg-I-heart-Parish-Café trance. The only thing that comes with a bite are the occasionally tart bartenders, but they bring the 'tude. You'll mostly find a crowd ranging from 20s to 30s lounging until the late hours.

—Victoria Young

The Pour House Bar & Grill

Bringing college back.

$

907 Boylston St., Boston 02115
(at Gloucester St.)

Phone (617) 236-1767
www.pourhouseboston.com

CATEGORY	College Bar
HOURS	Daily: 8 am-2 am
GETTING THERE	Street, metered parking along Boylston St. closest to the Copley stop on the Green Line.
PAYMENT	![AMERICAN EXPRESS] ![Mastercard] ![VISA]
POPULAR DRINK	Pour House serves all types of liquor, from wine to beer to mixed drinks. They are famous, however, for their drinks served at brunch, which include tall glasses of Bloody Marys, Mimosas, and Screwdrivers.
UNIQUE DRINK	The Creamsicle served at brunch is a must-try. This tasty treat is mixed with orange vodka, orange juice and vanilla ice-cream. The Pourmosa, also a brunch favorite, is a refreshing combination of champagne and cranberry juice.
FOOD	This is the place to be if you are craving a late-night snack, as food is served until closing. Prices are very economical, which not only applies to the cheap beer, but the American-style food as well.
SEATING	The bar consists of two floors, which is conducive to a packed crowd. If you would like to dine at one of the booths, seating is first-come, first-serve, and you must seat yourself.
AMBIENCE/CLIENTELE	The Pour House attracts a fun-loving, sometimes rowdy, down-to-earth crowd. It's great location to watch a game on one of their seventeen 42" plasma HD screens, or let your hair down with friends. Expect a bar that is always packed with a casual, college-type crowd.
EXTRA/NOTES	Take note of the weekly price reductions, which include "Crazy Chicken Night" on Wednesday nights (half off grilled chicken sandwiches), "Mexican Madness" on Thursday nights (all Mexican food is half-priced), "Burger Mania" on Saturday nights (all burgers are half-price) and brunch served on Saturday and Sunday afternoons.

—*Jessica Holmes*

Rattlesnake Bar & Grill

I'm sorry, did someone say roof deck?
$$
384 Boylston St., Boston 02115
(between Arlington St. and Berkeley St)
Phone (617) 859-7772
www.rattlesnakebar.com

CATEGORY	Neighborhood Bar
HOURS	Daily: 11:30 am-2 am
GETTING THERE	Green Line T to Arlington.
PAYMENT	![DISCOVER] ![AMERICAN EXPRESS] ![Mastercard] ![VISA]
POPULAR DRINK	While they do all the old standbys well, Rattlesnake has a great selection of cocktails (starting at $6). Try the Raspberry Lime Ricky, a glass or a pitcher of excellent Sangria, or a blended Strawberry Margarita or Pina Colada.
UNIQUE DRINK	Margaritas are apparently the "Signature Drink," and starting at $7, they have their own page in the menu. Rattlesnake is southwestern-themed so when in doubt, go with a drink that involves tequila.
FOOD	Depending on the time of day, one can find both bar food and a real meal. Fantastic quesadillas.

SEATING	A sizable downstairs area with tables and standing room around the bar. A large roof deck upstairs; on summer nights, it fills up fast.
AMBIENCE/CLIENTELE	Downstairs, a mix of suits and chinos for happy hour, tourists, and a potentially very scene-y crowd, depending on time of day or night. On the deck: a great place for happy hour, large groups, good friends, and dates.
EXTRA/NOTES	Table service is dicey, slow, and often inattentive (upstairs and down). But the roof is usually worth it. On a hot summer day, drinks on the deck are a heavenly oasis from the sticky city, an idyllic mood jilted only by the neon tank tops (that read "Snake") and impossibly short skirts worn by the waitresses. Yes, Toto, you're still in a Boston bar.

—*Kim Liao*

Saint

The swanky pits of hell.
$$$
90 Exeter St., Boston 02116
(at Blagden St.)
Phone (617) 236-1134
www.saintboston.com

CATEGORY	Dance Club
HOURS	Mon: 9 am-2 am
	Fri/Sat: 9 am-2 am
	Sun: 10 am-2 am
GETTING THERE	Valet parking is available, but I highly recommend taking the T down to Copley Sq. This is not the kind of place you should plan on driving to or from.
PAYMENT	
POPULAR DRINK	I'm not a big Tequila fan, but I had a really good Kamikaze at Saint. My girlfriends and I were there to celebrate someone's birthday, so we got a round to mark the night. They went down nice and smooth, especially Meg's, which landed on my boot when she tried to discretely rid herself of it by throwing it back…behind her (did I mention my girlfriends and I are totally glam-chic?). Note to readers: It's a good idea to stop drinking when you've had one too many, but it's dumb to waste a beverage and possibly cause a safety hazard. If you don't want it, give it to a friend!
FOOD	It's the only nightclub I've been to (note: I haven't been to many) that offers a $60 communal caviar platter. It's known to be a nightclub, but also prides itself on its menu, ranging anywhere from chicken noodles and mini cheeseburgers to caviar and pork tenderloin.
SEATING	Saint has comfy, leather seating throughout the bar, whether you're in the dining lounge, the in-between-heaven-and-hell lounge, or the Bordello.
AMBIENCE/CLIENTELE	Saint labels itself as a place for the refined and sophisticated, but does that populace really go to nightclubs? The main dancing area at Saint is decorated wall to wall in red fabric, giving a sinful glow to the entire area and its patrons. Oh, and they call it the "Bordello." Loud music beats through the speakers and into your skin. Drinks are pricey, but it's one of those places that incites heavy drinking. Not because the bartenders are forcing them down your throat, but

because you can't hear your friends, you don't know who's dancing next to you, and you just want this night to be fun because you paid a cover and swanked yourself up to get in. If you're not down with loud music and sweaty dancing, I'd recommend the dining lounge, which has a cozy and appropriately lounge-y feel; the music is tamer, and the conversation is easier – also, the devil is in the other room.

EXTRA/NOTES As stated on their web site: "upscale chic dress, no sneakers or hats."

—Stephanie Naudin

Sel de la Terre

A taste of Southern France with funky flair.
$
774 Boylston St., Boston 02199
(between Fairfield St. and Exeter St.)
Phone (617) 266-8800 • Fax (617) 266-8801
www.seldelaterre.com

CATEGORY	Wine Bar
HOURS	Daily: 11 am-2 am
GETTING THERE	There are several garages in the area, and valet parking is available at the front of the restaurant for a fee. The nearest public transit is Copley (Green Line) or Back Bay (Orange Line).
PAYMENT	
POPULAR DRINK	An extensive wine list of over 100 wines mainly concentrating on the Languedoc, Roussillon, Minervois, Pic St. Loup and Provençe regions of Southern France.
UNIQUE DRINK	The small list of featured cocktails has a few thoughtful concoctions, such as the Fleur de Poire or London Calling, which are well received by the late night visitors.
FOOD	Innovative French cuisine is served throughout the day with strong influences from the Southern regions. Even the lighter late night menu maintains many rustic favorites, available until midnight (Sun - Tues) and 1am (Weds - Sat). Sel de la Terre takes pride in their fresh and local ingredients. Everything is made in-house; they even cure their own bacon.
SEATING	The lounge area can comfortably seat people at tables and bars. The extensive space upstairs is filled with tables and partial booths for a full house of diners.
AMBIENCE/CLIENTELE	White brick walls and funky decor like bikes dangling from the tall ceilings, bottles on the walls and alley way lamps give this French bistro a swanky feel. The offbeat approach to sophisticated dining appeals to a hip Bostonian crowd can be found here delighting in a bottle of wine and or a cocktail. The Prudential Center looming above brings in professionals and tourists for a hearty meal.
EXTRA/NOTES	Every Monday night here is now Magical Mondays where "The Oyster Meets the Pig" with $1 Oysters, $1 Charcuterie Plates and $1 Pony Beers.
OTHER ONES	• 255 State St., Boston 02109 (617) 720-1300 • 1245 Worcester St., Natick 01760 (508) 650-1800

—Victoria Young

Solas Irish Pub

Easy going pub in the heart of Back Bay.

$$$

710 Boylston St., Boston 02199

(at Exeter St.)

Phone (617) 933-4803

www.solasboston.com

CATEGORY	Beer Pub
HOURS	Mon-Thurs: 11 am-10 pm
	Fri-Sun: 11 am-11 pm
GETTING THERE	Solas is next door to the Lenox Hotel, a block from Copley Sq., which is serviced by all Green Line trains as well as several buses and express buses. Garage parking is available, but only if you're willing to pay an arm and a leg.
PAYMENT	
POPULAR DRINK	Choose from Solas' impressive wine selection, or share a pitcher of the homemade sangria with friends.
UNIQUE DRINK	Have an Anne Bonney (Bacardi, Tullamore Dew, Peach Schnapps, triple sec, cranberry and OJ) and pretend you're sunning on the beach in Co. Wexford, or if you're in the mood for something a bit less tropical, try the dessert-in-a-glass Lochness Monster-tini (a creative mix of Bailey's, Midori and Butterscotch Schnapps). It looks scary, but tastes amazing.
FOOD	Copy the locals and stop in for lunch and a few pints with your mates. Solas' full menu features hearty, traditional Irish dishes with a modern flair, including several vegetarian options.
SEATING	A beautiful dark wood bar forms a square in the middle of the main room, and ample sized booths and tables fill the remaining space. The best seat in the house is the table nestled in the back corner by the fireplace and separated from the main area by a low, natural stone wall.
AMBIENCE/CLIENTELE	Solas lives up to its name; the easy-going staff and cozy atmosphere make it one of the most comfortable pubs in Boston. From the unique, blown-glass lamps and warm, marbled gold walls to the natural wood beams and jewel-toned rugs, Solas feels more like a plush living room than a traditional Irish pub.
EXTRA/NOTES	If you come here for a meal, save room for dessert! The toffee pudding is to die for.

—Jaime Kerry

Sonsie

Romanticize your evening.

$$$

327 Newbury St., Boston 02115

(at Massachusetts Ave.)

Phone (617) 351-2500

www.sonsieboston.com

CATEGORY	Restaurant Bar
HOURS	Daily: 7 am-1 am
GETTING THERE	Metered, street parking is available, although it can be a nightmare on this busy street, filled with shops and restaurants. The Green Line T stop at Hynes Convention Center is the closest mode of public transportation, located just a block away.
PAYMENT	

POPULAR DRINK For the wine lover who doesn't want to go all the way with a full bottle, this establishment gives the option of buying wine by half a bottle; the wine menu itself is a couple of pages long. There is a fully-stocked bar in the restaurant, giving the option to have a cocktail while waiting for your table.

UNIQUE DRINK Although you can order pretty much anything from the bar, including various types of reds, whites, blushes, and champagne, the bartender makes a tasty Sidecar, poured in a frosty martini glass, topped with sugar.

FOOD The "Starters" menu varies by season. For instance, enjoy a summer menu revolving around Summer Corn. Starters include Chilled Corn and Buttermilk Soup with Sorrel, Radish and Chives and BBQ Braised Duck Wings with Grilled Marshmallow Corn, to name a few. Also individual to Sonsie is its new Wine Room, which located on the lower level and is available to rent out for private parties or samplings.

SEATING The restaurant provides plenty of seating, as it is larger inside than it looks from the outside. Couples love to go to Sonsie for its window seating on warm summer days—the floor-to-ceiling windows open up to a street full of interesting people-watching.

AMBIENCE/CLIENTELE Dimly lit with candles and glowing chandeliers, playing swanky, contemporary music, Sonsie is a great place to take a date and enjoy a quiet meal in modern surroundings. During the day and early evening, folks of all ages settle in for a fine dining experience and later in the evening, young people come by to enjoy the nightlife and take advantage of the late-night menu, served daily until 12:30 am.

—Jessica Holmes

Top of the Hub

Have a drink at the tippity-top of Boston.

$$$

800 Boylston St # 52, Boston 02199
(between Fairfield St. and Gloucester St.)
Phone (617) 536-1775
www.topofthehub.net

CATEGORY Wine Bistro

HOURS Mon-Sat: 11:30 am-1 am
Sun: 11 am-1 am

GETTING THERE For drivers, there is parking in the Prudential Center Garage. Parking is discounted with a $10 purchase from any store, restaurant, cart or kiosk in the Prudential Center. The nearest public transit for the Green Line is the E train to the "Prudential" stop. On the Orange Line, the Back Bay stop is closest, then walk through the Copley Mall until you enter the Prudential Center.

PAYMENT

POPULAR DRINK When dining in, a bottle of wine pairs well with the food and the view. With such an extensive list of bottles, wine is obviously taken quite seriously making it no surprise that it is the overall bestseller. The tall list of single malt scotch, whiskey and cognac is just as noteworthy and ordered more often in the lounge area.

FOOD Top of the Hub maintains a healthy selection of new American cuisine for brunch, lunch, and dinner. All of which have their own three-course prix fixe menu. For dinner, you can kick up the fancy with more courses through the tasting menus available. A lounge menu comprised of less intimidating choices for eats, unless you go for the 1oz American caviar for $125, is perfect to soothe the stomach grumbles while indulging in drink and jazz.

SEATING So as to not waste the gorgeous view of Boston and beyond, tables are amassed along the long windows of two of the building sides. Aside from the stretches of dining areas, the bar and lounge take up a corner of the high-in-the-sky space. Unfortunately, the most disadvantaged seats in the whole restaurant are at the bar. In order to get a view from here, you need to get up and move.

AMBIENCE/CLIENTELE Business people impress their colleagues and clients by day while romantic couples swoon by night. With such a magnificent view of Boston, it's just the natural flow. Every evening, starting at 8pm, live jazz is performed in the lounge for anyone with $24 dollars to spend on drinks or food. It makes for a great place to complete your night.

EXTRA/NOTES Careful what you wear, the more casually dressed diners may be seated in the lounge area.

—Victoria Young

Trident Booksellers & Café

Where the bookworms are.

$$

338 Newbury St., Boston 02115
(between Massachusetts Ave. and Hereford St.)
Phone (617) 267-8688
www.tridentbookscafe.com

CATEGORY Smoothies/Juice Café

HOURS Daily: 8 am–Midnight

GETTING THERE Take the Green Line T to Hynes Convention Center Stop or the #1 Massachusetts Ave. bus to Newbury St. Trident located on the first block of Newbury St. from the corner of Massachusetts Ave.

PAYMENT

POPULAR DRINK The fresh juices and smoothies are very popular. Choose from their list: the Backache, ginger fizz made with ginger root, apple and seltzer, Body Cleanser—cucumber, beet, apple and carrot, Fresh Complexion, pineapple, cucumber, celery and apple or the Mood Enhancer, beet, parsley, spinach, carrot and apple. Or create your own customized juice—my favorite is cucumber, pineapple, ginger and lime. If that's not your thing then there's a myriad of other options on their multi-page beverage list: coffee and espresso drinks, as well as tea, lemonade, hot mulled apple cider, chai, Italian sodas, wine and beer.

UNIQUE DRINK The creamy, cinnamon inflected white hot-chocolate is the perfect antidote for an icy Winter's day.

FOOD The food menu is eclectic, with vegetarian friendly comfort foods such as soups, salads sandwiches, pastas, and mac n' cheese. The Trident fries, made

from sweet potatoes and beets with a salsa dip, are a guilt-free treat!

SEATING There is plenty of seating in the three sections of the café. The first is by the front windows, which is great for people watching; the second is a spacious bar where you'll find customers chatting with the servers and reading books; the third is a slightly quieter section located in the rear. While there's plenty of seating, during peak times you probably won't have much of a choice as to where to sit, you'll just take what the host can give you. Waits are common, but very short, and the best part is you can browse the bookstore until your table is ready.

AMBIENCE/CLIENTELE Trident is unique because it's a bustling café inside of an independent bookstore. Because of its location on busy Newbury Street, you'll find college students, tourists, Back Bay residents and workers. It's great place to go alone or to enjoy with friends.

EXTRA/NOTES One of the best things about Trident is that the staff won't mind if you take books or magazines off the shelves to read while you're enjoying your smoothie.

—Minh Luong

Vox Populi

Back Bay's yuppie magnet. Or at least one of them.

$$$

755 Boylston St., Boston 02116
(between Fairfield St. and Exeter St.)
Phone (617) 424-8300 • Fax (617) 424-1016
www.voxboston.com

CATEGORY Cocktail Bar

HOURS Mon-Sat: 11:30 am-1 am
Sun: 11:30 am-Midnight

GETTING THERE Valet parking is available Thurs-Sat after 6 pm for $14 per car. There is also parking in the Prudential Building Parking Garage is located directly across the street for a fee. Metered street parking is available, which is free after 8 pm and on Sundays. The closest public transit is Copley stop off the Green Line.

PAYMENT

POPULAR DRINK Moët and Chandon champagne is pushed into so many cocktails it has its own section on the menu for 15 dollars a sparkle. These and other fun cocktails are all the rage and whatnot, but they have a tendency to be on the sweet side. The kind of sweet that hurts your teeth, makes you order a hard whiskey on the rocks, but not without a shot of mouthwash beforehand. Dentists can be the worst. Luckily there's wine and beer a plenty, and a full bar for your own mix and match game. So order wisely.

UNIQUE DRINK The Lychee martini, served with Belvedere vodka, lychee juice, simple syrup and cranberry juice is an uncommon flavor to wake up any bored taste buds. Also, the 50 Carat is the first cocktail I've come across to use Vitamin Water as an ingredient. Quite the concoction.

FOOD People tend to show up for the after hours drinking scene. Regardless, there is a full menu all the typical American bistro specialties with meat and seafood as the centerfold.

SEATING There's a bar on both levels with a dining area tucked away upstairs and a patio area. Big booths and plenty of bar area seating somehow do not make up for the hoards of people that pack into the spaces in between. After 10 pm on a weekend night, get ready for the cram. The street-side patio is the most coveted space here. Either come early or come with sharpened claws.

AMBIENCE/CLIENTELE The hip and beautiful people flock here to be a part of all the martini madness at this trendy Boylston bar. It's a hot spot for the 25+ (and then some) to grab drink after drink while chatting up bar neighbors. If the swanky setting doesn't get your mojo flowing, I recommend going for one drink just for the people watching.

—*Alexis Vandeventer*

Whiskey Park

Chic cocktails mixed with a shot of glamour.
$$$
50 Park Plz., Boston 02116
(at Arlington St.)
Phone (617) 426-2000
www.bostonparkplaza.com

CATEGORY Hotel Bar

HOURS Daily: 4 pm-2 am

GETTING THERE Garage/Street. Off Arlington station on the Green Line.

PAYMENT [AMERICAN EXPRESS] [MasterCard] [VISA]

POPULAR DRINK Whiskey Park is famous for its innovative cocktails, such as a Honeytini and a Flirtini, as well as the Strawberry Mojito (a glitzy combination of rum, Grand Marnier, mint, sugar, lime and strawberries). They also serve classic drinks like red bull/vodkas, Rob Roys and Margaritas. Also on the menu are white, red, and sparkling wines, as well as top-notch champagne, scotch, whiskey, and vodka.

UNIQUE DRINK Add a twist to your usual Dirty Martini and order a Rosemary Lemon Martini (Rosemary vodka, cointreau, fresh rosemary, fresh lemon).

SEATING Lounge on the leather couches and chairs scattered around small dark mahogany tables. If you don't look twice, you wouldn't notice the two different rooms in the bar, separated by the main entrance.

AMBIENCE/CLIENTELE Not your usual hotel bar, Whiskey Park is two-fold as a place to have after-work drinks with a date or a friend, or a place to get dressed up and visit on a weekend night. Later on Friday and Saturday night, the music, a fresh combination of hip-hop and R&B, is turned up and there is often a line outside the door.

EXTRA/NOTES This hotel bar does have an upscale vibe, so it's definitely not the place to have a rowdy conversation with friends and watch the game. It is however, a great spot to visit after work, or go out with friends on weekend nights.

—*Jessica Holmes*

FENWAY/KENMORE SQUARE/SYMPHONY

An Tua Nua

After-hours hotspot for a boozy good time.
$$

835 Beacon St., Boston 02215
(between Miner St. and Munson St.)
Phone (617) 262-2121
www.myspace.com/tuanua

CATEGORY	Beer Bar
HOURS	Summer: Mon-Thurs: 11 am-1 am
	Fri/Sat: 11 am-2 am
	Sun: 11 am-1 am
	Winter: Mon-Thurs: 5 pm-1 am
	Fri/Sat: 11 am-2 am
	Sun: 11 am-1 am
GETTING THERE	Though there is street parking and plenty of parking lots, be careful of game days. Fenway can draw a crowd that will make parking impossible and pricey. Public transportation is the safe way to play it. The Green Line stop at Fenway is just a few blocks away.
PAYMENT	
POPULAR DRINK	Especially on college night (Thursday nights) when Miller High Life is just a dollar on draft, beer is pretty much the only thing ordered. Even without the once-a-week deal, beer is a big seller and still on the cheap side. But there is a full bar for those who have more then a few crumpled bills in the pockets.
FOOD	For a good price, you can find a menu of comfort food and daily specials to fill your belly in preparation of drinks to come. Happy hour is a good time for cheap finger foods.
SEATING	The front room has tables and a bar to fit a good-sized crowd. If there is some spilling over, it will probably leak into the back room where there is open floor space for standing and dancing. Here, you'll also find another bar and a row of lounge booths to park yourself while you people watch.
AMBIENCE/CLIENTELE	Sitting within blocks of Fenway stadium, An Tua Nua can expect a mix of rowdy sports fans when a game is on, but mostly they draw in a hefty crowd of students and young professionals that make up the majority of the hopping nightlife. The tangy glow of the main bar area makes this place feel like any other cool Boston spot for drinks and music, but the tucked away open floor allows for more than just dancing. If it isn't salsa and karaoke night or some other awesome theme night, DJs provide the musical flavor to keep the good vibes flowing until close.
EXTRA/NOTES	The bar opens at 11 am on all game days.

—*Lawrence Fong*

Audubon Circle

Fenway's best bar... Game Day or Not.
$$
338 Beacon St., Boston 02215
(at Miner St.)
Phone (617) 421-1910
www.auboncircle.us

CATEGORY	Restaurant Bar
HOURS	Daily: 11:30 am-1 am
GETTING THERE	Green Line to Kenmore or Fenway. Metered parking available on non-game days. Check ahead to see if there's a Red Sox game. Finding a spot on game day is futile and frustrating.
PAYMENT	
POPULAR DRINK	Audobon offers a limited but well selected choice of beer and wine. There is also a full stash of high-end and industry favorite liquor selections that lie hidden behind cabinets.
UNIQUE DRINK	With a handful of great and well crafted cocktails, it's the Passionfruit Caiporoska that makes every day feel like summer. Muddled limes, Ketel One Vodka, sugar and passion fruit juice.
FOOD	Audobon's unique take on comfort food has something for everyone. With reasonably priced appetizers like Cod Cakes, pulled beef Quesadillas and Pot Stickers, the dinner menu takes on high-end entrees such as seared tuna, steak, chicken pomodoro and a gourmet seasoned cheeseburger.
SEATING	With a long slate bar that spans the length of the room, a floating appendage and tables surrounding the room for dinner and a bamboo-lined seasonal back patio, Audobon is spacious, but filled to the brim during game days.
AMBIENCE/CLIENTELE	With stained wood walls and brushed slate table tops, Audobon is minimalist chic and the most stylish option of Fenway-area bars. Packed on game days with a roomy abundance on off days, plan your Audobon excursion according to Red Sox game days.
EXTRA/NOTES	Located just blocks from Fenway Park, this well-designed wood and marble room is the place to be (or the place to avoid) on game days and Marathon Monday. Despite it's chic atmosphere and bamboo perimetered back patio, Audobon is usually a roomy and well priced bar filled with a handful of original house cocktails, as well as a selection of wines and beer to fit any customer.

—Nolan Gawron

The Baseball Tavern

The cheapest way to drink on the Green Monstah.
$$
1270 Boylston St., Boston 02215
(between Park Dr. and Yawkee Way)
Phone (617) 867-6526 • Fax (617) 867-6527
www.thebaseballtavern.com

CATEGORY	Sports Bar
HOURS	Daily: 10 am-2 am
GETTING THERE	There are several parking lots and street parking nearby. The only time it's tricky is when there is a Red Sox game. You can take the T to Fenway (Green D Line) or Kenmore (Green B, C, or D Line), but both will be about a 15 minute walk.
PAYMENT	
POPULAR DRINK	This is a sports bar, so you can't go wrong with beer.
UNIQUE DRINK	The best part of this place is the roof deck. It looks right at Fenway and you can often hear the crowds cheer and boo. If you can't get tickets to the game, this

is the second best spot to sip your beer and enjoy the day.

FOOD The food is normal bar food with a full menu. Their burgers and wings are decent.

SEATING The bar itself is huge. There are three levels plus a roof deck. They have plenty of TV's for watching the game, as well seating and floor space for dancing later on in the night. Given the great roof deck, it fills up pretty quickly during a game day, so it is best to claim your spot early.

AMBIENCE/CLIENTELE The clientele is a casual sports-loving crowd. While it is near Fenway, it is on the opposite side of the Kenmore Bars, so this is a great place to go if you can't get into the Cast 'n Flagon or don't want to deal with crazy crowds.

EXTRA/NOTES The one aspect that makes this a great place to go is the roof top deck. It's painted like the Green Monster and has stadium lighting. You can hear the crowds of Fenway from the roof. The Baseball Tavern used to be a few doors down in a much smaller location. The old Tavern was every bit of a dive, although it held a special place in everyone's heart (in 2004 Red Sox players stormed the bar and gave everyone high-fives). This new location is a huge change, but certainly more fan friendly.

—Brandy Sprague

Beerworks

Give beer a proper stomach burial and drink it in its place of birth.

$$

61 Brookline Ave., Boston 02215

(at Yawkey Way)

Phone (617) 536-2337

www.beerworks.net

CATEGORY Beer Bar

HOURS Daily: 11:30 am-1 am

GETTING THERE As the brewery is so close to Fenway Park, parking can be a disaster. Rest assured there are parking lots, but depending on the game schedule, they can be quite pricey. On public transit, it is just between the Green Line stops Fenway and Back Bay.

PAYMENT

POPULAR DRINK Bunker Hill Blueberry Ale. Made from blueberries and served with blueberries dancing around the bottom of your glass.

UNIQUE DRINK Everything beer. They brew all their own beer and change the tap weekly to keep the taste buds intrigued.

FOOD Fish and Chips pairs up well with beer. But honestly, what doesn't?

SEATING When all the bar, table and booth seating cannot accommodate a huge influx of Red Sox fans, there is plenty of room to stand and grunt and cheer.

AMBIENCE/CLIENTELE Beerworks is proud of their beer and it shows. Enormous windows take up one side of the wall where shiny vessels of the brewing process stand tall. The industrial nature of these glorious tanks must have inspired the decorator to simulate the same atmosphere throughout the entire place. Besides the self-promotional posters and Americana parapherna-

lia, the place lacks color beyond grays and browns. Metal pillars and exposed pipe ceilings accentuate the warehouse essence. I'm sure the heavy duty metal trim helps maintain the teeming masses of Fenway as they spill through the doors on game days. Meanwhile, ticketless sports fans can crowd the televisions and get as drunk and rowdy as they please. They won't be bringing the place down. Not this one.

OTHER ONES 112 Canal St., Boston 02114, (617) 896-2337

—Bridget Halverson

Cask'n Flagon

Get your dose of Red Sox fever.

$$

62 Brookline Ave., Boston 02215
(at Lansdowne St.)
Phone (617) 536-4840
www.casknflagon.com

CATEGORY	Sports Bar
HOURS	Daily: 11:30 am-2 am
GETTING THERE	Cask'n Flagon sits dangerously close to Fenway stadium. Like across-the-street dangerous. Parking is already hard to find in Boston, but if there is a game, this is possibly the worst area in Boston as far as street parking and parking lot prices are concerned. Not to mention the traffic. The nearby public transit includes the Kenmore stop (closest) and the Fenway stop, both on the Green Line.
PAYMENT	ATM DISCOVER AMERICAN EXPRESS MasterCard VISA
POPULAR DRINK	Beers can be found on every table, in pitchers, glasses, and bottles. I've deduced that beer is best when enjoyed within close proximity to Fenway Stadium. That's sound reasoning, right?
FOOD	If you have some pre-game munchies, they have everything from wings to burgers with healthy portions all around.
SEATING	This place was built to handle the stadium-sized rushes they get on game days with tables economically laid out so as to fully take advantage of the large space that makes up the Cask'n Flagon. If you wanted a front seat to the action and the beer, there is bar seating fully around the front bar.
AMBIENCE/CLIENTELE	ESPN rated Cask'n Flagon as "The #2 baseball bar in America." But you don't have to be a sports fan or headed to a game to enjoy yourself here. Tourists sit for lunch with the Green Monster looming over them much as they would sit by the Colosseum in Rome. Locals are just looking for a good spot to watch a game on one of the many televisions in the company of cold beer. College students feed on the night life that is kept booming, game or not. Events go on year round with trivia, bands, and a proper nightclub area but nothing outweighs the boom this place gets when the Red Sox are up to bat.
EXTRA/NOTES	On Opening Day, the Cask'n Flagon opens at 10am.

—Jason Burnsworth

Church of Boston

Service held each night to the glory of food, music and booze.

$$

69 Kilmarnock St., Boston 02215
(between Queensberry St. and Peterborough St.)
Phone (617) 236-7600 • Fax (617) 236-1066
www.churchofboston.com

CATEGORY	Music Club
HOURS	Daily: 5 pm-2 am
GETTING THERE	Free parking is available directly behind the venue in their parking lot on non-home Sox games. The nearest T-stop is the Fenway stop off the Green Line- D.
PAYMENT	
POPULAR DRINK	Even though they shake up a mean cocktails, people are generally content with their beers or preferred mixed drink.
UNIQUE DRINK	Sip away your vices with the seven deadly sins cocktail list. Each of our favorite sins has been cleverly-designed signature cocktail to celebrate our moral shortcomings. I myself am a true glutton, so my drink is a rum based concoction of bananas, thai coconut milk and mint chocolate. You don't have to be pious in order to enjoy the devil's delights.
FOOD	A medley of internationally inspired dishes makes up the menu at the restaurant and the small bites at the bar. From wasabi peas to beef empanadas, shrimp bruschetta to braised lamb shank.
SEATING	This 225-capacity venue has a restaurant area is equipped with plenty of seating while the stage area will fill seats fast and then its up to you whether you want to stand, lean or sit on the ground.
AMBIENCE/CLIENTELE	Live music is featured here most nights of the week with a reasonable cover. The crowd is heavily influenced by the band. From low-key to crazy, Church is a wickedly good way to spend an evening.

—Victoria Young

Cornwall's

Where beer, board games, and darts collide (hopefully not in your face).

$$

654 Beacon St., Boston 02215
(at Commonwealth Ave.)
Phone (617) 262-3749
www.cornwalls.com

CATEGORY	Neighborhood Pub
HOURS	Mon-Fri: Noon-2 am
	Sat: 4 pm-2 am
GETTING THERE	Metered street parking is available on either Beacon St. or Commonwealth Ave. but taking the Green Line to Kenmore is your best bet. Cornwall's is literally steps away from the T stop, next to Barnes and Noble.
PAYMENT	
POPULAR DRINK	Boston's best imitation of a British pub, Cornwall's offers an impressive selection of beers from across the pond. They have everything from reliable standards (Boddington's, Beamish, and Smithwick's) to more obscure picks (Fuller's London Pride and Geary's Hampshire Ale) on tap. With pints priced at a consis-

tent $5.50 and pitchers for $16.50, a trip to Britain was never so economic.

UNIQUE DRINK Though Cornwall's has a full bar, they specialize in beer, especially British beer. Of course, one of the first things that come to mind when thinking of pubs in the UK is Guinness. Cornwall's offers several spins on this classic, among them the Black Velvet (Guinness and Strongbow cider) and the Black and Blue (Guinness and Wachusett Blueberry Ale). It's like a delicious beery dessert.

FOOD Cornwall's food menu is fairly typical, including burgers, salads, and appetizers, but it also features authentic British pub-grub such as fish 'n' chips, bangers 'n' mash, and shepherd's pie.

SEATING Cornwall's is spacious and inviting, with plenty of tables, booths, and even a couple of couches in the back near the dart-boards and board games.

AMBIENCE/CLIENTELE Though located in the heart of Kenmore, Cornwall's usually isn't packed with too many drunken Red Sox fans. Rather, you'll find a mix of hearty locals, an after-work crowd, and the occasional group of BU students. It's a very relaxed group, so it's the perfect spot to unwind after a long week or grab a quality beer and watch the game without fighting a crowd.

EXTRA/NOTES Though not exactly your quintessential romantic spot, Cornwall's works well for a date. It's quiet enough to hear the person you're with, but if conversation falters, there is an impressive selection of board games, two dart boards, multiple pool tables, and several video games to keep it interesting. THEY ARE ONLY OPEN ON SUNDAYS IF THERE IS A HOME RED SOX GAME!

—Jill D Urso

The Dugout

Dive all the way.
$
722 Commonwealth Ave., Boston 02215
(at St. Mary's St.)
Phone (617) 247-8656
thedugoutcafe.com

CATEGORY Dive Bar

HOURS Mon-Sat: Noon-2 am

GETTING THERE Metered street parking and pay lot parking are the options for drivers. The nearest public transit stop is Boston University Central on the Green Line.

PAYMENT $

POPULAR DRINK Beer. But a full bar awaits patiently to assist in getting a quicker buzz.

FOOD Aside from the complimentary popcorn, a fantastic little thirst-inspiring trick found in many of the greatest dives around, The Dugout serves dogs, roll-ups and pizza for cheap.

SEATING Two small rooms that make up the entirety of the bar. The front room holds the bar with booths wrapping around the entirety of the walls. The back room is the game room that has no seating beyond the two couches, unless you want to pull up a stool from the front.

AMBIENCE/CLIENTELE Set nose-to-nose with BU campus, students and professors alike only begin to make up the odd assortment of people that frequent this place. Once a popular game-day watering hole, The Dugout draws just as many sports junkies as it does old-timers. The subterranean locale intrigues passersby just enough to get them through the door, even if they 180 right back out in fear of the dive bar popcorn smell. Even at noon, you can find regulars lining the bar with beer in hand chatting with the owner or silently absorbed in a John Wayne classic. Walk into the back and find yourself in your cool friend's dingy basement turned game room with couches, a pool table, darts, and a TV.

EXTRA/NOTES Private parties are invited to rent out the space for free. Just remember to have everyone bring cash.

—*Victoria Young*

Eastern Standard

Where cocktails are king.

$$$$

528 Commonwealth Ave., Boston 02115

(at Raleigh St.)

Phone (617) 532-9100

www.easternstandardboston.com

CATEGORY Hotel Bar

HOURS Daily: 7 am-1:30 am

GETTING THERE Metered parking is scarce right in Kenmore Sq. If you're feeling flushed, valet your car with the attendants at the attached Hotel Commonwealth. Or just hop on the Green Line to Kenmore.

PAYMENT

POPULAR DRINK The Au Provence, a gussied-up vodka gimlet infused with tarragon. The resulting flavor is cool, spicy and refreshing, without a hint of Rose's lime juice. The Pom 75, a champagne cocktail made with pomegranate juice, is a bubbly, deep purple indulgence.

UNIQUE DRINK The bar at Eastern Standard is one of the few places in Boston to serve a bevy of flips—cocktails mixed with sugar and egg, then shaken until frothy. The Pisco Sour might intimidate with its combination of pisco (a grape-based Peruvian brandy), lemon juice, sugar and egg white, but at Eastern Standard it arrives expertly mixed and looking like a fluffy little parfait. It's cool and light and everything a cocktail should be on a warm evening.

FOOD Eastern Standard serves its regular dinner menu in the bar area until 11 pm, Sun-Thurs, and until Midnight Fri and Sat. After that, it offers a scaled down "adventurous menu" for another hour. The regular menu can be a bit pricey for a stint at the bar, but the appetizers, salads, and sandwiches that comprise the rest of the menu (and the whole of the late night menu) are a better value and come in generous portions, so if you're hungry, fill up with those.

SEATING The marble bar spans the length of the restaurant, with plenty of seats and separate high tables that are available for eating or drinking on a first come, first served basis. There's also a small lounge area and patio space with couches and other easy chairs.

AMBIENCE/CLIENTELE Eastern Standard draws a strange mix of people, but
the diversity of its clientele seems to blend perfectly.
In classic hotel bar fashion, it attracts the well-to-do
guests of the attached Hotel Commonwealth, but it's
not uncommon to find the place packed before and
after Red Sox games with fans (and sometimes play-
ers) looking for something a touch less beer-soaked
than the sports bars surrounding Fenway Park. You
won't see many students from the surrounding col-
leges, unless they've been raised to appreciate classic
cocktails. The crowd is mostly well-heeled but un-
pretentious. Eastern Standard is a big, loud, bustling
place—it gets crowded, but it feels like everyone's
been invited to the same great party. Pretty people
linger over pretty cocktails at the bar or on the patio,
and it's easy to spend a couple of hours there without
realizing it.

EXTRA/NOTES Both the bartenders and the servers are extremely
knowledgeable and friendly. If you're hesitant to try a
certain drink, they're quick to assure you can send it
back if you don't like it. Their eagerness to introduce
people to cocktails new and old is infectious. You'll
find yourself wanting to try drink after drink once the
bartenders explain them and you taste how perfectly
mixed they are. Cocktails are the showstoppers at
Eastern Standard. The wine list is extensive and
varied, but it doesn't dazzle like the drinks do. The
bartenders know and love what they're doing. There
are few other places in the city where you'll find a
better-made highball, julep, sour or sling. (Eastern
Standard serves breakfast, lunch and dinner (part of
being the hotel restaurant).

—Siobhan Ford

Espresso Royale Caffe

A hip place to get caffeinated and get smarter.
$
736 Commonwealth Ave., Boston 02215
(at St. Mary's St.)
Phone (617) 277-8737

CATEGORY Coffee Café
HOURS Mon-Fri: 7 am-10 pm
Sat/Sun: 8 am-9 pm
GETTING THERE There is metered street parking for drivers. The closest
public transit is the Boston University Central stop
PAYMENT [Discover] [American Express] [MasterCard] [VISA]
POPULAR DRINK The coffee is fair-trade and pretty decent, lattes are
well made and ordered often and the selection of teas
gets raided regularly.
UNIQUE DRINK Chai latte is so passe these days. Espresso Royale
shakes up the loose leaf world with tea lattes of as-
sorted varieties.
FOOD Scrumptious baked goods and sandwiches make up
the food menu. Breakfast eats make a proper pairing
with caffeine to get the brain functioning in the morn-
ing.
SEATING Front to back, tables are everywhere and a pair of
couches seclude themselves in the corner. Even when
it's packed, you can generally find a seat. Unless
exams are sneaking up, and then students go into

crunch-time mode and camp out with their laptops and ipods.

AMBIENCE/CLIENTELE Espresso Royale oozes with the hipster charm that we all know (and love?). From the bookshelf filled with fiction on par with the selection from the Goodwill to the tables and lamps each with their own persona (also probably found at a thrift store). The colorful walls are decked out with art right down to the clever signs made by a spunky barista with a set of markers. Beyond the whirring of the espresso machine, the chatter of the orders being taken and the unusually soft music, there isn't much bustling from the many heads in the café. Look around and you'll notice everyone has their heads down in a textbook or is crouched over a Macbook. BU undergrads have taken a firm grip on this place and turned the funky setting into their cram session den. It's just one way to stay hip while keeping those grades up.

OTHER ONES • 286 Newbury St., Boston 02115, (617) 859-9515
• 44 Gainsborough St., Boston 02115, (617) 859-7080

—Suki Chang

Game On

The next best place to watch the game that isn't a seat in Fenway Park.
$$
82 Lansdowne St., Boston 02215
(at Brookline Ave.)
Phone (617) 351-7001
www.gameonboston.com

CATEGORY Sports Bar
HOURS Daily: 11 am-2 am
GETTING THERE Parking is a nightmare. There are expensive pay lots and very rare metered parking. If taking the T, take the Green Line to the Kenmore stop. Take the left tunnel exit and walk straight through to Brookline Ave. .
PAYMENT
POPULAR DRINK There's no real surprise here. Beer is the winner of this department. And Bud Light dominates the category. But off the cocktail list, a Strawberry Lemon Drop is quite the lip-smacking treat.
FOOD Ever want to take charge of your french fries? Ever want to douse them in toppings and dip them in something other than ketchup? Their "Build Your Own Fries" is just the menu item for you! For fifty cents each, add toppings and dips to your favorite way to eat a potato. Brilliant! If you're looking to eat something a bit more substantial, go for the steak tips or the buffalo wings.
SEATING No matter what the size, as a sports bar next to Fenway Park, no size is big enough, but they certainly make a valiant effort. The two levels have just about every type of seating. Bars, tables, high tops, couches, booths, patio...all with plenty of breathing room in between. Even the merchandise counter has stool seating and televisions set up.
AMBIENCE/CLIENTELE Game On puts all other sports bars to shame. Its sleek, modern look, high ceilings, and red undertones make this place sexy. Almost 100 plasma or high-def televisions can be seen from any seat in the house.

The main cluster of screens above the bar hypnotizes any person, fan or not, into watching the action. The crowd is made up of riled up sports fans, and many times Fenway ticket holders before or after a game. It can get mighty crazy, but the high energy keeps the good vibes flowing (so long as the right team wins).

—*Bree Cummings*

Great Bay

A mermaid's paradise with all her sea creature buddies as the entrees.

$$$

500 Commonwealth Ave., Boston 02215

(at Kenmore St.)

Phone (617) 532-5300 • Fax (617) 266-5251

www.gbayrestaurant.com

CATEGORY	Hotel Bistro
HOURS	Mon-Thurs: 4:30 pm-10 pm
	Fri/Sat: 4:30 pm-11 pm
GETTING THERE	There is 24-hour valet available. Great Bay practically sits above the Kenmore station off the Green Line. The entrance is just next door.
PAYMENT	DISCOVER · AMERICAN EXPRESS · MasterCard · VISA
POPULAR DRINK	Although Great Bay has an extensive list of whiskeys and scotches, they pride themselves mostly with their cocktails. Most people by the bar can be found sipping on one of their many delightful libations. For those seated to dine, wine is often the drink of choice.
UNIQUE DRINK	The Remedy is simple but special with Eagle Rare bourbon, lemon, honey and cayenne pepper. Dr. Huxtable's Ugly Sweater has little to do with The Cosby Show, with raspberry vodka, Aperol, sake, lemon and a twist of burnt orange. I'm debating whether the number of colors pitched into the drink or the number of Jell-o flavors referenced is higher.
FOOD	Seafood is the cornerstone to Great Bay's menu with Japanese-inspired plates on the Island Bar menu to Lobster Dumplings for an appetizer or Skatewing for a main course. They always have a selection that was not plucked from the ocean, like a bacon cheeseburger or hanger steak. Alas, their menu is as fickle as the tides and changes daily.
SEATING	The bar can seat a dozen people with a small bar area that can fit a few more. People can feel comfortable ordering drinks or dining here for a more casual setting. The Island Bar is another way to enjoy dining solo. The rest of the area is dedicated to the more elegant dining experience with white-linen tables all around.
AMBIENCE/CLIENTELE	With a vibrant color scheme, surrealistic decor and tall flowing curtains, Great Bay strives to bring about the enchanting ocean essence for an unconventional look. The Hotel Commonwealth pulls in a good deal of tourists and the prime Kenmore location lures in curious people off the street. Plenty of suits bunker down for a couple of mellow cocktails after a grueling 9 to 5.

—*Ashley Rossington*

Lower Depths Tap Room

Where else can you get $1 Fenway Franks?

$$

476 Commonwealth Ave., Boston 02115
(between Charlesgate W. and Kenmore St.)
Phone (617) 266-6662

CATEGORY	Sports Bar
HOURS	Daily: 11:30 am-1 am
GETTING THERE	Because of its location in the busy Kenmore Sq. area, public transportation is best. There are parking lots near by, but if there is a game at Fenway, forgetaboutit. You can take the Green B, C or D line to Kenmore Sq.
PAYMENT	$
POPULAR DRINK	Beer is king. They have a small, yet very interesting beer selection.
UNIQUE DRINK	The bar itself is very small, with a great little patio. Kenmore can be a mob scene, but this bar is close enough to enjoy the action, but far away enough so that you don't have to put up with lines around the corner.
FOOD	The food is actually really good. It's standard bar fare, but well done. And, the best part is that they have delicious hot dogs starting at $1. You can't find that price anywhere NEAR Fenway. The hot dog topping bar is a nice addition.
SEATING	The seating is modest: a small bar (maybe 16), a few high tops and some patio seating.
AMBIENCE/CLIENTELE	This is a very casual bar that is perfect for a pre- or post- game snack, or a casual night out. Someone described it as a "friendly biker (petal, not metal) bar", which is a fair description. Attitudes and silk shirts need not apply.
EXTRA/NOTES	Lower Depths is a perfect niche bar for those who don't want quite the full on fancy of Foundation Lounge, but also wants to avoid the drunk fratsters of the Fenway Bars. It's great for after work, pre- or post-game, or your odd night out with friends.

—*Brandy Sprague*

Lucky Strike

A multiplex playground for adults.

$$

145 Ipswich St., Boston 02215
(at Lansdowne St.)
Phone (617) 437-0300 • Fax (617) 437-1246
www.luckystrikeboston.com

CATEGORY	Theme Club
HOURS	Mon-Sat: 11 am-2 am
	Sun: Noon-2 am
GETTING THERE	Because of its proximity to Fenway there are plenty of parking lots in the area, but beware on game days. Or take the Green Line to Kenmore Sq.
PAYMENT	ATM DISCOVER AMERICAN EXPRESS MasterCard VISA
POPULAR DRINK	Cocktails, mixed drinks and beer are all regularly ordered drinks.
FOOD	Just the regular crowd pleasers of burgers, pizza and sandwiches.
SEATING	Four floors and 70,000 square feet worth of space allow for all the lounge seating, bar seating, table seat-

ing imaginable plus plenty of room between. Private and semi-private function rooms are fully equipped to handle your spatial needs, well into the 1,000 head count.

AMBIENCE/CLIENTELE Within the pile of bricks called Lucky Strike, upscale bowling lanes, pool tables galore, a nightclub, lounges, plasma screen televisions, a Southwestern restaurant, table tennis, arcade games, a roof top patio and plenty more. It's an overwhelming experience of leisure and luxury all within one building. Corporate parties draw in a lot of older professionals while private parties have people going wild for their birthday. When the Red Sox are playing, sports fans come in to take advantage of the plasma screens for their viewing pleasure and Fenway stadium will unleash a mob still looking for a good time. Plenty of them will find their niche here.

—Victoria Young

BOSTON
GO WEST

ALLSTON

The Avenue Bar & Grill

Be a barfly on a budget at the Avenue.

$

1249 Commonwealth Ave., Allston 02134
(at Harvard Ave.)
Phone (617) 782-9508

CATEGORY	College Bar
HOURS	Daily: 11 am-1 am
GETTING THERE	Meter parking on the street, or simply take the Green Line to Harvard Ave.
PAYMENT	
POPULAR DRINK	The staff at the Avenue asserted that their most popular drink is, collectively, all their Budweiser products and Molson Canadian. These beers all go for just a single dollar. From 4 pm-7 pm daily and all day on Sunday, the Avenue boasts a 25-cent buffalo wings special, so if you show up at just the right time, you could conceivably have several beers and a whole plate of wings for under $10. This begs the question: what came first to the Avenue, the students, or the wings?
UNIQUE DRINK	The Avenue has 28 beers on tap, and the taps are arranged in rows on a wall behind the bar for easy viewing. The local favorites are all there: Harpoon, Sam Adams, Red Hook, et cetera. Beer prices top out at $5.50. There's no printed drink menu, and no doubt that most of the Avenue's clientele are drinking dollar draughts most of the time.
SEATING	The bar stretches across the left side of the room, and pub tables along the right side. If you can't find something in front, there are more tables in the back. And don't worry, you can see the game from anywhere you sit.
AMBIENCE/CLIENTELE	The Avenue sits in the heart of Boston's Allston neighborhood, a part of town that is infamous for the vast number of students who live there. Consequently, the clientele and staff there are largely part of the under-30 crowd. Exposed brick, a vinyl bar top, beer advertisements, and sports memorabilia lend the Avenue that relaxed college-hangout vibe, which could and often does result in your stumbling out of there at 1 am after showing up at 5 pm for wings and the Sox pre-game show.
EXTRA/NOTES	The Avenue appeals to students, neighborhood residents, and tourists alike, because everyone loves a bargain. The drink and food specials are seemingly endless. In addition to the wings special, from 11 am-4 pm on weekdays, you can get any sandwich (which would normally go for up to $8.95) and a beer for $7. Surprisingly, the food and beer even taste good: That's something that cannot be said for every student haunt.

—Joe Gallagher

Common Ground

"Take an alcoholic nostalgia-fueled dance down memory lane."

$$

85 Harvard Ave., Allston 02134
(at Brighton Ave.)
Phone (617) 783-2071
www.commongroundallston.com

CATEGORY	Neighborhood Bar
HOURS	Daily: Noon-2 am
GETTING THERE	Easily accessible by public transportation: take the #66 bus or the Green B line (everyone's favorite!) to the Harvard Ave. stop—it's about a five minute walk, at the intersection of Harvard Ave. and Brighton Ave.
PAYMENT	
POPULAR DRINK	Along with nearly 20 beers on tap, ranging from Miller Lite to Arrogant Bastard Ale, Common Ground features delicious and reasonably-priced mixed drinks as well. Drinking a couple of Mangoritas, Lemon Drops (citrus vodka, Galliano and lemons), and Cosmoallstons (Skyy melon vodka, Cointreau, and lime and cranberry juices) will give you just the boost you need to dance the night away.
UNIQUE DRINK	Despite being commonly referred to as "girly drinks," the Shady Lady (Bacardi Limon, Chambord, Midori, and a couple drops of cranberry and pineapple juices) and the J. Lo (raspberry vodka, triple sec, peach and raspberry liqueur, sour mix, and a combo or pineapple, lime, and cranberry juice) pack a bitch slap worthy of any cocktail connoisseur, male or female.
FOOD	Gastronomic offerings are, not surprisingly, pretty common here, not venturing far beyond the bar food palate of burgers, chicken fingers, and potato skins. However, their Irish Pizza is a simple pleasure: mashed potatoes on a pizza, with bacon, and cheese—can it get any better?
SEATING	Seating is ample, though you may have a tough time finding a place to sit when the tables are cleared away to make room for the dance floor. But if you're planning on sitting out from "Baby Got Back" or "Oops, I Did it Again," you should have stayed home, because you're no fun anyway.
AMBIENCE/CLIENTELE	The laid-back atmosphere and cheap prices are a breeding ground for a diverse crowd of hippies, hipsters, and the popped-collar set. There's nothing like nostalgic tunes to bring the crowd together.
EXTRA/NOTES	My So-Called 90s Night on Fridays and Love Night (80s music) on Thursdays are an Allston staple, luring those of us old enough to remember awkward middle-school dances where many of these same songs were played to attempt to replace those painful memories with happier ones. Don't bother. Nothing can replace those memories. However, if you're nice enough, DJ "Phat Mike" might play your favorite song (if he feels like it). Get there early to avoid the $3 cover charge and the line that starts forming around 9 pm.

—*Jill D Urso*

The Kells

The closest thing to a nightclub in Allston.

$$

161 Brighton Ave., Allston 02134
(at Harvard Ave.)
Phone (617) 782-9082
www.thekells.com

CATEGORY	College Bar
HOURS	Daily: 5 pm-2 am
GETTING THERE	Metered on street parking.
PAYMENT	[MasterCard] [VISA]
POPULAR DRINK	One thing that makes The Kells stick out from the rest of the Allston bar crowd is Monday Night Beirut (or Pong, if you prefer). You play with cups full of water, and you drink $5 pitchers. Sign up at 8 pm, and enter to win a $50 gift certificate to … the Kells!
SEATING	The Kells's setup is very open and spacious. It's used to accommodating large crowds of party-ers and lines up the DJs to keep them happy. If the Top 40 hits aren't your thing, there's another room and DJ downstairs.
AMBIENCE/CLIENTELE	The Kells attracts the usual Allston suspects (college kids, young professionals, and the occasional groper on the weekends). Don't be discouraged by the weekend line and cover charge. If it's a night of local dancing you want, this is where to go. Dress to impress 'cause you'll definitely meet someone tonight, whether you want to or not.
EXTRA/NOTES	DJs rock this place six nights a week, spinning mostly dance and Top 40. On Friday nights, ladies get in for free. No cover charge Sun-Thurs.

—*Stephanie Naudin*

The Model Café

Fashionistas and food be damned. We can call ourselves whatever we want.

$$

7 North Beacon St., Allston 02134
(between Brighton St. and Cambridge St.)
Phone (617) 254-9365

CATEGORY	Neighborhood Bar
HOURS	Mon-Sat: 4 pm-2 am
	Sun: 6 pm-2 am
GETTING THERE	Don't even attempt to park here. The Model is right on the 57 bus route and just a couple blocks from the Harvard Ave. T.
PAYMENT	[$]
POPULAR DRINK	You'll see a lot of PBR, the staple of any Allston dive, but this is also the only place in town you can get top-shelf gin for rail prices.
UNIQUE DRINK	Ask Charlie, the 60-something bartender, for a pineapple upside down shot. You won't be sorry.
SEATING	The booths in the back have been swapped for a leather sectional, high tables with leopard upholstery, and a thrift-store glass chandelier that you can bet came from Rick and Bubbles at WOW Vintage down the block. On the weekends after the other neighborhood bars' last call, every drunk in Allston shows up and it's standing room only.

AMBIENCE/CLIENTELE Despite the changes, the Model is still a dive at heart. Stop in and chat with the friendly staff and regulars or relax and have a few pints with friends. On the weekends, after the other neighborhood bars' last call, you'll see fewer skinny-jeaned anorexic types than in the past, but for the most part, this is still a hipster joint.

EXTRA/NOTES The Model suffers from a permanent identity crisis and tends to change its look every six months. The latest remodeling got rid of the extremely popular pool table (because it caused too many fights) as well as the cheap, kitschy decor that we've all come to love over the years. Thank god they kept the arcade games and the jukebox (even if it is one of those obnoxious internet ones). With the addition of four TVs playing constant Celtics games, let's hope the Model's next reinvention doesn't turn it into a full-blown sports bar.

—*Jaime Kerry*

Our House West

Foosball, fries + couches = most laid back sports bar ever.

$

1277 Commonwealth Ave., Allston 02134
(at Spofford Rd.)
Phone (617) 782-3228
www.ourhousewest.com

CATEGORY	College Bar
HOURS	Mon-Fri: 4 pm-2 am
	Sat/Sun: Noon-2 am
GETTING THERE	Take the Green Line (B) to Griggs St./Long Ave.
PAYMENT	ATM MasterCard VISA

POPULAR DRINK Our House features a good selection of beer on tap with cheap mixed drinks.

UNIQUE DRINK The Zephyr sits at the top of their cocktail list, a zesty mix of Absolut Ruby Red, grapefruit and a splash of cranberry juice.

FOOD The pub menu at Our House is extensive, with burgers, fish and chips and other sandwiches. There are a few entrees like stir-fry and soup, as well as a $1 menu on their off nights, featuring hot dogs and quesadillas. The waffle fries command the utmost respect, and you will probably end up ordering several baskets.

SEATING Our House centers around gigantic couches which encourage laid-back lounging. There are many tables around the corner, a sit-down bar and a separate room for games and foosball.

AMBIENCE/CLIENTELE The ambience is low-key, even though the music is loud. It's a place to mingle, not to dance. You will find a large amount of BU students on any given night, and the crowd tilts to the younger side. It's not the best place for a lively group; the couches discourage conversations involving more than two people. Go here with a couple close friends and you will have an interesting night.

EXTRA/NOTES Trivia night on Monday, Family Guy and Simpsons marathon on Tuesday, Foosball tournament on Wednesday.

—*Joe Gallagher*

Silhouette Cocktail Lounge

Allston's Ultra-Inclusive Dive.

$

200 Brighton Ave., Allston 02134
(at Allston St.)
Phone (617) 254-9306

CATEGORY	Dive Bar
HOURS	Mon-Weds: 4 am-1 am
	Thurs: 11 am-1 am
	Fri-Sun: Midnight-1 am
GETTING THERE	A fair amount of street parking, but Allston neighborhoods require a sticker. A five-minute stumble from the Harvard Ave. stop on the B (Green) Line.
PAYMENT	$
POPULAR DRINK	Mammoth $7 pitchers of Pabst Blue Ribbon remind us why life is worth living.
UNIQUE DRINK	Like most dives, the selection is limited to the demands of its cheapskate customers. Fine for domestic draft beer and bottom-shelf highballs, but if you're looking for Belgian witbier or 14-year-old scotch, keep on walking, city boy.
FOOD	Free popcorn! And a bunch of greasy garbage that will likely as not end up on the sidewalk later on. But as free popcorn!
SEATING	Quite a few tables, but the comfy booths are your best bet. Once the dart playing in the back room subsides, the place can hold about 120 of your closest friends.
AMBIENCE/CLIENTELE	Cozy early on, but gets upgraded to crowded right quick. Recreational opportunities abound: pool, Keno, lottery tickets, and a back room devoted to darts. Patrons include Allston old-timers, college students, intolerable hipsters and the homeless, a living smorgasbord of the Allston scene. Untuck your shirt and don't even think about wearing a necktie unless, you know, it's supposed to be ironic or something. Silhouette is cheap, dirty, cramped, and friendly. Expect all the characteristics of a classic dive bar: chipped glasses, sticky surfaces, poorly maintained restrooms, and leering patrons. Expect to drink a lot of cheap beer, meet a lot of weirdoes, and have a lot of fun. A great place to meet the kinds of people your mother warned you about.
EXTRA/NOTES	Great place to watch TV: fans of Lost, American Idol, and weeknight Sox/Celtics action are encouraged to claim a seat. Recently, a Wednesday movie night has been implemented. And, of course, darts are free and flyin'. Kind and smart-tongued souls that bring to mind the cast of Cheers. Don't take no guff, and the 1 am last call is strictly enforced.

—Django Gold

White Horse Tavern

Sweet home Allston where the tunes are blue and the friends true.

$$

116 Brighton Ave., Allston 02134
(between Harvard Ave. and Linden St.)
Phone (617) 254-6633
www.whitehorseallston.com

CATEGORY	College Bar
HOURS	Daily: 11:30 am-2 am

GETTING THERE On-street, metered parking available on Brighton Ave. Free after 6 pm. Two-hour parking lot behind Blanchard's Liquor Store.

PAYMENT

POPULAR DRINK The White Horse Tavern is a local Allston restaurant by day, bar by night. It caters to most local bar-goers' needs: TVs that play three different sports channels, two hefty bars, plenty of tables for a chat and some chow, two pool tables, and a jukebox with a great selection of your favorite old-school southern rock ("Free Bird," please). It's good to know that whether you get a beer on draught or in a bottle it's the same low price; none of that downtown pricey snobbery here.

FOOD Expect the usual bar fare from wings and potato skins to quesadillas and burgers all at very affordable prices.

SEATING This place is great for groups of all sizes. By day, you can scoot a bunch of tables together for a feast, and by night you can crowd around your favorite area, whether it be the baseball game on TV, your pals battling it on the pool table, or people-watching and slash schmoozing by the bar. The music is low enough to meet friends of friends or to catch up with old college roommates. In the summertime, The White Horse Tavern opens its bay windows, and patrons really get the sidewalk patio feel. You can almost smell Spike's hotdogs down the street, spot your friends waiting in line to get in after midnight, and overhear Suzie Q's drunken call to Kelly S about Judy D's outrageous Urban Renewal outfit (cue major Allston joint name-drop).

AMBIENCE/CLIENTELE Located in the heart of the Allston party scene, it attracts local diners and drinkers of all ages. Be careful BC grads, you're on Boston University's turf now. If you're a BU student, grad, or alum, you'll most likely bump into at least a couple of your old classmates at this hot spot. Because the bar opens at 11 am, you can find a regular at the bar closing up a tab at 4 pm or a large group of 9-to-5ers taking a long company lunch.

EXTRA/NOTES No dress code, no cover, and cheap drinks appeal to the college crowd at the White Horse. Get there early because after 11 pm there is usually a line.

—*Stephanie Naudin*

BRIGHTON

Cafenation
Cozy Neighborhood Coffee shop.
$
380 Washington St., Brighton 02135
(at Bromfield St.)
Phone (617) 783-4514
www.cafenation.com

CATEGORY Coffee Café
HOURS Mon-Fri: 7:30 am-9 pm
Sat: 8 am-7 pm
GETTING THERE Free two-hour parking on Washington St.

PAYMENT
POPULAR DRINK Known to have some of the best brewed coffee in the area, which makes sense since they started as a wholesale beans supplier to local restaurants. A wide selection of MEM teas and a perfectly balanced Chai Latte.

UNIQUE DRINK Dessert drinks like the Raspberry White Chocolate Mocha are a sweet pick-me-up whether hot or iced. Also feature seasonal specials like the Maple Spice Latte.

FOOD More than just coffee, this place serves crepes and paninis, including vegan options. They feature art on the wall which changes each month.

SEATING A wooden-top bar runs along the front window with several tables for two or three are scattered around. One high-top communal table in the back can accommodate groups.

AMBIENCE/CLIENTELE It seems everyone here is already a regular, a result of the laidback and welcoming vibe. An eclectic mix of people from local musicians and artists to many Boston College graduate students who take advantage of the free Wi-Fi.

—*Sarah Black*

Devlin's

Grown-Up Irish Pub.
$$
332 Washington St., Brighton 02135
(at Milk St.)
Phone (617) 779-8822 • Fax (617) 779-0028
www.edevlins.com

CATEGORY Beer Pub
HOURS Mon-Fri: 11 am-1 am
Sat/Sun: 9 am-1 am
GETTING THERE Free two-hour parking on street.
PAYMENT
POPULAR DRINK Sticking to its Irish roots, Guinness is always on tap and free-flowing. The wine selection is modest but chosen carefully.

UNIQUE DRINK Black and Tan, a mix of Guiness and Bass Lager.
SEATING Located on the left side of the restaurant is the bar with some tables and high-tops, while on the right side is the restaurant that also has a bar. The outdoor patio is a must in the summer.

AMBIENCE/CLIENTELE During the week an older crowd comes in around dinner time while the weekend sees a lot of young professionals ready to loosen up. A good mix of liveliness and intimacy, if desired.

EXTRA/NOTES Free live music some weekend nights. Call for details.
—*Sarah Black*

Mary Ann's

BC's legendary dive...pop your collar and raise your voice.
$
1937-1939 Beacon St., Brighton 02135
(at Chestnut Hill Ave.)
Phone (617) 555-1212
CATEGORY Dive Bar

HOURS	Mon-Fri: 2 pm-2 am
	Sat/Sun: Noon-2 am
GETTING THERE	Some metered street parking spots, or take the C line to the Cleveland Cir. stop.
PAYMENT	$
POPULAR DRINK	Here you'll find most of the standard mixed drinks and shooters, but you'll notice that 95% of the clientele drinks Busch Light in 12 oz. bottles, one of the cheapest drinks, and given the place's notorious dustiness, probably the safest.
FOOD	No food, no kitchen, one vending machine that never gets used. Best bet is to head across the street for hot Pino's/Presto's pizza. No one minds if you bring a couple of slices in.
SEATING	A mid-sized garage room with tables lining the walls that can fit perhaps forty people sitting and what seems like two hundred standing. Get a seat next to the Hoop Fever machine for optimal legroom and recreation.
AMBIENCE/CLIENTELE	Low lights, low ceilings. The place goes from musty to beer-drenched in about three hours' time. Populated almost exclusively by Boston College undergraduates that don't mind walking in beer puddles and broken glass. It gets very crowded on the weekends, so use those elbows. Bathrooms…well, bathrooms should probably be experienced and not described, but bring your own toiletries.
EXTRA/NOTES	Happy Hour on Friday from 4 pm-8 pm is probably the best thing to happen to BC undergrads since "Hail Flutie." A few hours' worth of dollar Busch Lights is a great way to kickstart the weekend.

—Django Gold

Moogy's

Pancakes, beer, and board games all under one roof.

$$

154 Chestnut Hill Ave., Brighton 02135
(at Embassy Rd.)
Phone (617) 254-8114
www.moogys.com

CATEGORY	Neighborhood Bar
HOURS	Mon-Fri: 11 am-10 pm
	Sat/Sun: 10 am-10 pm
GETTING THERE	Small free parking lot as well as free street parking. The #86 bus is steps away, and the Chestnut Hill stop on the B line is a 5 minute walk away.
PAYMENT	MasterCard VISA
POPULAR DRINK	The most appealing drink on the Moogy's menu is definitely the $1 Busch drafts, an offer difficult to refuse. If you prefer, there's also Bud, Bud Light, Stella Artois and Harpoon IPA on tap or wine to wash down your pancakes or grilled triple-decker peanut butter, fluff, and banana sandwich.
UNIQUE DRINK	One of the most popular options at Moogy's is the all-day breakfast, and in that vein, they offer mimosas with your choice of orange or cranberry juice. What's more amazing than the drinks themselves is the chance to enjoy a $1 beer with your "whatcha-ma-callit"—a banana and cheese omelette.

FOOD Moogy's is famous for their quirky sandwiches. Try the Mother Child Reunion, a chicken cutlet with eggs, bacon, and cheese, or the Full Monty, steak, bacon, provolone and BBQ sauce. If breakfast is your favorite meal, there's no shortage of sandwiches, omelettes, and pancakes to choose from.

SEATING Seating can be tricky here, especially when BC classes are in session. The diner is outfitted with several large wooden booths that can fit sx to eight of your closest friends.

AMBIENCE/CLIENTELE Moogy's is the perfect come-as-you-are spot to stumble into on that weekend afternoon when nothing but greasy food will quell your hangover, or when you're looking to grab a quick bite and a beer with some friends from the neighborhood.

EXTRA/NOTES Ask the friendly folks behind the counter for Scrabble or Connect 4 and settle into a booth for a cheap, low-key good time.

—Jill D Urso

BROOKLINE: BROOKLINE VILLAGE

Chef Chow's House
Tropical cocktails and tasty Chinese eats.
$$
230 Harvard St., Brookline 02446
(at Webster St.)
Phone (617) 739-2469 • Fax (617) 566-1999
www.chefchowshouse.com

CATEGORY Cocktail Bar

HOURS Mon-Thurs: 11:30 am-10 pm
Fri/Sat: 11:30 am-11 pm
Sun: 11:30 am-10 pm

GETTING THERE Either street parking, or take the 66 bus or the C line to Coolidge Corner.

PAYMENT

POPULAR DRINK As with most Chinese restaurants, Tsing Tao tops the beer list, but the real charm of Chef Chow's is in its various cocktails (Mai Tais, of course, and the best Scorpion Bowls in town), all served in a variety of brightly colored goblets and bowls.

UNIQUE DRINK The "Miserable Bastard" (a "potent concoction" of rum, brandy and fruit juice) will leave you anything but.

SEATING Chef Chow's is primarily a restaurant, so seating is at tables only, although there are a number of booths around the walls, including a few by the large windows, if you feel like people-watching.

AMBIENCE/CLIENTELE The middle-aged dinner crowd rules the early evening, and with no music the atmosphere is fairly muted. But later on customers are sparse, and you can largely make the place whatever you want it to be. Take a big group and claim a corner for yourselves. It's like having your own personal bar and waitstaff.

EXTRA/NOTES If the success of Harvard Square's Hong Kong is anything to go by, Chinese food and scorpion bowls become a pretty respectable way to spend a Friday night

in Boston. And while Chef Chow's doesn't have the upstairs dancefloor/meat market of the Hong Kong, their drinks are far superior and their crab rangoons have even been known to contain crab from time to time. (Their veggie tempura is also a great cocktail accompaniment.) They close early (11 pm on the weekend), but there are a handful of other bars within walking distance where you can carry on the night, or, if you really feel like the Hong Kong's meat market, it's still only a twenty-minute bus ride away.

—Andrew Ladd

Dalia's Bistro & Wine Bar

Classy Wine List with Casual service.
$$$
1657 Beacon St., Brookline 02445
(at Washington Sq.)
Phone (617) 730-8040
www.daliasbistro.com

CATEGORY	Wine Bar
HOURS	Mon-Sat: 5:30 pm-10 pm
GETTING THERE	Metered spots on Beacon St.
PAYMENT	
POPULAR DRINK	Both the old and new world Pinot Noirs are long-time favorites. Let the staff help you pick what's good at the moment. Their suggestions are based on regular tasting rather than fancy wine language.
FOOD	The food should not be overlooked here, especially the desserts, which change with the seasons.
SEATING	A mahogany bar with ten stools for those who come for the wine. Several tables feature intimate velvet booths.
AMBIENCE/CLIENTELE	Very much a date spot, though the family-owned business attract residents of all ages. Dalia's is a nice change from the hustle and bustle of other nearby pubs and taverns.
EXTRA/NOTES	Dalia's is open as long as there are people imbibing, so it's very possible they'll be open later than the posted 10 pm.

—Sarah Black

Matt Murphy's Pub

Beer for the belly, music for the ears.
$$
14 Harvard St., Brookline Village 02445
(at Webster Pl.)
Phone (617) 232-0188
www.mattmurphyspub.com

CATEGORY	Neighborhood Pub
HOURS	Daily: 11 am-2 am
GETTING THERE	Very limited street/metered parking. Brookline parking requires a window sticker. Take the D (Green) Line to Brookline Village and walk. Buses 39, 60, 65, 66 all go to Brookline Village as well.
PAYMENT	$
POPULAR DRINK	A variety of house cocktails, but this reviewer is more inclined towards their cast of mostly-Irish draft beers. The Pear Cider is a good one, as is the Old Speckled Hen.

UNIQUE DRINK	A few interesting cocktail ideas. House gimlet is strong and sweet, as is their whisky variation, "The Immigrant." They offer up a pretty decent "Dark and Stormy," which you don't see advertised very often.
SEATING	A fair number of tables against the wall, but no seats at the bar. Fits about forty people at its peak; we're talking close quarters.
AMBIENCE/CLIENTELE	A crowd of mostly young adults, working professionals in the 30-40 range, all nestled in a tiny room that will also fit a performing band come show time. Low lights and a few private seating areas make this a good place to bring a date, especially if he/she likes live music. Starting at 11 pm you can catch a house band just about every night of the year, in a variety of styles (No cover!). Acid jazz, reggae, hip-hop, mostly modern stuff. This place is laid back, friendly and authentically Irish. When was the last time you pulled up to the bar and the bartender automatically set down a glass of water with lime and lemon for you? The last time you went to Matt Murphy's, that's when.
EXTRA/NOTES	The Matt Murphy's people also run a record label, Pub Records. Quite a few talented local bands have risen through their ranks, and all perform at Matt Murphy's on a fairly regular basis. You can also download mp3s from the latest shows at the Matt Murphy's website. And don't miss trivia on Wednesday nights.

—*Django Gold*

O'Leary's

A tamer side of Irish pubs.
$$
1010 Beacon St., Brookline 02446
(between St. Mary's St. and Carlton St.)
Phone (617) 734-0049

CATEGORY	Neighborhood Pub
HOURS	Mon-Sat: 11 am-1 am
	Sun: Noon-1 am
GETTING THERE	There is metered street parking available, but O'Leary's is close enough to Fenway stadium that there may be a battle for spots and a hike in rates. The St. Mary's St. stop on the Green Line is the closest.
PAYMENT	
POPULAR DRINK	The full bar may be tapped into as the night persists, but the locals generally prefer to browse their standard beer selection with some Irish picks.
FOOD	A traditional Irish fare can be found here as well as hearty plates of pasta, meat and seafood and the usual starters of appetizers, soups and salads. It's essentially diner food with some Irish flair.
SEATING	Semi-booths line the walls of the narrow room of the pub. If you can't find a seat at the bar, there is a delineated standing area for those who want to hover.
AMBIENCE/CLIENTELE	Here you'll find a mixed crowd with locals having a quiet meal after work, older regulars at the bar, and occasional students stopping in for a friendly drink. Locals of all ages dig the live music featured Weds-Sun with sounds ranging from bluegrass to jazz to traditional Irish. But even the featured bands can't take away from the inner peace you might find if you sit here for a while.

—*Charlie Knol*

AURAL PLEASURE

The Rock 'n' Roll Scene in Boston

Anyone in the Boston area knows that the best live music takes place over the river in Cambridge at the two venues that occupy the same block of Central Square (Brookline St. and Mass Ave). Day after day, it's **The Middle East** and **TT the Bear's** that offer audiences the best and consistent selection of live music options. With three rooms, the Middle East hosts large national and international acts in its Downstairs room while local and smaller national acts perform in the Upstairs. If you need a break in between sets, the corner room often hosts Middle Eastern DJs and belly dancers. Just a few feet away, TT the Bear's is home to both local and international acts small enough to fill a club, but not large enough to fill an arena. Though there are seasonal downtimes, but chances are, between the Middle East and TT's, you'll probably find something interesting to watch.

Delve further into Somerville and it's **PA's Lounge** that now provides an unsuspecting home to both local and national bands. Separated into two rooms, the main bar occupies one side while the second room houses the bands. Though the venue resembles a function hall or sports bar, PA's Lounge is a sonic setting to be reckoned with.

Across the river in the student suburb of Allston **Great Scott** plays host to a consistent calendar of amazing shows and provides one of the best bets for nightly entertainment. Down the street at **Harper's Ferry**, with multiple bars and plenty of elbow room, is finally filling the void that was created after a decade of billing jam bands. Now showcasing national punk and hip-hop, the spacious club is finally taking advantage of their location and size.

Linking Allston with Boston, the **Paradise Lounge** has historically housed Boston's best shows over the years, and they continue to do so today. The venue's strange layout is wider than it is long, which creates tough navigation and obstructed viewing areas, but the great standing room balcony makes up for all that.

If there's a true legend or an especially popular band in town, look downtown to the **Wilbur**, the **Orpheum**, and the beautifully remodeled **Opera House**. Though these venues only open their doors to the occasional high-volume spectacle, each plays host to the biggest national and international bills. All of the three are theaters with tall ceilings, seat assignments and elevated ticket prices, but each venue is classic and beautiful, providing a special night out. Act fast, as many of these events sell out quickly!

Anyone looking for concert listings won't have to look too hard. With two free weekly entertainment papers in town, just look at any major intersection or at any record store or bar, and you should be able to find a copy of the *Phoenix* or *Weekly Dig*. While the *Weekly Dig* only limits event listings to their favorites, the *Phoenix* provides a more complete and comprehensive listing of all area happenings.

The Middle East
472-480 Massachusetts Ave., Cambridge 02139, (617) 864-EAST,
www.mideastclub.com

TT The Bears
10 Brookline St., Cambridge 02139, (617) 492-BEAR,
www.ttthebears.com

PA's Lounge
345 Somerville Ave., Somerville 02143, (617) 776-1557,
www.paslounge.com

Great Scott
1222 Commonwealth Ave., Allston 02134, (617) 566-9014,
www.greatscottboston.com

Harper's Ferry
158 Brighton Ave., Allston 02134, (617) 254-9743,
www.harpersferryboston.com

Paradise Lounge
967-969 Commonwealth Ave., Boston 02215, (617) 562-8800,
www.thedise.com

Wilbur
246 Tremont St., Boston 02116, (617) 248-9700,
www.thewilburtheatre.com

Orpheum
1 Hamilton Pl., Boston 02108, (617) 482-0650

Opera House
539 Washington St., Boston 02124, (617) 259-3400,
www.bostonoperahouse.com

—Nolan Gawron

Paris Creperie

Any beverage + Nutella = heaven.
$
278 Harvard St., Brookline 02446
(between Beacon St. and Babcock St.)
Phone (617) 232-1770
www.paris-creperie.com

CATEGORY	Smoothies/Juice Bar
HOURS	Mon-Thurs: 10 am-10 pm
	Fri: 10 am-11 pm
	Sat: 8 am-11 pm
GETTING THERE	Metered parking on Beacon St. and in a lot around the corner on Centre St. Green C Line to Coolidge Corner; #66 Bus to Harvard and Beacon St.
PAYMENT	
POPULAR DRINK	Someone had the brilliant idea to add nutella to the hot chocolate, lattes, and smoothies, and it paid off! Offering more than just crepes, Paris's smoothies are delicious, the hot chocolate is divine, and the brewed coffee is among the best cups in town.

UNIQUE DRINK	Mint Nutella Hot Chocolate, Tropical Green Tea, "Citrus Burst" smoothie and, seasonally, "Lemon Crush" (a smoothie mixing lemonade, strawberries, peaches, and pineapple sorbet).
FOOD	Crepes for snacks, breakfast, lunch or even dinner. Go simple, with lemon and sugar, or make it a meal, with the Quirky Albuquerque or the Spanish Omelette.
SEATING	A small, but cozy space has maximized its efficiency with seats and built-in benches. It's usually not difficult to find a seat, but beware of the after-school rush of Brookline school children on weekdays, and strollers on weekends.
AMBIENCE/CLIENTELE	Overall, the Creperie offers a very low-key, casual setting for a coffee or smoothie with a friend over lunch, a place to while away an afternoon, or to have dessert after a movie at the Coolidge Corner theater. A friendly atmosphere with few pretensions.
EXTRA/NOTES	Great for kids, but large groups may feel a bit squished.
OTHER ONES	326 Cambridge St., Boston 02114, (617) 589-0909

—*Kim Liao*

BROOKLINE: WASHINGTON SQUARE

Athan's European Bakery

Go for the baklava; stay for the espresso.

$

1621 Beacon St., Brookline 02445
(at Washington St.)
Phone (617) 734-7028
www.athansbakery.com

CATEGORY	Coffee Café
HOURS	Mon-Thurs: 8 am-11 pm
	Fri/Sat: 8 am-Noon
	Sun: 8 am-11 pm
GETTING THERE	Limited metered street parking; Green C Line T to Washington Sq.; #65 bus to Washington and Beacon Sts.
PAYMENT	DISCOVER AMERICAN EXPRESS MasterCard VISA
POPULAR DRINK	Athan's may in fact own a real, live, genuine Italian espresso machine because it makes some of the most glorious concentrated caffeine product in the greater Boston area. In short, the espresso will make you want to learn Italian.
UNIQUE DRINK	Coffee is the specialty; tea more the afterthought. If you have time, get your beverage to stay, and enjoy the calm atmosphere. To-go cups are so American! What's the rush?
FOOD	All coffee options go well with fresh croissants, baklava, and lunch paninis, with one of the many flavors of gelato.
SEATING	After you order, find a seat at the spacious room of tables with great windows and lovely light. There are a few outlets available for laptops. Solo seating is also available at the espresso bar.
AMBIENCE/CLIENTELE	Full of Brookline families, students, Euro-enthusiasts, and writers or artists coming to work, the scene at

Athan's offers something for everyone. Casual self-service on food and drink (pick up at the counter), but the staff is very friendly and incredibly competent.

OTHER ONES Brighton Center: 407 Washington St., Brighton 02135, (617) 783-0313

—Kim Liao

The Publick House

No shots, no pitchers, no problem! Brookline's own Hofbräuhaus.
$$

1648 Beacon St., Brookline 02445
(at Washington St.)
Phone (617) 277-2880
www.thepublickhousebrookline.com

CATEGORY	Beer Bar
HOURS	Mon-Fri: 5 pm-2 am
	Sat/Sun: 4 pm-2 am
GETTING THERE	A fair amount of street/metered parking, or the Washington Sq. stop on the C (Green) Line.
PAYMENT	
POPULAR DRINK	Beauty is in the eye of the beer-holder and everyone seems to find their own favorites. This reviewer recommends the Hercules Double IPA or the O'Hara's Irish Stout.
UNIQUE DRINK	In addition to a rotating cast of draughts, their Monk's Cell Promotion features 100+ varieties of Belgian beers, brewed and bottled by Trappist Monks throughout Belgium. Oh, and at this point it might be worth noting that though the bar is stocked with liquor, but to request some is a major faux pas. Leave the martinis for breakfast.
FOOD	Lots of savory, heavy dishes: cheese platters, mussels, burgers and fries. This reviewer recommends mac 'n' cheese with broccoli and bacon, followed by a nap.
SEATING	Large dining area that tends to get filled up fast and frequently at peak hours, with two bar rooms and a few tables scattered here and there. Fits about 120 at its most crowded.
AMBIENCE/CLIENTELE	A cozy, yet high-ceilinged structure sectioned into two bar rooms and a larger dining room. Big enough to accommodate a large weeknight crowd, yet the low lighting and "aged" interior design gives it an intimate feel. Mostly a casual affair; clientele tends towards the 30 and over crowd, those who like good beer and have the money to spend on it.
EXTRA/NOTES	Again, high demand dictates an in-and-out dinner policy, so if you really want to savor your meal, best bet is a seat at the bar where nobody will bother you. And you should understand that your standard light "lawnmower" beer has an ABV of around 4%, where most Publick House beers start at 6%, so watch yourself.

—Django Gold

Washington Square Tavern

The ultimate neighborhood gathering spot.
$$
714 Washington St., Brookline 02445

(at Beacon St.)
Phone (617) 232-8989
www.washingtonsquaretavern.com

CATEGORY	Gastro Pub
HOURS	Mon-Sat: 5 pm-2 am
	Sun: 11 am-2 am
GETTING THERE	Metered parking on Beacon St.; Green Line "C" to Washington Sq. stop.
PAYMENT	
POPULAR DRINK	Besides your typical draught IPA you have a lot of options to choose from off the cocktail menu. The Big-Ass Tavern Margarita comes with fresh squeezed lime juice, Ethan's Sidecar is a delicious throwback that you will want to throwback quickly. The wine list is very reasonably priced and food friendly.
UNIQUE DRINK	They claim to have a "real" Dark and Stormy made with Goslings Rum and Ginger Beer from Bermuda. There's nothing wrong with drinking your dessert in the case of Dermot's Chocolate Martini.
FOOD	The seasonal menu varies, but you can always count on Tavern menu basics with a gourmet twist, such as Grilled Stuffed Calamari with Linguica, Fennel and Cassoluet Beans.
SEATING	A small bar is comfortable for eating. Some communal high tops and banquet tables fill up the rest of this small cozy space.
AMBIENCE/CLIENTELE	The Washington Square Tavern is a casual meeting spot that draws the Brookline locals in droves. Leather-bound books adorn the walls, which gives the aura of an old English study. The bustling dining room is always filled with customers enjoying the gastro pub menu and well executed cocktails.
EXTRA/NOTES	Given the small space, tables on a Friday or Saturday night can mean a long wait, so if customers absolutely cannot wait, they can head down Beacon St. to the St. Mary's area for it's sister restaurant, The Beacon Street Tavern, which offers a larger dining area and an outdoor patio.

—Brandy Sprague

BOSTON
GO SOUTH

JAMAICA PLAIN

The Alchemist
I'd take the gold, but I'll settle for booze.
$$

435 S Huntington Ave., Jamaica Plain 02130
(at Centre St.)
Phone (617) 477-5741
www.alchemistlounge.com

CATEGORY	Neighborhood Lounge
HOURS	Daily: 11:30 am-1 am
GETTING THERE	Free parking at the Centre St. and Spring Park Ave. lot, metered street parking, or Stony Brook stop on the Orange Line.
PAYMENT	
POPULAR DRINK	With a solid beer list with some unfamiliar names, draught beer is preferred among regulars. But I must point out, places that dedicate a page of their menu to a full list of every spirit they carry generally do well by their cocktails.
UNIQUE DRINK	Occasionally, vanilla soy milk finds its slippery way into certain cocktails, like the Peach Cobbler, or the Honey Dove. If soy milk gets you hot and bothered, try these little numbers on for size.
FOOD	They sport the five S's. Starters, soups, salads, sandwiches and specialities. Vegetarian items are a plenty - savor your eggplant! A brunch is offered Saturday and Sunday 11 am-3 pm. And let's not forget their late night menu on Thursday, Friday, Saturday until 12 am.
SEATING	The lounge area has high tops, bar seating and booths, well spaced for that much needed breathing room. Another attached room has booths and semi-booths galore for your dining pleasure.
AMBIENCE/CLIENTELE	Locals flock to this neighborhood venue to soothe their mellow nature into a collective puddle of good things. Drinks. Food. Music. People. Take a cue from the locals and pencil in a drink at this place. You just might love it.
EXTRA/NOTES	Along with the music events that happen more nights than not, there is open-mic Mondays and parody Jeopardy trivia Wednesdays.

—*Victoria Young*

Brendan Behan

Your bring-your-own-food, dog-friendly neighborhood pub.
$$

378 Centre St., Jamaica Plain 02130
(at Sheridan St.)
Phone (617) 522-5386
www.brendanbehanpub.com

CATEGORY	Beer Pub
HOURS	Daily: Noon-1 am
GETTING THERE	Metered street parking for drivers. The closest public transit is the Jackson Sq. stop on the Orange Line.
PAYMENT	

POPULAR DRINK	Even with a full bar, it's rare to find someone not drinking beer. Especially with such a solid selection of draft beers.
FOOD	No food served here, but feel free to bring your own. Because you can.
SEATING	Pull up a stool to the bar or find a seat among the string of tables lining the wall. Other than that, there is just a low bench area in the front, which can only be slightly awkward to sit at.
AMBIENCE/CLIENTELE	This dim little Irish watering hole attracts the JP locals in for pint after pint. And why not? Good music, everyone is friendly, you can bring in take-out Chinese food from across the street, even your dog is welcome to chill by your side. As I said, why not?

—*Victoria Young*

City Feed

Eat, drink and shop natural, local and organic. At the same time.
$

672 Centre St., Jamaica Plain 02130
(at Seaverns Ave.)
Phone (617) 524-1700
www.cityfeedandsupply.com

CATEGORY	Neighborhood Café
HOURS	Mon-Fri: 6 am-10 pm
	Sat: 7 am-10 pm
GETTING THERE	JP is a bike friendly neighborhood and is just a few blocks from the Orange Line - Green St. stop. There is also metered street parking available.
PAYMENT	MasterCard VISA
POPULAR DRINK	A latte, pure and simple. The disguised fancy drinks have no place here.
UNIQUE DRINK	Equal exchange, organic coffee. A rare and refreshing, and hopefully up and coming, find. And well received in a conscientious community such as Jamaica Plain.
FOOD	City Feed offers fresh sandwiches made-to-order. I recommend Smoked Turkey (#1). It comes packed with smoked cheddar cheese, marinated red onion, red leaf lettuce, locally made red pepper relish pesto, and mayo on a brioche roll. It's a beautiful thing.
SEATING	Bright red chairs merrily invite you to sit and enjoy your sandwich and coffee beverage of choice at a few wood table tops. Bar seating faces out the tall windows, making it an ideal spot for peeping into the lives of strangers, if only for a sip.
AMBIENCE/CLIENTELE	City Feed began in JP as a snug store operating as coffee shop, deli and neighborhood grocery store and has only recently opened their shiny new store on Centre St. With taller ceilings, more aisle room and seating space, the new City Feed stays true to the mission of the original store, just with more breathing room. The people are not just patrons, they are part of the community that supports the natural and organic products City Feed provides.
OTHER ONES	66A Boylston St., Jamaica Plain 02130, (617) 524-1657

—*Suki Chang*

Doyle's Café

A Scotch-lover's mecca, a home away from home, a Boston institution.
$$

3484 Washington St., Jamaica Plain 02130
(at Williams St.)
Phone (617) 524-2345
www.doyles-cafe.com

CATEGORY	Neighborhood Pub
HOURS	Daily: 9 am-1 am
GETTING THERE	T: Orange Line to Green St.
PAYMENT	
POPULAR DRINK	Dozens of beers on tap, ranging from Lite beers to the occasional Lambic, perfectly built pints of Guinness, wine and mixed drinks, soda, tea, and one of the few bottomless cups of coffee you can find these days, espresso and cappuccino, champagne splits, mimosas, and Bloody Marys available at brunch.
UNIQUE DRINK	Doyle's is known for having a multi-paged Scotch list, which is available upon request.
FOOD	Fish and chips, clam chowder, sublime fruit pancakes bigger than your head, great omelettes, Braddock Hot 'n' Spicy Buffalo Wings, pizza, knockwurst plate with sauerkraut and fries, meatless Reuben (a sauerkraut and Russian dressing sandwich on grilled dark rye), corned beef and cabbage, Irish lamb stew, thin and crispy sweet potato fries.
SEATING	Flat-out huge. A bar with booths and tables in the front section, plus two more rooms, one large enough for functions. The wooden booths are somewhat intimate, with hard seats and backs reminiscent of old Puritan church pews.
AMBIENCE/CLIENTELE	Clean and bustling, yet divey in the most venerable and comforting way. Brunch and weekend nights draw a wait even with the place's seemingly endless capacity. Clientele ages range from infancy to second childhood. Some of the waitresses have been here most of their adult lives. The posters and clippings papering the wall display JFK, infamous Boston mayor Michael Curley, beer signs, and wartime warnings of the "Loose Lips Sink Ships" variety. Depending on the time, you can see families, hangovers in progress, hangover brunches, and deep, involved State of the Union relationship discussions.
EXTRA/NOTES	Doyle's is the only bar to stay open throughout Prohibition and survive to this day. It's well worth getting there and digging in for an hour or three. Look for glimpses of Michael Dukakis or that former teacher. It's well known that simply everyone goes to Doyle's at some point, from famous Boston politicos to local college students. As an added bonus, the nearby Sam Adams Brewery runs shuttle buses on Saturday afternoons from Doyle's for tours. Really, it doesn't get much better than that.

—*Lawrence Fong*

GET YOUR GROWLERS AND GO!

A Guide to Massachusett's Local Breweries

Boston is definitely a beer town more than a bean town, and there are many wonderful local producers of micro and craft beers who are waiting to fill your growlers.

In beer-speak, a growler is a half-gallon glass jug that was devised to transport beer straight from the brewer's tap to your home and eventually into your mouth. Many of these Massachusetts area breweries sell and refill growlers so that beer aficionados can take home some of the fresh product that they're sampling. So what are you waiting for?

Harpoon Brewery, is a true Boston brewery and the makers of the popular Harpoon IP and UFO Hefeweisen. They welcome visitors for free beer tastings Tues-Thurs at 4 pm, Fridays at 2 pm and 4 pm, and Sundays at Noon to 3 pm, every hour. Saturday tasting: 11:30 am - 4:30 pm, every half hour. Weekend tastings = $5.

Cape Ann Brewing Co. is a family owned microbrewery located on the North Shore. They are dedicated to "brewing beer whose bold flavor and character reflects the spirit and courage of the sailors of the North Atlantic fishing fleet." No organized tastings.

Established in 1995, **Paper City Brewery** produces around 20 different brews including the English style Holyoke Dam Ale, Cabot Street Summer Wheat, and Riley's Stout, just to name a few. They also produce their Diamond Cutter Energy Drink, and Rollies, a line of classic soft drinks from rootbeer, to honey lime, traditional and orange cream sodas . Tours of the brewing process are available Mon-Fri from 9 am-5 pm, or by appointment.

Cape Cod Beer produces the Cape Cod Red, a North American style Amber, and their namesake IPA, along with seasonal and specialty batch offerings. Growlers of their beers are available in stores all over the Cape, but it's more fun to get your own right from the source. Retail Hours: Mon-Fri: Noon-6 pm, Sat: 11 am-2 pm. Brewery Tours: Tues at 11 am and Sat at 1 pm.

Pioneer Brewing prides itself on "being small and staying small." They produce up to six regular and seasonal beers including their signature Pioneer Ale, Pioneer Bourbon Barrel Double Bock, a rich, complex German Style double bock, and the Pioneer Bavarian Wheat Beer. Head over to their Stein Hall to sample some beers and to sample some local drafts and to mingle with their in-house brewers.

Established in 1994, **Wachusett Brewing Co.** produces ten quality craft beers including their Nut Brown Ale, Blueberry Ale, and the seasonal Summer, Octoberfest, and Winter Ales. Red Sox fans will appreciate their Green Monsta Ale. Complimentary brewery tours take place from Weds-Fri, Noon-4 pm (condensed tour) and on Sat, Noon-4 pm (full tour). Although they are not currently filling growlers, the tours do include free samples.

Just an hour and a half drive from Boston, **Buzzards Bay Brewing** Co. is located in the idyllic seaside town of Westport. Owned and operated by the Russell Family, who also run the Westport River Vineyard (www.westportrivers.com), Buzzards Bay is committed to minimizing their carbon footprint in the production of their award winning beers such as their signature Buzzards Bay Lager, Pilsner, and Black Lager. Tastings are available on Saturdays from 1 pm-4 pm from January-April. Tours are by appointment. Be sure to call or check their website for hours for May-December.

Harpoon Brewery
306 Northern Ave., Boston 02210, (617) 574-955,
www.harpoonbrewery.com

Cape Ann Brewing Co.
27 Commercial St., Gloucester 01930, (978) 281-4782,
www.capeannbrewing.com

Paper City Brewery
108 Cabot St., Holyoke 01040, (413) 535-1588,
www.papercity.com

Cape Cod Beer
1336 Phinney's Ln., Hyannis 02601, (508)790-4200,
www.capecodbeer.com

Pioneer Brewing
199 Arnold Rd., Fiskdale 01518, (508) 347-7500,
www.pioneerbrewingcompany.com

Wachusett Brewing Co.
175 State Rd. E, Westminster 01473, (978) 874-9965,
www.wachusettbrew.com

Buzzards Bay Brewing Co.
98 Horseneck Rd., Westport 02790, (508) 636-2288,
www.buzzardsbrew.com

—Minh T. Luong

The Drinking Fountain
Heaven...I'm in blue collar heaven.
$
3520 Washington St., Jamaica Plain 02130
(between McBride St. and Rossmore Rd.)
Phone (617) 522-3424

CATEGORY	Dive Bar
HOURS	Mon-Sat: 10 am-Midnight
	Sun: Noon-Midnight
GETTING THERE	Free Parking Lot, Street Parking.
PAYMENT	$
POPULAR DRINK	New to the Fountain: Smirnoff Raw Tea, Don Julio Tequila, and PBR on tap. Draft PRB is priced right at $2.25. All well drinks are cheap and stiff.
FOOD	No food. Chips and nuts only.
SEATING	Bar, plus two long narrow tables down the length of the bar. Stools in the back behind the pool tables.

AMBIENCE/CLIENTELE This family owned and operated bar is blue collar heaven. Its a no-frills dive bar with dusty bric-a-brac on the wall: vintage milk cans, coca-cola bottles, and an extensive collection of early pump up blow torches. You can also find a Keno/Scratch-It/machine, two pool tables at $1 a game (pool tournaments Sunday/night), two TVs broadcasting ESPN, an internet jukebox and t-shirts for sale. There is also an old-fashioned telephone booth and radio, but folks don't come here to reminisce. They come for the Keno.

EXTRA/NOTES Rumored to be a speakeasy during prohibition, the bar supposedly closed down for two days and reopened to business like never before.

—*Colleen Devine*

J.J. Foley's Café

Not quite your local dive bar.
$$
117 East Berkeley St., Boston 02118
(at Washington St.)
Phone (617) 728-9101
www.jjfoleyscafe.com

CATEGORY Dive Bar

HOURS Tues-Sat: 9 am-2 am
Sun: 10 am-2 am

GETTING THERE Street parking along Washington St. The Silver line bus stop, at East Berkeley is just a block away.

PAYMENT

POPULAR DRINK Foley's has your basic mix of red/white wines, draft/bottled beers, and shelf/premium alcohol glittering behind the mahogany bars. The bartenders, donning white shirts and ties, can mix up pretty much anything your thirst desires.

SEATING The bar/restaurant is split into two rooms, with the bar dividing the two. Sit at the bar and catch up on the game on the flat screen suspended from the ceiling, grab a booth with a couple of friends after work, or perch upon one of the tall tables scattered about the bar.

AMBIENCE/CLIENTELE Set off on a quiet side street in the historic South End, J.J. Foleys is a hidden gem with a neighborhood feel. The diverse, all-ages crowd is both laidback and casual, enjoying a drink and conversation. A game room is located at the back of the bar, consisting of darts, a jukebox, and two arcade games. Foleys has a casual vibe with no specific dress code, with the exception of the usual "suit" grabbing a beer after work.

EXTRA/NOTES Tuesday nights at 8 pm, Foley's hosts "Trivia Tuesdays," a refreshing way to break up the work week. On weeknights, the bar is a great place to catch up with friends, with its well-lit, comfortable atmosphere. On weekend nights, expect a larger crowd.

—*Jessica Holmes*

J. J. Foley's Fireside Tavern

Old man bar for all ages.

$

30 Hyde Park Ave., Jamaica Plain 02130
(at Weld Hill St.)
Phone (617) 338-7713

CATEGORY	Dive Bar
HOURS	Mon: 10 am-2 am
	Tues: 10 pm-2 am
	Weds-Sat: 10 am-2 am
GETTING THERE	Across the street from the Forest Hills T stop (Orange Line).
PAYMENT	$
POPULAR DRINK	It's getting more and more rare to find a bar that serves draft beer under $3, but here you've even got options: Bud Light and PBR for $2. If your beer palate is more refined, stop by after you've filled up with good beer at another bar.
UNIQUE DRINK	The Fireside is perhaps more unique for what it doesn't offer. For example, you won't find wine here, but if you're looking for wine, this isn't the place for you.
FOOD	No food, although nobody will get mad at you if you bring pizza from the joint down the street.
SEATING	Plenty of tables and an enormous U-shaped bar. Considering the vast unused floor space, you'd think even more tables would fit inside here, but you won't have trouble finding a seat unless you come on Saturday night with the masses.
AMBIENCE/CLIENTELE	The Fireside evokes a curious combination of 1950s-era diner, with its fluorescent lighting and tiled floor, and American Legion lodge, with its dark wood wall paneling and decorative fireplace. Its smell reminds one either of a musty library or a cheap motel. The Irish flag speaks to the ancestry of the bar's founding family. If you take a seat at the bar, Dave the bartender just might tell you a story (and he's got plenty). Most of the people around you will be old men or twenty- and thirty-somethings are old men at heart.
EXTRA/NOTES	After all the other area bars close, the Fireside provides one last hour of entertainment for those who have not yet made enough of a spectacle of themselves. On Saturday nights, the too-cool crowd that favor swankier places deign to mingle with the regulars. Though often dismissed as a downer unless you're already drunk, it's only depressing if you expect confetti and parades when you go out drinking. Oh yes, and there are dartboards.

—*Anonymous*

Junebug Café

Chill, Connect, and Drink Bubble Tea.

$

403A Centre St., Jamaica Plain 02130
(at Adams St.)
Phone (617) 522-2393
www.junebugcafe.com

CATEGORY	Coffee Café
HOURS	Mon-Fri: 8 am-11 pm
	Sat/Sun: 9 am-11 pm

GETTING THERE Street parking available. Parking is easy at the Hi-Lo!
Take 39 Bus to Perkins or Orange Line to Stonybrook.
Alternatively, take Green Line to Heath St.

PAYMENT

POPULAR DRINK Taro Frozen Shake Bubble Tea (made with milk). Passion Fruit Bubble Tea (made with tea).

UNIQUE DRINK Vietnamese Coffee. Thai Tea.

FOOD Junebug serves breakfast, sandwiches, and desserts.
Highlights are The Gabriell (fake bacon with avocado)
and the signature Junebug (chicken salad with apple
and sprouts). The Tiramisu takes the cake.

SEATING Couches and chairs in Lounge. Regular tables and
chairs are located in main area.

AMBIENCE/CLIENTELE A chill, bohemian crowd that comes to chat quietly
or spend face time with their laptops. Music played
by staff at low volume includes reggae, jazz, and
Brit pop. Staff is friendly and helpful, but hands-off.
Students, artists, and young professionals converge in
bright, funky, cozy atmosphere.

EXTRA/NOTES Free Wi-Fi and the staff doesn't mind if you linger.
Junebug features an artist each month, usually local.

—*Colleen Devine*

The Midway

JP local gay hangout.
$$
3496 Washington St., Jamaica Plain 02130
(at Williams St.)
Phone (617) 524-9038
www.midwaycafe.com

CATEGORY Gay Bar

HOURS Daily: 4 pm-2 am

GETTING THERE There is adequate street parking available. Or take the
Orange Line to the Green St. stop. You can also walk
from Forrest Hills stop (10 min.), or take the 42 bus.

PAYMENT **VISA**

POPULAR DRINK The Midway is not a cocktail lounge. They have a
reasonable selection of microbrews on tap, offered by
the pitcher.

SEATING The Midway is fairly small, and has only a bar and a
few tables in its one main room.

AMBIENCE/CLIENTELE The Midway is a local gay/lesbian hangout, and also
has a good music scene, it's a neat little place to go
and catch a show. Wednesday night was voted best
Lesbian night in Boston.

EXTRA/NOTES Although the website boasts reviews that are at least a
decade old, the Midway is still a cool place.

—*Andrew Wiley*

Zon's

A well-rounded class act for any occasion.
$$
2 Perkins St., Jamaica Plain 02130
(between Centre St. and Huntington Ave.)
Phone (617) 524-9667
www.zonsjp.com

CATEGORY Wine Bistro

HOURS Tues-Sat: 5:30 pm-10 pm

	Sun: 5:30 pm-9:30 pm
GETTING THERE	There is metered street parking for drivers. The closest public transit is the Jackson Sq. on the Orange line.
PAYMENT	
POPULAR DRINK	Wine is the preferred libation among diners, which most patrons are. There are wine suggestions with each of the chef's selections. Their menu can guide you to a well-suited choice, as can their friendly staff.
UNIQUE DRINK	An interesting collection of beers may steer your night.
FOOD	Zon's compiles a well-rounded menu of starters, comfort food and specialties. It's good eats for any occasion. And if you're feeling a little extravagant, I suggest the three-course meal with wine pairings, which allows you to choose three smaller plates of anything available on the menu. It's a win-win-win situation.
SEATING	The small bar area offers a few seats for those looking to enjoy a glass of wine. There is a moderately sized dining area for those with food on the brain. Though if you find the bar area suits your fancy, you can order from there too.
AMBIENCE/CLIENTELE	Locals choose this neighborhood restaurant place to host any occasion that goes well paired with a glass of wine. The dim lighting and moody color scheme make for a comfortable setting for light conversation and love of food and drink. It maintains the simple luxuries of a fancy restaurant without the snobbery. A tough balance, but they pull it off with ease.

—Victoria Young

ROXBURY/MATTAPAN/DORCHESTER

Curtin's Roadside Tavern

Back from the dead and back to boozing.

$

1592 Tremont St., Roxbury 02120
(between Wigglesworth St. and Worthington St.)
Phone (617) 739-9826

CATEGORY	Dive Tavern
HOURS	Daily: 3 pm-1 am
GETTING THERE	There is metered street parking around the Mission Hill area. The nearest public transit is the Brigham Circle Station of the Green Line - E.
PAYMENT	$
POPULAR DRINK	Beer and liquor are both contenders. On one hand, beer is a quintessential aspect of dive bars. On the other hand, the handles of liquor they have behind the bar must give them an awful heavy pour. Tough call.
FOOD	Oftentimes the bartenders cook up a pizza that is sold for a dollar a slice. A fine deal, but the only one they've got.
SEATING	Stools all around for the bar, the counter lining the wall and the few table tops.
AMBIENCE/CLIENTELE	Stashed away in this neighborhood dive you can find all kinds of vintage pieces still in use like the old-school jukebox, the single-body phone booth, the

chiming cash register and beer mounts filling up the empty spaces. A dartboard and a pool table keep the gruffy older locals entertained when they're not sitting at the bar talking or watching TV.

—*Deepak O'Reilly*

Flann O'Brien's Pub

A good place to drink, heavily.

$$

1619 Tremont St., Roxbury 02120
(at Wigglesworth St.)
Phone (617) 566-7744
www.flanns.com

CATEGORY	Neighborhood Pub
HOURS	Daily: 10 am-1 am
GETTING THERE	No parking so take the E branch of the Green Line to Brigham Cir. By bus take the 39 from Forest Hills, or the 66 from Cambridge/Allston.
PAYMENT	
POPULAR DRINK	Get a Beer. Flann's has twenty something beers on tap for the twenty-somethings that inhabit the establishment. Get a pitcher of Molson for $8, or splurge and get a pitcher of a nice IPA or seasonal wheat brew for $12 and change.
UNIQUE DRINK	The mixed drinks are big, and a good value.
FOOD	Flann's has $5 food specials every day, and 2 for 1 happy hour appetizers, good tasting cheap pub food.
SEATING	Flann's has limited seating, and limited standing room too. The place usually fills up by 10:30 pm so if you want a table go early and camp out.
AMBIENCE/CLIENTELE	Flann's is usually loud, and often filled with a younger college crowd, but that doesn't make it a bad place to go and drink if you have your mind set on becoming intoxicated. The noise does make it difficult to understand the actual Irish folk in the bar who often strike up friendly conversation. If the bar becomes overcrowded with "bro-dudes" stumble across the street to The Mission.
EXTRA/NOTES	Flann's has a pool table in the back room, Trivia on Tuesdays, a live band on Thursdays, and Karaoke on Saturdays.

—*Andrew Wiley*

Geoffrey's

Where Everybody Knows Your Name, Rozzie-Style.

$$$

4257 Washington St., Roslindale 02131
(at Corinth St.)
Phone (617) 325-1000
www.geoffreyscafebar.com

CATEGORY	Cocktail Bar
HOURS	Mon-Fri: 4 pm-1 am
	Sat/Sun: 10 am-1 am
GETTING THERE	Street parking is generally available and, after 5 pm, you can park in the bank parking lot next to the bar.
PAYMENT	
POPULAR DRINK	There is a long list of house martinis, ranging from fruity ones to ones appropriate for an after dinner

drink. The bar also has a nice wine list that can be ordered by the glass.

UNIQUE DRINK Geoffrey's offers a full menu of champagne cocktails.

FOOD A full restaurant menu can be ordered at the bar. The appetizers at Geoffrey's, including the mozzarella sticks and the shrimp cakes, are particularly good. If you have the room, have a slice of the devil's food cake, which is better than your mom's.

SEATING There are ample barstools around the long-ish bar. However, since the bar backs right into the restaurant seating, standing room is virtually non-existent.

AMBIENCE/CLIENTELE Geoffrey's is the ultimate Roslindale neighborhood bar. On any given night, the affable bartender will greet at least half of the patrons that come through the door by name. The crowd is very diverse, reflecting the true character of Roslindale. It ranges from working class guys stopping in on the way home from work to well-dressed gay couples, all co-mingling happily together over cocktails and beers.

EXTRA/NOTES Geoffrey's has been around in Boston for a long time, in prior locations in the South End and the Back Bay. It is much beloved by many Bostonians for good reason. It's a great, comfortable neighborhood bar, where you can arrive alone, with a casual date, or even your kids, and all will be welcome. The staff at Geoffrey's is terrific.

—Courtney Scott-Howard

The Mission

Upscale College Gastro Bar.
$$
724 Huntington Ave., Boston 02120
(at Calumet St.)
Phone (617) 566-1244
www.themissionbar.com

CATEGORY College Bar

HOURS Mon-Fri: 11 am-2 am
Sat/Sun: 10 am-2 am

GETTING THERE Brigham Cir. has few metered spots. Take the E Branch of the Green Line to Brigham Cir., The 66 Bus From Allston/Cambridge, or the 39 Bus from Forest Hills/Copley.

PAYMENT

POPULAR DRINK The Mission features over 20 beers on tap, several of which are rotating, 112 bottled beers, including a great selection of Belgians. A great place for the college student who knows how to spend their parents' money in good taste!

UNIQUE DRINK Bartender Sarah makes one of the best Gimlets in town with Hendricks Gin, fresh lime juice, muddled cucumbers, mint and a dash of simple syrup.

FOOD Typical bar food such as wings and nachos are available, but so are a range of delectable culinary delights, like mussels sautéed in Pernod and white wine, served in a fennel and leak broth. Also good are the Risotto Balls and the Calamari tossed with sun-dried tomatoes. The Mission's salad's are also fantastic. Try the endive, or mandarin/spinach with grilled chicken.

SEATING The Mission has bar seating for around 20 with booth and table seating for around 30. Late night is standing room only!

AMBIENCE/CLIENTELE The Mission is frequented by med students, area workers, grad students, and locals, and provides them with drinks in a classy, yet unpretentious atmosphere. It has beautiful dark wood complimented by attractive accent lighting. Be careful after 1 am, when the bar fills up with local college kids taking up space ordering "six bud lights, dude".

EXTRA/NOTES The Mission has recently started doing brunch (10 am-4 pm), and live jazz nights. See the calendar on the website for details.

—Andrew Wiley

Penguin Pizza

Pizza and beer nights taken to a new level.
$$
735 Huntingon Ave., Boston 02115
(between Francis St. and Fenwood Rd.)
Phone (617) 277-9200 • Fax (617) 277-9204
www.thepenguinpizza.com

CATEGORY Beer House

HOURS Daily: 11 am-1 am

GETTING THERE There is metered street parking in the area for drivers. For those on foot, the Fenwoood St. and Brigham Cir. stations (Green Line - E) are both within a block away.

PAYMENT

POPULAR DRINK With a beer menu stretching into the high 200's, Penguin Pizza has the one of the largest beer selections in Boston. The fridge up front, which only displays a fraction of what is available, gives you a modest visual to your seemingly boundless options. Penguin Pizza is a place to take bold strides outside of your beer comfort zone and explore new tastes, both bad and good. Like most other mega multi-beer havens, there is a prize at the end of the 200+ road if you try them all within a year. To this I say good effing luck.

UNIQUE DRINK The beer menu is full of brews you've never tried or even heard of (unless you've already obtained your specialty mug). Then I say congrats, but there's nothing new for you here after that. Not even hard liquor.

FOOD A selection of specialty pies, both classic and adventurous, is the main feature of the Penu (yeah, they went there). To give you a taste, the Ultimate Penguin, their signature pizza, has bacon, ham, meatball, braised duck leg, sausage, roasted potatoes, hot cherry peppers, cabbage and caramelized onions. That would rank on the more adventurous side of the pies. If you're not in the mood for pizza, you can also find a standard set of pasta dishes, paninis, salads, appetizers and wraps. Food is served in house until 1 am daily.

SEATING Tables are scrunched into every corner and open space possible and the bar only seats a dozen, at best. On the weekends especially, there can be a long standing wait to jump on the next open table.

AMBIENCE/CLIENTELE Surrounded by colleges galore, Penguin Pizza is raided by students looking for that classic combination of pizza and beer. Rowdy packs of friends flock here before and after hitting up the local bars so it remains a noisy, crowded good time throughout the night.

—Victoria Young

Punter's Pub

It's what you make of it that counts.

$

450 Huntington Ave., Boston 02108
(between Parker St. and Ruggles St.)
Phone (617) 472-2330

CATEGORY	College Pub
HOURS	Daily: 11 am-2 am
GETTING THERE	A few metered street spots in the area. The closest public transit is the Museum of Fine Arts (MFA) stop on the Green Line (E).
PAYMENT	$ ATM
POPULAR DRINK	A full bar doesn't dissuade the majority from ordering round after round of cheap beer, bottles and pitchers alike.
FOOD	Place a take-out order through the small mysterious window and pizza you shall receive. Or anything else you can normally order from University House of Pizza. Because that's what lurks behind the walls.
SEATING	Even with the saggy booths around the main bar area as well as long benches around the game area, you'll find most people crowded around the bar.
AMBIENCE/CLIENTELE	Widely recognized as a college bar, this dark cavernous pub has everything students might dream of: a pool table, a dart board, arcade games, televisions, a jukebox, even a magical pizza window. Considering all the low-cost indulgences, there is a significant shortage of students. A just-finished-my-paper undergrad is just as likely to be found here as a gruffy old sports fan. The mixed clientele and the gritty dive feel can scare people back onto the streets, but Punter's has much potential for a good time.

—*Bridget Halverson*

The Savant Project

Innovative drinkables and edibles born from an artsy chic scene.

$$

1625 Tremont St., Boston 02120
(between Huntington Ave. and Wigglesworth St.)
Phone (617) 566-5958 • Fax (866) 884-6469
www.thesavantproject.com

CATEGORY	Cocktail Bistro
HOURS	Mon-Weds: 11:30 am-Midnight Thurs-Sat: 11:30 am-1 am Sun: 11 am-1 am
GETTING THERE	It's not hard to find a parking spot. Brigham Cir. is a Green Line (E) stop that is within a block.
PAYMENT	
POPULAR DRINK	The Savant Project revamped classic cocktails and popular beverages with their own kooky twist to create a list of specialty concoctions with clever names and descriptions that will even entice the most austere folk into a drunken stupor.
UNIQUE DRINK	The Mangria is a "masculine" version sangria made with Sauvignon Blanc and jalapeños. Absinthe makes its way into the Mad Hatter, and Crazy Pills will do just the trick with absinthe, vanilla and orange. A citrus-wasabi Bloody Mary (with optional Bacon vodka) is featured for brunch. These are just a small taste of the wonderful cocktail medleys created here.

FOOD Inspired by Asian and Latin cuisine inspire balanced flavor combinations in the small crafted plates of upscale food art from Tempura Veggies served with a tasty mustard peanut sauce to the adventurous Quesadilla Trio (chicken and mushrooms, steak and caramelized onions, shrimp and mango) to Pine Nut Crusted, Five Spice Pork Tenderloin served with ginger, bacon scalloped sweet potatoes and maple vinaigrette greens. Tapas are half-price everyday from 2:30 pm to 6 pm with a drink order. As if you would dare to resist the calling of cocktail candy.

SEATING The Savant Project keeps a small venue with a modestly-sized bar and 15, give or take, tables scattered about the restaurant. In the warmer months, the small patio opens up with a few extra tables.

AMBIENCE/CLIENTELE A heavy urban chic look gives The Savant Project a classy casual vibe. The soft glow of intimacy holds no restraints on the energy pervading through the pressed tin room. The small roar of ingenuity found in the food, drinks, art and music collectively scream for attention from the hip mid-20s(plus) that attend this trendy locale nightly.

—*Victoria Young*

Sophia's Grotto
Dreaming of a trip to Italy? Come to Roslindale.
$$$
22R Birch St., Roslindale 02131
(at Cornith St.)
Phone (617) 323-4595 • Fax (617) 323-4598
www.sophiasgrotto.com

CATEGORY Beer Bistro

HOURS Mon-Thurs: 5 pm-9:30 pm
Fri: 5 pm-10:30 pm
Sat: 1 pm-10:30 pm

GETTING THERE Parking is available on the surrounding streets. Also accessible from the commuter rail (Roslindale Village stop, Needham line) and several bus lines.

PAYMENT

POPULAR DRINK The menu offers a wide variety of drinks, including martinis, margaritas, and cocktails, as well as a full beer and wine menu. Many patrons enjoy a glass of wine at Sophia's, though the cocktails are also popular.

UNIQUE DRINK Sophia's offers a reasonably robust margarita menu (five-six varieties) for a non-Mexican restaurant.

FOOD Sophia's is a true restaurant bar, and a full menu is available at the bar. Many of the small plates are especially tasty and make for a good pairing with drinks.

SEATING Seating and standing room are both very limited at Sophia's Grotto. The restaurant and bar are both small, so show up early for a seat. On a weeknight when the restaurant is slow, you can probably get a booth by the bar.

AMBIENCE/CLIENTELE Sophia's is a beautiful Italian/Mediterranean trattoria in Roslindale Village, and the bar and restaurant are decorated with bright tiles, rough exposed brick, and terracotta shingles, all lit with Italian glass pendant lighting. You'd be hard pressed to find a more lovely spot in town for a glass of vino. Appropriately, the restaurant attracts a well-heeled crowd most nights of the weeks.

EXTRA/NOTES One of the most interesting features of Sophia's Grotto is that is shares a brick patio with several other restaurants, which is removed a bit from the street. Between the twinkling white lights in the trees and the soft bubble of the fountain, you will feel like you've been transported to an Italian village square. If you are heading to Sophia's for dinner, you can order a drink at the bar and wait out on the terrace for your table- you won't notice the time at all!

—*Courtney Scott-Howard*

The Squealing Pig

This little piggy went to the bar and got sloshed.
$$
134 Smith St., Roxbury 02120
(between Huntington Ave. and Worthington St.)
Phone (617) 566-6651
www.squealingpigboston.com

CATEGORY Beer Bar

HOURS Daily: 11 am-1 am

GETTING THERE There is metered street parking all around the area. The nearest public transit is the Longwood Medical Area and Brigham Cir., both on the Green Line - E.

PAYMENT

POPULAR DRINK With over 100 beers to choose from, Pig patrons tend not to stray from the glorious variety offered. Those lonely liquor bottles behind the bar don't really get put to much use. But they're waiting there if you've found that you've exhausted your beer buds.

FOOD From curry dishes to pizza, Shepard's pie to burgers, fish and chips to quesadillas, Squealing Pig covers all the international bases with a wide variety of feel-good food. Most of their menu, which includes sandwiches they've dubbed Toasties, is served until the wee hours. They are also quite proud of their one and only dessert dish: The Mars Bar Toastie, a gooey compilation of toasted waffles, sliced bananas and a European Mars bar.

SEATING The Squealing Pig is made up of two rooms. The main room holds the long, handsome bar and big wood tables that can bear the turbulence of larger parties. The side room is also equipped with large tables as it is more specifically designed for private parties to rent out. On the weekends, there is plenty of chair juggling to fill every seat. If you get caught without a seat, it's a rough standing ground. Come early or come aggressive.

AMBIENCE/CLIENTELE The Squealing Pig provides a cozy arena with quirky decor and a hint of Southern charm where you can oftentimes find music events like Kung Fu-Metal Mondays. Groups of boisterous 20 and 30 somethings flock to this Mission Hill trendy spot to snag a table and camp out for the night.

—*Victoria Young*

SOUTH BOSTON

Murphy's Law

Go, baby, go!
$$

837 Summer St., South Boston 02127
(at E. 1st St.)
Phone (617) 269-6667
www.murphyslawbar.com

CATEGORY	Neighborhood Pub
HOURS	Mon-Sat: 10 am-2 am
	Sun: Noon-2 am
GETTING THERE	Street parking on E. 1st St. or take the Silver line.
PAYMENT	$ ATM
POPULAR DRINK	Beah, beah, and more beah (and at wicked good prices!). Draught beer selection includes Guinness, Stella Artois, Magner's, Smithwick's, and the ubiquitous Sam Adams. Full bar is available if you're in the mood for something stronger.
UNIQUE DRINK	Don't expect any fancy cocktail menus. Many of the patrons like to take part in a Jager Bombs (a shot of Jagermeister dropped into a glass of Red Bull).
FOOD	If you get the beer munchies, frozen pizza ($6) can be nuked in the microwave upon request.
SEATING	A 15-seat bar spans the length of the room; high tops with plenty of elbow room.
AMBIENCE/CLIENTELE	Murphy's Law is the kind of quintessential Southie Irish bar that we love, adorned with family snapshots, political bumper stickers, and even a cigarette vending machine, and frequented by locals, Grandpas, and whoever else happens to wander in off the street. Video games and free darts will keep you occupied in between Red Sox innings and sips of beah.
EXTRA/NOTES	Murphy's Law was one of the locations in the Ben Affleck directed film, Gone, Baby Gone. This corner location has been a bar in one form or another since the 1920s.

—Minh Luong

CAMBRIDGE

KENDALL SQUARE

Hungry Mother

Home like it never was.

$$

233 Cardinal Medeiros Ave., East Cambridge 02141
(at Binney St.)
Phone (617) 499-0090 • Fax (617) 499-0091
www.hungrymothercambridge.com

CATEGORY	Neighborhood Bistro
HOURS	Tues-Sun: 5 pm-1 am
GETTING THERE	Metered street parking is ample and pay lots are in the area. Public transit is a little trickier. The two Red Line stops are best options. Unless you can catch the 68 bus or the CT2, which run within blocks.
PAYMENT	
POPULAR DRINK	Edgy house-designed libations are the preferred choice. An eclectic selection of beer and the extensive wine list still keep the night interesting.
UNIQUE DRINK	No. 2: Maker's Mark, Sorghum syrup, Luxardo amaretto, and boiled peanut. No. 43: rye, tawny port, maple syrup and bitters. No. 99: Bartender's Choice. A bold endeavour.
FOOD	An upscale take on Southern home cooking with a hint of French influence made from local and seasonal ingredients.
SEATING	Three levels of intimate seating areas with the main floor dedicated to the bar and small tables.
AMBIENCE/CLIENTELE	The unembellished walls of occasional rustic adornments and soft lighting give Hungry Mother a modern take on a homey ambiance. Locals enjoy this sophisticated neighborhood restaurant for dinner and drinks.
EXTRA/NOTES	The Kendall Square Cinema movie theater sits within blocks of Hungry Mother. If you dine before 6 pm, Hungry Mother will supply your movie tickets for just $6 a pop.

—*Victoria Young*

CENTRAL SQUARE

All Asia Bar

Every night is like the best house party ever.

$

334 Massachusetts Ave., Cambridge 02139
(at Blanche St.)
Phone (617) 497-1544
www.allasiabar.com

CATEGORY	Neighborhood Bar
HOURS	Mon-Fri: 5 am-1 am
	Sat: Noon-1 am
GETTING THERE	Metered street parking is generally easy to find. The nearest public transit is the Central Sq. stop on the Red Line.
PAYMENT	

POPULAR DRINK Pabst Blue Ribbon is on tap for cheap and cans of Miller High Life cheaper. Most patrons on a budget are able to close out a night's tab in the single digits. Most people are pretty content drinking their preferred beer of the good selection on draft. All Asia is also known for a heavy pour in their modestly priced cocktails. An All Asia frequenter has probably taken plenty of shots of whiskey. Jameson is pretty standard, but sometimes you need the notoriously high-proof Sailor Jerry's rum. Mmm. Oftentimes if one person orders a shot, a domino effect of orders pour in until half the bar is taking part in an uproarious cheers. Peer pressure works wonders.

UNIQUE DRINK A nod to the Asian influences, the Dragon Bowl is a medley of liquor and mixers served in a bowl with as many straws as you have friends to share with. The bartenders love to try out new concoctions and practice layered drinks and shots. Brain Hemorrhage is a sweet layered shot of Bailey's, peach schnapps and grenadine that creepily looks much like it sounds. Another recent experiment drink I encountered is the Sweet Tobacco Pie, a layered drink of rum, Midori and pineapple juice. Feel free to ask the bartender for something different. They love to cook up new recipes or introduce obscure classics.

FOOD All Asia serves yummy pub grub with some Asian zing. Among the favorites include crab rangoon, beef or chicken teriyaki skewers, pork dumplings, and onion pancake. They also serve the more traditional pub grub like spicy fries, soft pretzels, and chicken fingers.

SEATING The bar is the venue's centerpiece and the preferred seat among singles or pairs. For groups of friends, semi-booths line the walls with plenty of table space and the high tops are a superb spot to watch performances. Most people are perfectly content standing in order to stay mobile for interweaving social situations.

AMBIENCE/CLIENTELE From the outside, most people tend to walk right by the curtained windows and hidden door, unaware of the bar's presence until they hear the music escaping through the sturdy foundation. Inside, paper lanterns encompass the bar and provide a welcoming luminance for any stranger that strolls in. Don't be thrown off by the dressed up interior, All Asia is a dive bar at heart. At just a dollar a pop, the pool table is in constant use, but is shared with anyone interested in a game. A foosball table provides immediate entertainment and a boxing game in the corner keeps the testosterone levels high. Many regulars and locals of all ages make All Asia their second home. Even strangers to the bar have no problem finding lively conversation. The local artwork is featured on the brick walls is just one way in which this neighborhood bar supports the artistic community. Live local music of all genres is featured nightly, ranging from folk, rock and classical jazz to drum and bass, mash-up, experimental, and even comedy. Open-mix night on Wednesday nights gives local musicians and comedians an opportunity to perform for a supportive audience while getting the chance to listen to others.

—*Victoria Young*

NEED A PICK-ME-UP?

Try These Boston Beverages

Sometimes you want something different than your standard latte. For a much needed pick-me-up experience some of these unique beverages at some of Boston's best:

Chai:
For only a buck and a half you can get a cup of hot steaming Chai at India Foods and Spices, a small, hole-in-the wall Indian grocer, located outside of Central Square in Cambridgeport. Served in a styrofoam cup, the store clerk will add a few heaps of sugar in your cup if you don't request less upfront. The result is as close as you can get to a roadside Indian Chai experience. While you're at it, ask him to heat up some of the veggie samosas ($.75) as an afternoon snack to go with your Chai.

Turkish Coffee:
Settle into one of the Kilim rug banquets at Sofra Bakery, a wonderful Middle Eastern bakery and café for a dose of strong, grainy Turkish coffee. Enjoy it with a delicious pastry, or the Turkish breakfast consisting of a soft boiled egg dipped in crispy fideos, and an amazing tomato sauce with sesame seeds.

Hot Chocolate:
Chocoholics flock to Burdick's Chocolate in Harvard Square to enjoy chocolate delights in liquid, pastry, and even candied mouse shaped form. The hot chocolate here is very potent and should be called "liquid chocolate" because that's exactly what it is. It is rich, thick, and utterly decadent, which is what Burdick's is all about.

Afternoon Tea Service:
An afternoon tea service at Swans Café in the Park Plaza is something that any tea lover should experience, not only because of the hotel's charming, old world decor, but also because they have Cynthia Gold in residence, one of only a handful of the country's tea sommeliers. You will taste rare and refined teas from around the world alongside glimmering towers of elegant tea sandwiches and pastries. Afternoon Tea is served daily from 3 pm-5 pm.

Rosewater Mint Lemonade & North African Mint Tea:
It's difficult to choose between these two authentic, aromatic North African beverages at Baraka Café, so start your meal with a tall glass of cherbat, a refreshing, sweet lemonade, scented with fresh mint sprigs and pink rose petals. Finish with a relaxing pot of tradition sweetened mint tea served in beautiful vintage Moroccan tea glasses and paired with a dish of spiced nuts. Either way, your senses will thank you for this unique experience.

White Hot Chocolate:
After a day of shopping on Newbury St., indulge in a warm cup of white hot-chocolate topped with cinnamon at the charming bookstore Trident Café. It will be the boost that you need to get

through another cold winter's day.

Watermelon Soda:
While Flour Bakery is known for its delightful pastries, thirsty
Bostonians in-the-know enjoy their house made effervescent,
pink, watermelon soda. This refreshing treat will give you an extra
bounce in your step.

India Food and Spices
80 River St., Cambridge 02139, (617) 497-6144

Sofra Bakery
1 Belmont St., Cambridge 02138, (617) 661-3161,
www.sofrabakery.com

Burdicks's Chocolate
52-D Brattle St., Cambridge 02138, (617) 491-4340,
www.burdickchocolate.com

Swans Café, Park Plaza Hotel
50 Park Plz., Boston 02116, (617) 654-1906,
www.bostonparkplaza.com

Baraka Café
80 ½ Pearl St., Cambridge 02139, (617) 868-3951,
www.barakacafe.com

Trident Café
338 Newbury St., Boston 02115, (617) 276-8688;
tridentbookscafe.com

Flour Bakery
12 Farnsworth St., Boston 02210, (617) 338-4333
1595 Washington St., Boston 02118, (617) 267-4300
www.flourbakery.com

—*Minh T. Luong*

Andala Café

Strong Coffee and Hospitality.
$
286 Franklin St., Cambridge 02139
(at River St.)
Phone (617) 945-2212
www. andalacafe.com

CATEGORY	Coffee Café
HOURS	Mon-Fri: 7 am-11 pm
	Sat/Sun: 8 am-11 pm
GETTING THERE	Red Line to Central. Metered parking can be tricky. It is also near the #1 Massachusetts Ave. bus.
PAYMENT	
POPULAR DRINK	Coffee and espresso, fruit smoothies and juices made on premises, a startling and massive array of loose teas.
UNIQUE DRINK	Turkish coffee that'll stand your spoon up; house black tea with cardamom.
FOOD	Muffins and cinnamon brioche twists, very fresh Middle Eastern standards such as hummus, tabbou-

leh, and mjeddareh (lentils), salads, meat and spinach pies, soup and chili, and a small variety of wraps.

SEATING Many small tables, counter seating by window, couches. Ample outdoor seating.

AMBIENCE/CLIENTELE Andala's warmly painted walls and rich rugs are unusually welcoming touches in a city where cafés are more often function over form. The staff is friendly and beautiful, the light is good no matter where you sit, and even at full capacity the place never feels crowded. Students and business meetings alike share milk pitchers and outlets.

EXTRA/NOTES Café setting can bewilder those expecting only counter service. Sit where you like and staff will arrive with a menu. Remember to tip your server. Free Wi-Fi, and in warmer months ask about the huqqa (hookah) smoking! For $15 you can choose from eight different flavored tobaccos, with apple ranking most popular among them. The tobacco smell is not intrusive at all.

—Alison Pereto

The Cellar

The mood-lit dungeon where everybody knows your name.

$$

991 Massachusetts Ave., Cambridge 02138
(between Ellery St. and Dana St.)
Phone (617) 876-2580
www.gardenatthecellar.com

CATEGORY Beer Bar

HOURS Mon-Weds: 4 pm-1 am
Thurs-Sat: 4 pm-2 am
Sun: 4 pm-1 am

GETTING THERE Parking on street is a gamble in Cambridge. Best bet is to walk 10 minutes down Massachusetts Ave. from either the Harvard or Central T-stop.

PAYMENT $

POPULAR DRINK With its modest liquor supply and minute wine list ("One of each"), this bar is focused mainly on beer (ten on tap, a few select bottles). Hung proudly behind the bar is a framed Guiness "Perfect Pint Award" from 1997. Perhaps a glass of this classic is your best bet.

FOOD Upstairs is the pricier, classier tapas restaurant, Garden at the Cellar, with a more extensive wine list and full menu. A sampling of said menu is available downstairs until 11 pm (appetizers and snacks run $5-$10). Particularly amazing are the rosemary truffle fries, an upscale twist on the classic bar food, and the homemade tater tots, decadent fried blobs of mashed potatoes that will momentarily stop time (and your heart) with their buttery goodness.

SEATING Very little seating available if you show up after 8 pm on a weekend. With a watchful eye and scavenger morals, a table or cluster at the bar occasionally arises. Otherwise, be prepared to stand.

AMBIENCE/CLIENTELE The ambience of the Cellar reflects its name. It is, quite literally, a converted cellar. Red walls are warmed by rope lights, and tables are arranged cozily around the edges. For those who like to watch themselves spiraling progressively toward intoxication in flattering subterranean mood lighting, the walls are lined with mirrors. The deal is sealed by a sound-

track of classic blues, R&B and oldies, lending extra comfort to an already familiar atmosphere. Great place to go for a chill night with your buddies or significant other. While occasionally visited by on-the-prowl twenty- or thirty-somethings, this is not the ideal bar for hunting singles. A fairly small venue, the Cellar is usually populated by couples and impenetrable groups just looking for a place to settle. For a crazy night of dancing upon strangers, this is more a place to start the night and plot your course with a friendly beer and classy bar snack.

—Stacy Williams

Central Kitchen

The best Central Square has to offer.

$$$

567 Massachusetts Ave., Cambridge 02139

(at Pearl St.)

Phone (617) 491-5599

www.enormous.tv/central

CATEGORY	Wine Bar
HOURS	Mon-Weds: 11:30 am-1 am
	Thurs-Sat: 11:30 am-2 am
	Sun: 11:30 am-1 am
GETTING THERE	Take the T to Central Sq. There are also three public parking lots behind the restaurant on Bishop Allen St.
PAYMENT	
POPULAR DRINK	The wine list is long enough to suit the various flavors found on the menu, as well as the various wallet sizes that may stroll in. There is also a full bar and a decent selection of local and imported beer.
FOOD	The Steak Frites. Unless you are a vegetarian, just do it. The steak is an aged Angus rib-eye that melts in the mouth and the frites are home-cut and nicely spiced. They also have one of the only raw bars in the neighborhood, convenient for slurping down bivalves from New England and beyond.
SEATING	The restaurant is cozy, with perhaps fifteen copper topped tables. The bar is spacious and suitable for dining and imbibing. There is often a wait Thurs-Sat at dinner time.
AMBIENCE/CLIENTELE	Because of its location in the heart of Central Square (not traditionally a Mecca for fine dining) and its modest exterior, the Central Kitchen is usually only found by people looking for it. However, there are many people looking for it most nights, a testament to the quality of its food and atmosphere. The patrons are typically the well-heeled Cambridge set. The interior is appropriately dim. The wall opposite the bar is lit solely by illuminated wine bottles, and the music is just loud enough to make all conversations private.
EXTRA/NOTES	Owner Gary Strack can often be found working the kitchen. Their menu changes seasonally, so be sure to make this a regular visit. Also note the slate top on the service-side of the bar, on which your order will be written with chalk if you eat or drink there.
OTHER ONES	The Enormous Room bar and lounge, located upstairs is under the same ownership.

—Paul Collins

Clear Conscience Café

A presumptuous title with the beans to back it up.

$

581 Massachusetts Ave., Cambridge 02139
(between Prospect St. and Pearl St.)
Phone (617) 661-1580
www.c3cafe.net

CATEGORY	Coffee Café
HOURS	Mon-Sat: 7 am-10 pm
	Sun: 7 am-9 pm
GETTING THERE	Street parking along Massachusetts Ave. and two lots of metered parking (free after 6 pm and on Sun) behind the building. Do not park in the Harvest Co-op parking lot if you are not a Co-op member. Take the Red Line - Central station stop or the bus stop across the street for the 1, CT1, 47, 64, 70 and 70A. Just off Prospect St. is a stop for the 83 and the 91.
PAYMENT	ATM DISCOVER AMERICAN EXPRESS MasterCard VISA
POPULAR DRINK	C3 serves their own brand of fair-trade, shade-grown, organic coffee and espresso which is a guilt-free, tasty way to start your day. Baristas whip up traditional espresso beverages, which are also made with organic, free-range milk. The organic tea selection offers a variety of herbal, black and green teas for your choosing. Their organic sodas are divine. Black Cherry really gets my heart racing.
UNIQUE DRINK	This vegan-friendly establishment can makes 100% organic and vegan smoothies. The Multiberry is made up of strawberries, raspberries, blueberries and bananas with an apple juice base. With no milk, its a deliciously vegan way to get all the bang for your buck. The baristas here make a mean organic and dairy-free hot chocolate and mocha. They use a vegan cocoa mix and have soy and rice milk on hand to suit any non-dairy preferences. With a potent Chai brew made from their own brand of organic tea with a touch of honey, the Chai Latte is absolutely exquisite. And, like all of their beverages, can be made with non-dairy options. Everything that goes into tour cup is organic.
FOOD	Fresh baked goods and bagels greet you in the early morning while sandwiches maintain a serious presence throughout the day. Whenever possible, Clear Conscience Café uses all-natural and organic ingredients, free of pesticides, artificial fertilizers, and additives. The Roast Turkey sandwich has hand-sliced turkey breast, sauteed onions, sliced apples, fresh lettuce, cheddar and a cranberry mustard. The Roast Beef is a big seller and The Veggie sandwich comes loaded with hummus, roasted red peppers, tomatoes, sprouts, cucumbers, and feta on a dense seven-grain bread. Three-bean vegetarian chili and a daily soup-du-jour, generally vegan, are a hot, organic option for a relaxing meal. Each plate comes with a scrumptious dollop of three-bean salad that will make toes tingle with delight.
SEATING	Tables crafted from sunflower seed husks and bamboo are placed along the walls with ample electrical plugs for laptops and by the front windows for Central Square people watching. Cozy couches and arm chairs make up the main lounge area where people can comfortably sip on a cappuccino and read the paper. If the front seating area is filled, the beautiful bamboo

counter space along the back wall can accommodate people with tall-backed stools.

AMBIENCE/CLIENTELE This Central Square hot spot can bring in all kinds of local characters. Students can be found munching on brain food and downing espresso over their textbooks and laptops. Workaholics stop in here for a quick lunch or an after-work place to veg out. The soft glow of the energy-efficient pendant lanterns and lamps keep a mellow vibe while an eclectic selection of music comes straight from the staff members' personal collection. The knowledgeable staff is helpful enough to answer any questions about the café's mission and products. The owners of C3 are also approachable and welcoming and can often be found on-site chatting with regulars or new customers. The Harvest Co-op sits behind the café, making it a perfect stop for a hot drink and a trip to the grocery store. Every Thursday night, the café is transformed into a venue for local musicians to rock out in the name of sustainability. It's neat to see a small concept blossom into a reality with the support of the community.

EXTRA/NOTES C3 was renovated according to the LEED green building guidelines and won the 2008 Go Green award.

—*Victoria Young*

Craigie on Main

A full-bodied experience of seasonal delights.
$$$
853 Main St., Cambridge 02139
(at Bishop Allen Dr.)
Phone (617) 497-5511 • Fax (617) 497-5522
www.craigieonmain.com

CATEGORY Cocktail Bistro

HOURS Tues-Sat: 5:30 pm-1 am
Sun: 11 am-1 am

GETTING THERE There are public parking lots on Bishop Allen Dr. and a paid parking lot at Le Meridien Hotel. The Central stop on the Red Line is the closest T-stop. Central Sq. also has a number of bus routes that run through it.

PAYMENT

POPULAR DRINK Craigie's dedication to fresh ingredients results in an innovative list of seasonal libations. Each cocktail is crafted with a pre-prohibition technique that provokes intriguing flavor combinations. Their specialty cocktails may be their beverage forte, but their wine selection is an aggressive contender with most bottles selected from organic and biodynamic vineyards. Even the beer list offers a diverse set of obscure bottles to be discovered. It's a wonderful drink adventure.

UNIQUE DRINK The Casino Imperial is a classically-inspired beverage of sparkling wine, apple brandy and absinthe. It is just one of many that will tantalize, both in theory and in taste.

FOOD With braised pigs' tails and roasted bone marrow, many people might take one look at the menu and opt for Chinese take-out. The heavily French-inspired dishes can seem intimidating, but Craigie does it to perfection. Fresh ingredients demand a daily menu updates and only organic, local and sustainable goods are used. Craigie's commitment to this environmental cause ensures their food to be of the best quality pos-

sible. And the fervent following Craigie has, even after moving locations, is testament to their exceptional culinary craft. If this still doesn't sway you, at least try "The Best Burger" found on their bar menu. They do not lie.

SEATING The open-faced kitchen takes center stage while the formal dining room sits to one side and the bar area sits on the other.

AMBIENCE/CLIENTELE Craigie is a well-established bistro with quite a following of gourmet foodies and cocktail connoisseurs. Without hesitation, this place brims with the noisy excitement in anticipation of a fine meal and delectable cocktails. People will want to linger at their tables and at the bar, but it is well worth the wait so you can do the same.

—*Victoria Young*

Cuchi Cuchi

A unique and classy libation vacation.
$$$$
795 Main St., Cambridge 02139
(at Windsor St.)
Phone (617) 864-2929
www.cuchicuchi.cc

CATEGORY Cocktail Lounge

HOURS Mon-Sat: 5:30 pm-12:30 am

GETTING THERE Valet parking is offered, but metered parking is usually available nearby. Take the Red Line to Central Sq.

PAYMENT

POPULAR DRINK Every drink at Cuchi Cuchi is a work of art. Whether a muddled fresh fruit cocktail or a tried and true classic. The bar's two page drink menu is well developed, overwhelming and flawless. While every drink is special, Salome's Potion reigns supreme for customers. With Hendircks Gin, muddled blackberries and mint, this cocktail pays tribute to Salome, whose portrait hangs prominently over the bar.

FOOD Refusing to be labeled as a tapas bar, Cuchi Cuchi refers to their menu as "straight up small dishes". Specializing in eveything from South American and Spanish fare, to dishes from the Middle East and Russia, Cuchi's food options are small, but delicious and perfect for sharing multiple dishes.

SEATING With a dining room in the front, another in the back and a full-length bar with additional partition for seated drinking, Cuchi Cuchi is very spacious and only packed during dinner hours.

AMBIENCE/CLIENTELE With an extremely friendly staff dressed in vintage costume clothing from the 20s, 30s and 40s, Cuchi's ambience is truly stunning. Romantic and dimly lit, this well-decorated establishment prides itself on a variety of rare vintage furnishings, stained glass, antique glassware and unique floral arrangements.

EXTRA/NOTES Named after Charro's televised catch phrase, Cuchi Cuchi is Central Square's virtual vacation. Dedicated to decor and committed to classic and clandestine, laborious cocktails, Cuchi Cuchi emits an atmosphere of another time and another place.

—*Nolan Gawron*

The Enormous Room

Hip, Moroccan-styled lounge room.

$$$

567 Massachusetts Ave., Cambridge 02108
(at Pearl St.)
Phone (617) 491-5550
www.enormous.tv

CATEGORY	Cocktail Lounge
HOURS	Mon-Weds: 5:30 pm-1 am
	Thurs-Sat: 5:30 pm-2 am
	Sun: 5:30 pm-1 am
GETTING THERE	Take the T to Central Sq. There are also several public parking lots on Bishop Allen.
PAYMENT	
POPULAR DRINK	They got creative with the names here. Try a Grass-Stained Knees, and try to keep a straight face while ordering it. Coconut rum and lemongrass rickey will have you in the mood for, well… There is also a small beer selection and a one-page wine-list.
UNIQUE DRINK	Some more names for you: Geisha's Whisper, consisting of ginger-infused vodka and plum wine (delicious). And, God in Small Pieces, with pomegranate juice, tequila, and lime.
FOOD	There is upscale finger food available here, best enjoyed in a group while sitting on the platform. Dig into the Mediterranean dip plate, or sample the skewers (beef, salmon, or veggie).
SEATING	About ten swanky, vintage leather couches line the four walls, and an Oriental rug-covered platform near the bar beckons the relaxed to kick off their shoes and go cross-legged. Ottomans provide additional seating across from the couches, separated by tasteful glass tables.
AMBIENCE/CLIENTELE	The lighting is enough to avoid running into large objects and not much else, and effectively sets the scene along with the exposed brick walls and dark furniture. The Enormous Room is a Cambridge lounge (and all that entails), with a DJ in the cubby by the bar spinning electronica every night. Come here for a trippy, eerie, late night.
EXTRA/NOTES	The Enormous Room is owned by chef Gary Strack of the Central Kitchen. Head downstairs for dinner, and finish the night off upstairs with a Grass-Stained Knees. There is no sign announcing the Enormous Room, just an Elephant over the door. Find the Central Kitchen and walk in the door next to it.
OTHER ONES	The Central Kitchen downstairs is under the same ownership.

—Paul Collins

The Field

Classic Boston-area Irish pub with a Cambridge panache.

$

20 Prospect St., Cambridge 02139
(at Massachusetts Ave.)
Phone (617) 354-7345
www.thefieldpub.com

CATEGORY	Beer Pub
HOURS	Mon-Weds: 11:30 am-1 am
	Thurs-Sat: 11:30 am-2 am

	Sun: 11:30 am-1 am
GETTING THERE	Street parking, one of the few nearby municipal lots (good luck), Red Line to Central Sq., or MBTA bus #1, Dudley Sq. to Harvard Sq. via Massachusetts Ave.
PAYMENT	$
POPULAR DRINK	The Field features an enviable list of draught and bottled beers that includes Japan's Sapporo, Munich's Paulaner Hefeweizen, and Boddington's, the emblematic British bitter. Also, check out the wide-ranging Scotch menu, which varies in quality, but remains in the scope of $8 to $14.
UNIQUE DRINK	In the winter, come in out of the cold for a hot toddy, a robust, timeless hot cocktail. If that doesn't suit your fancy, perhaps one of The Field's other hot cocktails will, like the Peppermint Paddy (peppermint schnapps and hot chocolate; note the spelling).
FOOD	Pub grub and burgers. And, if you get there before the kitchen shuts down at 10 pm, try the potato skins – they're amazing.
SEATING	You and all your friends can swarm one of the big, wooden tables lining the walls, sit at the bar, or gather in the ample standing room the space allows.
AMBIENCE/CLIENTELE	The Field attracts the darts-and-pool crowd, young and old. Unlike the many establishments in Boston and beyond that unsuccessfully try to approximate an authentic Irish atmosphere, the owner of The Field, and seemingly most of his employees, are actually Irish. So whatever quality that sort of legitimacy allows, The Field has it in spades.
EXTRA/NOTES	The Field's diverse drink selections, close proximity to Central Square and the MBTA, and 2 am weekend closing time make it a perfect place to start the night, end the night, or stay all night.

—*Matt Rusteika*

Green Street

Low-key, upscale bar with great cocktails.

$$$

280 Green St., Cambridge 02139
(between Pearl St. and Magazine St.)
Phone (617) 876-1655
www.greenstreetgrill.com

CATEGORY	Cocktail Bar
HOURS	Mon: 5 pm-1 am
	Tues-Sun: 5:30 pm-1 am
GETTING THERE	Take the T to Central Sq. There is also a parking garage right next door.
PAYMENT	
POPULAR DRINK	You can't go wrong with a Dark and Stormy anywhere really, but they are tasty at this Caribbean-heritaged establishment. There is a small stable of draft beers, including Old Speckled Hen, Allagash, Smuttynose, and Guinness, and a larger assortment of imported beers from every country on the map. The wine list is mid-range, but come here for the cocktails.
UNIQUE DRINK	There is a bevy of unique drinks awaiting the adventurous, with a detailed cocktail menu at least 100 drinks long. Try the Rhum Cup (cava, Barbancourt 5-star rum, pineapple juice, and honey syrup).

FOOD The bar is located in the lower half of an excellent restaurant, and the full menu is available at the bar. Generally Nouveau American food, will please all comers.

SEATING The bar is standard size, and there are about five high tops downstairs by the bar. Upstairs is reserved for dining.

AMBIENCE/CLIENTELE The clientele is slightly less local than most Central Square establishments. The patrons tend toward the well-heeled Cantabrigian set with some hipsters mixed in. The atmosphere and fare are upscale and appropriate for romantic dates or serious discussions. The bar is nicely appointed with a minimalist, but warm, interior, contrasting with the downscale exterior.

EXTRA/NOTES This establishment, under the longer guise of The Green Street Grill, for years served a Caribbean-based menu. Owner Dylan Black recently changed things up and the restaurant now serves food more aptly described as American comfort.

—*Paul Collins*

Mariposa Bakery

Funky Café on the Edge.

$

424 Massachusetts Ave., Cambridge 02139

(at Central Sq.)

Phone (617) 876-6500

CATEGORY Coffee Café

HOURS Mon-Fri: 7 am-8 pm
Sat/Sun: 9 am-8 pm

GETTING THERE Metered spots on Massachusetts Ave. or park in public lots behind Harvest Co-op; Red Line to Central Sq. stop; No. 1 or CT1 bus line.

PAYMENT MasterCard VISA

POPULAR DRINK Fair trade coffee is a decent brew whether on-the-run or planning to stay awhile. Freshly squeezed orange juice represents the healthy vibe to the menu and is just as refreshing as any caffeinated drink.

UNIQUE DRINK The Chai-der, a spicy mix of chai tea and apple cider.

SEATING Plenty of mix-and-match of tables and chairs means patrons will find a spot, maybe even spread out, when other cafés are packed. One high top wooden slab is a good campout for loners on their laptops to share.

AMBIENCE/CLIENTELE Located on the edge of Central Square, everyone from MIT professors to firemen from the nearby station stop in. Exposed brick gives this spot a modern feel, while the pastel green and plum walls convey the casual vibe.

—*Sarah Black*

The Middle East

The rock music epicenter of Cambridge – and good beer, too.

$

472-480 Massachusetts Ave., Cambridge 02139

(at Brookline St.)

Phone (617) 864-3278

www.mideastclub.com

CATEGORY	Beer Bar
HOURS	Mon-Weds: 11 am-1 am
	Thurs-Sat: 11 am-2 am
	Sun: 11 am-1 am
GETTING THERE	55 Franklin St. Garage (enter on Green St.), Red Line to Central Sq., MBTA bus #1, 47, 70, 64, 83, or 91.
PAYMENT	

POPULAR DRINK The Middle East slings PBR and High Life for $3 a bottle, and the taps ($4.50) exclusively feature major local brews Harpoon and Samuel Adams, favorites anywhere in Boston. Pitchers go for $13.95, and you're sure to see a couple of those floating around. This, overall, is a beer-and-shots crowd.

UNIQUE DRINK Aside from some notably fancy whiskies and tequilas, the drink menu is pretty unremarkable as far as cocktails go, in that it doesn't really exist. The bartenders mix classic cocktails with recognizable names in between opening bottles and pulling pints. Their beer list includes such interesting additions as Taj Mahal from India (22oz for $7.50) and Julius Echter from Germany (liter for $6.50).

FOOD Great Middle Eastern and Mediterranean eats. If you're a garlic lover, make sure to get a side dish of Whipped Garlic with any meal. You will reek for days, but it is so worth it.

SEATING The Middle East is actually two bars, as in two separate bar rooms with the same menu. They are separated by ZuZu, a higher-end Middle Eastern restaurant under the same management. Each has a few rows of tables and booths in the front, and a bar toward the back near the entrance to the rock clubs, of which there are two (Middle East Upstairs and Downstairs). The capacity of both bars is in the 60s, and at night, most of those people simply stand.

AMBIENCE/CLIENTELE Not just a popular watering hole, the Middle East is also one of the preeminent rock music venues in the Boston metropolitan area. Its clientele varies nightly and reflects whatever kind of concert is taking place behind the doors of the two rock clubs. High ceilings make the rooms look bigger than they are, while colored Christmas lights, hanging plants, and framed works of funky art create a casual, relaxed atmosphere.

EXTRA/NOTES The Middle East complex includes two music venues, three restaurants and five bars in total. No matter which Middle East restaurant you visit, though, you can expect authentic Middle Eastern food made from scratch and a diverse beer and liquor selection.

—Matt Rusteika

Middlesex Lounge

Minimalist, Urban Lounge.
$$$
315 Massachusetts Ave., Cambridge 02108
(between State St. and Village St.)
Phone (617) 868-6739
www.middlesexlounge.us

CATEGORY	Cocktail Lounge
HOURS	Mon-Weds: 11:30 am-1 am
	Thurs/Fri: 11:30 am-2 am
	Sat: 5 pm-2 am

GETTING THERE	On-street parking available, and access to nearby garages. Located near the Central Sq. stop of the MBTA's Red Line. Massachusetts Ave. #1 Bus also goes there.
PAYMENT	AMERICAN EXPRESS · MasterCard · VISA
POPULAR DRINK	Fresh muddles mojitos; large Red Stripe in the bottle; Cool Cucumber: Hangar One vodka, simple syrup, freshly muddled cucumbers.
UNIQUE DRINK	Aged rum punch: Pampero Anniversario rum (aged rum), simple syrup, lemon and lime juice, dash of bitters. Served on the rocks with a dash of freshly grated nutmeg.
FOOD	Bar bites and pressed sandwiches. Most popular: shrimp shumai, formaggio cheese plate (changes seasonally), and ten tiny tacos (heaped with pulled pork, a taste of avocado, and a slice of jalapeño).
SEATING	Entire lounge is designed with low, moveable benches. Capacity is 120 but best feature about Middlesex is its mobile furniture allowing guests to showcase the exclusivity of their party while in a public setting.
AMBIENCE/CLIENTELE	Simply put, Middlesex is a stylish, urban lounge. Check the website for an up-to-date schedule of rotating DJs spinning cutting-edge dance music, 90s hip hop, mash ups, and video art entertainment. Depending on the night you'll see Harvard and MIT grad students, industry people, music scene people, hipsters, perhaps doing the snake inside a break dance circle.
EXTRA/NOTES	Get there by 9 pm on weekends to avoid the $5 cover and the long lines that can snake down the block.
OTHER ONES	The Middlesex Lounge is owned by Matthew Curtis and Chris Lutes, who also run the Miracle of Science, Cambridge 1, and Audubon.

—*Sam Mazzarelli*

Miracle of Science

Have a beer with hip scientists.
$$
321 Massachusetts Ave., Cambridge 02139
(at State St.)
Phone (617) 868-2866
www.miracleofscience.us

CATEGORY	Beer Bar
HOURS	Mon-Fri: 7 am-1 am Sat/Sun: 9 am-1 am
GETTING THERE	Take the T to Central Sq., or find metered parking on Massachusetts Ave.
PAYMENT	AMERICAN EXPRESS · MasterCard · VISA
POPULAR DRINK	Their beer selection is small but represents well. UFO, Guinness, Bass, Brooklyn are on draft, the standard Boston fare.
UNIQUE DRINK	You can enjoy wine served out of beaker-like glasses, in keeping with the scientific theme.
FOOD	The Miracle was something of a new concept when it opened, a step above the typical pub or sports bar in terms of atmosphere, with food that is much more than an afterthought. They may just have the best burgers in town. The menu is small, but it's all good. Try the Ronie Burger if you're a fan of spicy food. It's packed with heat-seeking jalapeños.
SEATING	The seating is limited, with about ten tables for two to four people. There is one large central, triangular-

shaped table that ten people can squeeze around on stools; a great place to get to know your fellow Cantabrigians.

AMBIENCE/CLIENTELE The dinner ambience is friendly, with dimmed lights and the pleasant loud buzz of a bar hosting lots of conversation. By day, it has more of a café feel, especially in the summer when the wall next to the bar can be rolled open to let in the breeze. The clientele is the cooler side of MIT grad, in addition to some local hipsters and after-work drinkers.

EXTRA/NOTES The Miracle has stood the test of time well, and the little touches in the minimalist space are still nice: the menu is a large periodic table drawn on a chalkboard covering one wall, the bar stools are lab stools, and the table tops and bar top are made of slate like you would see in a chemistry classroom just down the road. And, there's free Wi-Fi.

—Paul Collins

Paradise Café

Cocktailing? More like cockflailing.

$

180 Massachusetts Ave., Cambridge 02139

(at Albany St.)

Phone (617) 868-3000

www.paradisecambridge.com

CATEGORY Gay Club

HOURS Daily: 7 pm-1 am

GETTING THERE Easy street parking in the area. Use the Central stop off the Red Line. The No. 1 bus runs here too.

PAYMENT $

POPULAR DRINK Cheap beer and mixed drinks with heavy pours.

FOOD You won't find food here unless you count eye candy.

SEATING The upstairs is made up of the bar, the wall counter area and a few tables in between while the downstairs is mainly a dance floor.

AMBIENCE/CLIENTELE You can't tell much from the outside, but behind the walls is a flesh festival with gay porn playing on all the televisions and a male go-go dancer down to a sock (and not on his foot) on the strip pole. The dingy dive feel only partially prepares you for the sketchy mix of 40+ and youthful gay men. The dance floor opens up on weekend nights for a sweaty good time.

—Lawrence Fong

The People's Republik

Who knew Communism could be so much fun?

$

878 Massachusetts Ave., Cambridge 02139

(between Hancock St. and Sellers St.)

Phone (617) 491-6969

www.myspace.com/peoplesrepublick

CATEGORY Dive Bar

HOURS Mon-Weds: Noon-1 am
Thurs-Sat: Noon-2 am
Sun: Noon-1 am

GETTING THERE Street parking on Massachusetts Ave. Otherwise, take the Red Line to Central Sq. and walk 3-4 blocks. #1 Massachusetts Ave. bus will also take you there.

PAYMENT	$ ATM
POPULAR DRINK	They have a healthy selection of beer, an active dart-board, and a relaxed atmosphere.
FOOD	They serve tasty bar food like Guinness Stew.
SEATING	High tops line the walls, but the crowd of Cambridge hipsters mixed with casual locals usually just bellies up to the spacious bar.
AMBIENCE/CLIENTELE	The People's Republik has the potential to move from dive bar to hipster hangout, but has managed to keep its dive bar status by remaining the slightly smelly local Central Square joint we all love. It gets crowded, but the bartenders remain friendly, the drinks stay cheap, and the dart board stays busy. Who can't love a bar that ironically embraces a Communist theme?

—*Brandy Sprague*

The Plough & Stars

The oldest Irish bar in the Boston area.

$$

912 Massachusetts Ave., Cambridge 02139
(at Hancock St.)
Phone (617) 576-0032
www.ploughandstars.com

CATEGORY	Neighborhood Bar
HOURS	Mon-Sat: 11:30 am-2 am
	Sun: Noon-2 am
GETTING THERE	Take the T to Harvard Sq. or Central Sq. There is also metered parking on Massachusetts Ave.
PAYMENT	ATM AMERICAN EXPRESS MasterCard VISA
POPULAR DRINK	Guinness, obviously. The best pour in town, as fits the Plough's nomination as best Irish Bar in America by several publications. There is also a full bar, and other beer on tap includes Bass, Stella Artois, Newcastle, Bellhaven, Harpoon, Smithwick's, and Magners.
FOOD	The menu is fairly small and relatively cheap, but the food is pretty decent pub fare, served from 5:30 pm on.
SEATING	The bar is small and cozy, so if you come later in the evening, any evening, seating will be hard to come by, especially if a band is playing. There are about ten tables lining the wall, but the only place to enjoy your Guinness is at the bar (or as close as you can get to it).
AMBIENCE/CLIENTELE	The Plough feels like a time trip to the halcyon days of counter-culture, mixed with a classic Irish drinking scene. There is an ancient wooden plough over the bar, and big copper stars hang from the ceiling. The dark wood paneling and deep red walls lend perfect character. The clientele is, of course, older, lefter, and Irish-er.
EXTRA/NOTES	The Plough has been a favorite hangout (and stage) for some of Cambridge's best musicians, including Mark Sandman and Mary Lou Lord. There is live music almost every night, and the flavor ranges from rock to country to blues and everything in between. The Plough is also a great place to watch English football on the telly. The literary journal, Ploughshares, was founded in the 1970s at the Plough & Stars by Harvard Ph.D. student DeWitt Henry and one of the Plough's owners, Peter O'Malley.

—*Paul Collins*

THE OTHER HAPPY HOUR

Happy Hour in Boston is not as happy is the name suggests. Massachusetts has strict regulations regarding some of our favorite liquids, so instead, bars offer smashing deals on food to encourage our drinking habits. Noshing on cheap munchies will require a quenching libation, of sorts. It's an ol' bar trick. Beer nuts were invented to bring about the thirst. Here in Boston, it's a part of the happy hour culture.

Noir in Harvard Square cuts a sweet deal with a little breakdown they like to call the "5-4-3-2-1-0 Happy Hour Nibblers: $5 flat breads, $4 sandwiches, $3 snacks, $2 salads, $1 sweets and $0 for nuts. This creative little number can be found Mon-Thurs from 5 pm-9 pm. The drinks may be a little pricey, but when you get the check, it's a well worth venture.

Also found in Harvard Square, **Grendel's Den**, a mellow subterranean pub, has an award winning happy hour. No surprise here: the whole menu is half-off. Even with the regular prices, it's hard to pay more than $10 per plate. Just imagine what kind of prices you can get on your grub during the hours of 5 pm-7:30 pm daily, and also 9 pm-11:30 pm Sun-Thurs.

Great Bay in Kenmore Square keeps a bar menu handy they like to call the Sand Dollar Menu with deals for $1, $5 or $10. For just a buck, order up a mini feast of fancied up small bites of tater tots or grilled cheese. For $5, you get to choose among a few savory little snacks. The small bites at this upscale bar are the best deal.

Bukowski Tavern, also located in Back Bay and in Cambridge's Inman Square, offers amazing hot dogs and decent burgers for a dollar, Mon-Fri until 8 pm. In the South End, **Masa**'s tapas combo platter of small Southwestern bites is offered for $5 from 5 pm-7 pm every night, and all day Thursday. Nestled in the swingin' streets of Roxbury, **The Savant Project** serves their Asian/Latin tapas at half-off between 2:30 pm-6 pm daily.

Wings are the most common Happy Hour bait. **The Point** lures in hungry drinkers with promises of 25 cent wings every Monday from 4 pm-10 pm, and 3 for 5 tacos on Tuesday (4 pm-10 pm, again). Just around the block on Union St., **The Tap** keeps in close competition with their own 25 cent wing offers every weeknight from 4 pm-10 pm. Allston's **Roggie's on the Avenue** also boasts a similar deal during 4 pm-7 pm daily, plus Sunday all day. Over by the Blue Line final stop, Bowdoin, **Red Hat Café** trumps them all with a 10 cent wing Happy Hour on Mondays and Tuesdays. Pile in with all your friends and share a plate of 200 wings for just 20 bucks. Those spicy sauces get you thirsty, so you're gonna need a cold one to wash it all down.

Noir
One Bennett St., Boston 02138, (617) 661-8010,
www.noir-bar.com

Grendel's Den
89 Winthrop St., Boston 02108, (617) 491-1160,
www.grendelsden.com

Great Bay
500 Commonwealth Ave., Boston 02215, (617) 532-5300,
www.gbayrestaurant.com

Bukowski Tavern
1281 Cambridge St., Boston 02108, (617) 497-7077

Masa
439 Tremont St., Boston 02116, (617) 338-8884,
www.masarestaurant.com

The Savant Project
1625 Tremont St., Boston 02120, (617) 566-5958,
www.thesavantproject.com

The Point
147 Hanover St., Boston 02108, (617) 523-7020,
www.thepointboston.net

The Tap
19 Union St., Boston 02108, (617) 367-0033

Roggie's on the Avenue
1249 Commonwealth Ave., Allston 02134, (617) 782-9508,
www.roggies.com

Red Hat Café
9 Bowdoin St., Boston 02114, (617) 523-2175,
www.bostonredhat.com

—*Victoria Young*

Rendezvous

A Central Square escape from mayhem.
$$$
502 Massachusetts Ave., Cambridge 02139
(between Pearl St. and Brookline St.)
Phone (617) 576-1900
www.rendezvouscentralsquare.com

CATEGORY	Cocktail Bistro
HOURS	Mon-Thurs: 5 pm-10 pm
	Fri/Sat: 5 pm-11 pm
	Sun: 5 pm-10 pm
GETTING THERE	There is metered street parking all around the Central Sq. area that can get dicey on the busy weekend nights and hard to scrounge up. The good news is that the Red Line Central stop is just a block away.
PAYMENT	
POPULAR DRINK	Rendezvous is well-recognized for a fine collection of specialty cocktails that lures in cocktail connoisseurs with a list that is updated regularly to keep a fresh appeal. Many diners opt for a bottle of wine from the extensive list and daily specials are offered by the glass or the bottle. Guests can also find a wide selection of beer, from Pabst Blue Ribbon cans to $16 bottles of Brut Cider.
UNIQUE DRINK	The excellent house-made ginger beer gives the Mamie Taylor a special kick and helps to make a killer Dark 'n' Stormy.

FOOD Locally grown, sustainably-farmed, fresh ingredients make up the seasonal menu of Mediterranean inspirations. An ever-changing prix-fixe menu is offered every Sunday for anyone looking to fully experience this Central Square delight.

SEATING Although there are 15 seats at the bar, many loyal patrons quickly fill every chair by nightfall. The restaurant area has many booths and tables to seat a capacity of 75, which is ample enough on most nights.

AMBIENCE/CLIENTELE Large windows expose the entirety of the bright and moody restaurant to the busy street of Massachusetts Ave. inviting in curious passersby to do more than just gander. Inside, the bar captivates couples with promises of another delightful cocktail and tables are packed with satisfied diners lingering over dessert and good conversation.

—*Victoria Young*

River Gods

Central Square's comfort zone.
$$
125 River St., Cambridge 02139
(at Kinnaird St.)
Phone (617) 576-1881
www.rivergodsonline.com

CATEGORY Neighborhood Bar

HOURS Daily: 3 am-1:30 pm

GETTING THERE Parking is by permit only, but the parking lot across the street at Keezer's clothing is fair game after store hours. For public transportation, take the Red Line to Central Sq. and walk 3 blocks up River St.

PAYMENT

POPULAR DRINK Guinness! The friendliest Irish bar in town, bet on the best Irish drafts and Irish whisky.

UNIQUE DRINK While drink suggestions are offered for each type of alcohol, nothing strays too far from the norm.

FOOD Arguably the best pub food in the Central Square area, River Gods offers menu selections for carnivores, vegetarians, and vegans including one of the best cheeseburgers and veggie burgers in the area. Gourmet and relatively cheap for the extreme quality level.

SEATING Though it's a small room, the beautiful bar spans the length of the room and tables pack the rest of the space. Prime time dinner hours are packed, but otherwise you'll usually find a place to sit.

AMBIENCE/CLIENTELE Just three blocks from the freak show and alcoholic amateurs of Central Square, River Gods is hands down Cambridge's most comfortable and homey bar. Hipsters, neighborhood residents, music scenesters all gather at River Gods to grab drinks, and nestle into their medieval thrones.

EXTRA/NOTES With interior decorations that changes seasonally and around holidays, and nightly DJ sessions from college radio stations and local bands, River Gods creates a pleasant and artistic atmosphere for everyone who knows it's there.

—*Nolan Gawror*

Thirsty Ear

Booze it up, the smart people way.

$

235 Albany St., Cambridge 02139
(at Pacific St.)
Phone (617) 258-9754
thirsty-ear.mit.edu

CATEGORY	College Pub
HOURS	Mon-Weds: 8 pm-1 am Thurs/Fri: 8 pm-2 am
GETTING THERE	Metered parking is not hard to find. Take the Red Line to the Central stop. There are bus routes that run down Massachusetts Ave. bringing you to Albany St.
PAYMENT	$
POPULAR DRINK	A pitcher of beer. What could be more beautiful among a group of friends than the shared commodity of alcohol?
UNIQUE DRINK	All of the beer. Not that they are individually unique, per say, but if you frequent the Thirsty, drinking all the different kinds of beer can win you your future favorite T-shirt. Start your Thirsty card now.
FOOD	As they continue to revamp their menu every so often, Thirsty Ear changes their options occasionally. The french fries, almost assuredly a permanent item, are addicting.
SEATING	Since the Thirsty Ear moved locations, they took the time to install new furnishings and get rid of the tattered and graffiti-covered old tables, save one. With their new industrial looking tables, no one can mark up the tops, keeping the place looking fresh. The new location on Albany has plenty more room than the former location and can easily accommodate their 80 person capacity, though some nights it can be a scramble to grab an actual chair. There are a few seats at the bar, a couple high tops and the rest of the room is filled with tables that are shift around nightly to fit any size pack.
AMBIENCE/CLIENTELE	From the outside, it may look like an MIT dorm area, which it is, but behind those metal gates enforcing security, there is a bar not too far in the distance. Everything is still sparkly and new, which will be balanced out when they finally hang up the collection of beer plaques. There are two big screens and a TV so their whole bar can enjoy whatever ridiculousness is onscreen. The place is swarmed with MIT students, usually each one with a loyalty to a particular night of the week, depending on their social niche.
EXTRA/NOTES	The Thirsty Ear is the proud bar of MIT that sponsors nightly shenanigans to take place in the form of Monday night Trivia, Wednesday night Games, Thursday night Karaoke and Friday night Fiesta (featuring live local music).

—*Victoria Young*

Toscanini's

Coffee snobs and ice cream fanatics rejoice!

$

399 Main St., Cambridge 02139
(between Columbia St. and Bishop Allen Dr.)
Phone (617) 491-5877
www.tosci.com

CATEGORY	Coffee Café

HOURS Daily: 8 am-11 pm

GETTING THERE Metered parking lot behind Harvest Co-op on Bishop Allen Dr.; Metered parking on Main St. and Massachusetts Ave.; or take Red Line to Central Sq. Stop and walk a few block; #1 Massachusetts Ave. Bus.

PAYMENT [Cash Co-op] [VISA]

POPULAR DRINK Coffee snobs enjoy the cult coffee brands Batdorf Bronson and George Howell served up at Toscanini's. Whether you order a straight up cup of joe or a fancy espresso drink, the coffee beans are quality and the taste and aroma will be sure to wake you up!

UNIQUE DRINK Vietnamese coffee, which is coffee with sweetened condensed milk (don't add cream and sugar, as it's already creamy and sweet). The chai is remarkably good as well. If you're craving something cold, go for a frappe chosen from their selection of first rate ice creams.

FOOD Toscanini's is known for making the "best ice cream in the world," according to the New York Times, and their regular clientele would agree. The ice cream is made on the premises and comes in traditional and unusual flavors such as Guinness, Cardamom, and Mango. Weekends they offer Breakfast @ The Big Table with all sorts of fresh and gourmet-esque breakfast treats.

SEATING The Big Table is a tall communal table that can easily fit a large group; small café tables dot the space upfront along with a sofa to lounge on and a small counter.

AMBIENCE/CLIENTELE Toscanini's is a classic Cantabrigian spot with an influx of MIT and Harvard students, hipsters, aging hippies, artists, families and professionals all taking part in the Cambridge coffeehouse scene. Don't be scared off by their edgy, tattooed looks; the staff is intelligent, friendly, and helpful.

—*Minh Luong*

INMAN SQUARE

1369 Coffee House

Steamers, slides, and soup.
$
1369 Cambridge St., Cambridge 02139
(at Hampshire St.)
Phone (617) 576-1369
www.1369coffeehouse.com

CATEGORY Coffee Café

HOURS Mon-Thurs: 7 am-10 pm
Fri: 7 am-11 pm
Sat: 8 am-11 pm

GETTING THERE Limited metered parking- why not take the T? Red Line to Central Sq. will still leave you a bit of a hike. Or you can opt to take a bus, like the 83, 91 or 69, which will get you closer to your destination.

PAYMENT [$]

POPULAR DRINK Coffee, espresso, and loose teas; iced herbal tea in summer; frozen fruit or mocha "slides;" Italian sodas.

UNIQUE DRINK	London Fog: Earl Grey tea with vanilla extract and steamed milk. Homemade chai and hot chocolate. Candy apple cider (tastes like its name)!
SEATING	Large room with many small tables quite close together. Also minimal counter seating at window.
AMBIENCE/CLIENTELE	Award-winning café is bustling at nearly all hours, with a constant turnover of freelancers, students, parents with young children, tattooed hipsters, and Cambridge intelligentsia. Good music ranging from Gram Parsons to Beastie Boys. A fine place to hide on a rainy day, and one can only imagine the sheer number of dissertations completed here.
EXTRA/NOTES	Wi-Fi for sale by the hour, day or month. Keep the staff happy by ordering something every so often if you're on an extended visit. (They get a lot of customer complaints about the laptop militia.) If you're there at the right time of the day, you'll smell chocolate chip cookies baking out back.
OTHER ONES	757 Massachusetts Ave., Cambridge 02139, (617) 576-4600

—Alison Pereto

Bukowski Tavern

Popular Inman Square hangout for beer geeks and hipsters.
$$
1281 Cambridge St., Boston 02139
(at Prospect St.)
Phone (617) 497-7077

CATEGORY	Beer Bar
HOURS	Mon-Weds: 11:30 am-1 am
	Thurs-Sat: 11:30 am-2 am
	Sun: 11:30 am-1 am
GETTING THERE	Street parking, or MBTA bus #69, Harvard Sta./Lechmere Sta. via Cambridge St.
PAYMENT	$ ATM
POPULAR DRINK	There are about 147 bottled beers and 18 draughts available at Bukowski at any given time, so it is hard to say which is the most popular. This fact is supported by Bukowski's beer wheel, a Wheel of Fortune-esque spinning wheel – labeled "Spin it, you own it!" – mounted on the wall next to the bar. If the immense beer list is too intimidating, the wheel will pick a beer for you.
UNIQUE DRINK	While Bukowski boasts several exceptional and unusual offerings, if you're in the market for a truly unique beer, try Deus ($45). Deus starts off as a European-style lager, but then travels to the Champagne region of France, where champagne yeast is added. It then undergoes a secondary fermentation and two years of aging before it hits the bottle.
FOOD	The beer list is the reason why most people choose to go to Bukowski, but the food isn't half bad either. In fact, the sweet potato fries, served with a side of brown mustard, are to die for. After all, nobody wants to drink on an empty stomach.
SEATING	Two rows of diner-style, pleather-upholstered booths take up the middle of the space, while high tables surrounded by bar stools line the periphery. There's also plenty of standing room around the bar for when things get busy.

AMBIENCE/CLIENTELE Bukowski Tavern is named for Charles Bukowski, the prolific 20th century writer from Los Angeles who was often called the "poet-laureate of Skid Row." His poems decorate the walls of this broad, open space, and the clientele is of the ilk that might have one of his books in their messenger bag. The lights in Bukowski are kept dim, though during the day the vast window that takes up the whole front wall of the place lets in plenty of light. In warm weather, the staff opens up the windows so that the whole front of the restaurant becomes a sort of patio.

OTHER ONES 50 Dalton St., Boston 02215, (617) 437-9999

—Matt Rusteika

The Druid

Irish the Inman Way.
$$$
1357 Cambridge St., Cambridge 02139
(at Springfield St.)
Phone (617) 497-0965
www.druidpub.com

CATEGORY Irish Pub
HOURS Mon-Thurs: 11 am-1 am
Fri/Sat: 11 am-2 am
Sun: 11 am-10 pm
GETTING THERE Take the T to Central Square and be ready for a walk or bus it over. Parking can be difficult but not impossible. It's mostly metered parking.
PAYMENT
POPULAR DISH Meat-heavy Irish appetizers and entrees sure to please. Try the burgers and the Sunday Brunch is a must. For 10 dollars you can get yourself a damn good Irish Breakfast.
DRINKS Beer is the only true way to enjoy an Irish pub.
SEATING Aside from the bar, the small room has tables lining the walls. On a busy night you might find yourself hovering by the bar.
AMBIENCE/CLIENTELE This dark neighborhood bar draws in many locals for nightly brew. It can get rowdy, but in that mellow fun way that will keep you there for the long stretch.

—Victoria Young

East Coast Grill

Seafood, sangria, and spice.
$$$
1271 Cambridge St., Cambridge 02139
(between Prospect St. and Oakland St.)
Phone (617) 491-6568 • Fax (617) 868-4278
www.eastcoastgrill.net

CATEGORY American Bistro
HOURS Mon-Thurs: 5:30 pm-10 pm
Fri/Sat: 5:30 pm-10:30 pm
Sun: 11 am-10 pm
GETTING THERE Metered parking lines the streets, but they're usually-pretty filled. Check out the lot across the street at the Cambridge Nissan Shop where you can park for just $5 during the hours of 5:30 pm-11 pm. The nearest T-stop is a walk away in Central, but not terribly far. I recommend taking the bus.

PAYMENT	DISCOVER AMERICAN EXPRESS MasterCard VISA
POPULAR DISH	Cocktails here make it feel like summer all year round. Margaritas are a hit and a pitcher of sangria is perfect among friends.
DRINKS	Most people steer towards the internationally inspired seafood dishes and the raw bar. East Coast Grill has a dangerous love for spice they reserve for dishes marked with bombs on the menu made specifically for the steel-tongued. If you get your kicks from habanero overloads, check out their Hell Week.
SEATING	Aside from the bar, East Coast Grill is divvied up into festive rooms filled with booths and tables.
AMBIENCE/CLIENTELE	This is a great place to gather with friends and enjoy good food and drinks a plenty. It's mainly a dinner place but it's where to start off the night right. Especially if you'll be heading to more bars in the area.

—Victoria Young

HARVARD SQUARE

Border Café

Mo' better margaritas for your money.
$$$
32 Church St., Cambridge 02138
(at Palmer St.)
Phone (617) 864-6100
www.bordercafe.com

CATEGORY	Restaurant Bar
HOURS	Mon-Thurs: 11 am-1 am
	Fri/Sat: 11 am-2 am
	Sun: Midnight-1 am
GETTING THERE	Parking on the street is difficult in Cambridge, but there are a few nearby parking garages. Take the T – get off at the Harvard Sq. stop on the Red Line.
PAYMENT	AMERICAN EXPRESS MasterCard VISA
POPULAR DRINK	In a college town like Cambridge, a Mexican restaurant is judged first and foremost on the quality of its margaritas. Border Café delivers in terms of quality, variety and value. Try the Texas Margarita for a surefire hit. The frozen fruity 'ritas are also top-notch. Whatever drink you choose, you'll be under the table by round number three, but not out of money.
FOOD	The Cajun food puts Border Café over the edge. You can get spicy, pork-filled Jambalaya with any meal. Enchiladas and Burritos abound, along with some truly original and tasty entrees from Mexico, Texas and Louisiana. Of course, the fajitas are grilled to perfection.
SEATING	There are two floors for seating. The upstairs is noisy and rambunctious while the basement seems slightly more refined. The hosts are usually very accommodating when it comes to large parties, but if you get there later in the evening on the weekend expect to wait for a table. The bar area, raised up on a sort of indoor patio, feels small and tends to turn into a cattle pen very quickly at night. You'll want to sit down and have some enchiladas after your first drink anyway.

AMBIENCE/CLIENTELE The ambience is completely casual and rather youthful. It's better for a party than a date, and it's a favorite place for office lunches and dinners around Cambridge. If it's crowded, you might have to yell to be heard at the other end of the table.

—*Joe Gallagher*

Café Pamplona
A spanish oasis in Harvard Square.
$$
12 Bow St., Cambridge 02138
(at Arrow St.)
Phone (617) 492-0352

CATEGORY Coffee Café

HOURS Daily: 11 am-Midnight

GETTING THERE Parking is tough in Harvard Sq. Take the Red Line T to the Harvard Sq. stop or take the #1 Massachusetts Ave. bus to Quincy St. stop.

PAYMENT

POPULAR DRINK The Café Con Leche ($3.25) is fit for bringing your European friends around They also have teas, iced coffee, and everything you'd expect from a café drink list.

UNIQUE DRINK Their refreshing Italian sodas come in glasses of crushed ice and feature unusual flavors such as tamarind, mint, and almond.

FOOD Spanish delights such as tortillas de patatas, Cuban sandwiches, homemade empanadas; and tamales make you feel like you are dining in your Spanish abuela's kitchen.

SEATING Outdoor seating is where you'll find the patrons for most of the year. The tables are packed close together so expect to eavesdrop on your neighbor's conversation. Inside, the subterranean room looks exactly like what it is: a white washed basement. Be sure not to bring your super tall friends, they might not clear the ceiling.

AMBIENCE/CLIENTELE Café Pamplona is a Harvard Square institution that offers the European street-side café culture Cambridge style. The servers wear simple black and white uniforms, and they are pretty laid back. The clients are mainly Harvard-affiliated, hipsters, international students, and local literati. It's a great spot for people watching. You'll never know if a Nobel Laureate or a Pulitzer prize winner will be sitting next to you. And if they were you wouldn't care 'cause that's just Cambridge for you.

EXTRA/NOTES Free Wi-Fi is available for Facebooking, among other internet activities.

—*Minh Luong*

Charlie's Kitchen
A summertime gem and an all-year place to chill.
$
10 Eliot St., Cambridge 02138
(between Mt. Auburn St. and Bennett St.)
Phone (617) 492-9646 • Fax (617) 576-2315

CATEGORY Beer Bar

BREW 'N' VIEW

The Movies Get a Grown Up Refreshment

Leave your flasks at home, save those nips, and don't bother with large purses or baggy jackets. Drinking in movie theaters is a thing of the present and Davis Square's **Somerville Theater** has just what you want. Across the way from the candy, hot dogs and popcorn, the 21 and up concessions stand serves a small selection wines and Harpoon beers to round out your movie watching experience.

As with any privileges, there are a few drawbacks. Beer is served in plastic cups, which is more to the dismay of the environment than to the casual drinker. To keep the booze out of the hands of our youngsters, individuals are required to have the usual valid ID, and wristbands are distributed after the first round which they only allow a person to buy one drink at a time. And though you may have swiped plastic to get your movie tickets, the bar is cash only. However, unlike the scheming theme parks or music venues that tend to capitalize on ticket-holders with outrageous prices, Somerville Theater keeps their prices reasonable, so don't forget to tip your make-shift bartender.

There are predictable consequences that may result from mixing movies with insobriety. Cinematic judgment may be impaired to the point of enthusiastically recommending the latest Nicholas Cage blockbuster to your unsuspecting friends. The booze may also assist a tediously drawn out courtroom drama in lulling you into an hour long nap, so drink wisely, as always. Spice up an awkward date, turn a bad movie into a drinking game, or just celebrate the existence of a good movie with a cold brewski (because you can). Check your local listings and gather all your friends. It's time to brew 'n' view.

Somerville Theater
55 Davis Sq., Somerville 02144, (617) 625-5700,
www.somervilletheatreonline.com

HOURS	Mon-Thurs: 10:30 am-1 am Fri/Sat: 10:30 am-2 am Sun: 11:30 am-1 am
GETTING THERE	Parking can be difficult, but there is street parking if you can find it and pay lots. The Harvard stop (Red Line) is the nearest T-stop.
PAYMENT	
POPULAR DRINK	Beer or pitchers of such. Unfortunately, they no longer serve pitchers outside. I guess they figured out it was too wonderful to stay true.
FOOD	Great New England bar food munchies like waffle fries and cheap burgers.
SEATING	The downstairs has a long bar with diner booths. The upstairs has another bar with tables. The outside patio, open for the nicer seasons, has tables all around and a bar.
AMBIENCE/CLIENTELE	Harvard students flock here for a solid night of fun and the rest of Cambridge is well aware of the grungy allure

of Charlie's Kitchen. The breezy outdoor patio makes this place a shady gem of hot and humid Cambridge. Expect a huge summertime influx of sweaty and thirsty Bostonians looking for comfort in a pint glass.

—*Charlie Knoll*

Daedalus

Cool sophistication for the snob within the layman.

$$$

45 ½ Mt. Auburn St., Cambridge 02138
(at Bow St.)
Phone (617) 349-0071
www.daedalusharvardsquare.com

CATEGORY	Restaurant Bar
HOURS	Mon-Weds: 11 am-1 am
	Thurs-Sat: 11 am-2 am
	Sun: 10 am-1 am
GETTING THERE	Finding street parking is rare. Take the Red Line to Harvard. From there it's just a 5-7 minute walk.
PAYMENT	
POPULAR DRINK	Good wine selection, and an extensive scotch menu for the connoisseur.
UNIQUE DRINK	The "Coconut Mai Tai" is a sweet delight with two kinds of rum, pineapple juice, and a bit of grenadine.
FOOD	A fairly pricey, albeit romantic, restaurant by day, Daedalus is a good place to start the night.
SEATING	Decently large, especially when the outside roof deck is open. The bar areas can, however, become crowded at times.
AMBIENCE/CLIENTELE	On some nights you just want to belly up to a haggard pub table. Occasionally, however, even the boy/girl next door wants a roof deck, a fancy cocktail, and an excuse to wear something purty. Bars designed for chronic sophisticates tend to have snobbish overtones. Daedalus and its crowd seem to match the sophistication without alienating the common man. Average dress is somewhat fancier than pubwear, but nothing is required. With a decent wine list, 10+ beers on tap, and a full liquor selection, there's something for everyone to wield with their pinky directed skyward. Beginning the night as a slightly pricey, but quite tasty restaurant, the atmosphere is handed over to a smattering of grad and undergrad students at night, with warm lighting and a lovely remodeled roof deck for decent weather. Not cheap, but a great place for a special celebration.

—*Stacy Williams*

Darwin's Ltd.

Ideal venue for diligent workers or people-watching wallflowers.

$

148 Mt. Auburn St., Cambridge 02138
(at Brewer St.)
Phone (617) 354-5233
www.darwinsltd.com

CATEGORY	Coffee House
HOURS	Mon-Sat: 6:30 am-9 pm
	Sun: 7 am-9 pm

GETTING THERE	Some street parking is available, but difficult to find. A short (5-10 minute) walk from the Harvard T-stop.
PAYMENT	(MasterCard) (VISA)
POPULAR DRINK	This is a classic coffee shop without the bells, whistles, and sickly sweet dessert lattes of the popular chains. Darwin's features a wide selection of loose teas, freshly ground coffee and espresso drinks, and an array of bottled libations. Whatever you crave, you're not likely to be disappointed here. Great for a good 'old raw cup of coffee. Fair Trade is often available.
FOOD	The deli/sandwich shop will inevitably satisfy. For an end-of-meal treat, the café is stocked with fantastic fresh pastries, muffins, cookies and the like, all of which are an excellent complement to a great cup of coffee or tea.
SEATING	However comfortable, seating is limited, and the place is usually swarming with patrons in search of a place to settle. If you're lucky enough to get a cushy chair, hold on for dear life.
AMBIENCE/CLIENTELE	This Mt. Auburn St. establishment consists of three main compartments, serving many-a-useful-purpose. First, to satiate wanton tummies, there is the widely-praised sandwich shop offering a sophisticated selection that is friendly to vegetarians and rabid carnivores alike. Second, a small market with fresh produce, wine, beer, and a few other staples. Third is the self-proclaimed "shabby-chic" café, with cushy chairs and Wi-Fi access, where graduate students and borderline hipsters settle to gobble and sip. Save for the constant competition for space, Darwin's is the perfect atmosphere off the beaten path in which to study, work, or catch up with friends on a Saturday afternoon.
EXTRA/NOTES	Worth noting: both the Mt. Auburn St. and Cambridge St. locations are staffed with hot young hipsters, eye candy for those who enjoy thick-rimmed glasses and a smattering of tattoos. Service is generally efficient and civil, but just icy enough to play hard-to-get and leave you coming back for more.
OTHER ONES	1629 Cambridge St., Cambridge 02138, (617) 491-2999

—Stacy Williams

Grafton Street

Elegant yet accessible intoxication in the heart of Harvard.
$$$
1230 Massachusetts Ave., Cambridge 02138
(at Bow St.)
Phone (617) 497-0400
www.graftonstreetcambridge.com

CATEGORY	Restaurant Bar
HOURS	Mon-Weds: 11 am-1 am
	Thurs-Sat: 11 am-2 am
	Sun: 11 am-1 am
GETTING THERE	Parking is a nightmare in Cambridge, though Grafton offers valet parking Weds– Sat from 6 pm. Take the Red Line to Harvard and walking a block is advisable.
PAYMENT	(AMERICAN EXPRESS) (MasterCard) (VISA)
POPULAR DRINK	Many bars lack in the wine department, so if you're a fan, go for it. Really, though, there's something for everyone, even tea or cappuccino (and other coffee variants) for those who are opting out of alcohol.

FOOD A somewhat pricey, yet surely delicious menu is available from 11 am on. If you'd like to start your night off with a belly full of happy eats, this is a good place to go.

SEATING As a restaurant, the place is large and comfortable, especially as the weather warms up and outside seating is available. It can get crowded late on a weekend, but still has many areas in which to settle.

AMBIENCE/CLIENTELE Named after the tourist-laden shopping district in Dublin, Grafton offers a classy ambience without oft-associated snobbery. Simply want a beer, cocktail, or glass of vino post-hard-day-of-work? Come on in! The selection for all is ample (though again, not cheap). Bar and wait staff are friendly and eager to please. Thurs-Sat nights, DJs turn the classy façade into a room of well-dressed undergrads (and a smattering of older students), as the bar borders on the Harvard campus. Warm, elegant ambience, good food, myriad choices of libations, Grafton Street is an all around great choice for a 'place to take an out-of-towner' in search of Cambridge/Harvard culture.

—Stacy Williams

Grendel's Den

Funky Harvard Square bohemian rendezvous.

$

89 Winthrop St., Cambridge 02138
(at JFK St.)
Phone (617) 491-1160
www.grendelsden.com

CATEGORY Beer Bar

HOURS Daily: 11:30 am-1 am

GETTING THERE Grendel's validates for the Harvard Sq. Parking Garage (1 Eliot St.), Charles Hotel Garage (1 Bennet St.), and University Place Garage (124 Mt. Auburn St). Street parking is very limited. Also, Red Line to Harvard Sq. or a wide variety of MBTA buses.

PAYMENT

POPULAR DRINK Grendel's boasts a diverse list of craft beers from around the country and beyond. Taps (which top out at around $5) range from Guinness to Magic Hat #9, to the Amber Ale from right down the street at Cambridge Brewing Company. If that doesn't suit your fancy, there's a long list of bottles as well, written in brightly-colored marker on a board behind the bar.

UNIQUE DRINK In the summertime, potent Mojitos and lemonade are made from scratch; in the winter try hot rum cider and the Fallen Apple (vodka, apple cider, apple liqueur, and a splash of Jaegermeister). Or, embrace the arty vibe of the place with a sugary glass of imported Lucid absinthe.

SEATING Colorfully tiled tables for two to four people fill the front of the space; wooden tables and chairs take up the back. Larger parties efficiently pack into the several big tables that mark the corners of the underground space. The centerpiece of the Den is the semi-circular wooden bar: everyone sitting around it can see everyone else without really having to turn their head.

AMBIENCE/CLIENTELE The close proximity of Grendel's to Harvard packs the place nightly with students, professors, and staff from the University. The subterranean hangout is also a

popular destination for the Cambridge and Somerville hipster crowd, vast numbers of tourists, and thanks to its homey, informal atmosphere, about anybody at all.

EXTRA/NOTES Grendel's Den is one of the last remnants of a once-thriving Harvard Square hippie scene. Even today, Grendel's resists corporate homogenization: they don't carry Bud, Miller, Coors, Michelob, or any other Massachusetts-produced light beer. Their focus on quality has kept them in the same spot for 37 years, and there are regulars at the bar (and at least one waitress) that have been coming down to Grendel's since the very beginning. Only a truly great haunt inspires that kind of dedication.

—*Matt Rusteika*

John Harvard's

 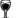

Get your degree in inebriation at this reputation-tainting brewery.
$$
33 Dunster St., Cambridge 02138
(between Dane St. and Centre St.)
Phone (617) 868-3585 • Fax (617) 868-4341
www.johnharvards.com

CATEGORY College Brewery

HOURS Mon-Thurs: 11:30 am-12:30 am
Fri/Sat: 11:30 am-1:30 am
Sun: 11:30 am-Midnight

GETTING THERE Street parking is rare, but there are pay lots too. The nearest T-stop is Harvard stop on the Red Line.

PAYMENT

POPULAR DRINK Unfiltered lagers and ales are brewed in-house, each made with fine ingredients that embolden the individual flavors. Get your fill with 10 oz. glasses, pints or pitchers.

UNIQUE DRINK John Harvard's pulls from over 250 recipes to make a few small batches of brew at a time. Check each day to see what's on their rotating menu of 5, or try a flight of the day's tap and get to know all the beers.

FOOD Quality food for a reasonable price. Sandwiches and burgers are popular but the entrees and specialties are more enticing but for a bit more out of the wallet.

SEATING The underground world of John Harvard's is an unexpectedly vast space of sturdy wooden tables and booths that can accommodate most serious diners immediately. A super family-sized roundtable is designed for large parties to take over a murky corner. The bar area is usually packed with people and open high tops are an uncommon luxury.

AMBIENCE/CLIENTELE The subterranean essence is retained with rich woods, dim cave lighting and rocky stone walls all around. Music plays loudly in the background, but all you can hear over the chat-happy crowd is the bass line. Even the traditional stained glass figures with famous faces smirk upon the hoards of Harvardites having a ruckus-inducing good time.

EXTRA/NOTES John Harvard was a 17th century English clergyman after whom Harvard University was named. It's a shame you can't receive credit for attending this pub house.

—*Victoria Young*

Noir

The place for last call, y'all.
$$$$
One Bennett St., Cambridge 02138
(between University Rd. and Eliot St.)
Phone (617) 661-8010
www.noir-bar.com

CATEGORY	Cocktail Lounge
HOURS	Daily: 4 pm-2 am
GETTING THERE	Red Line to Harvard Sq.; $10 validated parking after 5 pm in Charles Hotel garage.
PAYMENT	
POPULAR DRINK	Cocktails are the prevailing drinks here because Noir seems to always be on the cutting edge of mixology. They have a "Classic Cocktails" list, which includes the good ol' Sidecar. Think lots of muddling, sugared rims, bitters, and champagne floats. The mojitos are first rate as well. Expect well-mixed drinks with top shelf liquor.
UNIQUE DRINK	Noir's seasonal cocktail menu is always full of interesting choices such as the Naughty O'Pear: Grey Goose "Le Poire," Poire William, pear nectar, and champagne; Mika's Cup: Pimm's Cup, Hendrick's and ginger ale served with fresh ginger and a cucumber; Blue Velvet: blueberries and grapes with Idol Vodka, Blonde Lillet, simple syrup, and a champagne Float; Earl Grey Iced Tea: Milagro Tequila with Earl Grey Iced Tea, simple syrup, and lemon; chartreuse basil, green chartreuse, basil, fresh lime and simple syrup, shaken, strained and served up.
FOOD	Food is available until 11 pm and includes small plates, sandwiches and flatbread pizzas and that will enable you to keep drinking until close.
SEATING	Comfy booths, tables, a small bar, and outdoor patio.
AMBIENCE/CLIENTELE	Anyone that goes out in Cambridge knows that because it's in a hotel, Noir is the only place to have a 2 am liquor license every day of the week, thus it attracts a good last call crowd after the other bars close at 1 am. So don't be surprised to see some familiar faces from the bar you just left. The clientele is a good mix of industry people grabbing a drink after work, grad students and locals in the 25 and up age range.
EXTRA/NOTES	Mon-Thurs from 5 pm-9 pm they have an amazing Happy Hour Deal called 5-4-3-2-1-0. With a minimum $6 beverage purchase you can get $5 flatbread pizza; $4 sandwiches; $3 snacks (Get the artichoke parmesan dip!) $2 salads; $1 sweets; $0 nuts.

—*Minh Luong*

Shay's

A kickback bar that doesn't mind the smoke.
$
58 JFK St., Cambridge 02138
(between Winthrop St. and South St.)
Phone (617) 864-9161

CATEGORY	Beer Pub
HOURS	Daily: 11 am-1 am
GETTING THERE	No parking spots, so stick with the lots. The Harvard stop on the Red Line is just a close to Shay's.
PAYMENT	

POPULAR DRINK	The beer list is decent, especially the bottled selection, and for a good price. Even though there is equally proper wine list, people tend to go for beers. No full bar here.
UNIQUE DRINK	Try a snakebite. Sam and cider. It's a rattler.
FOOD	Tex Mex picks and pub grub sandwiches and apps. Burgers here are exceptional.
SEATING	The small outdoor patio is a big hit, especially among smokers. There are just as many tables outside as their are in the front inside area. The rest of the bar is made up of stool seating, either for the oddly-shaped bar or the tall counter top against the wall.
AMBIENCE/CLIENTELE	You get a lot of laid back people here who venture here to drink and socialize. And if you're a smoker, you come here to smoke too (outdoors, of course). It's just a mellow place to be on a nice evening.

—*Jason Burnsworth*

Tealuxe

A tea lover's mecca.

$

9 Brattle St., Boston 02108
(between Sparks St. and Appleton St.)
Phone (617) 441-0077
www.tealuxe.com

CATEGORY	Tea House
HOURS	Mon-Thurs: 8 am-10 pm Fri/Sat: 8:30 am-10:30 pm Sun: 8:30 am-10 pm
GETTING THERE	Parking around Harvard Sq. is a nightmare. There are a few meters. The bus or T (Red Line) to Harvard Sq.
PAYMENT	DISCOVER AMERICAN EXPRESS MasterCard VISA
POPULAR DRINK	The bubble tea and traditional flavors are staples but there are about 70 different teas to choose from. The Kashimir Chai is full of delicious cardamom, tellicherry pepper and spice notes, perfect for a frosty winter afternoon. Soy milk available.
UNIQUE DRINK	Chocolate tea (and yes, it is surprisingly delicious). There is also white tropical tea with coconut and pineapple, decaf green ginger peach and butterscotch caramel, to name a few.
FOOD	At this location, cookies, coffee cakes, and sometimes pie. At larger locations, such as Newbury St., expect table service and a whole menu of salads and sandwiches (mmm, toasted sandwiches).
SEATING	The tea shop is very quaint and cozy, which is also another way of saying it is small, so seating is limited.
AMBIENCE/CLIENTELE	This location has a very "Harvard Square" feeling; a big, young and alternative crowd frequents the place. You can feel an artistic vibe in the air. It is also the perfect setting to plop down with your laptop and enjoy a few hours as you sip your tea.
EXTRA/NOTES	You can buy the tea loose leaf to go. The best buy is to get one of the prepackaged sets of tea which has 3 tins at 80 grams of tea each (about 40 cups per tin); the prices ranges from $18-35 depending of which teas blends you choose. They also sell all kinds of tea paraphernalia.
OTHER ONES	108 Newbury St., Cambridge 02138, (617) 927-0400

—*Leah Bagas & Alison Pereto*

PORTER SQUARE

Boca Grande Taqueria

Authentic Mexican watering hole.

$

1728 Massachusetts Ave., Cambridge 02138
(at Linnaean St.)
Phone (617) 354-7400
ww.bocagranderestaurant.com

CATEGORY	Smoothies/Juice Bar
HOURS	Daily: 10 am-10 pm
GETTING THERE	Red Line to Porter Sq. Stop; #77 bus along Massachusetts Ave.
PAYMENT	AMERICAN EXPRESS, MasterCard, VISA
POPULAR DRINK	Freshly squeezed lemonade is the perfect summer cooler, not too sour or sugary. Garnish with a big fat lemon wedge. Also, cool down with any of the ten varieties of Jaritos, fruity sodas straight from Mexico.
UNIQUE DRINK	Mexican Horchata, a sweet milky agua fresca made from rice and cinnamon.
FOOD	Good burritos and taco plates at great prices that the college students love to eat up.
SEATING	Plenty of tables of different sizes.
AMBIENCE/CLIENTELE	Real-deal Mexican at affordable prices attracts all types. Large enough for big groups or good for a quick, casual bite.
OTHER ONES	• 1294 Beacon St., Brookline 02446, (617) 739-3900 • 149 First St., Cambridge 02142, (617) 354-5550 • 366 Washington St., Brighton 02135, (617) 782-9600 • 642 Beacon St., Boston 02215, (617) 437-9700

—*Sarah Black*

Café Zing
at Porter Square Books

Coffee that goes well with "fiercely independent" books.

$$

25 White St., Cambridge 02138
(between Massachusetts Ave. and Elm St.)
Phone (617) 497-9464
www.portersquarebooks.com

CATEGORY	Coffee House
HOURS	Mon-Fri: 7 am-9 pm Sat: 8 am-9 pm
GETTING THERE	Parking in the Porter Sq. Shopping Center lot (just outside the door). Red Line T to Porter Sq.; #77, 87, or 96 bus to Porter Sq.
PAYMENT	$
POPULAR DRINK	Try the Yerba Mate tea (hot or iced), any espresso drink, or in the winter months, the Spicy Aztec Hot Chocolate, which is unlike any other hot chocolate north of the river.
UNIQUE DRINK	As the café compliment to a "fiercely independent" bookstore, it's no surprise that coffee and tea tend to be organic, fair trade, and delicious.
FOOD	Along with the usual array of scones, cookies, and full o' bran muffins, Café Zing makes its own Vietnamese summer rolls (tofu and veggies in a cold wrap). They

SEATING are amazing, but sell out early (1 for $3, 3 for $5, with peanut sauce for dipping).

SEATING Seating is extremely sparse. Be prepared to fight for laptop or study space at the 6-seater counter or at one of two tiny tables (that look more like footstools). But if you're flexible, you can sip your beverage while browsing through the bookstore or admiring the lovely view of the parking lot from benches outside.

AMBIENCE/CLIENTELE The staff is friendly but there is an air of a neighborhood in-crowd; several features of Café Zing, like the famous "Coffee Ring" (a digital frequent buyer discount program) are just out of sight. Since it's frequented primarily by Cambridge locals and Harvard graduate students, your neighbor at the counter will probably be less than eager to strike up a chat. But if you join the Coffee Ring or ask for Vietnamese rolls, you too can feel like a Zing Insider.

EXTRA/NOTES Implausibly enough, it's cash only. There's no better way to out yourself as a first-time Zinger than to flash your credit card, or worse: whine.

—*Kim Liao*

Jose's Mexican Restaurant

A Mexican Margarita fiesta tucked away in West Cambridge.

$$

131 Sherman St., Cambridge 02138

(at Bolton St.)

Phone (617) 354-0335

www.JosesMex.com

CATEGORY Cocktail Bar

HOURS Mon-Thurs: 11 am-10 pm
Fri/Sat: 11 am-Noon
Sun: 10 am-10 pm

GETTING THERE Free parking in a lot on left just past the restaurant, just before the railroad tracks.

PAYMENT

POPULAR DRINK You have to walk into Jose's with the attitude that if it doesn't have tequila in it's not worth drinking. They have an impressive selection of 32 different tequilas, so step outside of your Patron and Jose Cuervo comfort zone and try some of their snifter worthy tequilas. If you must dilute your tequila try one of their special margaritas, which come in two sizes, small and large. Try Jose's 24 –Karat Gold Margarita with Conquistador tequila and a Grand Marnier float, or get your Spring break on with a Tropical Margarita blended with mango, peach, strawberry, raspberry or blue Hawaii. To maintain your hand-eye coordination in between Margaritas, drink one of their 10 Mexican beers, which are only $3.75 each.

UNIQUE DRINK This is one of the only places which offers a michelada, what I call the poor man's margarita, on the drink menu. Made with Mexican beer and fresh lime juice over ice and served with salted rim, micheladas are a refreshing beverage enjoyed regularly in Mexico. Kids and adults alike will love the homemade horchata, a milky colored rice-based beverage with cinnamon, sugar, and vanilla.

FOOD Good Mexican mole can be hard to find in these parts. Try the Enchiladas con Mole, if you enjoy those Aztec flavors of chocolate, chilies and spices. Jose's also offers

a good selection of hearty burrito plates that can be customized to your taste. Also, every meal begins with free homemade tortilla chips and salsa. You will probably want seconds! Dona Reyna's Chile Rellenos are irresistible and sublime. They are made with poblano peppers stuffed with your choice of chicken or cheese, and then batter dipped and fried and topped with salsa verde. This place is heaven for people who enjoy spicy foods, however, do not be shy about asking for less spicy versions of your dish. The staff is very accommodating and can often help you come up with different sauces and combinations to suit your taste.

SEATING Jose's offers abundant seating indoors and outdoors, as well as a small bar. Plan ahead and make a reservation for large parties.

AMBIENCE/CLIENTELE Jose's feels like a culinary oasis on a Mexican road trip. The decor embraces the colorful decorative arts tradition of Mexico, charming lights, and the sound of wistful Mexican ballads. The clientele of neighborhood patrons, couples on their first dates, and those willing travel from across town to have an authentic taste of home cooked Mexican cuisine while enjoying the finest, most affordable election of tequilas around.

—*Minh Luong*

Lizard Lounge

A comfy subterranean nesting hole for reptiles and humans of all walks of life.

$$

1667 Massachusetts Ave., Cambridge 02138
(at Wendell St.)
Phone (617) 547-0759
www.lizardloungeclub.com

CATEGORY Cocktail Lounge

HOURS Mon: 9 am-1 am
Tues/Weds: 7:30 am-1 am
Thurs-Sat: 7:30 am-2 am

GETTING THERE You can park in the back of Cambridge Common. If you're taking the T, take Red Line to Porter Sq. stop.

PAYMENT

POPULAR DRINK Good selection of beers, rotating as the seasons roll along, from beloved pumpkin ale to bottles of throaty Stone Arrogant Bastard Ale.

UNIQUE DRINK A number of unique cocktails, but nothing too groundbreaking. A Margarita with (gasp!) Chambord. A Long Island Ice Tea with (oh heavens!) Banana Liqueur and Sprite. Stick with your favorites, old scout.

FOOD Standard, albeit tasty, fare. The sweet potato fries are worth a sampling, natch.

SEATING A decent number of tables, about 2/3 of the room gets to sit. But, hey, there's plenty of room to lean, too. Holds about fifty patrons.

AMBIENCE/CLIENTELE The red lights, the low ceilings, the stairway descent; this place emanates cool. Seems very much like the after-hours joint that curfew-minded Boston so desperately needs, this is as close as we'll get it seems, so drink it in. Crowd ranges from mid-twenties to the coolest of the septuagenarians. Definitely a casual place to hang out and catch a drink and some music. Come with friends, bring a date, go it solo, it's all gravy, baby.

EXTRA/NOTES Live shows five nights a week, six if you count open mic night on Monday, seven if you count Sunday's

poetry jam/slam (words got rhythm too, man). Check the website for the exact opening times each night.

—*Django Gold*

The Tavern

A great place to watch the game-any game!

$$

1815 Massachusetts Ave., Cambridge 02138
(at Porter Sq. T)
Phone (617) 354-7766
www.taverninthesquare.com/portermain.html

CATEGORY	Sports Bar
HOURS	Mon-Thurs: 11:30 am-1 am
	Fri: 11:30 am-2 am
	Sat: 10:30 am-2 am
GETTING THERE	The Tavern is located directly around the corner from the Porter Sq. stop on the Red Line.
PAYMENT	
POPULAR DRINK	They offer a full bar, but it seems to be mostly a beer establishment.
FOOD	The menu is AWESOME! Page after page of delicious sounding food that won't disappoint.
SEATING	There is extensive seating, including a small outdoor patio facing Massachusetts Ave.
AMBIENCE/CLIENTELE	A wide mix of people, most of whom are sports fans. The atmosphere is very relaxed, except when the game of the hour is intense!
EXTRA/NOTES	The staff here is outstanding, especially at the bar. They also offer the full sports package so even if you're from outside the Boston area, you can watch any and all of your hometown sporting events, just ask the bartenders! Stump Trivia also available both Monday and Wednesday nights.
OTHER ONES	730 Massachusetts Ave., Cambridge 02139, (617) 868-8800

—*Sarah Wolf*

Temple Bar

Flock here for holy and decent sacrament!

$$$

1688 Massachusetts Ave., Cambridge 02138
(at Sacramento St.)
Phone (617) 547-5055 • Fax (617) 547-8650
www.templebarcambridge.com

CATEGORY	Cocktail Lounge
HOURS	Mon-Fri: 5 pm-1 am
	Sat/Sun: 10:30 am-1 am
GETTING THERE	T to Porter; #1 bus on Massachusetts; on-street parking on Massachusetts Ave.
PAYMENT	
POPULAR DRINK	A nice selection of beer and wine.
UNIQUE DRINK	Cocktail highlights include Death in the Afternoon, made of absinthe and cava.
FOOD	Like other aspects of TB, the food is good and portions are generous. Standouts include "lomi lomi" salmon ceviche and gnocchi.
SEATING	TB offers enough seating for the whole congregation. Semi-private groups can be hosted.

AMBIENCE/CLIENTELE	The decor is nice but insipid in a Banana Republic-Starbucks-Pottery Barn sort of way. In the shadows of Harvard Law School, grad students and professionals (30-50) will enjoy TB; hipsters from Allston, not so much. You can take your parents here and they won't complain that the music is too loud.
EXTRA/NOTES	Make reservations to request a booth on the far left side of the restaurant (spacious booths; intimate for couples and comfortable for groups of 4).

—*Joshua Goldstein*

West Side Lounge

Low-key lounge that brings out the cool in everyone.
$$$
1680 Massachusetts Ave., Cambridge 02138
(between Hudson St. and Martin St.)
Phone (617) 441-5566
www.westsidelounge.com

CATEGORY	Neighborhood Bar
HOURS	Mon-Weds: 5 pm-Midnight
	Thurs-Sat: 5 pm-1 am
	Sun: 11 pm-11 pm
GETTING THERE	Street parking fills up. Take the Red Line to Porter Sq.
PAYMENT	
POPULAR DRINK	A constant favorite at West Side is their mojito. Their mojito comes in a pint glass and is bursting with minty, summery freshness. The sugar, lime and mint are muddled to perfection and just cover the taste of the rum without completely obscuring it. And the dash of club soda seals the deal. There's nothing worse than a flat mojito, and you won't get one here.
UNIQUE DRINK	Sometimes the name of a drink is more enticing than the actual cocktail itself. Not so with West Side's Blood and Sand. It might take you a few visits to get past that name, but once you do, you'll keep ordering. Scotch, cherry brandy, sweet vermouth and orange juice are shaken with ice and served straight up in a martini glass. The cloudy brown color is almost as off-putting as the name, but one sip plunges you into a swirl of sweet and smoky goodness. The cherry balances out the pungency of the scotch and the OJ ties everything together.
FOOD	You can order West Side's full menu at the bar. The entrees are on the pricier side, but the appetizers make for tasty, more reasonable bar fare.
SEATING	The bar at West Side sits along on wall and is not huge. With about 15 seats, it can be tough to find two together, but even if you're peeking between two patrons to try and order a drink, the bartender will swiftly and cheerfully see to what you need.
AMBIENCE/CLIENTELE	If you're a local who's looking for some solitude with your drink, you've found the right spot. At the same time, if you want a bit of conversation, the gregarious bartenders will be happy to oblige. You might secretly feel cool and in-the-know sipping cocktails at West Side, but you won't feel like a poser. As stylish as it is, it never crosses the line to pretentious. If you're wondering what exactly a caipirinha is, the bartenders will tell you, and they won't imply you're moronic for not knowing. Whether you're in your twenties or your fifties (and the diverse crowd definitely varies), West

Side is about enjoying your cocktails, your friends, or the atmosphere. And as the night wears on and the bar empties out, the soft, low lighting and subtle music even encourage you to enjoy a little seduction.

EXTRA/NOTES The tables at West Side are reserved for diners until around 9pm. If you're on a date, take advantage of one of the corner booths to sit tantalizingly close together as you sip your drinks.

—*Siobhan Ford*

WEST CAMBRIDGE

True Grounds

Oh, the Terroir!

$$

717 Broadway, Somerville 02144
(at Willow Ave.)
Phone (617) 591-9559
www.truegrounds.com

CATEGORY Coffee Café

HOURS Mon-Thurs: 7 am-9 pm
Fri: 7 am-7 pm
Sat/Sun: 8 am-7 pm

GETTING THERE Metered street parking, tighter on weekends; 89 bus on Broadway; Red Line to Davis, walk north on College Ave. (10 min.), right onto Broadway.

PAYMENT $

POPULAR DRINK Local Terroir espresso and coffee, excellently made; many loose teas; chai; Italian sodas; "Raz Mocha" (raspberry mocha) and other permutations of flavored chocolatey/coffee goodness; honey latte.

FOOD Cedar sandwich (homemade hummus, lettuce, sprouts, shredded carrots, cukes and Granny Smith apple); Tunapple wrap (tuna, apples, mesclun salad, walnuts and balsamic dressing); Kitchen Sink cookie (cranberries, chocolate chips, white chocolate, nuts). Food from local sources whenever possible.

SEATING A couple of couches and many small tables. Very crowded on the weekend and midterm/finals week. Hover near the milk/sugar stand and pray for turnover.

AMBIENCE/CLIENTELE Your living room has turned into a café, but with tiled floors and more lime green. During the week, Tufts students and other laptop denizens slave away to a soundtrack of Blondie and Radiohead. On weekends, families gather at the larger tables while solitaries lose themselves in a book or crossword. Staff is friendly and responsive. Free Wi-Fi, but no cell phones allowed!

EXTRA/NOTES True Grounds features an ever-rotating selection of local art, a small bookshelf offering everyone from Marquez to Crichton, and board games. Cool mosaic-top tables hold laptops but make crayon drawings bumpy. Seasonal hours, so call first on that dark winter evening as the place may have closed at 7 pm. A popular and cozy place for local "game nights" and knitting groups.

—*Alison Pereto*

SOMERVILLE

DAVIS SQUARE/TEELE SQUARE

Blue Shirt Café

Cheap and healthy. Simple as that.

$

424 Highland Ave., Somerville 02144
(at Elm St.)
Phone (617) 629-7641
www.blueshirtcafedavis.com

CATEGORY	Smoothies/Juice Bar
HOURS	Daily: 8 am-10 pm
GETTING THERE	There is metered street parking available which can be difficult at times. On the T, take the Red Line to Davis.
PAYMENT	
POPULAR DRINK	Of all the light and fruity smoothies to choose from, the Peanut Butter Delight, made with peanut butter, bananas, low-fat milk, non-fat yogurt, and chocolate syrup, is the top pick of the public. From the juice blends, the Apple-A-Day (apples, lemon, and ginger) is tops.
UNIQUE DRINK	A healthy, but odd juice concoction is the Creative Cocktail: pineapple, pear, wheatgrass and mint.
FOOD	Sandwiches and wraps make up the bulk of their edibles menu. Vegans and vegetarians will be most pleased with the variety of selection for their choosing, thanks to tofu. Come early (8 am-10 am) and check out the breakfast menu: eggs, pancakes, meat (or non-meat) and other food choices.
SEATING	There is the main ordering room, which has a few tables to sit at, but generally people mosey on over to the quieter seating room made up of tables aplenty. The room is essentially dedicated to making sure seating will be available.
AMBIENCE/CLIENTELE	The lime green walls with the vibrant photographs warm up the otherwise dreadfully dull, but efficient, layout of the place. Patrons are generally health-conscious, vegan, vegetarian, wise-budgeters, workaholics, students, or all of the above. It's cheap, it's healthy, and it's good. It pretty well fits in with most people's agendas.

—Deepak O'Reilly

The Burren

The quintessential Irish pub.

$

247 Elm St., Somerville 02144
(between Chester St. and Grove St.)
Phone (617) 776-6896
www.burren.com

CATEGORY	Neighborhood Pub
HOURS	Mon-Thurs: 11 am-1 am
	Fri/Sat: 10 am-2 am
	Sun: 11 am-1 am
GETTING THERE	Take the Red Line to the Davis Sq. Stop. If you are driving, there is a parking lot behind the Burren.
PAYMENT	
POPULAR DRINK	Guinness. The obvious must be stated. Beer lovers will rejoice at the selection of over 40 beers (20 on tap

and 20 bottled). Choose from Magner's Irish Cider, Boddington's, Stella Artois, and Czech Rebel to name a few. They also have a few wines by the glass, but people clearly come here for the brew.

UNIQUE DRINK Raspberry Cider Jack on draught; Sam Adams 375 Year Anniversary Ale.

FOOD The only proper Irish complement to your Guinness is more beer. Much on the Burren's beer battered fish and chips or the Guinness beef stew.

SEATING You can either grab a seat at the warm wooden bar after you walk in or at the tables that line the walls in the front room, or you can take a seat in back area.

AMBIENCE/CLIENTELE The Burren is a genuine Irish pub. You won't feel like you are walking into a tourist trap parody of an Irish bar. The crowd at the Burren is an interesting mix of college kids and Somerville locals, usually all looking to have a laid-back good time.

EXTRA/NOTES There is live Irish music seven nights a week. Music can be fairly loud during the evening, but you can still have a conversation. There is no dress code so leave your haute couture at home. The Burren is casual.

—*Arna Wilkinson*

Diesel Café

Fuel up on coffee drinks.
$
257 Elm St., Somerville 02144
(between Day St. and Grove St.)
Phone (617) 629-8717
www.diesel-cafe.com

CATEGORY Coffee Café

HOURS Daily: 7 am–11:30 pm

GETTING THERE Take the Red Line to the Davis Sq. Stop. The T is recommended over driving.

PAYMENT

POPULAR DRINK Choose from a plethora of automobile-themed coffee drinks, such as "The Accelerator," (vanilla latte with almond). Hot chocolate connoisseurs should definitely take a taste of "Tuck's Turtle," (caramel, hazelnut syrup in hot chocolate with whip cream). Diesel also has a wide variety of teas.

FOOD To curb your caffeine jitters, feast on some of Diesel's sandwiches. Meat-eaters can munch on the "Monkey Wrench," a pile of turkey, avocado, tomato, lettuce, havarti, dill, and sprouts. Vegetarians can get filled up on the "Lil' Piston," which is made up of mozzarella, homemade pesto, tomatoes and greens.

SEATING Diesel is huge. If you require seating variety, this is your place. They have retro red booths, comfy couches and tiny tables so you can select your seat depending on your caffeine-saturated needs.

AMBIENCE/CLIENTELE The artist? The student? The hipster? The computer nerd? Yes, they are all here at this casually hip café. With its pool tables, old school photo booth, typewriters and candy-colored walls, Diesel Café is an equally great place if you are hanging out with friends, on a low-key date, or if you need to sip something solo.

EXTRA/NOTES Diesel and Bloc 11 are sister cafés.

—*Arna Wilkinson*

Diva Lounge

A funhouse for adults.

$$

248 Elm St., Somerville 02144
(at Chester St.)
Phone (617) 629-4963

CATEGORY	Cocktail Lounge
HOURS	Daily: 5 pm-1 am
GETTING THERE	Metered street parking isn't easy The closest public transit is the Red Line T-stop at Davis.
PAYMENT	[credit card logos]
POPULAR DRINK	Overall, the specialty martinis are the main squeeze. Exotic ingredients, like all-spice infused vodka or fruit purees, are used in each drink to liven up the selection. As for the favorite pick, that's a toughie. Even the bartenders will tell you it's difficult to suggest any one beverage. They all have their own qualities that appeal to different people. I guess that means you'll have to try them all.
UNIQUE DRINK	Spice up your night with some of these Indian inspirations: Mirchitini: Rangpur Tanqueray, muddled jalapenos, green chili pepper, cucumbers, cilantro, and simple syrup; Teeka Meeta: mango-infused Reyka vodka, cayenne pepper, fresh tamarind, pineapple juice
FOOD	Find some quick and tasty bites on the Indian Tapas bar menu like small plates of mini-burger lamb sliders or skewers of chicken lollipops. If you crave more than tapas can offer, Diva India Bistro, a classy sit-down restaurant that looks nothing like its sister counterpart, is just a doorway away from the lounge.
SEATING	Juxtaposed to the bar lies a strip of lounge seating with pillows and partitions. On a happening night, this space can crowd up quickly. Then begin the standing wars, let alone the dancing wars.
AMBIENCE/CLIENTELE	This is like no other lounge. The walls and ceiling are infested with masses of white bubbles backlit with a psychedelic array of colors. The pod-shaped bathrooms look like futuristic spaceship compartments and a cascade of warped mirrors add a hint of carnival to the joint. Willy Wonka would feel right at home. With DJs blasting music every weekend, the vibe can switch from lounge to club if the crowd wills it so. Most people come in for the atmosphere, which is unlike anything in Davis. And occasionally the madness will attract plenty of snoots and suits looking for a stylish spot to saunter around (And they've found it.)

—*Victoria Young*

Johnny D's

Music quenches a thirsty soul.

$$

17 Holland St., Somerville 02144
(between Winter St. and Elm St.)
Phone (617) 776-2004 • Fax (617) 628-1028
www.johnnyds.com

CATEGORY	Beer Club
HOURS	Mon-Fri: 12:30 pm-1 am
	Sat/Sun: 9 am-1 am
GETTING THERE	Across from the Davis stop off the Red Line (Holland St. exit). There is metered parking for drivers and a few bus routes that run through Davis Sq.

PAYMENT

POPULAR DRINK The variety in music each night draws in a mix crowd. There is no drink left unordered. Considering the Saturday/Sunday Jazz Brunch every weekend, the bartenders can whip up a mean Bloody Mary.

UNIQUE DRINK The Horny Pirate is a Johnny D's original made up of rum and pineapple juice with a splash of grenadine and lime. The question remains: who doesn't enjoy a horny pirate? Yaar-har.

FOOD When I think Johnny D's, I think music. Then drinks. Then get distracted by something shiny. Point being, I don't go there for the food. Not that it doesn't make for a good casual date locale, I'm just usually driven there by something more potent than hunger: drinkin' up and gettin' down. If you're curious, try the catfish for starts.

SEATING The club has a smart set-up with regards to their heavy focus on live performances. Even though the bar is the furthest seating entity from the stage, it is fully encompassed with bar stools that have viewing potential from every nook. Surrounding the stage, a medley of tables and booths are available for those looking for a meal to accompany their music. But even with plenty of seating, some nights it can still be difficult to find a place for your butt. If you're hoping to make a night of it with dinner and a show, I recommend reservations.

AMBIENCE/CLIENTELE Johnny D's is fashioned in such a way as to facilitate the travel of music to each and every ear. It's as if they knocked down walls just to provide more space for the sound waves. The decor doesn't take itself too seriously and the exposed brick behind the stage gives the place a mellow feel. Depending on the night, which really means depending on the music, the clientele can vary greatly. The club has a 300 person seating capacity, so it has the potential to get crowded quite easily. Even during the slower hours, the bar staff is attentive and prepared for an unforeseen rush of thirsty patrons, a quality in a bar that is most appreciated.

EXTRA/NOTES Beware the cover charge.

—*Victoria Young*

Orleans Bar & Restaurant

Classy cocktail joint attacks sports bar. Classy joint wins.

$$

65 Holland St., Somerville 02144

(at Buena Vista Rd.)

Phone (617) 591-2100 • Fax (617) 591-0166

www.orleansrestaurant.com

CATEGORY Cocktail Bar

HOURS Mon-Fri: 11 am-1 pm
Sat/Sun: 10:30 am-1 am

GETTING THERE Take the Redline to the Davis Sq. Stop. Street parking can be a pain.

PAYMENT

POPULAR DRINK Try the "Pineapple Mojito," a mix of fresh mint, fresh lime juice, sugar, pineapple rum, soda water and pineapple juice. Orleans also has a standard selection of beer and wine.

FOOD Bar menu includes such staples as "Grilled Sliders" (mini cheeseburgers), taco pizza, veggie spring rolls, and chicken quesadillas.

SEATING If you are with a larger group, grab the comfy couches
at the front of the bar. Orleans has an outdoor seating
area in the warmer months.

AMBIENCE/CLIENTELE The decor is mixed: TV's compete with romantic little
candles and a disco ball. The overall effect is trendy,
but with subdued sports bar undertones. There is no
dress code, but you might want to put on your nicer
pair of jeans. Live music takes place Weds-Sat. Music
can be fairly loud during the evening.

—Arna Wilkinson

Redbones

Beer me some barbeque.

$

55 Chester St., Somerville 02144
(between Elm St. and Massachusetts Ave.)
Phone (617) 628-2200
www.redbones.com

CATEGORY Beer House

HOURS Daily: 11:30 am-12:30 am

GETTING THERE Metered parking for drivers. Take the Red Line to
Davis Sq., exit the Holland St. side. There is a bus
stop just at Chester and Elm where the 87 and 96 run.
Bikers rejoice: free bicycle valet!

PAYMENT

POPULAR DRINK Dark and Stormy. You just can't beat a glass of lo-
cal ginger beer and Gosling's dark rum. Or if that
doesn't suit you, there's always beer. Redbones offers
24 microbrews on tap with plenty of local/regional
selection. Indecisive? Spin the wheel and let the fates
decide. It's a dangerous, but glorious game.

UNIQUE DRINK One for the Brandy lovers: the Grand Sidecar Martini:
Hennessey and Grand Marnier. And the Goombay
Smash caught my eye with ingredients like Myer's and
Mount Gay, banana liqueur, blackberry brandy, orange
and cranberry juice. Pick your poison.

FOOD You can't go wrong with their homestyle Southern
cooking. The place oozes with the smell of BBQ
and cornbread, making it irresistible not to consider
everything on the menu. But hey, a hearty meal makes
for an excellent stomach sponge for all that beer. But
definitely try the ribs. And keep in mind the late-night
menu for those drunk munchies.

SEATING On the main level, there is a bar area with barstool
seating as well as a main dining area that has table
seating reserved for those that came for the grub. The
basement has even more table and bar seating that
allows Redbones to do the crazy amount of business
they are prone to taking in. Plenty of seats, but plenty
of customers as well.

AMBIENCE/CLIENTELE Generally you'll find a crowd of hungry BBQ lovers in
for the food and beer. However, with three different
seating areas each generating their own vibe, you'll
find an older, laid back few hanging around bar up-
stairs, some big-bellied, or soon-to-be, fellows in the
dining area and a younger, louder crew downstairs in
the funky darkness that is the basement.

—Victoria Young

Rosebud Diner

And here I thought diners were good for sobering up.

$

381 Summer St., Somerville 02144

(at Cutter Ave.)

Phone (617) 666-6015

CATEGORY	Neighborhood Bar
HOURS	Mon-Thurs: 8 am-10 pm
	Fri/Sat: 8 am-11:30 pm
	Sun: 8 am-10 pm
GETTING THERE	Metered parking on the street. Take the Red Line to Davis and take the Holland St. exit.
PAYMENT	
POPULAR DRINK	The famous Bloody Mary is in high demand. Now what makes it so famous, I have yet to find out. Especially with so many other Bloody Marys with a similar claim. Something to ponder. Perhaps while sipping on a Bloody Mary.
UNIQUE DRINK	On those chilly evenings, try the their warm rum and apple cider.
FOOD	Rosebud has many greasy spoon classics to choose from. A burger is a good bet. And if you get a chance, try the corned beef hash.
SEATING	The seating space is limited in the authentic Worcester Semi-Streamliner to just a few high-back booths and a row of counter-top swivel chairs, and because of this there are occasional waits. Aside from those moments of restrained capacity, seating is readily available and service is quick.
AMBIENCE/CLIENTELE	Rosebud has been around for decades and has revamped their look more than once, but they stay true to their diner roots and kept a strong hold of their now-vintage style. Gruff, but friendly servers have a knack for casual chit chat, spilling family stories when the mood strikes them and telling it like it is. The clientele enjoy the low-key atmosphere, homestyle cooking and the full bar. It may not be the final destination for the night, but it's worthy of a quick bite and a hard drink.
EXTRA/NOTES	The posted closing times aren't set in stone. They close whenever the crowd thins out.

—Ashley Rossington

Sligo Pub

Cheap beer and a jukebox make for a rowdy good time.

$

237 Elm St., Somerville 02144

(at Chester St.)

Phone (617) 628-3950

CATEGORY	Beer Pub
HOURS	Daily: 11 am-1 pm
GETTING THERE	Metered parking available for drivers. Take the Red Line to Davis, exit Holland St. There is a bus stop right across the street that picks up the 87 and 96.
PAYMENT	
POPULAR DRINK	Guinness. Like proper Irish folk.
UNIQUE DRINK	A Sligo Punch, which is essentially their own take on a Red Death.
FOOD	Food? What food?
SEATING	Stools, stools. And a few places to stand in between. Just remember, a seat in Sligo is a rare commodity.

AMBIENCE/CLIENTELE What Sligo lacks in class, it makes up for in wood.
Head to toe, this place is carved out of wood. And
in return the wood is carved into by the clientele.
Because who doesn't want to leave their mark in the
sea of scratched graffiti? Of course, if it means avoid-
ing those singles looking to swoon, it's a good evasion
tactic, or a conversation piece. Depending on which
position you're playing. By the end of the night, this
neighborhood dive will be the one to win over your
drunken heart.

EXTRA/NOTES Sligo, for those forgetting their Irish etymology and
geography lessons, is a county in North-West Ireland.
The word itself, pronounced "sly-go," means "shelly
place," regarding the abundance of shellfish found in
the region. Many cheers to Wikipedia.

—*Victoria Young*

UNION SQUARE

Atwood's Tavern

Cozy tavern on the Cambridge/Somerville border.

$

877 Cambridge St., Cambridge 02141
(at Hunting St.)
Phone (617) 864-2792
www.atwoodstavern.com

CATEGORY Beer Tavern
HOURS Mon-Fri: 3 pm-1 am
Sat/Sun: 11:30 pm-1 am
GETTING THERE Decent street parking. Or take the T and get off at the
Central Sq. stop on the Red Line.
PAYMENT [AMEX] [VISA]
POPULAR DRINK Above average selection of beer and wine. This re-
viewer recommends the Dogfish Head 90 Minute IPA,
followed by a second.
UNIQUE DRINK Again, it's mostly the usual suspects. Big bottles of
cider are nice, though.
FOOD Any place that sells premium Sloppy Joes can't be
discounted.
SEATING An intimate affair, though popular live acts will draw a
deserving crowd. Tables, barstools and standing room
combined, you're looking a capacity of around 60.
AMBIENCE/CLIENTELE An "adult" bar, the clientele generally falls into the
"30 and up" range. Its location on the Cambridge/
Somerville border makes it nearly impervious to
college students, so don't come here to get bombed.
A comfortable, low-lights, hardwood kind of place.
Offers a full menu and a few tables in which to eat up,
or chow down at the bar.
EXTRA/NOTES Live music five or six nights a week. See the Duke
Levine band! There is outta sight Trivia on Wednesday
nights, usually followed by a live show. Bartender
Liam offers a video advice column of questionable
value. Do a YouTube search for "Ask Liam" and pre-
pare to be enlightened.

—*Django Gold*

The Biscuit

Wake up and smell the biscuit

$

406 Washington St., Somerville 02143
(at Beacon St.)
Phone (617) 666-2770
www.visitthebiscuit.com

CATEGORY	Coffee Café
HOURS	Mon-Fri: 7 am-8 pm
	Sat/Sun: 8 am-8 pm
GETTING THERE	Most people walk or bike here. The closest T Stop is probably the Red Line Harvard and it's a good 15-20 minutes walk from there.
PAYMENT	$
POPULAR DRINK	For many people this is their sacred neighborhood coffee shop because they have great coffee and espresso drinks, teas, and the usual café beverages. The chai latte and the Vietnamese coffee are popular with the clientele.
FOOD	The scones, and other pastries are baked on the premises. They also have sandwiches, grab-and-go salads, and soups. Make sure you go there earlier in the day to try the yummy frittatas, which often include nice, thick bacon, and tend to sell out quickly.
SEATING	They have around eight indoor tables, and more tables on their outdoor deck.
AMBIENCE/CLIENTELE	Situated on a busy street corner in between Inman and Harvard Square, this café is a very popular spot for Grad students, writers, and hip neighborhood regulars who have been going there in its different incarnations (Panini, Tosci and Sons) over the years. In warmer months, the outdoor deck, with its potted plants, is a nice refuge from the busy crossroads between Cambridge and Somerville.

—Minh Luong

Bloc 11

Lock yourself into your seat with some joe, and secure a safe path to vaulting over those finals.

$

11 Bow St., Somerville 02143
(at Warren Ave.)
Phone (617) 623-0000
www.bloc11.com

CATEGORY	Coffee Café
HOURS	Daily: 7 am-9 pm
GETTING THERE	Easy metered street parking. There are no close T-stops besides bus routes from Davis and Central Sq., both connected to the Red Line.
PAYMENT	
POPULAR DRINK	Coffees and espresso drinks fuel the energy-hungry minds that come here for studies. Teas are also available for the loose-leaf enthusiasts.
FOOD	A wide selection of sandwiches serve as intermission for long stretches of butt-in-chair. For a sugar boost, baked goods line the window to tease you with rewards for hard efforts.
SEATING	Surrounding the island espresso bar and sandwich line sit rows of tables as well as another small espresso bar with bar seating. There are a few other tables

hidden in the back room and in the vaults. Yes, you heard right. The café kept the previous bank layout and leaves the two vaults open with tables for the non-claustrophobic folk.

AMBIENCE/CLIENTELE A flurry of students come in to plant themselves and attempt to take root, laptops and textbooks in hand. Besides the occasional whirring of the espresso machine, and the small chatter among friends, the only sound is the soft type type type over the music. It's a mellow place to get things done, however long it takes.

EXTRA/NOTES With such scavenging for internet hotspots in this college town, the internet comes with a small fee. Good news is that if you find yourself a regular, the monthly rate is well worth the small price.

—*Avalynn Michaels*

The Courtside Restaurant & Pub

Boston's best dive-tastic karaoke. Get your 15 minutes of fame.
$$
291 Cambridge St., Cambridge 02141
(between Fulkerson St. and Max Ave.)
Phone (617) 547-4374
www.courtsidekaraoke.com

CATEGORY Dive Bar

HOURS Mon: 11 am-10 pm
Tues/Weds: 11 am-11 pm
Thurs-Sat: 11 am-Midnight
Sun: 1 pm-7 pm

GETTING THERE Difficult street parking. Take the 69 bus from Harvard or Inman Sq. to Lechmere. Also accessible on the Green Line.

PAYMENT

POPULAR DRINK Nothing unusual - a few beers on tap, full selection of liquors.

FOOD Courtside is a restaurant by day, with typical pub food: wings, burgers, sandwiches, pizza, and the like. The kitchen is open until 9 pm Mon-Weds, and Midnight Thurs-Sat.

SEATING On first glance, it appears tiny. Go back and to the right and Courtside opens into a spacious restaurant with plenty of seating. It still manages to fill up during karaoke, but you're almost always going to find a seat. Arrive early if you have a big group.

AMBIENCE/CLIENTELE On weekend nights, Courtside transforms into a venue where any karaoke performer will feel at home. Whether you're Beyonce, or tone deaf and just willing to be an ass, you will be lauded by the crowd at Courtside, the only reliable weekend karaoke in the area (Thurs–Sat at 9 pm). With an extensive catalog of songs and alcohol available at a moment's notice, this is the perfect bar in which to stage your next karaoke disaster. Look for Courtside karaoke celebrity "Mark the Shark," always on hand to sing unknowns and toe the line between painful awkwardness and wondrous novelty.

EXTRA/NOTES Tuesday is trivia night. Be sure to bring a history buff, pop culture expert, and sports fanatic for a fighting chance against trivia regulars.

—*Stacy Williams*

Dali

An unusual space in an unlikely place.

$$$

415 Washington St., Somerville 02143
(at Beacon St.)
Phone (617) 661-3254
www.dalirestaurant.com

CATEGORY	Restaurant Bar
HOURS	Mon-Thurs: 5:30 am-11 pm
	Fri/Sat: 5:30 am-1 am
	Sun: 5:30 am-11 pm
GETTING THERE	Nowhere near a T stop, but some busses go by. An abundance of free on-street parking.
PAYMENT	
POPULAR DRINK	Though they carry an array of ports, ciders, sherries and a handful of beers, it's the extensive selection of Spanish wines and sangria that Dali is best known for.
UNIQUE DRINK	The Casanova: OJ, Campari, Ginger, Cayenne and Orange Liquor. It's the first time I've come across this delicious oddity.
FOOD	Dali is best known for their food. With an array of tapas, Dali specializes in game fare as well as strange seafood selections and plenty of selections for the chicken lover or strict vegetarian.
SEATING	A huge space with three beautiful rooms, the bar is small, but if you're seated for dinner there should be space available for you. Reservations, however, are recommended.
AMBIENCE/CLIENTELE	There is no place like Dali. Livening up a residential neighborhood with flair, character, ornate decor, gourmet food and an extensive wine selection, the place is as great and usual as the menu.

—*Nolan Gawron*

Sally O'Brien's

Sally O' is a good friend indeed.

$$

335 Somerville Ave., Somerville 02145
(between Warren Ave. and Bow St.)
Phone (617) 666-3589
www.sallyobriensbar.com/

CATEGORY	Beer Pub
HOURS	Daily: 11 am-1 am
GETTING THERE	Metered parking available in Union Sq. The bus also runs though Union Sq.
PAYMENT	
POPULAR DRINK	There's no surprise here. Guinness fuels the eternal Irish flame of this bar.
UNIQUE DRINK	Nothing. Drinks are ordered to the customer's preference. Keeps drinking simple.
FOOD	Although the menu tries to diversify their menu with Irish, American and Mexican selections, I'd say they do up their Sally's Special Pub Burger with pride. It's the bacon and mushrooms that slay me.
SEATING	The bar is cut into two areas. One side for bar seating and the other for high rounds tops. More seating can be found along the dividing barrier. Some nights, seating can be in short supply, but you'll find plenty of people standing around chatting. It's the new sitting.
AMBIENCE/CLIENTELE	This place has a lot more going for it than would lead you to believe from its grungy appearance. Sometimes

it's just a pub. Sometimes a dive. But many times, something more. The windows support small posters of local bands keeping passersby informed on the weekly music bookings. The live shows work well to draw in small crowds of people just out for good fun. And there are definitely older regulars that hover over their beers, backs turned to the stage. The lounge area is surprisingly intimate, even when there is a bluegrass-punk band wailing in the tiny corner stage. On the good nights, the place just glows and the universe feels like it's tilting on just the appropriate axis to match your mood. And yes, small pleasures can be that intense.

EXTRA/NOTES Wednesday night poker. Play for free, win some prizes, drink some beer, make some friends. Done.

—Lawrence Fong

Sherman Café

Industrial Espresso and Sandwiches.

$

257 Washington St., Somerville 02143
(at Webster Ave.)
Phone (617) 776-4944

CATEGORY	Coffee Café
HOURS	Mon-Fri: 7 am-7 pm
	Sat/Sun: 8 am-7 pm
GETTING THERE	Easy 2-hour free parking or, for locals, longer-term permit parking; 86 and 87 buses to Union Sq.
PAYMENT	$
POPULAR DRINK	Excellent espresso drinks, solid array of loose teas, chai, Italian sodas, lemonade, and hot apple cider (seasonal).
FOOD	A side of greens for your sandwich is cheap, delicious and far from iceberg. Half-sandwiches available, a godsend for the merely peckish. Unique daily specials with local, seasonal produce.
SEATING	Small, slightly haphazard tables, wooden benches (with backs), and one soft couch up in the window.
AMBIENCE/CLIENTELE	Sunny bricks-and-mortar environment seems always in progress. Lots of hipsters with laptops, but also neighborhoodies looking for a cup of java, and baby-bound parents seeking refuge in a turkey, brie, and apple sandwich. Sometimes they play cutting-edge music, which, one suspects, comes from the barista's band.
EXTRA/NOTES	Co-owner Ben Dryer is the former publisher of satiric Boston newspaper The Weekly Week. Take a moment in the bathroom to read "Willy Wonka Busted for Labor Violations," or perhaps to get "Advice from a Pimp." Also, Sherman Café has free Wi-Fi.

—Alison Pereto

The Thirsty Scholar

An Irish pub with room to stretch your legs.

$$

70 Beacon St., Somerville 02143
(between Cambridge St. and Washington St.)
Phone (617) 497-2294
www.thirstyscholarpub.com

CATEGORY	Beer Pub
HOURS	Daily: 11 am-1 am

GETTING THERE	Street parking is available on Beacon St The nearest T stations are Central Sq. or Harvard Sq. (both Red Line), but both are many blocks away.
PAYMENT	
POPULAR DRINK	As with any good Irish pub, the Guinness is poured well and it is the choice of many patrons.
UNIQUE DRINK	The Thirsty Scholar has dozens of beers on tap, including a number of harder to find brews.
FOOD	The bar offers a lunch, dinner, and brunch (on Sundays) menu. The offerings are nicer than standard pub fare, and the curry fries are a unique and delicious treat at any hour.
SEATING	Unlike many Irish pubs in Boston, The Thirsty Scholar is quite spacious with tables and stools throughout the entire establishment.
AMBIENCE/CLIENTELE	As the name implies, The Thirsty Scholar attracts a good number of local college and grad students. Though many young, local professionals congregate there as well. It's a slightly more up-scale pub, with wall-sized windows that open to the street in the warm weather.
EXTRA/NOTES	One of the best features of The Thirsty Scholar is the huge projection TV, in addition to nearly a dozen flat screens around the room. It makes it a great place to catch games, including any major soccer match. The bar shows nearly every English Premier League game.

—*Courtney Scott-Howard*

MEDFORD

Danish Pastry House

Sugar and caffeine buzz, European style.

$

330 Boston Ave., Medford 02155

(at Winthrop St.)

Phone (781) 396-8999

www.danishpastryhouse.com

CATEGORY	Coffee Café
HOURS	Mon-Thurs: 7 am-9 pm
	Fri/Sat: 7 am-10 pm
	Sun: 8 am-8 pm
GETTING THERE	Free parking lot behind the dry cleaners on the corner of Winthrop St. and Boston Ave.
PAYMENT	
POPULAR DRINK	Fine coffee and tea drinks will help cut the richness of the sugar overload you will inevitably experience.
FOOD	The vast array of Danish pastries are the main attraction. The menu distinguishes between "morning pastries", "afternoon pastries", and "anytime pastries". For those who want savory fare, they have a good selection of cold sandwiches, hot panini, salads and a daily soup.
SEATING	A good number of round, café-style tables are available inside with a few outdoor tables for street side dining al fresco.
AMBIENCE/CLIENTELE	This place is buzzing with Tufts students on study breaks, faculty, and local residents aiming to get a sweet fix. The corner space is clean, bright and cheery

with lots of attractive pastries on display for gazing while sipping café au lait.

EXTRA/NOTES The Danish Pastry House claims to be the first of its kind European boutique bakery in the region. For the selection and range of its pastry offerings, it should be called the "Danish Pastry Warehouse." The owners regularly donate their leftover pastries to local charities and shelters.

OTHER ONES Retail Bakery: 205 Arlington St., Unit 4, Watertown 02472, (617) 926-2747

—*Minh Luong*

HAPPY GRAPE TRAILS

Wineries of Massachusetts

In 1602 Bartholomew Gosnold named Martha's Vineyard for the wild grapes he found growing there. Known by many merely as a lovely tourist destination, today more than twenty wineries in Martha's Vineyard and beyond produce over 100,000 gallons of wine annually.

Massachusetts boasts a wide range of grape growing climates, which yield abundant harvests of both the vinifera varieties such as Chardonnay, Pinot Noir, Riesling, Gewurztraminer, Pinot Blanc and Pinot Gris, as well as the American Hybrids Vidal Blanc, Cayuga, Seyval, Vidal, and Marechal Foch.

Visits to most of these wineries are only day trip or a weekend away from Boston, but you'll feel like you're a world away from the hustle and bustle of the metropolis. Here are a few:

Alfalfa Farm
267 Rowley Bridge Rd., Topsfield 01983, (978) 774-0014,
www.Alfalfafarmwinery.com

Broad Hill Vineyards
583 Winter St., Holliston 01746, (508) 429-2891,
www.Broadhill.com

Cape Cod Winery
681 Sandwich Rd., East Falmouth 02536, (508) 457-5592,
www.capecodwinery.com

Chester Hill Winery
47 Lyon Hill Rd., Chester 01011, (413) 354-2340,
www.blueberrywine.com

Furnace Brook Winery (at Hilltop Orchard)
(Route 295) 508 Canaan Rd., Richmond 01254, (800) 833-6274,
www.furnacebrookwinery.com

Hardwick Winery
3305 Greenwich Rd., Ware 01082, (413) 967-7763,
www.HardwickWinery.com

Les Trois Emme Winery
8 Knight Rd., New Marlborough 01230, (413)528-1015,
www.LTEwinery.com

Nantucket Vineyard
5 Bartlett Farm Rd., Nantucket 02584, (508) 325-5929,
www.NantucketVineyard.com
Open: Mon-Sat 10-7 PM and Sun 12 to 5 PM.

Nashoba Valley Winery, Spirits & Brewery
100 Wattaquadoc Hill Rd. 01740, Bolton, (978) 779-5521,
www.Nashobawinery.com

Neponset Winery
50 Kearney Rd., Needham 02494, (781) 444-7780,
www.neponsetwinery.com

Obadiah McIntrye
Farm Winery @Charlton Orchards, 44 Old Worcester Road
(Rt. 20), Charlton 01507, (508) 248-7820,
www.Charltonorchard.com

Pioneer Valley Farm & Vineyard
41 School St., Hatfield 01038, (413)247-3007,
www.pioneervalleyvineyard.com

Plymouth Bay Winery
114 Water Street, Plymouth 02360, (508) 746-2100,
www.Plymouthbaywinery.com

Plymouth Colony Winery
Pinewood Rd. (Rte 44), Plymouth 02362, (508) 747-3334,
www.plymouthcolonywinery.com

Red Oak Winery
325 North Main Street, Middleton 01949, (978) 774-5118

Running Brook Vineyards
335 Old Fall River Rd., North Dartmouth 02747, (508) 985-1998,
www.runningbrookwine.com

Russell Orchards
143 Argilla Rd., Ipswich 01938, (978) 356-5366,
www.Russellorchardsma.com

Truro Vineyards
11 Shore Rd. Route 6A, North Truro 02652, (508) 487-6200,
www.Trurovineyardsofcapecod.com

Turtle Creek Winery
PO Box 69, Lincoln 01773, (781) 259-9976,
www.turtlecreekwine.com

West County Winery
106 Bardwell's Ferry Rd., Colrain 01340, (413) 624-348,
www.westcountycider.com

Westport Rivers Vineyard & Winery
417 Hixbridge Rd., Westport 02790, (508) 636-3423,
www.westportrivers.com

—Minh T. Luong

STILL
THIRSTY?

Our glossary covers many of those drinks and terms that everyone else seems to sort of know but we occasionally need a crib sheet.

BARWARE AND TERMS

ABV—the standard measure of alcohol by volume in beverages as expressed in percentage.

Call drink—a cocktail ordered with the liquor brand of choice. Always "call" the brand first. (So a vodka tonic would be a Stoli tonic.)

Cask strength—the strength of a liquor's ABV is not diluted and therefore stronger. We're mainly talking whiskey here.

Collins glass—the tallest cocktail glass (14 oz.); used for soft drinks, Bloody Mary's, and Tom Collins, of course!

Desert dry—martini sans vermouth. A theatrical bartender will wave the bottle of vermouth over the glass just for show.

Dry—opposite of wet. How to order your cappuccino if you want less milk and more foam; how to order your martini if you don't want to taste the vermouth.

Highball—the most widely used cocktail glass (8 oz).

Keg—a Frat boy's favorite word, referring to a large metal container of beer tapped at the top and capable of upwards of 100 cups.

Last call—what the bartender yells at the end of the night and your last chance to order a drink. Period.

Misted—cocktail served over crushed ice.

Muddled—bar technique whereby some ingredients are ground in the glass (see mojito).

Neat—booze straight outta the bottle, nothing added—for those who like the taste of their liquor.

On-tap—beer from a keg which you won't see from your side of the bar; usually cheaper than bottled water.

Pilsner—a glass for beer.

Rail—the bar's house liquor; it's what you'll be served if you don't request a particular brand; well.

Rocks— (also, on the rocks) ice, and what your order your liquor with to water it down a bit.

Screaming—code word for "add vodka" to any drink.

Shot—1.5 oz. of the potent liquid in a drink (e.g., espresso, bourbon); also a small glass size.

Straight-up—see neat.

Top-shelf—the expensive brand spirits, so called because they've kept on display on the bars top shelf.

Up—a drink that's chilled over ice than strained into a glass, beautifully ice free; how you want your martini.

Well— the bar's house liquor; it's what you'll be served if you don't request a particular brand; rail.

Wet—how to order your cappuccino if you want more milk than foam; how to order your martini if you want the taste of vermouth.

COFFEE AND TEA

Americano (Italian)—a shot or two of espresso poured over a glass of hot water, (basically watered-down coffee, which is what Italians think we drink here).

Barista—your best friend in the morning—the guy or girl behind the espresso counter, the unofficial coffeehouse bartender.

Black eye—house coffee with a double shot of espresso.

Café—Spanish and French for coffee.

Café au lait (French)—coffee served with warm milk.

Café con leche (Spanish)—see café au lait.

Café de olla (Mexican)—Mexican coffee, right from the pot, hot and spiced with cinnamon.

Café den nong (Vietnamese)—French-Vietnamese style coffee with sweetened condensed milk.

Caffé—Italian for coffee.

Cappuccino (Italian)—the quintessential espresso drink. A perfect balance of espresso, steamed milk, and milk foam.

Chai— a tasty special tea from India, usually served with milk and very popular in the U.S.

Crema (Italian)— the thick medium brown coating that tops a good shot of espresso.

Cremosa (Italian)—a milky iced blended without the coffee and with the syrup flavorings of your choice.

Cupping—process of tasting coffee employed by coffee professionals to determine which crops of beans to buy

Demitasse (French)—small delicate half-size coffee cup mainly used for Turkish coffee or espresso, today's often come with intricate artful designs and delicate handles.

Dopio (Italian)—two shots of espresso (double).

Double—drink with two shots of espresso; also a cocktail that's double the norm and priced accordingly.

Espresso (Italian)—a shot of concentrated coffee made by forcing hot water through finely ground, tightly pressed beans, and the basis of all Italian coffee drinks.

Espresso Cubano (Cuban)—(a.k.a. café Cubano) espresso brewed with raw sugar. ¡Qué dulce!

Frappé—a blended mix of frozen fruits; variations include mixing alcohol with shaved ice or going non-alcoholic and making a iced blended style coffee drink.

French press—a glass pot with metal plunger, used to brew coffee and (more recently) tea by isolating the ground beans or leaves at the bottom of the pot once it has steeped in boiling water, and voilá, the perfect cup!

High tea—traditional British afternoon tea service, complete with tea sandwiches and sweets.

Italian syrup—Flavorings mixed in with ice and club soda to make great Italian soda, also used to flavor coffee drinks. Torani and Monin are popular brands.

Latte (Italian)—(also, caffé latte) espresso drink filled with steamed milk and a touch of foam on top—milky, but not so milky you can't taste the coffee anymore.

Macchiato (Italian)—literally, Italian for "mark" or "stained." In coffee terms, espresso stained by a dollop of steamed milk foam on top.

Mocha—(also, café mocha) essentially a latte with chocolate added and served with whipped cream (only if you say, "pretty please").

Red eye—house coffee with a single shot of espresso.

Ristretto (Italian)—the mother of all espresso drinks. With less water (almost half) but the same amount of coffee as your average espresso, this super-concentrated liquid will definitely keep you up.

Single—one shot of espresso.

With room—how you order coffee if you want the barista to leave room for you to add cream.

JUICE, SMOOTHIES, AND STUFF THAT'S GOOD FOR YOU

Cider—juice made by pressing fruit, usually apples, (and sometimes available in alcoholic varieties).

Gingko biloba (Chinese)—herbal supplement shown to improve circulation, increasing everything from memory to sex drive.

Ginseng (Asian/North American)—a tonic herb extracted from the root of the ginseng plant, very popular in Asian countries and now worldwide to enhance overall health.

Kombucha—a fermented tea made with yeast culture and also a popular health drink.

Protein powder—a common smoothie supplement for folks who want to stay "in the Zone."

Psyllium husk—a soluble fiber supplement. Add it to your juice and go go go.

Smoothie—a thick mixture of fruits, juice, ice (and sometimes yogurt or milk) together in a blender and boom, you've got a smoothie!

Spirulina—a rich amino acid popular for its protein qualities.

Thai iced coffee/tea—iced tea/coffee filled to the top with sweetened condensed milk for a double punch of caffeine and sugar.

Wheat grass—a juice made from nutritious wheat sprouts, creating concentrated forms of vegetable properties. Packs a punch!

WHAT YOU'RE DRINKING

40—slang for a 40-ounce bottle of malt liquor (Mickey's and Colt being the most popular brands).

Absinthe—a highly alcoholic anise-flavored spirit with a natural green color.

Ale—heavy thick beer made with a top-fermenting yeast and available in a range of varieties including brown ale and pale ale.

Bitters—an aromatic, oftentimes alcoholic, beverage infused or distilled with herbs, roots or fruit used sparingly in cocktails to add a little zing.

Bloody Mary—a strictly pre-dinner hour cocktail of tomato juice, vodka, lemon juice, Worcestershire and Tabasco sauce, stirred and garnished with celery or other stalky vegetable.

Caipirinha—Brazil's most popular drink: lime, sugar and cachça (sugarcane brandy).

Cape Cod—(a.k.a. Cape Cod) a cold and sour cocktail of vodka, cranberry juice and lime, served in a highball.

Cava—Spanish sparkling wine made the same way as champagne.

Chaser—a non-alcoholic drink (often water or soda) ordered on the side to cut the taste of a strong drink.

Flip—a classic cocktail made up with a spirit, egg, sugar and spice shook up for a rich foamy layer at the top the drink.

Hops—an ingredient used in the brewing process of beer that balance out sweet or malt flavors with an earthy bitterness.

Infusion—a beverage that has extracted the flavors from chosen ingredients. The most common ingredients infused include teas, spices, and fruits, though some can be more adventurous.

Irish coffee—sweetened coffee spiked with Irish whiskey and topped off with whipped cream.

Kamikaze—vodka, triple sec, and lime chilled and served in a shot glass.

Lager (German)—style of beer usually aged for about month to two months, and golden in color; your basic European brew.

Long Island iced tea—a cocktail made with so many kinds of liquor you don't taste any of them! Actually, vodka, gin, light rum, tequila, triple sec, sweet-and-sour mix, and cola served over rocks in a collins glass.

Mai tai—a sweet cocktail with rum, crème de almond, triple sec, pineapple, sweet-and-sour mix, and topped with more rum, evoking tropical breezes and better days.

Malt—(also, malted milk) a classic soda fountain drink made by mixing ice cream and flavoring with malted milk powder and milk.

Margarita—an icy cold sweet drink from Mexico served with white or gold tequila, triple sec, and lime juice, on the rocks or blended. Salt on the rim of the glass is up to you.

Martini—gin with a splash of vermouth, chilled, stirred and served up with an olive. Variations substitute vodka for gin or a pearl onion or lemon twist for the olive, but true martini drinkers will tell you that's those aren't real martinis.

Mexican Coffee—Coffee, Kahlúa, and tequila- only for the strong!

Microbrew—a handcrafted beer produced by a small brewery.

Milkshake—a creamy blend of ice cream, milk and flavorings ranging from coffee to Oreo to the king of all milkshakes, The Elvis Shake(with peanut butter and banana), available at Cafe '50s, www.cafe50s.com.

Mojito (Cuban)—refreshing rum drink filled with muddled mint leaves, lime juice, and sugar.

New York egg cream—(also, egg cream) a soda fountain beverage originated in Brooklyn in the late 1800s that tastes a lot like a melted chocolate ice cream soda. No, it doesn't have a single drop of egg in it!

Phosphate—frothy old-school soda fountain drink.

Pisco Sour—a classic cocktail made up of brandy, lemon/lime juice, egg whites, simple syrup and bitters.

Rickey—syrup-sweetened soda water served at classic fountains, usually flavored with cherry or lime or both.

Red Bull and Vodka—a simultaneous upper and downer; gets you buzzed and keeps you awake.

Sake (Japanese)—centuries-old fermented rice drink similar to a crisp white wine. Drink hot or cold.

Sangria (Spanish)—popular concoction of red wine over ice with floating fruit and a bit of bubbly.

Sex on the Beach—a cold sweet cocktail with vodka, peach schnapps, and filled with cranberry and orange juice. Possibly the most embarrassing drink you could order in a real bar.

Singapore sling—a cold sweet layered drink of grenadine, gin, club soda, and sweet-and-sour, topped with cherry brandy.

Stout—the darkest beer known to man, sweet or dry, the style has been popularized by the Guinness brand, a meal in and of itself.

Tapioca pearl drink—see bo ba nai cha.

Tequila sunrise—tequila, orange juice, and grenadine served in a highball glass. Watch the grenadine fall to the bottom of the glass, then rise.

MISCELLANEOUS

Agua fresca (Mexican)—(also agua natural) flavorful drink that's not quite juice, not quite soda. Popular flavors include horchata (sweet rice milk with cinnamon), tamarindo (tamarind), jamaica (hibiscus flower), limón (lemon), piña (pineapple).

Atole (Mexican)—thick malt drink made of corn meal and sometimes cinnamon.

Bo ba nai cha (Taiwanese)— iced tea or coffee drinks with sweetened condensed milk and chewy little marble-sized tapioca balls (boba or pearls).

Batido (South American)—see licuado.

Canela (Mexican)—a favorite! Mexican cinnamon tea made with real cinnamon sticks.

Eau-de-vie (French)—(plural, eaux-de-vie) literally "water of life" and a stone fruit brandy popular with Europeans. The best are made from plums or sweet or sour cherries.

Guanabana (Latin American)—delicious tropical fruit used in licuados in many Latin American countries.

Halo-halo (Filipino)—milk, shaved ice, mixed tropical fruits, tropical ice cream, leche flan, and crisp puffed rice-very popular!

Horchata (Mexican)—a mix of water, cold rice, and cinnamon to create a sweet beverage from heaven. One of the best aguas frescas this side of México!

Jamaica (Mexican)—remember those aguas frescas we told you about? This is another great one, made from hibiscus flower.

Lassi (Indian)—a yogurt drink served salted or flavored with mango, banana, or even rose.

Licuado (Mexican)—(also batido) fruit juice blended with ice, milk and sometimes honey. Essentially a smoothie or frappé.

Maccha (Japanese)—green tea that has numerous health benefits, as well as a delicious clean and refreshing taste.

Michelada (Mexican)—beer with lime juice and salt over ice.

Piscorita (Latin American)—Latin margaritas with Peruvian eau-de-vie in place of tequila.

Soju (Korean)—a popular Korean distilled liquor usually served by the bottle, strong but good.

Tamarindo (Mexican)—a tropical Mexican juice drink (agua fresca) made from tropical tamarind fruits.

Yerba maté (South American)—an herbal drink long used by the Guarani Indians in the forests of Paraguay for its medicinal qualities. It's most definitely an acquired taste.

MADE IN BOSTON

Boston Club—gin, Italian vermouth, and lime juice, garnish with a pickled onion.

Bostonian—gin, Italian vermouth, sweet & sour syrup, fresh-squeezed orange juice, and muddled mint leaves.

Boston Flip—whiskey, Madeira, simple syrup, half an egg yolk. Grate nutmeg over drink and sever.

Boston Cocktail—dry gin, apricot nectar liqueur, grenadine, lemon juice

Boston Cooler— rum, simple syrup, lemon juice, and soda water or ginger ale. Garnish with an orange or lemon peel over the rim of the glass.

Boston Sidecar— brandy, white rum, triple sec, lime juice; better known as Between the Sheets.

Boston Sour— rye or bourbon, one egg white, simple syrup, lemon juice. Top with seltzer water and decorate with a lemon slice and cherry.

Boston Special— brandy, French vermouth, Italian vermouth, a few dashes of curaçao, a couple of dashes of absinthe.

Growler—a half-gallon glass jug that was devised to transport beer straight from the brewer's tap to your home and eventually into your mouth.

Hard cider—alcoholic version of your favorite fruit beverage, slightly carbonated and, can be sweet or dry.

Maccha (Japanese)—green tea that has numerous health benefits, as well as a delicious clean and refreshing taste.

PBR—short for Pabst Blue Ribbon, generally the cheapest beer on a menu and oftentimes in can form.

Sam—short for Boston's popular beer Samuel Adams Boston Lager.

Ward Eight— the most famous old Boston cocktail! Rye whiskey (if you can't find rye, use bourbon), fresh-squeezed lemon juice, real pomegranate grenadine.

ALPHAPETICAL INDEX

Jennifer Adams shares culinary musings on her blog, palatetopen.com. She's also a contributor to publicradiokitchen.org and intent.com. An ever-curious student of culinary and wine arts, she's studied recipe and food writing in NYC as well as wine through Boston University and the Wine & Spirit Education Trust.

Kaitlin Alayan is a writer living in Boston.

Leah Bagas loves to eat and drink her way across cultures. She loves traveling, writing and is always in search of her next meal.

Abby Bielagus is a writer living in Boston.

Jason Burnsworth is an actor who loves word play, and fell into writing by accident. A gregarious personality and a love of good friends and fun brought him to write for Thirsty? Boston and he's loved being a part of it.

Suki Chang is an adventurous traveler and tries new tea in every country she visits. (Other beverages too, but teas are the most interesting!)

Paul Collins is a writer living in Boston.

Chris Coveney is a life-long Bostonian working in non-profit information technology. He lives in the South End where he frequently hosts themed cocktail parties.

Bree Cummings has a good time wherever she goes because life is what you make it, and the company you keep can only make it better- cheers!

Jill D'Urso has lived in Boston for three years, and just received an MA in Publishing and Writing from Emerson College. She is the blog editor for Fringe magazine and a contributing blogger for Vernacular. Though she's become intimately acquainted with many of the city's best bars, she does all her best drinking at weddings.

Colleen Devine is a writer living in Boston.

Kate Finnegan studied Japanese tea ceremony under the direction of Mr. Kaji Aso for 26 years from 1980 to 2006. Mr. Aso passed away on March 11, 2006. It was his wish, as is ours that Kaji Aso Studio and the tea ceremonies continue. At Kaji Aso Studio's "House of the Flower Wind," Kate Finnegan continues hosting Mr. Aso's way of tea. For reservations please call 617-247-1719.

Lawrence Fong is a poet and a performer, bringing words to life on a daily basis.

Siobhan C. Ford is a twenty-something public relations specialist in Boston, MA. She loves prosecco, tuna tartare, heirloom tomatoes, and talented bartenders.

Joe Gallagher is from Orlando, FL. He writes a blog about meat, Chomposaurus.com.

Taking over the world thru trial and error, **Nolan Gawron** is a writer, photographer and a wide-eyed wanderer who has trouble standing still.

A music journalist and day-trip travel writer for publications of Boston and beyond. Sometimes hard at work on a book he's afraid to have published, "The End of an Error: One Day We'll Get the Disrespect We Reserved", may or may not be a more intense version of "Go Ask Alice". Truth is scarier than fiction.

Django Gold is a Boston-based writer and journalist. His interests include music, cycling, food and drink, and hustling for work.

Kate Golden is a writer living in Boston.

Wag, bon vivant and pioneer of the palate, **Joshua L. Goldstein** is an immigration attorney based in Boston, Massachusetts and can be reached at www.jgoldlaw.com.

Bridget Halverson has never met a beer she didn't like, a bar she couldn't make herself at home in, or people she didn't love. A lover of all things Boston, she's your go-to girl when you need the best recommendations for a night out on the town.

Shanon Heckethorn loves to wet her whistle. A Maine native on a quest for the perfect rounded brick facade with garage doors: real estate in Cambridge to open her quaint high tea hot spot. Want in? Shanon Heckethorn loves to wet her whistle. A Maine native on a quest for the perfect rounded brick facade with garage doors: real estate in Cambridge to open her quaint high tea hot spot. Want in?

Jessica Holmes is a writer living in Davis Square, Somerville. She received her Bachelors in English from Loyola Marymount University and a Masters in Fine Arts, Writing, from Otis College, both located in Los Angeles, CA. She is currently pursuing her credentials as a High School English teacher and attempting to adjust to New England weather!

Jaime Kerry is a writer living in Boston.

Charlie Knoll is a wildlife photographer, an undercover agent, a lover and a fighter, a space cowgirl.

Andrew Ladd has lived in Edinburgh, Montreal, and London, and now resides in Boston — where he teaches and studies as a grad student in the writing program at Emerson College. When not visiting bars, he spends his spare time freelancing and working on his first novel, and also maintains a blog at http://hotscot.blogspot.com.

Sarah Leech-Black is a writer/cheesemonger who loves to eat, drink and cook so much of her writing is seasoned by her culinary curiosities. To read more of her writing go to www.sarahleeckblack.com.

K. N. Liao is a freelance writer, former bartender, and part-time writing faculty at Emerson College, where she'll be finishing her MFA in creative writing this spring. Her writing has appeared in the Boston Phoenix, Weekly Dig, Bostonist, Sex Appeal, and Fringe Magazine. She is the nonfiction editor of Redivider, a nationally distributed literary journal, and editor of Vernacular, a Boston literary blog.

Kimberly Loomis is a writer living in Boston.

Minh T. Luong is a food writer and chef who is also the author of a popular food blog at www.MinnieEatWorld.com. She is the editor of Hungry? Boston: the Lowdown on Where the Real People Eat, a restaurant guidebook featuring local eats from secret barbecue rib trucks, to historic diners and hole-in-the-wall Mom and Pop joints. Her work has also been published in The Boston Globe, The Somerville News, Boston's Weekly Dig, and Swindle Magazine.

Sam Mazzarelli is a Boston-based PR and marketing consultant specializing in consumer products and services. With a background in museum studies and art history he hits the streets in his hometown and globetrots abroad to track trends in style and culture.

Avalynn Michaels is a BU alumna who fell in love with the city and never left. Go Terriers!

Stéphanie Naudin is a former New Yorker, who traded her Park Avenue strut for college, love, and independence in the land of Sam Adams and Harpoon. She loves ice-cold beer, Magic Hat fortunes, and booty-shakin' nights on the town with her girls.

Jason O'Bryan is a writer living in Boston, and has a profound love and knowledge of classic cocktails.

Deepak O'Reilly is a beer connoisseur who lives for a real-deal pub, and will write about the best ones he finds whenever possible.

Kashlin Romero loves the Red Sox, hot coffee on snowy days, running along the Charles river, any kind of dessert, and good red wine.

Bridget Pelkie is a freelance writer living in Somerville, MA. She recently earned an MFA in creative writing from Emerson College. Right about now, she could go for a beer.

Alison Pereto is a writer living in Boston.

Brandy Sprague moved to Boston from Denver six years ago and quickly fell in love with Boston and the Red Sox. During her six years of residence, she has lived in Somerville, Dedham, Fenway, Brighton, Brookline, and now Watertown. While Human Resources is her professional title, her favorite hobby is exploring the New England area in search of the best bars, restaurants, activities and events.

Neely Steinberg is a freelance writer living in Boston. She is a regular contributor to the Boston Phoenix and has written for Boston Magazine, the Boston Globe's Lola Magazine, and Metro Boston. She can be reached at comments@ordinarygal.com.

Ryan Rose Weaver is a Boston-based food writer and new media editor. You can find her nursing a nameless cocktail in Fort Point, opening a bottle of crisp sauvignon blanc on her balcony in Brookline, or cracking open a cold Bud Light on a cliffside somewhere west of here.

Ashley Rossington's favorite drink is a Colorado Bulldog. She loves going out dancing, shopping, SHOES, great food, and crunching numbers.

Matt Rusteika loves writing and beer: he studied both extensively while in college. Matt has also worked for several years as a bartender, most recently in Honolulu, where he has moved to avoid things like snow and the wind chill.

Courtney Scott-Howard has lived in Boston for over ten years, during which time she estimates that she has sampled at least 300 of the city's bars and restaurants. She loves tasting a new dish or sipping a new cocktail and frequently reports on her experiences on her blog at boston-foodieguide.blogspot.com.

Christina Tuminella is a writer living in Boston.

Alexis Vandeventer is a martini (shaken, not stirred) kind of gal and enjoys the finer things in life. You can find her at any swanky lounge with dim lighting, moody clientele, and mysterious men.

Andrew Wiley is a writer living in Boston.

Arna Wilkinson lives near Boston. She is working on acquiring a Massachusetts accent. Wicked!

Stacy Williams is a high school teacher by day and a connoisseur of local cuisine by night. She believes firmly that all food and drink taste better with a shot of karaoke.

Sarah Wolf is a writer living in Boston.

Victoria Young is an aspiring hedonist with a weakness for bacon and whiskey. If she's not romping around a dive bar, she can be found on a quest for fine foods and a well-crafted cocktail. Her tummy never tires of her fervid love of all things edible.

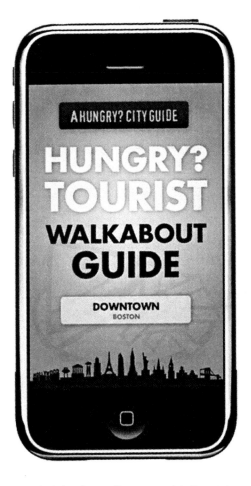

Nothing is more of a buzzkill than trying to find your way home after a marathon night out on the town. Save yourself some trouble and leave your car at home. Boston's a great city for public transportation, but the buses and subways shut down shortly after midnight. Here's a list of cab companies to get your to your next destination:

BOSTON:
Town Taxi: (617) 536-5000
www.towntaxiboston.com

Metro Cab: (617) 782-5500
www.boston-cab.com

BROOKLINE:
Bay State Taxi: (617) 566-5000
www.baystatetaxi.com

Town Taxi Brookline: (617) 232-2800

CAMBRIDGE:
Yellow Cab: (617) 492-0500

Ambassador Brattle & Yellow: (617) 491-1100

Cambridge Star Taxi: 617) 876-1700, (617) 876-8888
cambridgestartaxi.com

BRIGHTON:
Hello Taxi: (617) 734-1111
www.hellotaxi.net

SOMERVILLE:
Green Taxi: (617) 628-0600

SOUTH BOSTON:
Southie Taxi/ Checker Cab
South Boston (617) 269-4444
Charlestown (617) 242-1111

For all other areas within Boston city limits:
(617) 266-4800